OBJECTS : USA

Lee Nordness

A Studio Book
The Viking Press
New York

First published in 1970 by The Viking Press, Inc.
625 Madison Avenue, New York, N.Y. 10022

Published simultaneously in Canada by
The Macmillan Company of Canada Limited

SBN 670-52013-6
Library of Congress catalog card number: 73-87253

Printed in U.S.A.

ACKNOWLEDGMENTS

Acknowledgments are pressingly in order: correlating information on two hundred and fifty artists when there is a deadline would be beyond the diligence of any one man or even one team.

I am grateful first to Paul Smith, Director of the Museum of Contemporary Crafts, and Ola Storleer, Director of Art Objects at the Lee Nordness Galleries in New York, who accompanied me on most of my regional trips to make acquisitions. Their enthusiasm for objects as well as their contacts with artists were always catalytic; their advice on the make-up of this book always sound.

Next I wish to thank the many artists who organized our visits throughout the country, allowing us in a few days to gain a perspective on the creative energy in an area. There is not space for all names, but some are LaMar Harrington (Seattle), Mary Nyburg and Jean Delius (New Hampshire), Joan and Philip Hanes (North Carolina), Frank Colson (Sarasota, Florida), Bernard Kester (Los Angeles), Ken Shores (Portland, Oregon), John Paul Miller and Fred Miller (Cleveland), Miska Petersham (Kent, Ohio), Donald Drumm (Akron), Richard DeVore (Cranbrook Academy of Art), Nancy Jurs and Wendell Castle (Rochester and Alfred, New York), Harvey Littleton (Madison, Wisconsin), Dorothy Meredith (Milwaukee), Sheldon Carey (Lawrence, Kansas), John Stephenson (Ann Arbor), and finally Lois Ladas, a staff member of the American Craftsmen's Council in San Francisco, who maintains contact with artists throughout California.

In New York, the American Craftsmen's Council and the Museum of Contemporary Crafts could not have exhibited more cooperation in this project to promote object makers. In particular I should like to name Mrs. Vanderbilt Webb, who graciously endorsed the program at its inception, and Lois Moran, head of the research department at the American Craftsmen's Council, who offered her artists' files for my use—on and off hours. I also wish to thank Rose Slivka for commenting on my text. Her frankness was of great value, and while our attitudes toward this new art form differ in some respects, her suggestions arose from conviction and were, therefore, significant.

My personal staff worked—I am happy and proud to say—with dedication beyond any limit of duty. In particular I wish to thank Harriet Siegel, Anne Astner, John Kilgore, and José Vazques. John E. Brown, who wrote most of the thumbnail sketches, worked uncomplainingly against an impossible deadline; and Milton Sonday, assistant curator of textiles at Cooper-Hewitt Museum of Design, came generously to our assistance at the final moment to write articles on many of the artists involved in fibers.

Hugh Laing, the photographer most sympathetic to art forms I have encountered, unfortunately could not, due to illness, reproduce all of the objects in this book. Joseph DelValle and Richard DiLiberto completed the photography in his stead.

contents

this book is dedicated to **IRENE PURCELL JOHNSON**

APPROACHES TO THE OBJECT

This book represents a pictorial survey of the art objects being created in the United States. The objects range from the unpretentious teapot to the monumental sculpture; from the everyday cutting board to the unique twelve-foot woven cube. The materials range from local clays to sophisticated synthetic plastics. The styles are myriad, philosophies varied, and techniques diversified; but common to each object is its creation from start to finish by one person. Each was formed in a studio by an artist or craftsman—depending on how the person wishes to label himself— and in most cases created only in the taste and for the spiritual satisfaction of its maker. Beyond depicting contemporary objects, the book attempts to establish the creator behind each work by showing photographs of him, by commenting briefly on his contribution, and by presenting his personal statement whenever he has chosen to make one.

Notes on the Text. The text itself will, it is hoped, serve to provoke further interest in this new art form; it does not pretend to be a scholarly study of the field, although such books are now, at last, being written. Here various aspects of the contemporary object—its recent history, its aesthetic, its influence—are approached tentatively to provide some perspective on the subject. The historical background is presented in very general terms only, and key points are discussed with capsule coverage. I regret more space could not have been devoted to the history of such focal groups and institutions as the Southern Highlands Handicraft Guild, the League of New Hampshire Arts and Crafts, the Cleveland Institute of Art, the School for American Craftsmen, and many more. Later in the text, in discussing the contemporary scene, the writing becomes more subjective as I attempt to probe what I feel is the major problem facing the object and the object maker today: the problem of where the object and its creator are to be placed in the arbitrary hierarchy established between crafts and fine art. As an art dealer, my background has been with paintings and sculpture; my reactions to works created in craft media will be different from those of people working within the field. It is hoped that my personal—and often strong—feelings will not seem out of order in a book that is essentially an objective pictorial survey of contemporary objects. If, as stated above, this book is to provoke interest in objects, it is perhaps well that the reader's interest also be provoked in some of the controversies facing the object maker today.

In any case, I feel that the perspective this digest allows is better than no perspective. My intention is to provide the climate within which the artist-craftsman works by indicating the progression of attitudes toward crafts. It is for this reason that movements which involved conceptual ideas were selected rather than those which involved more practical contributions.

Object or Handcraft. *Anything that is visible or tangible and is stable in form; anything that may be apprehended intellectually; a thing to which thought and action are directed; the end toward which effort is directed, goal, purpose*—so a dictionary defines 'object.' What about 'handcraft?' *An art, craft, or trade in which the skilled use of one's hands is required*— another dictionary definition. The biting problem is that neither 'object making' nor 'handcrafting' describes the full physical and psychological involvement of a man in this contemporary field of expression. 'Handcraft' carries with it a parasitic multitude of connotations ranging from therapeutic to folksy. 'Object' represents the opposite attitude, a word almost without emotional content. Nevertheless, the purity of 'object' is preferable to the pejorative connotations of 'handcraft.'

There is a further ramification to the problem of labeling: painters and sculptors are presently confusing museum officials, critics, and collectors by creating works which do not fit into established categories. Media labeling is next to impossible: artists now mix in the same work watercolor, graphic techniques, acrylics, or oil paints, not to overlook bicycle tires, clocks, and bones. Format labeling is equally impossible: sculptors paint their surfaces and painters shape their canvases into structures which turn corners and protrude into three-dimensional space. For some time, observers of the art scene have referred to the need for new classifications—or perhaps better, no classification except 'work of art'—and perhaps the unpretentious 'art object,' due to the physical ambiguity it represents, is even safer. Paintings and sculptures are handcrafts by the dictionary definition, but only squeamishly would one label either a handcraft.

Therefore, 'objects,' and let the value-judging connoisseurs decide if the object be art.

Early Tradition. Handmade objects have been an obvious part of our national environment as far back as there have been inhabitants. The earliest settlers brought their skilled workers with them, and once here discovered the traditions of the Indian; but unfortunately there was little direct exchange of concepts and techniques: the rapport between the two approaches to handcrafts mirrored the social rapport between the two peoples. As a result of

this neglect, the Indian's crafts remained traditional, with the same forms and patterns repeated infinitely, whether in blankets or sand paintings or pottery. For the early settlers almost all furnishings and objects of decoration were handmade, the poorer people fabricating their own, the wealthy commissioning the talented. Everyone is familiar with the work of Paul Revere. (In 1967 one of his teapot and creamer sets sold at auction for $70,000.) In those days, one became a craftsman by apprenticeship, and a young man often entered servitude to a master at the early age of fourteen. Out of fear the apprentice would learn enough to open his own shop, his instruction was limited: the master carefully guarded the alkahest. Most of the work was done on commission, although a few masters set up shops for works created by inspiration alone.

The coming of the Industrial Revolution augured the end of handmade traditions. As the amount of mass production increased, fewer people turned to craftsmen. After all, manufactured objects were in general of better quality than those most poor people could make, and they were priced within almost everyone's reach. Because of our puritanical streak we did not have the wealthy class so typical of European cultures to patronize the artist-craftsman by commissioning one extravagance after another. Marcescent, the craftsman was forced to close shop and join factory ranks as designer. A few survived to work on special assignments—something the White House might order, for example—but most craftsmen associated themselves with leading jewelry or furniture companies.

Reproduction by machine became the national aesthetic.

Movements toward Craft Revival Abroad.
In England the fumes from factories' chimneys had also smoked out the craftsmen, but in the 1880s, as a reaction to the ever-diminishing quality of mass-produced goods, a revival commenced. The studio workers in this movement had undoubtedly been encouraged by the pre-Raphaelite painters whose accent on medieval form had rekindled an interest in design, thereby indicating, in bold relief, the banality of contemporary industrial forms. The pre-Raphaelites, while primarily concerned with painting, sculpture, and poetry, extended their interest to objects in an attempt to achieve a totally revitalized environment, and one of the leaders of the movement, Dante Gabriel Rossetti, designed furniture himself. Another influence emanated from the workshop of William Morris, himself a poet, weaver, book designer, illuminator, wood engraver, and most important, catalyst to all who surrounded him. The climate was favorable for artist-craftsmen: they emerged in numbers and not only banded together (in 1844) in an Art Workers' Guild, but in 1888, when it became obvious that the painting and sculpture salons would not include their work on an equally dignified level, arranged an audacious Arts and Crafts Exhibition. This exhibition restored the artist-craftsman to his position in creative society and, as well, rejuvenated the craft tradition in England.

America had much longer to wait.

Some thirty years later (1919) in Germany a significant art movement was systematized by the architect Walter Gropius—the Bauhaus Group. Its schools tuned the creative person into harmony with all the visual arts: each student was trained by a painter or sculptor and by a master craftsman, the same aesthetic intent to be applied to a painting, a chair, or pot. This broadening step accomplished, the student's training was then further integrated with architecture. Bauhaus artists were free to work in oil as well as yarn, unafraid one time to create a painting and another to make a ceramic teapot. Through his study of architecture the student would create objects sympathetic to the environment. Machines were not to be rejected or feared: they were to be placed in their proper perspective as tools. At the summit of the Bauhaus influence, Hitler disbanded the schools. Nevertheless, not only did word of this movement reach creative minds in the United States but, a few years later, when Hitler declared war, many of the converts migrated here.

U.S. Climate at the Turn of the Century.
As the twentieth century opened in America, Louis Comfort Tiffany was in the midst of his robust mission to rebeautify the object. Himself a painter (student of George Inness), decorator (he refurbished several important rooms in the White House), and finally, an artist with both stained and free-blown glass, Tiffany set up his famous glass-production studios in Corona, Long Island, in 1893. The company was soon to have over one hundred workers and employ glass blowers imported from abroad as well as any talent available in this country. But Tiffany was more than a creator—he was a crusader as well: his goal was to place art objects in every home, and he moved through a public and highly social world proclaiming his distaste for the usual environmental settings. He was influenced more by the pre-Raphaelite group (undoubtedly through his exchange of ideas with Oscar Wilde, whom he and his friends entertained during the writer's U.S. sojourn) than by the William Morris circle. While Morris rejected the machine, Tiffany welcomed it enthusiastically: it could rapidly reproduce enough handsome objects to

replace all the tastelessly designed ones in use. Tiffany's stained glass, mosaics, and Favrile pieces enjoyed great vogue during the turn-of-the-century opulence, but the statement—rich and exotic—was so special that two decades later it had no public appeal. TIffany's efforts to encourage craftsmen to work hand-in-hand with the machine by designing for industry did not have much immediate effect; but certainly he did focus attention back on the object, and undoubtedly can be given credit for encouraging the few studio craftsmen working at the time.

With the growth of union influence, working hours grew shorter and leisure time increased: those who were culturally oriented supported municipal symphony orchestras, new museums, even opera companies. A few turned to art, but the interest was really limited to the wealthy, most of whom were corralled into obedience by Lord Duveen. He would 'allow' the millionaire collector to buy a masterpiece (for six figures) while intimidating him into believing that he would probably never be able to appreciate the work fully. Duveen managed to put art on such a high pedestal that its general appreciation was probably stunted for a couple of decades. Nevertheless Duveen must be credited with having brought a healthy percentage of the world's great art to the United States. Native painters and sculptors enjoyed very little public acclaim, but they persisted and by the thirties received government subsidization through the WPA art programs.

With no craft tradition from which to work, it is a miracle that a revival was able to be generated. In the twenties there were several artist-craftsmen establishing reputations, but they were creating in isolation. Most of them were working with clay, and in general the growth of the entire craft movement in the U.S. will be approached in this text through ceramics. Original work in metal did not start until the late thirties. Margret Craver, silversmith-enamelist-jeweler, has said that in the thirties she could find no one to teach her to raise a container from a flat piece of silver; in frustration she finally sought training in Sweden. Weaving was not regarded as an art form until the forties, and glass blowing was not revived as one until 1962.

One of the influential artist-craftsmen in the twenties was Adelaide Robineau. Since there were no studio artists (or if there were, they worked privately), no potters who started and finished a piece with the same pair of hands, there were also no teachers to impart technique: Robineau not only taught herself how to throw on a wheel, but also how to work out glazes. Her statement was highly stylized—an obvious extension of art nouveau—but her works were prized, then as now, for their sophistication of execution. In fact today, with most of her work in museums, pieces are almost impossible to acquire at any price. But her influence (she taught at Syracuse University) extended far beyond the studio and classroom: she founded a magazine, *Keramic Studio*. While a publication essentially directed toward painters of china, its articles on techniques and design not only furthered knowledge in the field but maintained a dignified attitude toward the medium.

Another significant potter of the twenties was Charles Binns, known for his insistence on high technical standards in his classes at Alfred University (in New York State). Stylistically opposed to Robineau, Binns, a Britisher, was one of the first proponents in the U.S. of the understatement typical of Oriental pottery, and his high-fired stoneware was aligned with classical forms, his glazes subtle. It seems bizarre that so little could be known about the working of clay in those so very recent days: for example, ceramist Val Cushing could reminisce of when he started studying at Alfred in the early fifties, 'There was a great deal of mystery. We'd read Bernard Leach at that point, and we'd seen a couple of exhibitions—mostly of stoneware. There was an interest in finding things out. We didn't have it all on our bookshelf.' And clay artist Daniel Rhodes, speaking of the same period, said, 'We had no way of knowing what other people were doing, because the lines of communication weren't very good. We didn't know who was involved or where the whole thing was going.' This was the fifties—imagine the isolation of the artist-craftsman in the twenties.

The thirties was a period of increasing enrichment for the field, and several important studio artists working with clay emerged: Charles Harder (who perfected reduction firing as well as the copper-red and celadon glazes); Glen Lukens (who experimented with textures and surfaces); Arthur Baggs (salt glazes and porcelains and high-fired stoneware); Henry Varnum Poor (the first painter of stature to take up ceramics, indicating how clay surfaces could be used for painterly expression). One of the most dynamic personalities in ceramics—and one of the first to emigrate from Europe—was Maija Grotell. After receiving her training at the Central School of Industrial Art in Helsinki, she came to New York in 1927, where she taught for several years at the Henry Street Craft School. Then she accepted the position of head of the department of ceramics at the Cranbrook Academy of Art in Michigan. Like most of the transplanted Europeans, her technical knowledge was advanced.

More important, she was able to communicate her own dedication to clay and the object. Miss Grotell is still at Cranbrook and is a living myth; her works are on display in twenty-one museums and her ex-students (many today important potters themselves) regard her as the high guru through whom they found themselves.

When the Depression was in full swing, the public was hardly in the mood for the luxury of buying one-of-a-kind objects, nor was the number of major craftsmen working very impressive for a nation so large, but the message was spreading—even if only by word of mouth; and more important, the stage was being set, with props securely placed, for the decade to come. Important in this respect was the opening of art schools with craft courses in their curriculums: Alfred and Syracuse, the Cranbrook Academy of Art, and the Cleveland Institute of Art.

In the evolution of crafts leading to the art object, the war years were noteworthy for stimulating the migration of several mature artists to this country—many of whom turned to teaching. Just as painting received an adscititious stimulus during those years by having Max Ernst, Fernand Léger, and Marc Chagall here, so the craft scene was enlivened (and enlightened) by the appearance of distinguished European reputations. Four such personalities were Marguerite and Franz Wildenhain, Anni Albers, and Trude Guermonprez, disciples all of the Bauhaus. The Wildenhains settled north of San Francisco and soon established the now-famous Pond Farm School of Ceramics. (Later Franz moved to upstate New York to teach.) Each sought to establish technical excellence in clay and to nullify the long-standing judgment of the medium as 'minor.' Marguerite's writings on the integrity of the art of the potter are some of the most eloquent in print. Anni Albers and Trude Guermonprez, both weavers, taught American craftsmen to re-evaluate the loom as an expressive tool by demonstrating that fibers could be bound in nonfunctional forms with the probing validity of a work of art.

Also during the war Mrs. Vanderbilt Webb, a wealthy patron of crafts, opened America House in New York, the first major retail outlet designed to acquaint the public with the richness of the handmade object. Mrs. Webb's contribution will be discussed at length later.

The war effected a serious reassessment of values by the younger generation—whether the war had been spent in battle, at volunteer work, or in detention as a conscientious objector. Instincts of self-protection and chauvinism can bolster one's toleration for war only so long: piercing and sinuous doubts appear with increasing frequency during the night watches. All wars, ironically enough, leave an aftermath of spirituality. Although for the many a return to Sunday religion may suffice, for the sensitive it is often not enough: more important is finding an ambient pattern of existence commensurate with serious moral values, whether this involves theistic, agnostic, or atheistic approaches. In 1947 a group of American men and women in their twenties emerged who had been torn by the war away from the usual American way of life. They were ready to consider their futures—especially the educations for them—but what involvement could guarantee self-respect? Alienated from the *status-quo* social structure, they foresaw the more general and serious alienation which would come in the fifties and keep psychiatric couches occupied. Of this war-shaped generation many creative people turned to the crafts where one could work with the hands and make something from start to finish without demotic interference. In a 1966 interview potter Robert Turner said, 'When I got involved, we weren't so much concerned with the object as with a way of life—a result, I think of the war period. We were looking for—the word used then was—integration.' The World War II graduate turned to object making so that he could symbolize through earth and fire (or wool and loom, hammer and metal) his individual *rapprochement* with the universe. And because he would create his object from start to finish with his own hands—a privilege in our day reserved almost exclusively for the artist—he could hope to integrate the meaning of his labor with the dictates of his spirit.

One may well ask why many of these sensitive people did not enroll in painting and sculpture classes, or if they did, why they changed later to creating in a craft medium. The decision to take craft training, to work with the hands professionally, was obviously not a spontaneous stampede. First of all it must be remembered that ceramics, weaving, enameling still really represented underground movements, or at best movements active only in certain cities or areas. Over and again one hears from one artist after another that he or she 'accidentally' started weaving or making mosaics or jewelry, 'accidentally' in the sense that the person had not realized that one could study in this field. These people searching for a way of life found a suitable solution through a chance article in a magazine, through conversation, through wandering down a hallway in an art department and stumbling into a ceramics class, through seeing a pot or a silver chalice at an exhibition (although this was the rarest introduction since there were few shows of contemporary objects).

Others started with painting and sculpture, remaining with these traditional art expressions until discovering object making. Again, why objects? For many there was of course the lure of the medium itself, a rapport with yarns, silver, glass. Important indeed, but just as influential was the impression that the milieu of painting and sculpture was impregnated with values the young idealist could not endorse. The art world of the late forties and early fifties was hardly the giant business operation it is today, but for someone young it still appeared to be 'swinging.' Art magazines were publicizing and celebrating painters; one read of glamorous gallery openings and rumors were abundant of behind-the-scenes intrigue between adherents of various stylistic approaches. Even today object makers often admit they did not go into painting and sculpture because it seemed to represent a 'big deal.' The milieu of the art world was tainted: but crafts seemed unencumbered from pressures outside the studio (public demand, critics, publicity).

Another important motivation for turning to the crafts by this group should be considered. The avowed painter or sculptor, even as a student, is concerned with the solution of problems much larger than himself, and is working both subconsciously and consciously toward the creation of universally understood forms which will express his time and place. There was little, if any, of this kind of elevated talk among people going into the crafts during the five years after World War II. Moreover there was seldom reference to the crafts as an art form; the vocabulary referred to craftsman, not artist; and object, not art object. The drive was not to join the ranks of Da Vinci, Reubens, Rembrandt, Picasso: it was to belong to the ranks of the spiritually integrated, the Thoreaus, the Emersons, the Whitmans. For the creative person seeking spiritual harmony, working by hand in craft media was an answer.

After World War II, crafts found an additional outlet in the university. Unlike the earlier tradition where the young man was apprenticed to a master, learning more skill than philosophy, the contemporary object maker as college student concentrated more on philosophy than skill. And because there were few gifted college craft teachers, the student often had to seek his technical proficiency by attending private summer workshops under masters. It is important to be aware of this university orientation for two reasons: first, one can then understand how serious was the commitment to work with the hands. If, through a formal education one was exposed to many professions for a career and still elected the least glamorous field of the arts, the decision indicated deep dedication—whether to the object itself or the way of life it represented. At that time, and for years to come, there was little or no market for the objects to be created, and certainly no assurance of enough income so that one could be self-supporting by object making alone.

Secondly, a university education acquainted these artists not only with many cultural fields, but with many cultures. It was important for the contemporary object maker to be aware of the many forms that had been created in the past. Only then could he face the challenge of forging a new tradition. The chain had been broken in the nineteenth century in the U.S., and one could not start with 1850 forms and expect them to express the attitudes of 1950. The student-artist drew from source material as varied as Han bronze vessels, Egyptian glass tearbottles, Byzantine mosaics, Limoges enamels, pre-Colombian Peruvian weavings, Etruscan terra-cotta burial figures. For the hand's future use form after form was mentally stored and perhaps tactily known by being imitated. What resulted would be an international— i.e., non-national—individual statement. There is no identifiable American style in objects unless diversity itself be a style.

This much space has been devoted to discussing the education of the craftsman only because it is so often overlooked. The public assumes a contemporary painter or sculptor has been to college: one does not necessarily assume the contemporary ceramist or furniture maker has. In nine cases out of ten, however, the person involved with the handmade object is an intellectual who regards his home as a temple and has built within or nearby it a studio he regards as his adytum.

After the World War II object maker finished his education, the next move frequently was to locate a natural setting in the country for his home and studio-workshop—usually as far away as possible from urban centers. This was the mode already established by the war emigrants. The Wildenhains selected a mountaintop on the southern edge of California redwood country (later to become a state park) to build—with their own hands—a school of ceramics. Anni Albers and her painter husband, Josef, established themselves at Black Mountain College in a North Carolina village. The graduates scattered far and wide: Paolo Soleri in the Arizona desert outside Scottsdale; Paul Soldner in a valley near Aspen, Colorado; Dorian Zachai on the edge of a New Hampshire village; Jerome Wallace on the northernmost Hawaiian island of Kuaui. The reasons for these artists' avoiding cities: those working

with media involving kilns often encountered zoning restrictions; on a small income, country-style life kept overhead low. Yet the painter and sculptor resolved these two problems and remained urbanized: a sculptor working with blowtorches or casting equipment found warehouse space with no zoning prohibitions; and he and his family kept down expenses by renting an apartment in a slum area. Evidently the country was a major ingredient of the living pattern chosen by the object maker. After all, what did the city offer? It held little or no market for his works, and few or no museums interested in showing them. To visit artist-craftsmen today, especially those of the postwar generation, is to know silent valleys, dirt roads, unhampered vegetation—and usually homes crafted by hands concerned with every surface.

Varieties of Object Makers. Before going on to look at the development of the object-making movement, it might be well to put into relief the different directions the crafts can take. Broadly speaking, there are three.

Industrial designer: a craftsman who truly designs (a discussion of 'design' will follow), working out drawings and models for objects to be mass-produced, no matter how large or small the commercial concern is. He must adapt his designs to the image of his company, as well as consider their technical potentialities. Usually very complicated designs are avoided because of the great expense in setting up such machinery. The role of designer for industry is not necessarily unpleasant: if the company is forward-looking the designer will be respected, and if he is a good designer it will certainly mean an upgrading of the efficiency and aesthetics of our manufactured objects.

Production designer: a craftsman who reproduces his own objects. Most production craftsmen work in functional forms (teapots, vases, dinnerware), and they enjoy certain advantages over the industrial designer. The production craftsman runs a shop and may have as many people working with him as he requires; all of the prototypes for the objects are made by the owner, and each object coming out of the shop is made by hand—but not necessarily by the owner's hands. The craftsman-owner is able to maintain close supervision over the entire production. Also, because little complicated machinery is involved, forms can be changed and redesigned at will without great expense. These craftsmen usually market their objects through department stores or gift shops, producing various pieces as orders come in.

Studio object maker: an artist who works alone and with complete freedom (whether he is successful or unsuccessful) in a studio creating objects satisfying only his standards of technique and aesthetics. These are the artists about whom this book is mainly concerned. I have included a few production craftsmen (Bill Sax and John Glick, as well as two designers for industry, Dorothy Liebes and Jack Larsen) to illustrate the superiority of their work over that of the usual mass-produced object.

Concern with the Object. It has been stated earlier that in general the numbers of people who entered craft training at the close of World War II were looking more for a 'way of life' than for an involvement with either the medium or the object itself. By the fifties the mood had changed and the studio artist returned to a primary concern with the object. And well he might.

It was not just that the look of the object in the U.S. was banal (as long as banal business heads control production firms there will be banal objects). Equally offensive to the sensitive are the manufactured objects with 'built-in obsolescence.' With few physical 'things' in our lives made to last it becomes a throw-away world—throw-away plastic bags, neckties, wall-to-wall carpets, even automobiles. If an object is easily disposable how can it have any possibility of containing an enduring meaning? The result: further alienation from the environment. A recent New York *Times* book review quotes a line from a new novel (*Slaughter-House—Five*) by Kurt Vonnegut, Jr.: 'Like so many Americans, she was trying to construct a life that made sense from things she found in gift shops.' With many objects having the same function to choose from (a vase, for example), one selects the one which elicits an emotional response. ('It's *you*, madame, and it's only $29.95'). But how long can this emotional response last when the owner runs into an identical vase in friends' homes, in hotel rooms, in other shop windows? If the objects in one's home reflect the owner but many other people have the same objects, then the owner must only be one of a type. And so after tiring of seeing the same form in other places—and chances are it wasn't technically well constructed— she throws the vase out. This search for some object which is unique (one of a kind) has led many people toward antiques: there the problem of duplication is greatly reduced. But antiques are expensive, and there are—thank heavens—people who prefer to live with contemporary forms.

The studio-craftsman, choosing his profession so that he could work with his hands, inevitably had to assess what it was he was making. When he found how strong was the need for an object with technical excellence and aesthetic vitality, these goals became his new dedication.

The Fifties. A period of creative expansion

arrived in the fifties, as well as a period of serious (although still tentative) recognition of the artist-craftsman's contribution. It was also a period of cross-fertilizations among object makers themselves as organizations and national conferences were initiated; but this communication between the craftsmen of the nation will be discussed later in relation to the magazine for the field, *Craft Horizons.*

The studio artist during this period revolutionized the creative concept of the object. Three figures, each working in a different medium, illustrate the change. Wendell Castle, an artist who took his university degree in fine arts as a sculptor, turned to furniture making (no such course was taught at his university, so, as often happens with the artist-craftsman, he had to teach himself). Instead of the traditional method of making furniture by joining finished parts, he laminated untooled layers of wood together to make large blocks: now the size of the piece of furniture need not be restricted by the size of the log available. He then attacked the man-built mass of wood as a sculptor would a mass of granite, carving his furniture in one piece. As a result new freedoms were opened, and Castle's flowing organic forms received quick national and international response: his furniture was taken as near sculpture as possible while still remaining functional. In textiles, Lenore Tawney, for some time well known as a weaver, moved into three-dimensional forms, constructions evoking the power and spatial relationships of sculpture. In ceramics, Peter Voulkos, reputedly the most dexterous wheel potter in the country, put more than one neck on a container, gave it a variety of uneven forms, developed flowing, moving surfaces, and finally closed the opening altogether. The pot became a nonpot, a nonfunctional object. Because this once-revolutionary concept has been assimilated, it is hard to believe the development is so recent. But not until the fifties, when many object-makers trained in functional forms broke from the pattern to create objects *per se,* was fine-art terminology applied to the works of craftsmen.

With the proliferation of craftsmen maturing in the fifties and the quality of their work—both along consuetudinary and experimental lines—so obviously progressing, museums (mostly smaller ones) and galleries gradually began to take notice. In the Spring 1950 issue of *Craft Horizons* a 'Craftsmen's Calendar' appears for the first time, with a one-column list of exhibitions across the country. A good number of the shows were not even of contemporary objects. The following announcement is not atypical of one of the early listings: 'Through March. Englewood Weavers Guild, 1950 Spring Exhibit, 447 West 60th Place, Chicago 21, Illinois.' Nevertheless, the object maker was being noticed, and several were given one-man exhibitions in New York galleries. America House, before its move in 1956 to new quarters on 53rd Street, also gave a series of significant one-man shows. But the New York galleries did not show a sustained interest in these artists: the public was not ready to regard the handmade object, then often still functional, with the same seriousness as a painting or sculpture.

At the end of 1955 full-fledged reviews of object exhibitions began to appear in *Craft Horizons,* reviews written by fellow object makers—which is still mainly the case in the magazine. At the end of the decade (June 1960) Rose Slivka writes at the head of the 'Exhibitions' section, 'It has been a heavy exhibition season with the number of shows so large that it was necessary to reduce the type size of this section in order to fit them in. . . . The number of competitive group shows, local, regional and national were overwhelming. The comparative number of individual, one-man shows—giving a clear idea of a craftsman's body of work, dedication, style and development—were meagre.' In other words, the object was being recognized, but not the artist behind it. And it is depressing that even today many nongallery retail outlets display artist-craftsmen's work with no identification of the artist, and sales slips are too often written up without the artist's name.

Another significant change occurred in the fifties: an important segment of the movement became university oriented when its most inventive artists turned to teaching. Ever-increasing numbers of universities and colleges added 'craft courses' and 'design departments' to satisfy the demands of students. As with painting and sculpture departments, the university wanted the most renowned artists: the instruction would be superior, and their names would lure even more students. Interviews with many artists who now teach indicate that the three most cogent reasons for having relinquished the private studio for the classroom were, in order of importance: (1) a feeling of responsibility toward proper education in object making, which at that point was mostly provided by nonprofessionals. It was also necessary to have a strong creative faculty to assure crafts their proper position in the university hierarchy: although more and more students were enrolling, 'craft media' were in general snubbed by the art department: ceramics and weaving classes were located in basements or temporary buildings, and the painting and sculpture faculties ignored object makers' demands. (2) Many leading

artists who accepted teaching positions also felt that the university had much to offer technically: varieties and sizes of kilns for ceramics or enameling and looms for weaving were available which many studio craftsmen could not afford; materials were often provided at no cost; and teaching loads were light enough to provide adequate studio working periods. Most artist-craftsmen had had to maintain outside jobs anyway to make ends meet until a market could be built up—and in general the more experimental the artist, the slower his market was in appearing. The artist also felt that while the university was not the private world of his home studio, it was nevertheless a world immured from the everyday urban crises on one hand and the stultifying commercial effects of industry on the other. (3) The final reason was assurance of financial security.

The university proved to be primarily responsible for bringing public attention to the new object artist. As campus art departments grew in importance, college museums opened and the object was shown along with painting and sculpture. Many collectors of contemporary ceramics, enamels, and weavings have made their first acquisitions at university exhibitions; commercial galleries off-campus opened to show these artists all year. And as the object movement gained respect at the colleges, grants were given to their craft departments for special studies which led to significant advances. As an example, the Tyler Institute in Philadelphia built an expensive laboratory for Stanley Lechtzin to experiment in electroforming. Its success gave jewelers a new dimension: the possibility of making massive body ornaments still light enough to be worn comfortably. The University of Wisconsin has recently given a similar grant to its metals department: a metal-forming process evolved which builds up objects with a fraction of the effort required by using traditional tools. The university has also provided a great meeting house for ideas: leaders in the field exchange posts throughout the country, bulletins are published, frequent seminars and conferences are held.

Even though the American Craftsmen's Council, the Museum of Contemporary Crafts, and America House are in New York, the objects movement at present has barely made a dent on the city. Most of the creative breakthroughs by the object makers—as well as recognition for them—have occurred either rurally or in other cities—and usually cities with a university campus. The states with the strongest craft movements (California and Wisconsin) are those with the largest number of universities teaching craft media.

The past decade has seen further proliferation of dedicated object makers as universities across the country graduate them by the thousands. It has seen a few well-known metropolitan galleries, museums, and collectors treating objects with dignity. It has also seen a great variance in attitude from the 'way-of-life' climate which prevailed in the early fifties. With a plethora of artist-craftsmen has come a plethora of statements; simultaneously considerable recognition among artists has come to the field. The artist-craftsmen from the early fifties still speak with humility. Robert Sperry says, 'How many radical ideas are brought forth in each generation which create significant new trends in the art world? Usually very few. The majority of us must be content to do what we are capable of, with honesty, and to the best of our ability.' Daniel Rhodes comments, 'We have to recognize that all objects that men are making, with few exceptions, are for future rummage sales. There is this obsolescence that is overtaking us all, and we can't really judge things anymore on the basis of whether they're going to last. It can be assumed that nothing is going to last, and that we have to live it as an experience.' It would be unfair to quote specific younger artist-craftsmen, those who have been graduated in the past two or three years, but suffice it to say that often their attitude contains much less humility. They are ready to exhibit—and most of them are doing so. The notoriety from which the early artist shied is a lure for many of the new-wave artist-craftsmen. There is a dire need now for serious critics to review their works. New York, as the contemporary art center for the world, still has not one critic to assess the merits of new objects: announcements of exhibitions appear in New York papers as feature stories (usually on the woman's pages). There are good critics of objects in other parts of the country, but not many people in Detroit or New York follow what a critic says in San Francisco, and certainly few people abroad do. With critics of national reputation (one assumes good critics), a framework of standards can be set and the lesser talents reduced to size. *Craft Horizons* reviews exhibitions throughout the country, but the reviews seldom weigh relative merit: if not completely laudatory, they are solely descriptive.

Public response to the object movement has not yet exploded, but any sensitive observer can see that the fuse is lighted. With the explosion one hopes that the seventies will bring some sober evaluating from museums and critics so that there can finally be a moment of truth for the thousands of object makers turning out

at the Museum of Contemporary Crafts entitled 'Objects are . . . ?' This topical and pertinent show specifically examined the issue under discussion here—is the object craft or art? is the maker craftsman or artist? By being shown an extensive variety of objects—some on exhibition, some seen on slide machines—the public was exposed to the difficulty of doing what it likes best: pigeonholing.

The magazine commented: 'The show does not answer the question. What it does is present us with some startling evidence that the traditional artistic categories are undergoing real changes. Is Henry Halem a potter? Yes, he certainly is. But is it just, proper or even accurate to label him "potter Henry Halem" when his skills so obviously extend into other directions? Is Claire Zeisler a weaver, a sculptor, or both, or neither, or is she a brand-new kind of craftsman?'

The magazine and the Museum of Contemporary Crafts have still not committed themselves unequivocally to the position that the crafts movement is basically an art movement (that some objects are art), but they certainly are acutely aware that the issue can no longer be avoided. Nevertheless they mark time: it is after all the artists who must lead the critics, museum directors, magazine editors. The artists' recent expressions so extend the established definition of art that the term may soon not define either contemporary paintings or objects. Perhaps in a few years 'fine art' will be an anachronistic expression: perhaps it is even today.

This thumbnail encounter with one basic and recurrent theme of the leading craft journal illustrates that the movement had unpretentious beginnings indeed. The initial encouragement was voiced in almost schoolmarm fashion—practical, patriotic, moral. And yet, homiletic as the early articles appear, a concern that high technical standards be mated with originality (born of strong character) accounts in no small degree for the probity so typical of today's mature object maker.

Design. To follow another leitmotif which illustrates the object maker's relationship to fine-art terminology: for someone arriving at an appreciation of the contemporary object after having been immersed in painting and sculpture, one term special to the object field jars against the sensibilities—*design*. Painters and sculptors rarely use the word.

Painters and sculptors speak of composition and form; *design* connotes a surface or shallow expression: in other words, decoration. Obviously some artist-craftsmen hold deeper

definitions of design. Fred Meyer writes that design previously meant 'applied decoration,' but that its definition has now evolved so that 'design is that which remains with a given piece of craft or art work after the technical aspects of the craftsmanship have been exempted. Design, as creativity, is the soul of the piece. . . . Design must therefore be defined as a religious or philosophical matter.' Meyer admits that educators in the crafts think of design as a merely decorative matter: 'The word "design," as generally accepted, is ephemeral and manufactured and of use only to define an artificial science which defeats itself by hewing to formula, and adopting labyrinthine terminology. Current output from these design schools incriminates itself by an easily identifiable sameness.'

To the art world in general the term 'design' is certainly more often used to indicate contrived decoration than the quiddity of a work of art. It seems more logical that if an object maker considers himself an artist he should be realizing his work in terms of composition and form, and throwing out of his creative vocabulary such an unstable word as design. The Museum of Modern Art in New York maintains a tradition, however, of putting objects—at least functional ones—by artists (such as Gertrud and Otto Natzler and Harvey Littleton) into its Architecture and Design Department, juxtaposing them with objects which are rightly labeled designed—because they are for production—such as radios, can openers, computer parts. When Rose Slivka became editor of *Craft Horizons* in 1959 a fresh perspective and sophistication appeared. Mrs. Slivka, who is equally at home in all of the arts, soon revealed her preference for 'form' over 'design.' In a 1965 editorial she wrote, 'The craftsman is probing at the limits of his expression and in so doing has expanded his materials, his *forms* [my italics], and his scope.'

One of the major reasons that this inconsistency in the field occurred—thinking of objects in terms of art, but using verbal references which apply to production work —was that there was an obvious dichotomy within the realm of crafts, a dichotomy established in the forties with the founding of *Craft Horizons*. Mrs. Webb, in an interview, said that her commitment to the field was one of 'utter happenstance.' In the late thirties, in order to find a means of income for the Depression poor in Putnam county (where the Webbs maintained a home), Mrs. Webb organized these village people into crafts groups. An outgrowth of this involvement led to the opening of America House, thereby assuring craftsmen of at least one sympathetic retail outlet. With America House, as we have seen,

came *Craft Horizons,* and both at that point (in the beginning America House's range of 'crafts' included hand-processed cornmeal) were servicing amateur or folk craftsmen, psychologically production craftsmen. But already appearing in other parts of the country were studio artist-craftsmen (Maija Grotell, Lili Blumenau, Alfred Binns) who did not wish to exhibit in such an atmosphere. Mrs. Webb, concerned with this problem, reorganized the exhibition standards—out went the cornmeal. Nevertheless, Mrs. Webb's heart was with the country craftsmen, and the magazine, particularly during the forties, reflected it. If it had been founded by a Marguerite Wildenhain or if a Rose Slivka had appeared earlier, undoubtedly the tone, and certainly the terminology, would have been more closely allied to that used by painters and sculptors. In the context of the aesthetics of serious object makers it seems futile to defend a word like 'design.' It can be defined and redefined, but why bother when the sculptor's terms of 'form' and 'composition' are really what one intends? Any definition of 'design' beyond the meaning of a preliminary sketch must, if the dictionary and the connotations derived from usage are to have any legitimacy, involve the shading of 'contrived.' An art object cannot be designed or contrived out of a piece of clay, metal, fabric: it must be *formed,* with the hands and the media shaping each other's direction until a concinnity is reached. Few completed objects ever duplicate the design (preliminary sketch), and if they do the chances are that the objects will appear 'forced.' A form only becomes significant when the illusive quality of 'x' happens between the intent of the artist and his hands and his media: this is the private 'happening' that results in art. In the case of the object maker, it could be called a 'haptic happening.'

In 1947 Mrs. Webb turned the magazine over to the hands of professionals, but it is obvious her direction continued to guide its philosophy for the next few years. Mrs. Webb, herself a potter, eventually recognized—and accepted—the shifts in emphasis, directions, and intentions occurring in the field. In 1943 she founded the American Craftsmen's Educational Council (later to drop Educational) in order to establish contact between the isolated craftsmen across the country, and in 1957 she organized a Craftsmen's Conference at Asilomar, California. Craftsmen still relish the *esprit* of this first catalytic confrontation between talents from all over the nation: few words in the history of contemporary objects retain the magic of Asilomar. As hundreds of object makers met, many for the first time, and exchanged enthusiasms,

Mrs. Webb demonstrated her belief in her fellow artists by granting them aesthetic liberty: she realized that what they would let happen would be right for them—as well as right for the state of the contemporary object. In 1956 she effected the opening of the Museum of Contemporary Crafts, sensing there must be a museum showcase on a national level. Her personal tastes—often conservative—are not in rapport with a great deal of the work displayed there, but again she has wisely placed responsibility for its exhibition program back into the hands of artists. (The museum director must account for his exhibitions if the artists who are members of the National Craftsmen's Council complain to the board.) At present Mrs. Webb is deeply committed on an international level—organizing the World Craftsmen's Council. Two successful conferences have been held, the first in New York, the second in Lima, Peru.

Today the dichotomy has been workably resolved. Mrs. Webb has erected a superstructure with which the artists can remain in stimulating contact—and rural craftsmen have been replaced by studio artists on the committees. That is, Mrs. Webb's refined sense of organization provides the platform for the studio artists' credenda. No more cornmeal (no matter how well intended), no more magazine sermons directed to farm women. Mrs. Webb is now respected as a superactive guardian angel, respecting and respected by the creative object maker. And if for no other reason (and certainly there are many more) Mrs. Webb will be mentioned in all histories of the American object movement as the person responsible for the one written record of its development since 1943.

The Collection. Most of the objects and artists discussed in this book are represented in the OBJECTS:USA collection purchased by S. C. Johnson & Son, Inc. However, the collection, limited to three hundred works so that it would not be too cumbersome to tour the country, does not and could not represent every excellent artist working with objects today.

Some artists did not have major works for acquisition at the time; in many cases there are numerous artists working within the same expression, and selection was made on the best works within each style available. The entire range of object making could not have been shown in depth with three hundred works—it would require at least three hundred objects alone to show the field of ceramics comprehensively. The objects in the collection were selected to reflect a representative cross section of the materials, techniques, and styles evident today.

The purpose of forming the collection

was to focus public recognition on the hand-made object.

To acquire the collection Paul Smith, who unstintingly served as advisor to the OBJECTS:USA project, traveled with the writer throughout the United States— through cities, arable, champaign, and forest—for an eight-month period. These trips were necessary for a number of reasons, two of which made the trips indispensable. First, most mature object makers working long hours to make a living can hardly afford time to keep the research files at the Museum of Contemporary Crafts stocked with photographic documentation of recent work. Second, there are literally thousands of younger artists being graduated from universities who had to be checked out. Letters were sent to leading artists for recommendations, and art schools were alerted for names of recent graduates.

In New England summer is the time for craft fairs, and three of the largest were visited. It was moving indeed to have this tour begin with the fair at Mt. Snow, New Hampshire. Half of the artists were squeezed into booths crammed into a lodge; the other half occupied an uncovered, unpaved parking lot called the 'tailgate' area: the 'booth' was improvised by dropping the rear gate of a station wagon or bus. No one complained: the object maker may be idealistic about his objects, but he is realistic about his public. Since there are not enough galleries providing markets, he accepts the concept of the fair: from three or four outdoor shows a summer he can sell enough to last the winter. How different these craft fairs are from the usual summer painting and sculpture fairs—whether it is on a city street or in the high-school gymnasium. Unless some charity is involved, the show is usually dominated by bad artists (really nonartists), with an occasional student showing promise: the good artists sit tightly in their galleries. But at the craft fairs the percentage of fine artists is high indeed, and they proved good sources for the collection.

The regional museum exhibitions were further sources of talent for us, and we visited as many as possible, such as the American Craftsmen's Invitational at the Henry Gallery (Seattle), the Toledo Glass National, the Wisconsin Designer-Craftsmen exhibition (Milwaukee). Most of these exhibitions are juried by artists and officials of museums, thereby eliminating most amateur work.

At universities and colleges the art departments cooperated by providing exhibition areas for artists in the region to bring in their works. At these institutions we also saw at first hand the incredible numbers of young artists working in craft media who a few years ago would probably —because there were no such classes offered—have gone into painting and sculpture.

All of our documentation was then correlated in New York. Acquisitions of actual objects were made in the following manner: from established artists acquired when seen, or if the artist had nothing major but had time to do a commission, one was negotiated; from lesser-known or younger artists by waiting until all trips and research were completed and then selecting those works which would represent best the different trends in media and technique. Because these decisions were often made long after the initial contact with the younger artist, the specific object we wanted might have been sold: in this case we asked, at our expense, to have a selection of newer works sent to New York for review.

We discovered on our trips that a number of American Indians had been liberated from traditional forms and were now creating in personal directions. Again it has been a matter of education: excellent schools have been established for the Indian craftsmen, particularly the Institute of American Indian Arts in Santa Fe and the Extension Center for Arts and Crafts at the University of Alaska. The collection includes work by several of these artists.

Having to face a cutoff date and make final selections was the only unpleasant part of the project: with only three hundred objects to be acquired, hundreds of talented people could not be included. Therefore, with justifiable repetition, it must be stated that the artists in this book represent merely a cross section of some of the most talented people working in the U.S. today.

The entire collection was financed by S. C. Johnson & Son, Inc. (Johnson's Wax) as part of its corporate-responsibility program. Just as this company, through its previous art program, ART:USA, brought international attention to the painters in this country, it has endorsed the OBJECTS: USA project to focus attention on the quality and originality that has taken the revival of handcrafts out of the realm of folk art and into the world of contemporary art as documented by museums. It seems difficult to believe now that in 1962, when S. C. Johnson & Son put a corporate stamp of approval on contemporary painting, there were few corporations who dared a public endorsement of contemporary fine art. Certain businesses were acquiring art for internal decoration, but Johnson's Wax ventured to assemble a collection under the name of its firm and tour it throughout the world. The paintings were sent first to Europe and Japan, the feeling being that

museums in this country had already recognized and acquainted a large segment of the public with the vitality of these artists; but that Europeans, because our government would not appropriate funds to export art abroad, were not fully aware of the power and scope of our art since World War II. With objects the situation differs: although European object makers are well aware of our leading artists in craft-media, and in fact are influenced by them, the general public abroad still thinks our contribution lies mainly in the field of design for mass-produced products; but then in general this same misconception governs the American public as well. Most Americans seem to associate leading artists in the field with the Scandinavian countries, or perhaps with Germany and Italy. But in fact, most of the artists there are not working in private studios: it is they who are allied with industry as designers. The American craftsman is the one who was dedicated enough to work alone in his studio without a market, and who, because of this privacy and freedom, elevated the handcrafted object to that of an art object.

There is no question but that the Johnson company's endorsement of painting in 1962 had a quiet influence on government thinking, and this endorsement of our healthy artistic climate gave Smithsonian officials the leverage to get appropriations for their new building for the National Collection of Fine Art. Happily it is now rare for a senator or congressman to rant for the record about the sick or Communist-tainted or irreligious painting some people want to send abroad as examples of our cultural maturity. Nevertheless it is equally rare for a congressman to spend speech time endorsing our artists' contributions. For this reason, ART:USA was opened for its U.S. tour in Washington; and for the same reason the exhibition, OBJECTS:USA commenced its tour in the national capital.

Although S. C. Johnson & Son's products are not in any way allied with the arts, the company still maintains a profound respect for creativity, a heritage handed down from father to son in the Johnson family. It was no wonder then that the past chairman, H. F. Johnson, sought out Frank Lloyd Wright (in 1936 when he was hard on his luck) for the company's building in Racine. Nor that Mr. Johnson should have endorsed American painting (with the guiding influence of his wife, Irene Purcell Johnson); nor that the same Mr. Johnson should have commissioned Francis Thompson to do the Academy Award-winning film short, To Be Alive; nor is it a wonder that the new young president, Sam Johnson, should use his corporate-responsibility funds to promote the American object maker.

The involvement of business in the arts is a serious one, and this writer firmly believes that it is the obligation of business, whenever it can, to act as the patron of our cultural statement—particularly when the government's endorsement is so quixotic. At the time of ART:USA's opening in Washington the local critic, Frank Getlein, wrote a report which his paper, the Evening Star, considered important enough to be placed on the front page. In effect, the review stated that when the government fails to supply a need of the public, the public has a way of doing it itself.

Coda. With the typewriter effecting such cacography that the survival of handwriting is questionable; with twentieth-century working hands stretching out only to make some part of a product; with mass production engendering a detached attitude toward the object, it seems logical, in retrospect, that some creative sensibilities would revolt, would return to the studio with the most unpretentious of goals: to create from start to finish objects with which a public could personally identify.

From the twenties through the forties this pioneering group returned to hand work, some as a way of life in reaction to the machine monarchy and its resulting environment of the impersonal, and some explicitly to beautify the object, to instill in a form an aesthetic that would consume its function. These objects were never intended (nor are they now) to replace or even compete with the mass-produced object: every environment requires functional disposable objects for twentieth-century ease; but the responsive person must balance these objects with those which can serve as extensions of his own personality. The mass-produced objects of today will never be the antiques of tomorrow: at best they might survive (if they hold together) as possible curiosities of tomorrow.

It now seems a miracle that these artists persisted, despite their isolation not only from the public but from each other, and despite the fact that mass production rang up all the sales and garnered all the attention through lavish advertising and publicity campaigns. But awareness of this expression finally spread among the public as the objects passed from hand to hand. The passion put into the object was transferred to the owner: tactility became a new alertness. Following the visual and tactile response came a deeper emotional-intellectual involvement: the one-of-a-kind object is inherently personal, the rapport intimate.

Today one realizes that a good number of these objects are art, and their creators artists, and it is these artists who fire an object with aesthetic endurance that OBJECTS:USA honors.

Note: Due to space limitations the biographical data noted for each artist is abbreviated. In almost all instances the 'collections,' 'teaching,' and 'commissions' noted are partial, as each artist was limited to only five listings.

Measurements for objects are, unless otherwise specified, always height first, width second; if a third measurement is given it represents depth.

there are no tonal variations, no detail or
embellishment, no clutter to dilute the bold
impact of the shape. The enameling
technique itself is quite elementary, which
only serves to reinforce the presence of the
total object, rather than its parts.

birthplace: San Diego, 1913
education: San Diego State College • Los Angeles Art
 Center
collections: Everson Museum of Art (Syracuse) • Joe and
 Emily Lowe Art Gallery (University of Miami) • Dallas
 Museum of Fine Arts • Wichita Art Museum •
 University of Illinois
residence: San Diego, California

NOW EMBLEM: two-sided construction of
enamel on copper with wood: 24¼″ ×
37½″ x 7¼″: 1966

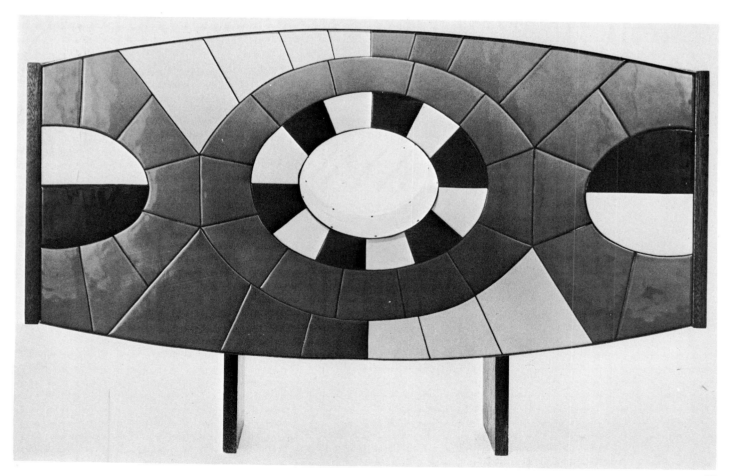

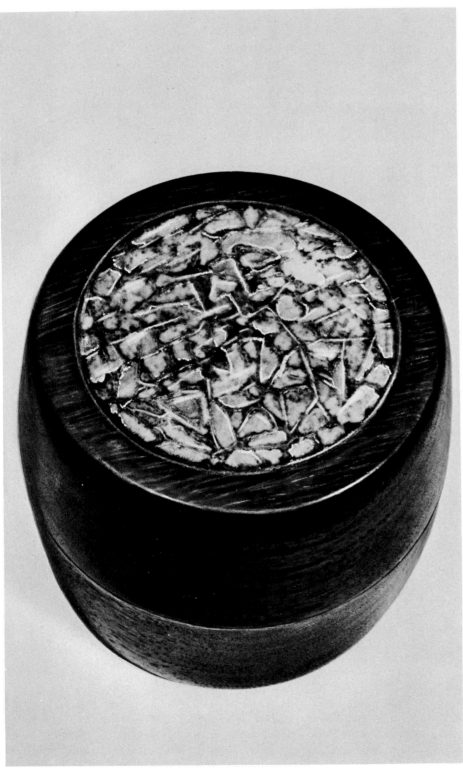

J. ORMOND SANDERSON JR.

Ormond Sanderson received his formal training in architecture, painting, music theory, and piano. It was only later, with the encouragement of the artist Peter Ostuni, that he turned his attention to vitreous enamels. He has engaged in university as well as private teaching and now works primarily in his studio, Design Gallery, in Durham, North Carolina.

Using silver or gold deposits and oxidation coloring on exposed metal surfaces, Sanderson executes his objects almost exclusively with two basic enameling techniques, basse-taille and champlevé.

The pale blue-and-gold medallion recessed into the lid of the rosewood box illustrated here presents succinctly the intricacies of basse-taille enamel.

Technically, five metal depths are represented, each successive one showing a deeper shade of blue with gold threads crossing back and forth over the entire medallion. The purpose of cutting out areas of varying depths, shapes, and sizes was to impart a faceting to the metal surface which, when fused by heat to a vitreous enamel, would reflect the lights of hundreds of mirrorlike areas which change as the angle of perspective changes.

The medallion deals, as does most of Sanderson's work, with the relationship of man to the forces of nature. It is divided into cell-like compartments, some of which harbor almost microscopic animal and plant-seed forms to suggest the interdependence of all living matter.

birthplace: Durham, North Carolina, 1931
education: North Carolina State University • University of Michigan, B.M., M.M.
teaching: University and private
collections: Royal House of Monaco • Addison Gallery of American Art (Andover, Massachusetts) • Everson Museum of Art (Syracuse)
residence: Durham, North Carolina

BOX: rosewood, blue and gold basse-taille enamel: 3¾″ high × 3¼″ diam. (enamel medallion 2¼″ diam.): 1968

VIVIAN KOOS

The enamels of Vivian Koos bring to the medium the visual rationale of the painter in combination with the craftsman's respect for material. In a medium in which intimate scale and delicacy are more often expected, the boldness of her work introduces another dimension to the expressive possibilities of enameling. The starkness of the composition on the black and red-orange tray suggests an almost mural-like presence.

Mrs. Koos has executed many commissioned works for business and liturgical organizations and has exhibited extensively.

At present, she devotes much of her time to painting.

birthplace: Barterton, Ohio, 1927
education: Ohio State University, B.S., M.S.A. Italy
collections: Akron Art Institute • Murray College
 (Kentucky)
residence: New York, New York

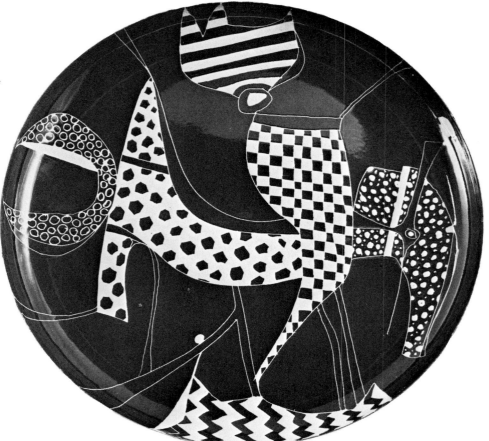

RED AND BLACK: vitreous enamel on iron
tray: 17¾" diam.: 1958

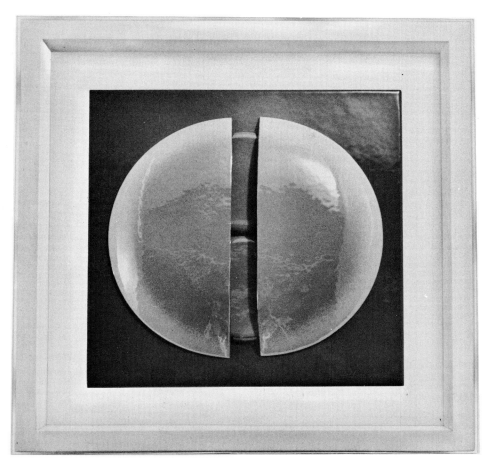

BROWN AND BLUE: vitreous enamel on
copper: 11″ x 11″ (with frame
15½″ x 15½″): 1968

ARTHUR AMES
Ames traces his interest in vitreous enamels
to an exhibition of the work of Karl Drerup
at Scripps College in 1940. It was during
the immediate postwar years that he turned
his attention seriously to this interest, and
with his wife, Jean Goodwin Ames, he was
among the first to develop enameling as an
art in the U.S. The Ameses have since
collaborated on a number of architectural
commissions in a wide variety of media, and
have played an important role as teachers
in southern California.

The abstract style of Arthur Ames's work
is rooted essentially in geometric and
formal interests. He cites an
acquaintanceship in the thirties with F.
MacDonald Wright and Lorser Feitelson as
having had a profound impact upon the
development of his own ideas.

In *BROWN AND BLUE,* executed in low
relief, the artist uses color as a major
element. It is applied without any textural
interest to increase the sense of scale and
impact.

birthplace: Pamaroa, Illinois, 1906
education: California School of Fine Arts (San
　　　Francisco) • Architectural research, Europe, 1954 •
　　　Tapestry-weaving research, France, 1964
teaching: Otis Art Institute (Los Angeles), present
collections: Everson Museum of Art (Syracuse) •
　　　Wichita Art Association • Museum of Contemporary
　　　Crafts (New York) • Pasadena Art Museum
residence: Claremont, California

HAROLD B. HELWIG

Helwig, one of the younger artists involved with enamels, works figuratively. The expressionistic subject matter of much of his work is drawn from mythological or metaphysical sources, with imagery reflecting a highly personal approach. Helwig works with two of the most difficult enameling techniques, basse-taille and grisaille. Illustrated here is a good example of the latter method, which involves the firing of various thicknesses of white opaque enamel on a black opaque background.

birthplace: Wellington, Kansas, 1938
education: Fort Hays Kansas State College, B.S., 1960; M.S., 1961
teaching: Creative Craft Center at the State University of New York (Buffalo)
residence: Buffalo

My work is as I am, drawn from a persistent and quiet influence of mutual attraction between one's encouraged approaches and readiness to receive. For as long as intention has no visible effect, it has no importance to the outside world and leads into nothingness. What takes place in the depth of one's being, in the unconscious, can neither be called forth nor prevented by the conscious mind. For if we cannot be influenced ourselves, we cannot influence the outside world. In my work I embody an enduring meaning of my way of life and thereby an object is formed that has duration; from this one can come to understand the nature of beings living and dead, and what endures is the unswerving directive, the inner law of one's being, which determines all his actions.
—Harold B. Helwig

ANGELIC DEVILS: grisaille matte enamel: 11″ diam.: 1968

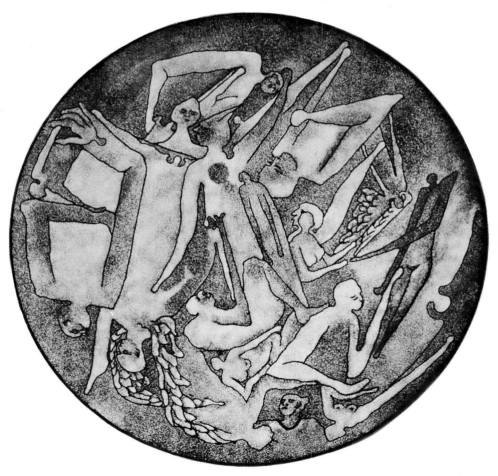

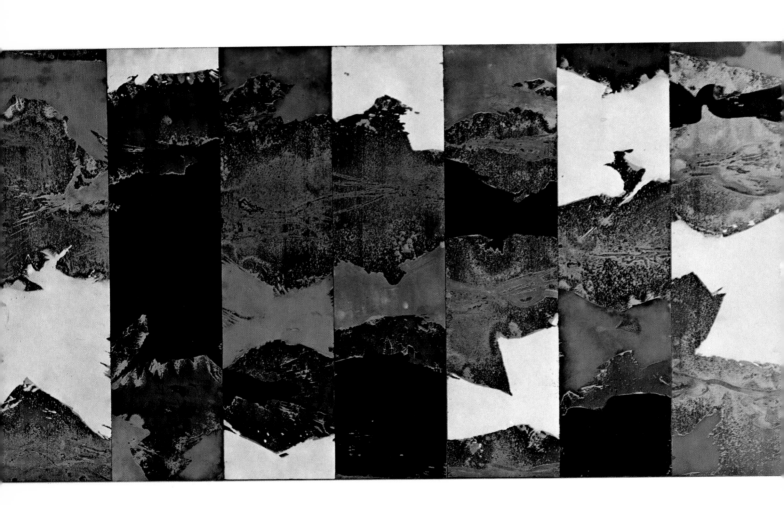

JOHNSON TOGETHER: enamel: 48″ × 84″: 1969

PAUL HULTBERG

A veritable virtuoso in the field of enameling, Hultberg freely translates the forms and the random occurrences of nature into painterly abstract images. His technique and his style are clearly within the context of Abstract Expressionism, and both contribute essentially to a final effect of spontaneous creativity. Working swiftly—the application of the powdered glass on unworked copperplate can be accomplished in minutes—he sifts and scatters the ground enamels into random patterns which reflect and embody the orderly chaos of natural phenomena.

Hultberg is well known for his large architectural panels. The work constitutes an unusual adaptation of the traditional craft in that he magnifies the scale; normally artists in enamels concentrate on jewel-like brilliance.

In addition to numerous architectural commissions, the works of Hultberg have been exhibited internationally and were included in both the Seattle and New York World's Fairs. He is represented in the permanent collection of the Museum of Modern Art, New York.

The principal concern in the work illustrated here is the juxtaposition of images and colors within fixed modules. Each of the panel units can exist independently; together they form a larger unified composition, much as one tree can be related to another in a landscape.

It is often said that the enamel medium creates images of such jewel-like brilliance and intensity that its full visual potential can best be appreciated in small-scaled works. If Paul Hultberg ever heard this view expressed, it is clear that he has not let it bother him. No one knows better than he the problems of adapting enamels to the needs of a large format. Well known as a producer of enameled architectural panels, Hultberg has repeatedly used this erstwhile miniaturistic medium in works of grand scale. In doing so, he evolved a style which relied heavily on mat and opaque colors and broad, clearly marked imagery.

Often strokes of color were applied as thickly as paint or ceramic glazes, and the delicate coloristic effects which can be achieved with enamels were willfully disregarded.

The works in the present exhibition show a much different approach to style. Although of modest size in comparison with Hultberg's past architectural designs, they are larger than the average enameled panel; nevertheless their size is an integral part of their visual impact, and it is never wasted on pure rhetoric. Using transparent enamels to a much greater degree than in his earlier work, the artist has made a deliberate attempt to uncover the most sensuous nuances possible with his medium. The strong forms and color contrasts of the past have given way to more subdued colorations, often in the same warm key as the copper plate itself. Through lakes of clear glaze, the metal surface or opaque layers of color glisten and move in a manner that is both exquisite and intense. Though in no way paint-like (for the sense of glass upon metal is never obscured) these are truly paintings.

They are bravura pieces, done by an artist so sure of his craft that he dares to exercise a minimum of control in the process of creation; so certain of his medium that he relies almost solely on the natural behavior of glass, metal and heat in determining the figuration. The work is done alla prima and preferably in a single firing. From the bare, unworked copper plate to the fired panel, the technical process can be completed in minutes. Working swiftly and in an apparently effortless manner, Hultberg sifts and scatters the powdered glass into water-patterns splashed at random on the plate. Although he exercises the right of choice over the colors and qualities of the enamels, and knows roughly how the elements he selects will work together, the artist enjoys the sense of risk which stems from the fact that he cannot foresee the final form until the plate has been fired and it is too late to change. Of course, he knows that some unwanted effects can be improved with subsequent firings, but the fine gauge of the copper Hultberg uses puts a practical limit on the number of refirings possible. In any case, he does not really like to work that way.

There is a kind of gentle madness in the way Hultberg gambles with the expensive materials he uses; and the costs are as high as the number of panels which he finds unacceptable. He seems to feel, however, that the high cost of failure is part of the price he has to pay for the freshness and vitality of his successes. Spontaneity is for him a condition, not only

of his creative technique, but of the very content of his work. Through a recreation of the randomness of natural processes, he seeks to produce a 'similar environment' in art.

The artist recognizes and accepts the power that the forms of nature have over his work. The time of day, the seasons, light, sounds—all these contribute directly to the state of mind and being that are translated and transformed in his effort to create art with a 'feeling of place' about it. Yet only a few of his panels actually have a definable landscape figuration; they seem rather to embody the feeling of natural phenomena—the events of light and space, the very rhythms of creation are caught in these luminous, shimmering surfaces.

—Elizabeth Breckenridge

From *Enamels by Paul Hultberg*, published by the Museum of Contemporary Crafts of the American Craft Council.

birthplace: Oakland, California, 1926
education: University of Southern California (Los Angeles) • Fresno State College • Institute Politecnico Nacional (Mexico City) • Brooklyn Museum School
teaching: Brooklyn Museum School
architectural commissions: Mural, Alcoa Corporation, Pan Am Building (New York) • Panel, Hotel Statler (Washington, D.C.) • Forty enamel sculptures, Abraham and Strauss (Huntington, Long Island) • Panels, Henry J. Kaiser residence (Hawaii) • Mural, Columbus Park Towers (New York)
film: Reflections, about work of Hultberg by American Crafts Council, 1967
residence: near Stony Brook, New York

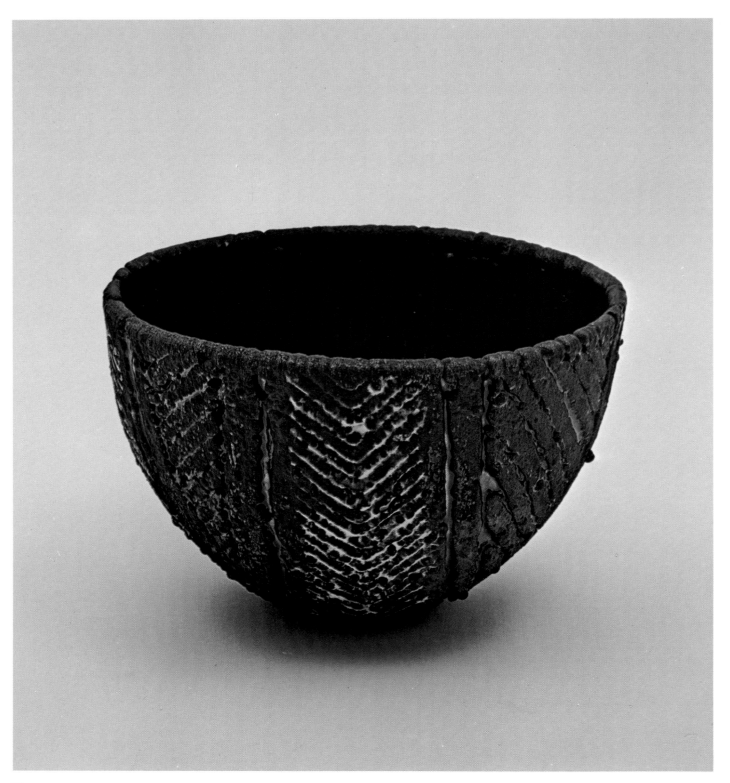

JUNE SCHWARCZ

June Schwarcz, one of the recognized leaders in experimental enameling, has attended three universities but has had no formal degree in the field. Actually, she started enameling as a pastime, but fascination with the medium resulted in its becoming a lifetime profession.

Organic references are abundant in her work and often derive from the small and half-hidden worlds of nature (or from the strong contours of primitive art). 'If you take little things out of context,' she says, 'they become unfamiliar and therefore become something fresh and new. It's like looking at the world with a magnifying glass and disassociating the things you see.'

Mrs. Schwarcz is usually not concerned with the utilitarian aspects of her work; she is more interested in its sensual qualities—its look, its tactile and reflective aspects.

The exploration of materials and techniques is an important direction in her work, and she has made a distinguished contribution in researching and experimenting with the creative uses of sophisticated plating processes. She believes that she was among the first artists in this country to utilize etching, enameling, electroplating, and electroforming in a single object. At present her experimentations are concerned with the possibilities of working with nonrigid surfaces, such as copper foil.

Mrs. Schwarcz favors the basse-taille technique because it allows her to develop surface variations which achieve magnified effects of both reflected and retained light.

birthplace: Denver, Colorado
education: University of Colorado • University of Chicago • Pratt Institute (New York)
collections: Joe and Emily Lowe Art Gallery (University of Miami) • Everson Museum of Art (Syracuse) • Oakland Art Museum • Wichita Art Museum • The Museum of Contemporary Crafts (New York)
residence: Sausalito, California

BOWL: enamel with electroplating: 6¾" diam.: 1968

OVAL BOWL: enamel with etched oyster-shell design: 2¼" x 7¼": 1968

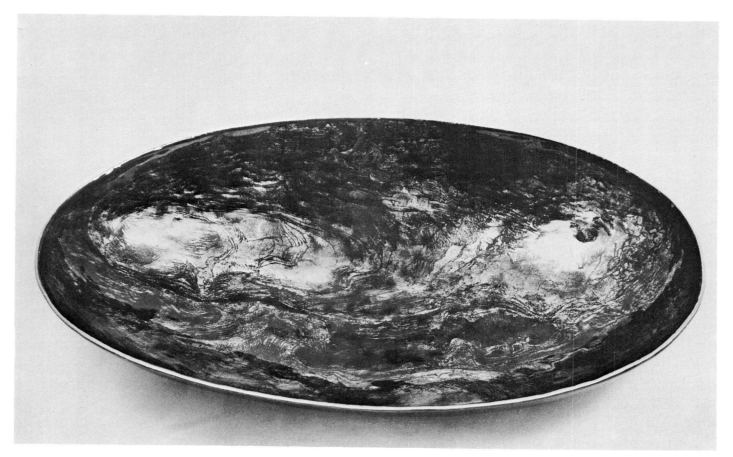

ceramic

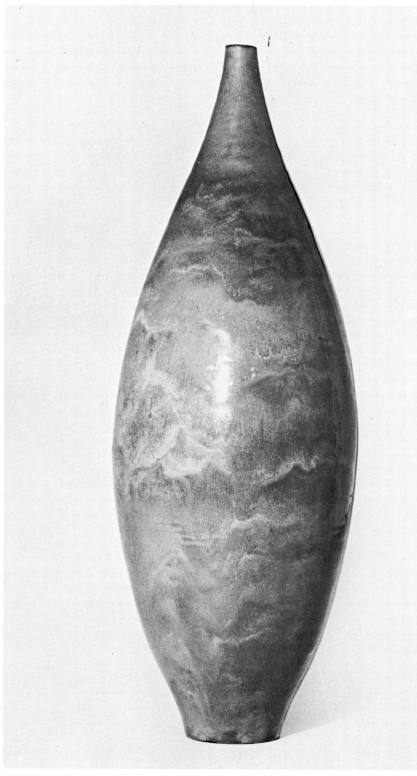

GERTRUD AND OTTO NATZLER

Undoubtedly Gertrud and Otto Natzler are the most publicized ceramists in the U.S. today. They were among the many European artist-craftsmen who, to escape the threats of World War II, emigrated to the U.S., bringing with them vast technical knowledge and aesthetic refinement. In 1939 the Natzlers chose to settle in California, where their influence on the revival of creative ceramic pottery has been widespread and inestimable.

Their own serious involvement in the medium started with their initial collaboration in Vienna in 1933. With no formal training in ceramics, they addressed themselves to an intensive study of the chemistry of glazing and to the perfection of outline and proportion in wheel-thrown pottery. From that time to the present they have united their separate efforts to a single end, the realization of utilitarian forms of simple, gemlike elegance. Gertrud creates the classic, straightforward forms, and Otto the glazes. He has become one of the world's foremost authorities on glazes, having developed some twenty-five hundred of them, many of which are regarded as among the most aesthetically distinguished in the history of ceramics.

Since 1937, when they won the Silver Medal at the Paris International Exposition, the Natzlers have won awards in virtually every major ceramic exhibition throughout the world. Their work is represented in the permanent collections of more than thirty-five leading museums.

birthplace: Vienna, Austria, 1908
collections: Metropolitan Museum of Art • Museum of Modern Art (New York) • Art Institute of Chicago • Philadelphia Museum of Art • Los Angeles County Museum of Art
residence: Los Angeles

TEARDROP: earthenware, sang-mariposa reduction glaze: 22¼'' high: 1964

BOWL: earthenware, crater glaze: 14½'' high x 18½'' diam.: 1956

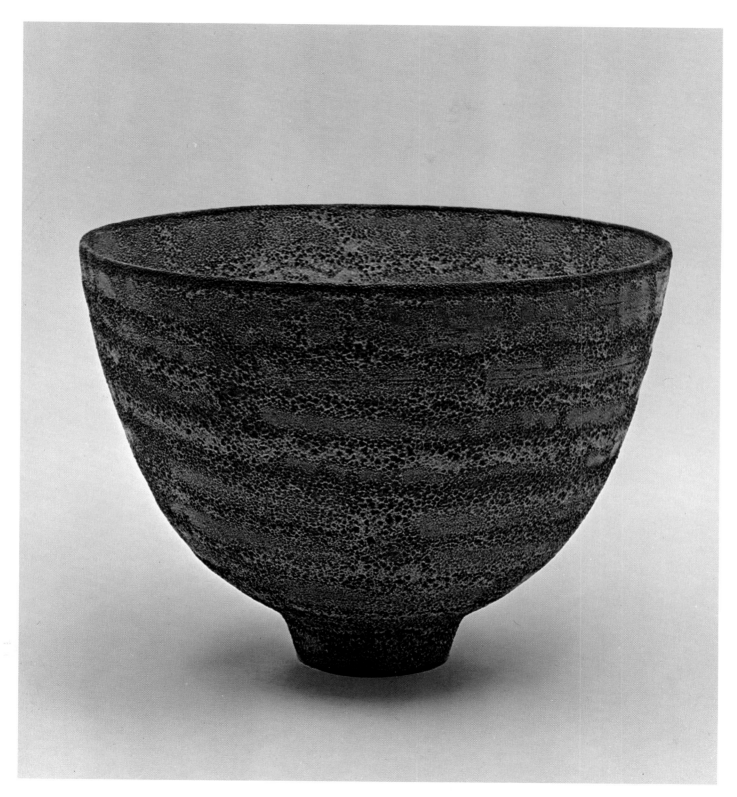

MAIJA GROTELL

In addition to her contributions to the
American ceramic movement as a teacher
(discussed in the text), Maija Grotell's own
creative achievements have gained
international recognition, winning awards
in Barcelona, Paris, Boston, Cleveland, and
Syracuse. Her works are exemplary for their
excellence of execution.

birthplace: Helsinki, Finland, 1899
education: Central School of Industrial Art (Helsinki)
teaching: Union Settlement (New York) 1928–1929 •
 Henry Street Craft School (New York) 1929–1938 •
 Rutgers University, 1936–1938 • Cranbrook
 Academy of Art
collections: Metropolitan Museum of Art • Art Institute
 of Chicago • Cleveland Museum of Art • Detroit
 Institute of Arts • Cranbrook Academy of Art
residence: Bloomfield Hills, Michigan

BOWL: stoneware with blue-green glaze
inlaid in brown: 9½" high: 1955

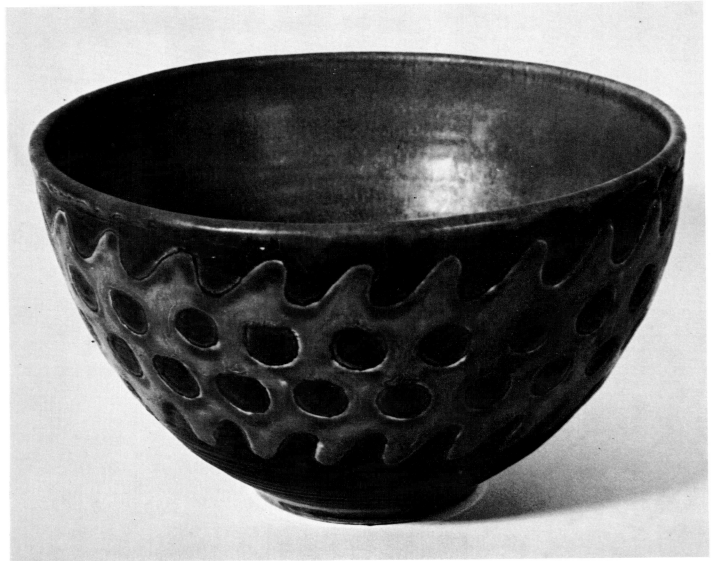

40

F. CARLTON BALL

Ball represents one of the early university-trained ceramic artists. He studied to be a painter or sculptor and wrote his master's thesis on fresco painting. His one semester of beginning pottery was taken under Glen Lukens. Advanced sculpture, jewelry, and and pottery were studied by Ball in a sixth year at the University of Southern California (1932–1935).

Ball has taught ceramics, jewelry, silversmithing, design, and painting at twelve universities and art schools. He is especially known for the size of his pots—some are six feet tall—and for intriguing surface textures. His work has been shown in over five hundred exhibitions in the U.S. since 1940, and has received national awards in jewelry and silversmithing. Ball is also well known for his articles, which have appeared in national magazines for many years. His books on the techniques and aesthetics of potting have been influential in maintaining dignity for the medium, and many are used as texts for high schools and colleges.

birthplace: Sutter Creek, California, 1911
education: University of Southern California, 1932–1935
teaching: California College of Arts and Crafts,
 1935–1938 • Mills College (Oakland, California)
 1939–1949 • University of Wisconsin, 1950–1951 •
 Southern Illinois University, 1951–1956 •
 University of Southern California, 1956–1968 •
 University of Puget Sound (Washington), present
collections: Everson Museum of Art (Syracuse) •
 Oakland Art Museum (California) • Akron Art
 Institute • Art Institute of Chicago
residence: Tacoma, Washington

JAR: wheel-thrown stoneware: 12½" high: 1967

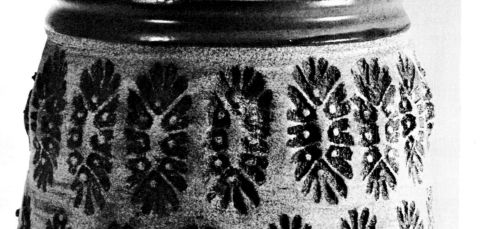

MARGUERITE WILDENHAIN

The pottery of Marguerite Wildenhain is a combination of old and new, complex and simple. Although derived from classic utilitarian objects of the past, her ceramics embody meaningful contemporary forms. Born in France, Marguerite Wildenhain was educated in the best classic European tradition. In 1919, after working as designer of porcelain for a factory in Thuringia, she was apprenticed at the Bauhaus in Weimar, Germany, under Max Krehan and the sculptor Gerhard Marcks. After seven years of this disciplined training, she accepted a teaching position at the Municipal School for Arts and Crafts in Halle-Saale. During this period (1927–1933) she also made extensive models for the Royal Berlin Porcelain factory.

With the rise of the Nazis in 1933, she moved to Putten, Holland. In 1940 she was forced to flee again, and came to the United States. She first taught at the College of Arts and Crafts in Oakland, California (1940–1942), then settled in Guerneville where she founded the now famous Pond Farm Pottery, with a workshop and summer school in ceramics. Since 1945 the school has been an experiment in education and living through the crafts, not only for Marguerite Wildenhain, but for hundreds of students from all over the world. The contribution of Marguerite Wildenhain in bringing dignity to the field of clay cannot be overstated.

birthplace: Lyons, France, 1896
education: School of Fine and Applied Arts (Berlin) • Bauhaus (Weimar, Germany)
teaching: Municipal School for Arts and Crafts (Halle-Saale, Germany) • College of Arts and Crafts (Oakland, California) • Pond Farm Workshop (Guerneville, California)
collections: Art Institute of Chicago • Dallas Museum of Fine Arts • Stedelijk Museum (Amsterdam) • Detroit Institute of Arts • Museo Internazionale delle Ceramiche (Faenza, Italy)
residence: Guerneville, California

Today I feel that it is increasingly more important to stress again the value of the way of life of a craftsman and to try to educate young people to a basic understanding of what is the essence of a life dedicated to an idea that is not based on success and money, but on human independence and dignity. . . . I believe that pots are just as good or bad as the potter who makes them; the person making the pots is the key to the quality of the pot, not any technique or any big flashy 'new' tricks.
—Marguerite Wildenhain

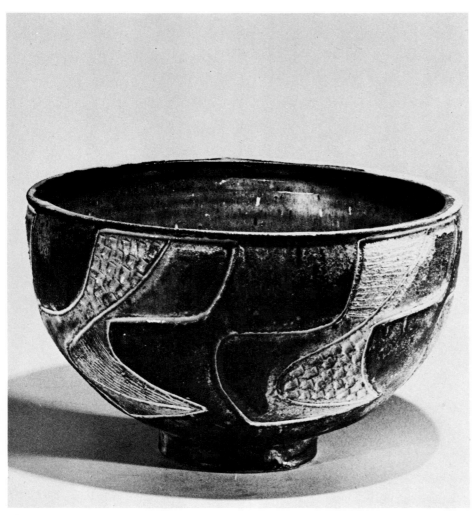

DECORATED BROAD BOWL:
stoneware: 9¾″ diam.: 1968

SQUARE AND TEXTURED VASE:
stoneware: 11″ high: 1966

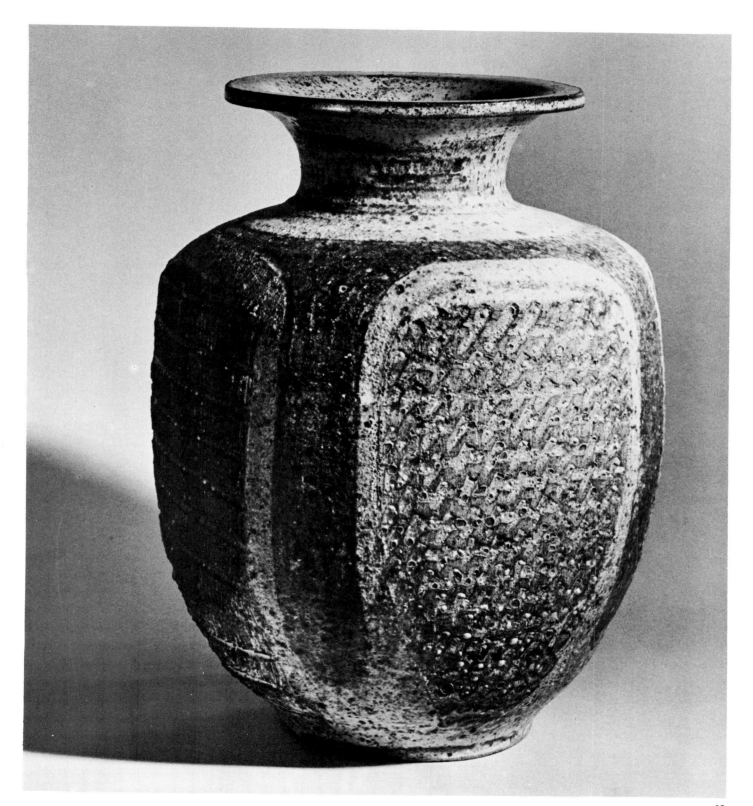

WALL HANGING: raku and nylon:
86″ high: 1968
(detail below)

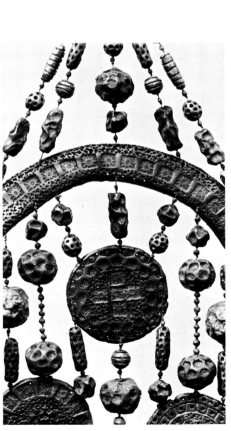

CHARLES M. BROWN

At the age of fifty-eight Brown resigned his job as manager for a large produce company, rededicating his life to being a potter. Some twelve years earlier he had taken some night extension courses from the University of Florida in ceramics, and slowly his interest in clay grew. When fifty-one he entered works in two important national shows—one the Syracuse National— and was accepted in both. This encouragement led to his momentous decision seven years later.

Brown works exclusively with hand-building techniques. Most of his pots are in the low-fire range (using electric kilns) and for the past five years he has worked only with raku.

birth date: 1904
education: Night extension courses, University of Florida
residence: Mandarin, Florida

I do a lot of experimenting with glazes and engobes, and do only the things that appeal to me as an individual, get on no bandwagons and follow no crowds.
—Charles M. Brown

ROSE CABAT

Some twenty years ago, Rose Cabat's husband brought home some clay for a relaxing exercise, and soon they were both creating objects. This pastime led to serious study at the Greenwich House Pottery, New York. Later the Cabats moved to Arizona and devoted full time to clay. Mrs. Cabat is best known for her small satin-smooth pots—called 'feelies' because of their pleasing tactile quality. The glazes—dramatic desert off-colors—are of matte crystallines, with the crystals under the skin. The glaze must run to produce a crystal, so that often the vases have a 'drip' or 'apron' effect. Mrs. Cabat throws each piece on a wheel, and no two are alike.

birthplace: Bronx, New York
collections: St. Paul's Gallery and School of Art •
 Tucson (Arizona) Art Center • Kansas City Art
 Institute • Phoenix Art Museum • Arizona State
 University
residence: Tucson, Arizona

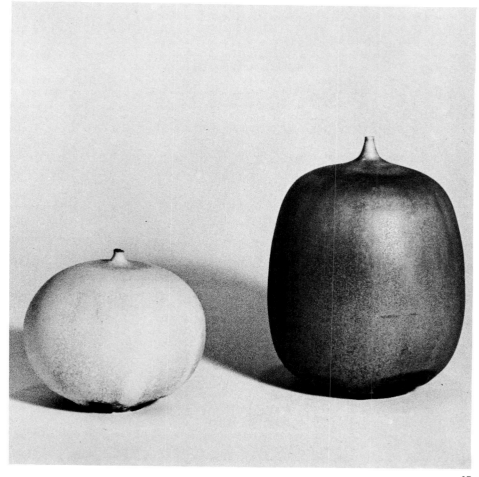

PAIR OF FEELIES: porcelain: 5¼" high,
3" high: 1969

HENRY VARNUM POOR

For Poor 'the history of art shows no long line of progress. It is a journey from simplicity to complexity—then a return to simplicity,' he says. In his own life he has traveled a similar journey. After receiving his early education in the public schools of Kansas, he went from Stanford University to the Slade School in London, then to the Julian Academy in Paris to study drawing and painting. In the twenties he was the first painter of note to turn to ceramics as part of his total artistic statement. Since that time Poor has contributed to the craft movement not only by bringing his disciplines of art to pottery but by his striking painterly approach to ceramics surfaces. Now in his early eighties, Poor still produces objects—usually functional—and continues as well with his painting.

birthplace: Chapman, Kansas, 1888
education: Stanford University • Slade School (London) • Julian Academy (Paris)
collections: Museum of Modern Art (New York) • Whitney Museum of American Art • Philadelphia Museum of Art • San Francisco Museum of Art • Cleveland Museum of Art
teaching: Chairman of the Board of Governors, Skowhegan School
residence: New City, New York

STILL LIFE: stoneware: 12″ diam.: 1968

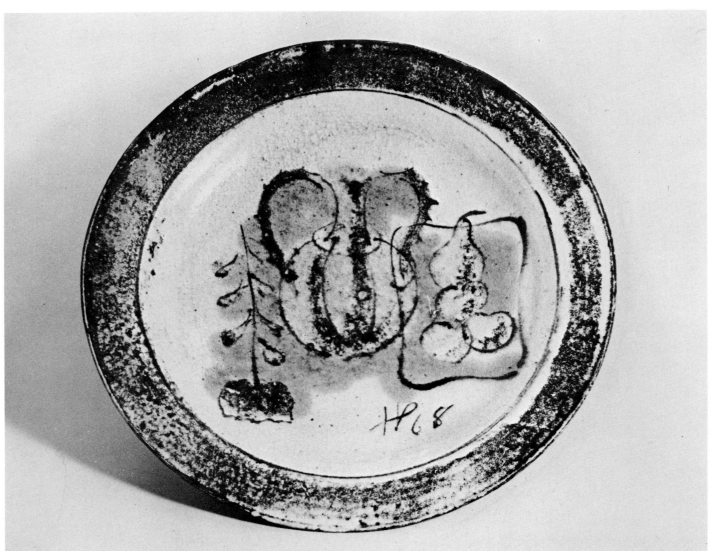

HERBERT H. SANDERS

Sanders, who studied with Arthur Baggs, is a key figure in the contemporary ceramics movement in the U.S. He is noted not only for the excellence of his own work but for the influence of his teaching. A master of stoneware and porcelain, Sanders has developed glazes of subtle elegance. A good number of ceramists use crystals in their glazes, but few—if any—can control their placement on the surface after firing. Sanders can, and has given numerous demonstrations to prove it. He has served on twenty-seven juries, won twenty-eight awards, and been shown in over one hundred exhibitions of national and international importance.

birthplace: New Waterford, Ohio, 1909
education: Ohio State University, B.S.Ed. 1932; M.A. 1933; Ph.D. 1951
teaching: School of American Craftsmen (Alfred), 1946–1948 • University of Hawaii, summer 1957 Fulbright Research Scholar in Ceramic Art and Education (Japan), 1958–1959 • San Jose State College, present
collections: Columbus (Ohio) Gallery of Fine Arts • Everson Museum of Art (Syracuse) • Metropolitan Museum of Art • Fine Arts Gallery of San Diego • Museo Internazionale delle Ceramiche (Faenza, Italy)
residence: Los Gatos, California

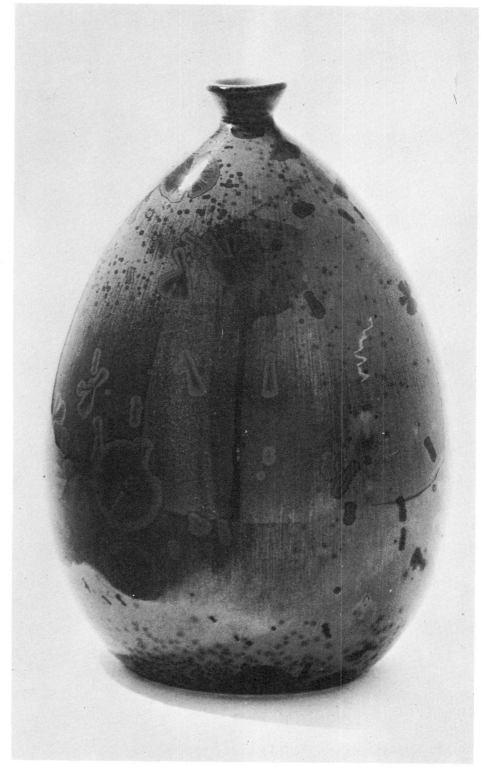

PADDLED BOTTLE: gray-green porcelain with blue crystals: 11" high: 1968

EDWIN AND MARY SCHEIER

This husband-and-wife team has occupied a pre-eminent position in the ceramic field for nearly thirty years, exhibiting and winning awards in virtually every major ceramics exhibition in the U.S. Their work is represented in the permanent collections of more than thirty museums throughout the world.

The Scheiers, working together, have remained within the format of traditional wheel-thrown utilitarian objects, constantly experimenting with new glazes, new techniques, and new designs. Largely self-taught, they were invited in the late thirties to teach ceramics at the University of New Hampshire, and continued in that capacity until 1960, when they retired.

The pottery of the Scheiers is particularly notable for its masterful control of the wheel-thrown form. A long and deep interest in the powerful and eloquent simplicity of pre-Columbian, Oceanic, and African art has served as a persistent source for their own expressive ideas.

birthplaces: Mary Scheier, Salem, Virginia, 1910
Edwin Scheier, New York, New York, 1910
teaching: University of New Hampshire
collections: Metropolitan Museum of Art • Museum of Modern Art (New York) • Cleveland Museum of Art • Detroit Institute of Arts • Cincinnati Art Museum
residence: Oaxaca, Mexico

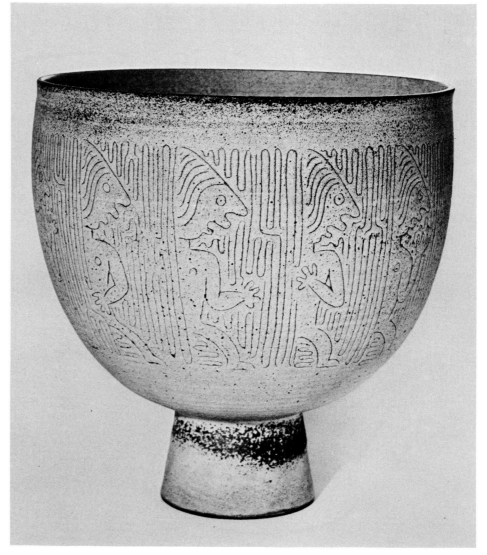

YELLOW BOWL: earthenware: 14¾" high: 1955

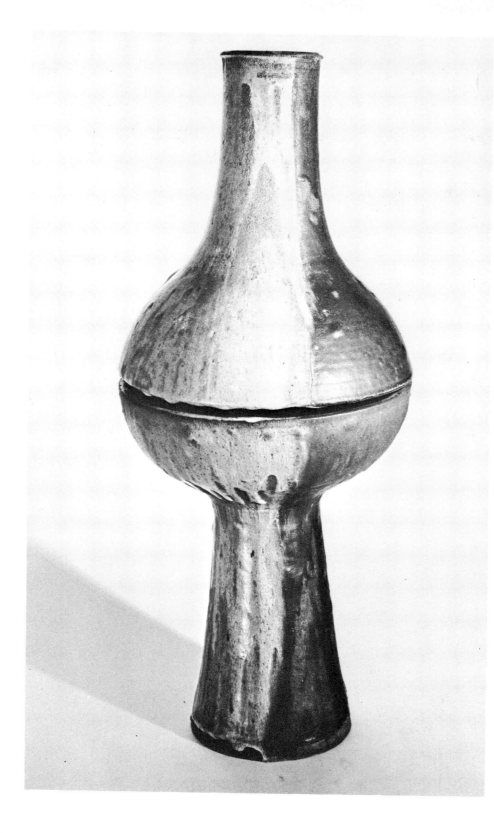

FRANS WILDENHAIN

Until 1947, when he came to the United States, Wildenhain lived and worked in Europe. He was born in Leipzig, Germany, and after an apprenticeship as a draftsman and lithographer, became involved with the Bauhaus movement in Weimar. When Hitler closed the Bauhaus, he worked and taught pottery in Essen-Ruhr and Halle-Saale, and then moved to Holland to establish his own workshop. After the war he left Europe to ally himself with the Pond Farm Pottery school in Guerneville, California. His strong sense of discipline served him well as a teacher, and with his former wife, Marguerite, a rigorous program of instruction was set up where every phase of the art of throwing pots had to be mastered. He now lives in Pittsford, New York, where he teaches ceramics at the Rochester Institute of Technology. Again his respect for clay, for expert craftsmanship, and for creative expression has made the department one of the finest in the country.

Wildenhain has executed some of the major ceramic reliefs in the U.S., besides continuing his functional and nonfunctional studio pottery. His works have been seen in every national and international exhibition to do with clay.

birthplace: Leipzig, Germany, 1905
education: Bauhaus, 1924–1925 • State School of Applied Art (Halle-Saale)
teaching: School for Applied Arts (Amsterdam) • School for American Craftsmen (Rochester)
collections: National Library of Medicine (Bethesda, Maryland) • Strasenburgh Laboratories (Rochester)
residence: Pittsford, New York

CENTER-SPLIT VASE: stoneware: 30″ high: 1966

OTELLIE LOLOMA
A Hopi Indian born in Second Mesa, Arizona, Otellie Loloma is among the first American Indians to break away from traditional designs and to create forms in clay that remain personal without denying the richness of her heritage. Loloma works both with container forms and figures, but neither is to be considered academic. The pots she makes are more like ceremonial vessels, and her figures are usually mood studies. Loloma has had a great influence in bringing younger Indian talents to the Institute of American Indian Arts in Santa Fe, where she encourages high standards of craftsmanship and full individual expression.

birthplace: Second Mesa, Arizona
education: School for American Craftsmen (Alfred) • Northern Arizona State University
teaching: Shungopavy Day School (Second Mesa) • Southwest Indian Art Project, Rockefeller Foundation, University of Arizona • Institute of American Indian Arts (Santa Fe), present
collections: Bureau of Indian Affairs, Department of the.Interior (Washington) • Heard Museum (Phoenix)
residence: Santa Fe

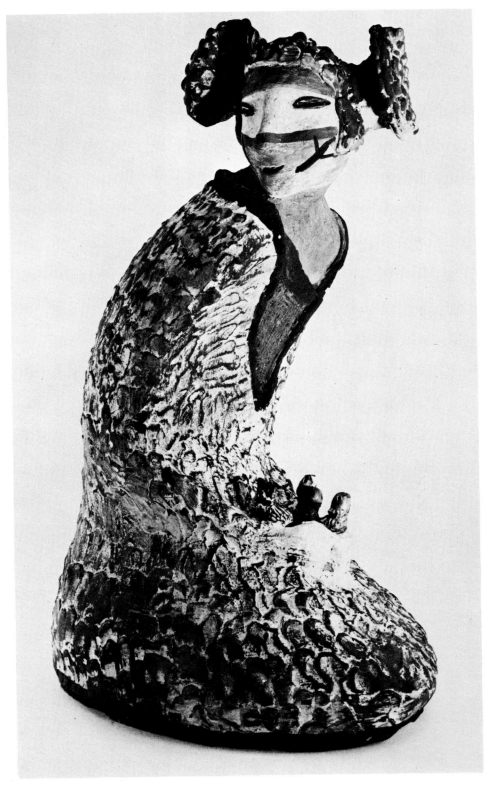

THE BIRD GIRL: stained stoneware: 17″ high: 1969

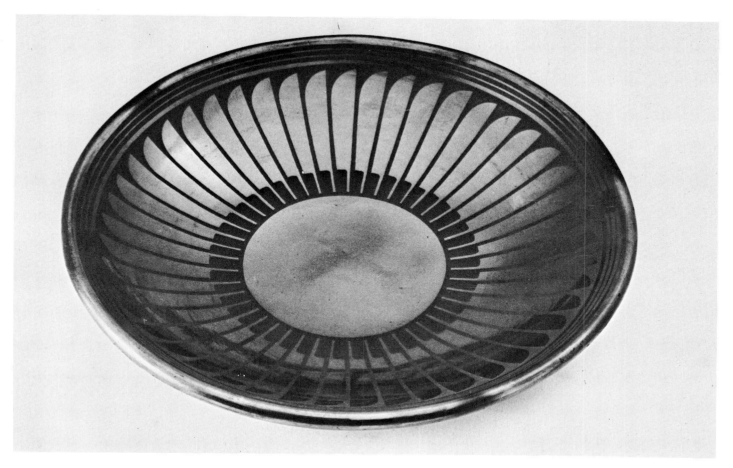

MARIA AND POPOVOI

Maria and Popovoi, mother-and-son craftsmen, continue the tradition of pottery making at the San Ildefonso Pueblo in New Mexico. In 1919 Maria and her now deceased husband, Julian, sought to break away from the age-old black-on-red style characteristic of their Pueblo; and they developed the now popular pure black-matte earthenware. Popovoi continues to work with his mother, decorating, glazing, and firing the molds she fashions without the aid of even a potter's wheel. Layers of clay are coiled round and round, then smoothed and shaped by hand. The pottery is sun-baked, then placed in an oven until the required hardness is achieved. Maria and Popovoi work in black, terra-cotta, polychrome, and sienna pottery. Designs are painted directly on the piece with yucca-leaf brushes. No mechanical means of any kind are used. Maria and Popovoi continue to operate a shop in their native Southwest, and their works are represented in many collections throughout the country.

birthplace: San Ildefonso Pueblo, New Mexico; Maria, 1887; Popovoi, 1922
collections: Philbrook Art Center (Tulsa) • Museum of Natural History (New York) • Folk Art Museum (West Germany)
residence: Santa Fe

BOWL WITH FEATHER DESIGN: terra-cotta, black matte glaze: 12½″ diam.: 1968

ROBERT TURNER

Turner studied art at the Barnes Foundation, near Philadelphia, and received two traveling and study scholarships in painting at the Pennsylvania Academy of Arts before going into ceramics. But once working with clay, his commitment was final. Since 1951 he has been a potter, and his trademark is the beautifully executed stoneware vessel. A traditionalist of impeccable taste, his casseroles and covered jars are noted for their elegant glazes. He has shown in most U.S. ceramic exhibitions, as well as in Cannes, Geneva, Prague, and Buenos Aires.

birthplace: Port Washington, New York, 1913
education: Swarthmore College, B.A. • Pennsylvania Academy of Fine Arts • Alfred University (New York), M.F.A.
teaching: Black Mountain College, 1949–1951 • Alfred University, present
residence: Alfred, New York

CASSEROLE: stoneware: 10½″ high: 1968

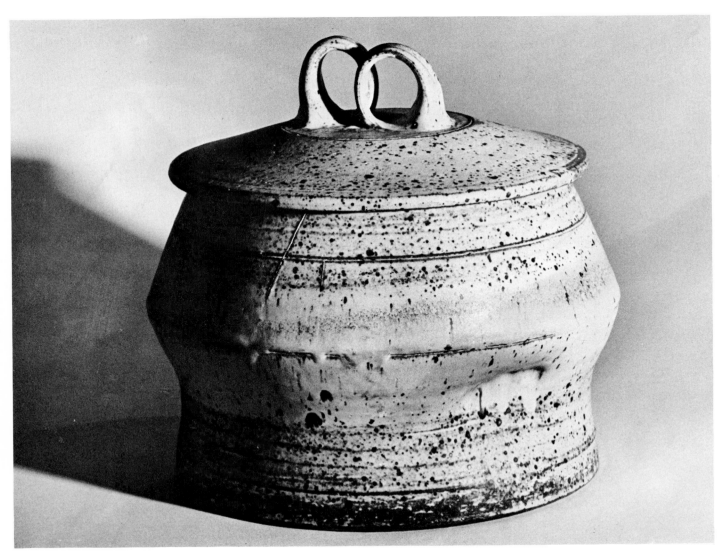

BEATRICE WOOD

After her earlier studies in theater and painting, Beatrice Wood entered ceramics with an intensity of feeling and energy that has characterized her art ever since. 'My curiosities were inflamed with the endless inventive approaches to clay and glaze,' she says. Today the artist channels her energies by the rigid discipline of an imposing work schedule in the almost monastic seclusion of her studio in the Ojai Valley near Santa Barbara, California. Her pottery forms are usually variations on traditional shapes: Wood's expressive quality is imparted by rich tactile surfaces and exotic glazes. Her lusterware reveals

the sensitivity of a colorist—a single piece may show reds ranging from copper to ox-blood. Her work covers a wide range of modes—from humorous fantastic figures reminiscent of Klee and Chagall to simple earth-bound forms. She has traveled extensively throughout India on a State Department grant, and has completed a book on Indian folk art which she researched during the trip.

birthplace: San Francisco
teaching: Happy Valley School (Ojai, California)
collections: Metropolitan Museum of Art • Museo
 Internazionale delle Ceramiche (Faénza, Italy)
residence: Ojai, California

There are theories about pottery and rules, and many asserting strong colors are for the ashcan. A hundred years hence none of this will matter. Culture is an endless chain, in which one person gives a pearl for the next one to add on to.

In today's world man is faced with greater leisure than at any time, and also submerged in confetti-like pleasures, and brain-washed with television. Therefore the importance of so many thousands turning to work of the hand and crafts. In America where there is much talent, young people everywhere are exploring new ways of handling materials and expressing form.

With more comfort than ever before, man can be dangerously lulled into accepting packaged thought. But creativeness fades under authority. The rebel in any field, daring to explore imaginative concepts, leads the way. It is always the individual thinking above the masses who sets the pace, be it for good or evil, and changes the world.

—Beatrice Wood

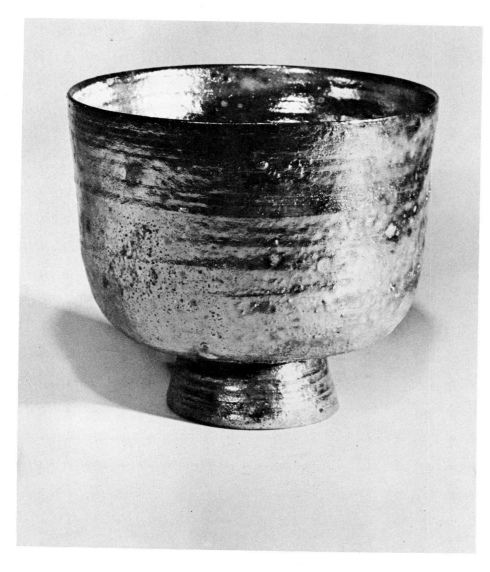

GOLD LUSTER BOWL: red clay, reduced luster glaze: 7" high: 1968

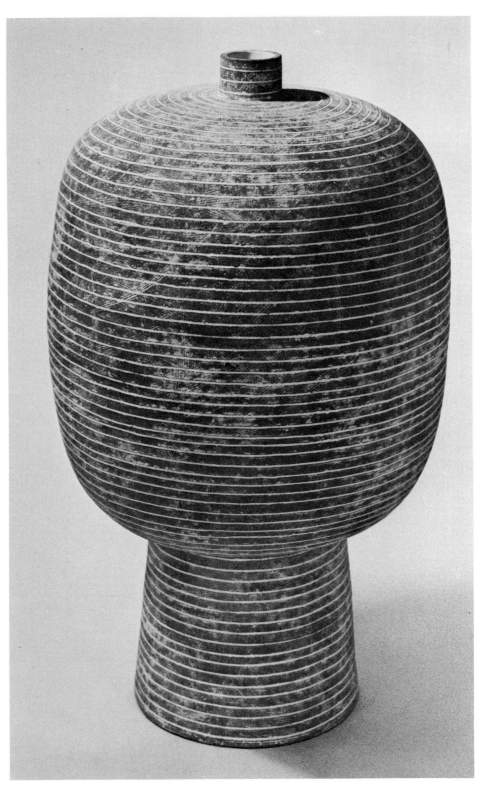

CLAUDE CONOVER

Conover took his formal college degree in art, but for many years he worked as a commercial designer before turning to potting. He now works full time at ceramics. Created mostly in stoneware (from clay Conover works himself) at high firings, his forms are usually variations of classical shapes; his surface compositions—in earthtone colors—usually linear and geometrical. He has received the Horace E. Potter Memorial Medal for excellence in craftsmanship, and the Governor's Award (Ohio) for 'craftsmanship of highest merit.'

birthplace: Pittsburgh, 1907
education: Cleveland Institute of Art
collections: Columbus Gallery of Fine Art • Cleveland Museum of Art • Everson Museum of Art (Syracuse)
residence: Cleveland

ULUA: stoneware, natural white scoring: 30½'' high: 1968

MICHAEL COHEN

Cohen, with his wife, Harriet, runs one of the more successful pottery concerns in the country, specializing in utilitarian stoneware pieces. They often collaborate on designs, but each executes the actual work single-handedly. As do most production craftsmen, the Cohens also create one-of-a-kind studio objects, such as the *MIRROR* illustrated here. In this case the work was done by Michael.

birthplace: Boston, 1936
education: Massachusetts College of Art, B.F.A. •
 Cranbrook Academy of Art
collections: Addison Gallery of Art (Andover,
 Massachusetts) • Everson Museum of Art (Syracuse)
 • Walker Art Center (Minneapolis) • Museum of
 Contemporary Crafts (New York) • Museum of
 Modern Art (New York)
residence: New Ipswich, New Hampshire

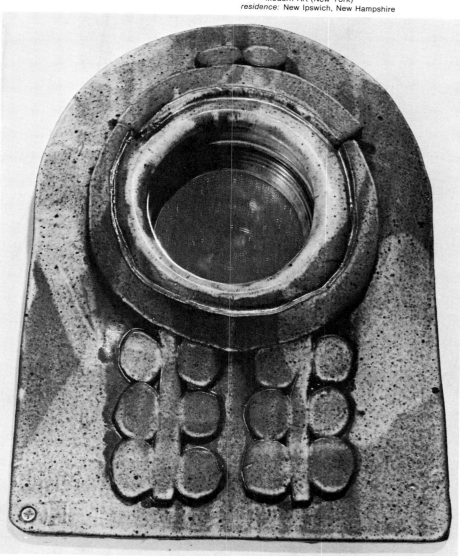

MIRROR: stoneware, orange-brown glaze: 23″ x 17¾″: 1968

birthplace: Centerville, Indiana, 1933
education: Ball State University • Brooklyn Museum Art
 School • Haystack Mountain School of Crafts
 (Maine) • Leach Pottery (St. Ives, England)
teaching: School of the Art Institute of Chicago •
 Philadelphia College of Art
residence: Lambertville, New Jersey

BYRON TEMPLE

Temple was born in Indiana, but received his early training in England. After his apprenticeship with Leach Pottery in Cornwall, he built (with Colin Pearson) the Quay Pottery in Aylesford. Back in the U.S. he established his own studio in Lambertville, New Jersey. Temple has recently done some individual pieces in salt glaze, in addition to maintaining his production work.

As a production potter I limit myself to designs which can be easily repeated. I do not find this restrictive or inhibiting; rather I'm able to explore more intensely the very basic qualities of the clay. For me utility is a focal point rather than a brace. I've always admired pots that stand tall despite their lack of adornment: the Bizen, the pre-Columbian, the early-American bean pots and crocks, the naked Haniwa figures. These pieces were made to fulfill a function: they acted as storehouses for grains or vessels for water, or were to be buried with the dead. They were supplied in mass because of a mass demand, thus they lost any possibility of affectation or preciousness.
—Byron Temple

PAIR OF STORAGE JARS: stoneware, salt glaze: 6½'' high each: 1969.

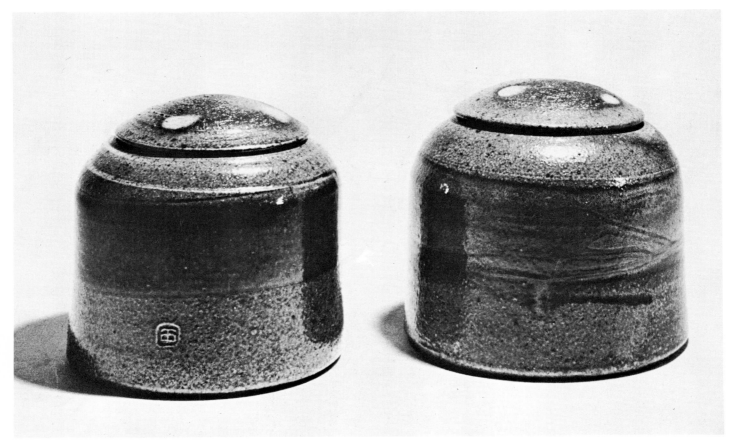

KAREN KARNES

Karen Karnes is one of the most successful
production potters in the U.S., and sells her
functional pieces through some of the most
prestigious retail shops across the country.
Her casserole with its spiraled, easy-to-
grasp handle has become one of her
trademarks, as have her delicate earth-hued
covered jars. Recently she has been
experimenting with salt-glazed objects, and
occasionally she creates one- or two-of-a-
kind pieces, such as the pair of stoneware
GARDEN SEATS illustrated here.

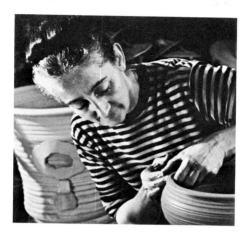

birthplace: New York, New York, 1925
education: Brooklyn College
collections: Museum of Contemporary Crafts (New York)
• Metropolitan Museum of Art • Everson Museum of
Art (Syracuse)
residence: Stony Point, New York

GARDEN SEATS: stoneware: higher 18″:
1968

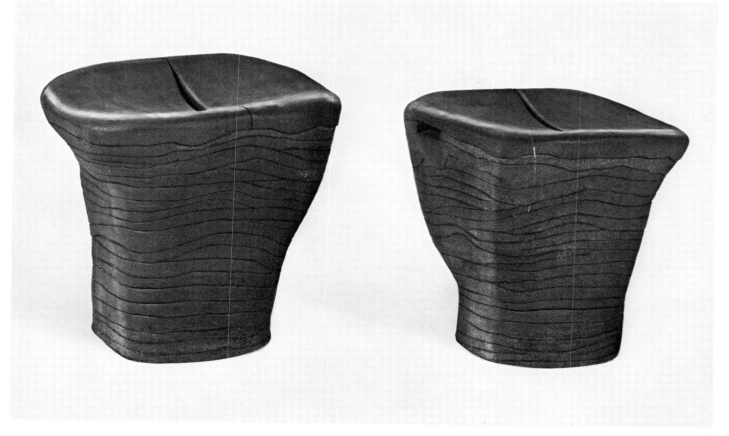

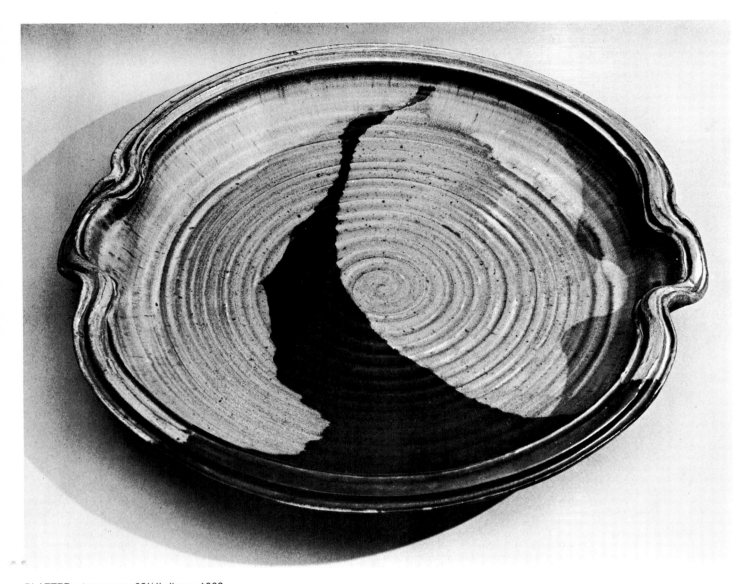

PLATTER: stoneware: 23½'' diam.: 1968

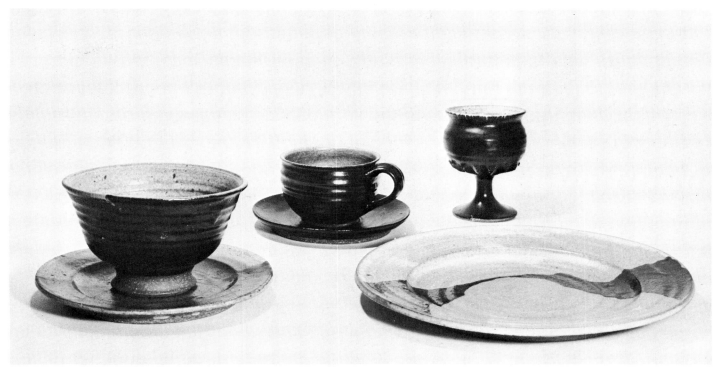

BILL SAX

Sax is a full-time potter who makes his living entirely from his utilitarian stoneware and flameware production pieces. He lives and operates his studio from a small Massachusetts town, but his dinner sets, casseroles, and platters sell in some of the best gift shops across the country. His ceramics are particularly noted for their glazes of earthen hues with usually only one accent color. In the works illustrated here the accent is black.

birthplace: Newark, New Jersey, 1934
education: Frans Wildenhain (Rochester) apprenticeship
residence: South Hadley, Massachusetts

PLACE SETTING: glazed stoneware: plate, 10½'' diam.; wine cup, 4½'' high: 1969

PETER VOULKOS

No name has been more prominently identified with the revolution that has taken place in recent years in contemporary American ceramics than that of Voulkos. The experiments leading to this breakthrough occurred in California, roughly between 1954 and 1958. At the earlier date Voulkos came from Montana to teach at the Otis Art Institute in Los Angeles, and for the first time became aware of current painting vitality—in this case it was Abstract Expressionism. A group of ceramists and painters, particularly John Mason, Ken Price, and Al Bengston, caught the fervor of Voulkos, and each made important contributions to this liberation of clay. But Voulkos, with his dynamic personality and incredible skill at the wheel, is credited with being the catalyst for this new statement. So exciting was the challenge to these artists that they often worked in the ceramic shop for fourteen hours a day. Departing from the traditional concepts of utility, symmetry, and equilibrium that had governed the history of the ceramic art for centuries, Voulkos energized a generation of creative ceramists into breaking pottery out of its traditional form. By adding this new expressive potential to clay, he was also mentor to a group of young West Coast artists who later became identified with the Funk aesthetic, such as Robert Arneson and Joe Pugliese.

By the end of the fifties and at the beginning of the sixties Voulkos's clay pieces were sculptures. At this point the Museum of Modern Art in New York gave the artist a small one-man show in its top-floor Members' Gallery. But recognition was slow for the sculptor working in what critics and public considered a minor medium, clay. As Voulkos's ideas for sculptures grew in mass and scale, clay had to be abandoned. Around 1961 he started working directly in bronze. A discussion of his work in this medium, with an illustration of a major bronze, appears in the METAL section.

The ceramic CROSS, illustrated here, is an example of Voulkos' multi-part forms of the late fifties and marks the end of the dependence of the potter upon shapes inherited from functional vessels. The wheel no longer determined the final shape the object was to assume. Voulkos was able to join flat slabs to wheel-thrown forms by the use of epoxies, and later, with the use of glazes combined with epoxy paints, thus anticipating the development of polychrome sculpture on the West Coast.

ARATSA, also illustrated here, is a recent work and points up the fact that although Voulkos now works mainly in cast bronze, his love for clay persists. This slate-colored pot, a masterful feat of wheel throwing, well illustrates the discipline and vigor of which Voulkos is capable.

birthplace: Bozeman, Montana, 1924
education: Montana State College (Bozeman), B.S. •
 California College of Arts and Crafts, M.F.A. 1952
teaching: Archie Bray Foundation (Helena, Montana) •
 Black Mountain College (North Carolina) • Los
 Angeles County Art Institute • Columbia Teachers
 College (New York) • University of California
 (Berkeley), present
collections: Museum of Modern Art (New York) •
 Baltimore Museum of Art • Den Permanente
 (Copenhagen) • Folk Art Museum (Tokyo) • Los
 Angeles County Museum of Art
residence: Berkeley

CROSS: stoneware with low-fire glaze: 30½" high: 1959

ARATSA: clay: 26¼" high: 1968

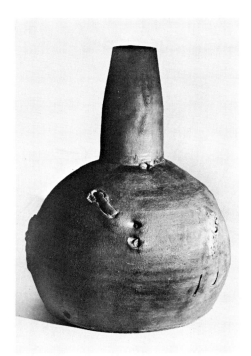

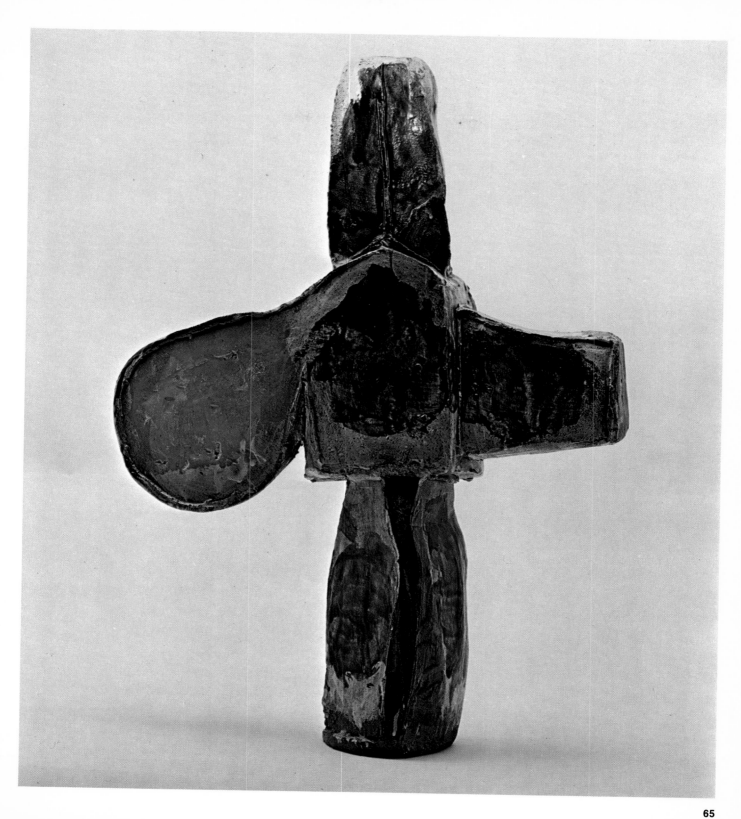

ROBERT SPERRY

Respected as one of the senior artists in clay in the country, Sperry early adapted the Oriental technique of brush-painted surfaces, endowing Western clay objects with a lyricism few other artists have achieved. In 1963 he spent three months in Japan, working and making a film of Onda, a small, traditional pottery village. During his stay there he came to respect the Oriental aesthetic of chance, the accidental magic which awaits each pot in the fire of the kiln. A prolific potter (as are the traditional Japanese), Sperry gives little thought to the question of whether he is 'artist' or 'craftsman.' The demand for his work is great, and from the many forms created he selects those which most satisfy him for entrance into national exhibitions. Recently he has devoted much of his creative energy to film making, and one of his shorts was shown in the 1968 New York Film Festival.

BOWL: stoneware, gold overglaze: 17¼″ diam.: 1968

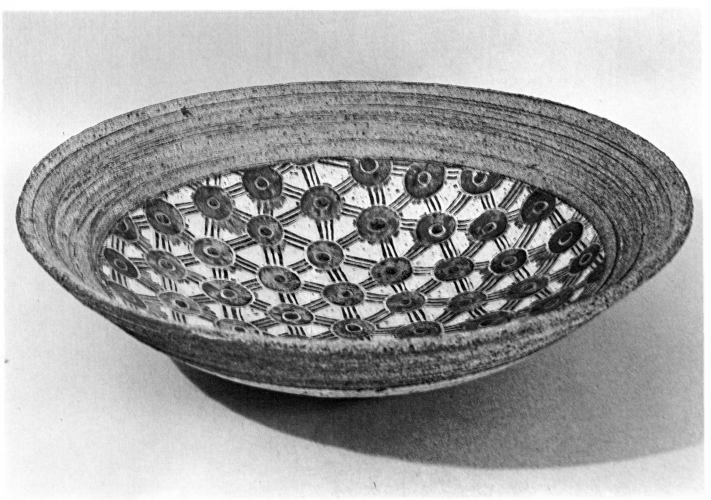

birthplace: Bushnell, Illinois, 1927
education: University of Saskatchewan, B.A. 1950 •
 School of the Art Institute of Chicago, B.F.A.
 1954 • University of Washington, M.F.A. 1955
teaching: University of Washington, present
collections: Smithsonian Institution • Everson Museum of
 Art (Syracuse)
residence: Bothell, Washington

COVERED JAR: stoneware: 8½" high: 1968.

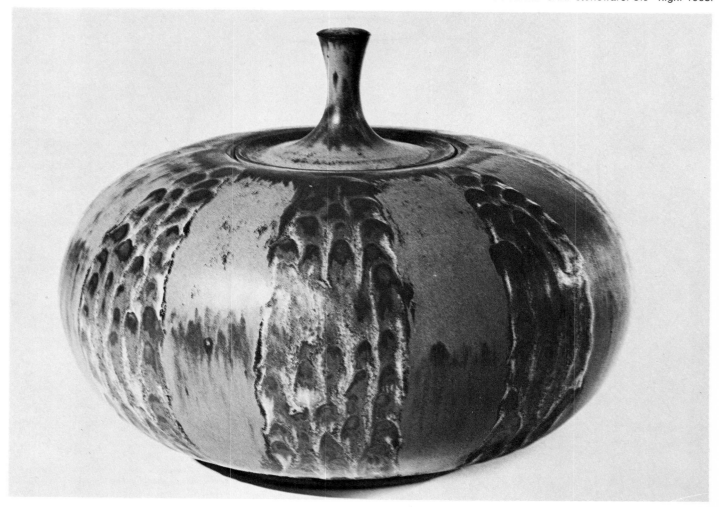

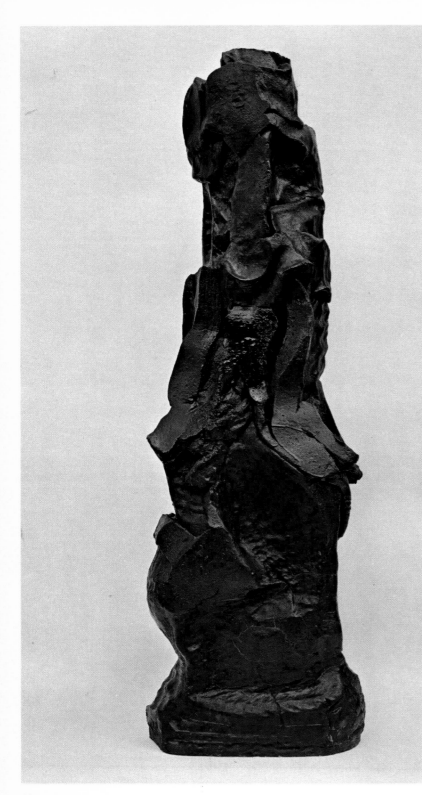

JOHN MASON

Mason was among the first group of artists —including Peter Voulkos—in Los Angeles (mid-fifties) whose experiments led directly to the adaptation of the Abstract-Expressionist aesthetic in ceramics. Mason's irregular organic forms of that period already gave indications of the direction his work was later to take— preoccupations with the monolithic totem, or tower form, and the multi-variation of crosses (or X's).

The development of Mason's forms has indicated an increasing emphasis on simplification. The intensely personal and powerful free-form works of the fifties and early sixties have lately given way to flat, geometric sculptures which subordinate details to a comprehension of the whole form. While this newer work tends toward the minimal and hard-edge aesthetic, its retention of interest in the totem and X forms reveals the essential continuity of development. There has been an increasing use of massive scale in the recent sculptures, and the articulation of these works has required awesome technical application.

The sculpture of Mason has been exhibited throughout this country and abroad, and an extensive one-man show was held at the Los Angeles County Museum of Art in 1966.

birthplace: Madrid, Nebraska, 1927
education: Otis Art Institute (Los Angeles) • Chouinard
 Art School (Los Angeles)
teaching: Pomona College (Claremont, California) •
 University of California (Berkeley) • Otis Art
 Institute • Claremont Graduate School •
 University of California (Irvine), present
collections: Pasadena Art Museum • Wichita Art
 Association • Art Institute of Chicago • Los Angeles
 County Museum of Art • Museum of Contemporary
 Crafts (New York)
residence: Los Angeles

VERTICAL SCULPTURE: glazed stoneware:
55″ high: 1963

WALL: ceramic relief, stoneware with
low-fire glazes: 84″ x 108″: 1959

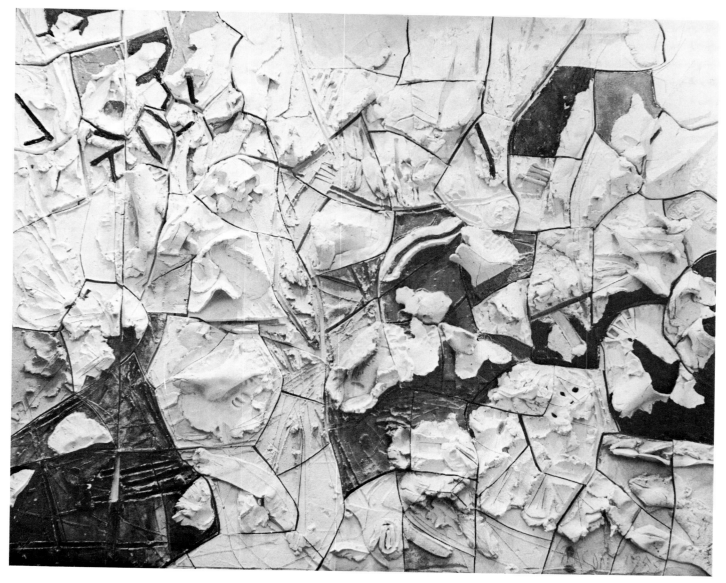

COPPER-RED VASE: porcelain: 5¾'' high: 1968.

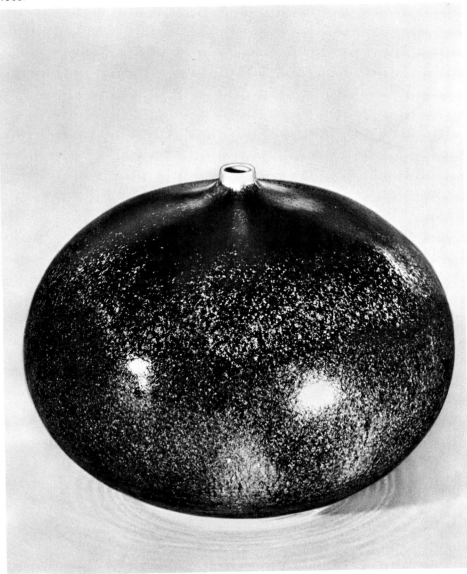

GERRY WILLIAMS

Williams was born and spent his boyhood in India, where his parents were missionaries. After returning to the U.S. and studying at Cornell College in Iowa, he entered the craft program of the League of New Hampshire Arts and Crafts. Since becoming a professional potter, Williams has sold his works throughout the U.S., and has exhibited both nationally and internationally. His work in clay ranges from sensitively glazed utilitarian pieces to murals, from small pots to unusually large coil-built pieces. He has executed architectural commissions, including mosaics, ceramic murals, and wall sculptures of polyester resin and acrylics. Currently, following his belief that 'new technology and freedoms urge the craftsman to create objects that reflect a significant sense of exploration and of deep commitment to his world,' he is involved with clay constructions conveying keen social commentary.

birthplace: India, 1926
education: Cornell College (Iowa) • League of New Hampshire Arts and Crafts • John Butler Pottery (apprenticeship)
teaching: Currier Gallery of Art (New Hampshire) • Haystack Mountain School of Crafts (Maine)
collections: Fitchburg Museum (Massachusetts) • Syracuse University
residence: Dunbarton, New Hampshire

RENDERING LORRAINE is my attempt to articulate an event of our time. The assassination of Martin Luther King, with its overtones of conspiracy, is here a sinister gathering of clay figures. By double meanings of words, gestures and positions of figures, by torn clay and dripped stain, I have tried to suggest dark violence underlying society.

—Gerry Williams

RENDERING LORRAINE: stoneware: 14½'' x 17¼'' x 11'': 1969

70

DANIEL RHODES

Daniel Rhodes is widely known not only as a potter and sculptor but also as a teacher and writer. His work in ceramics—functional objects and sculpture—has been exhibited in the major ceramic exhibitions in the U.S. and abroad, and since 1948 he has had numerous one-man shows, including one at the Museum of Contemporary Crafts in 1967. This latter exhibition introduced work done in a technique utilizing fiberglass in clay, a process developed by Rhodes in 1964 to extend the possiblities of clay as a sculptural medium.

In addition to his numerous articles, Daniel Rhodes' three books, *Clay and Glazes for the Potter, Stoneware and Porcelain,* and *Kilns,* are notable contributions to the literature on ceramics. A fourth book dealing with Japanese pottery will soon be published.

birthplace: Fort Dodge, Iowa, 1911
education: School of the Art Institute of Chicago •
 University of Chicago • Art Students League (New
 York) • Alfred University (New York) • Fulbright
 Research grant to Japan, 1962–1963
teaching: University of Southern California • Black
 Mountain College (North Carolina) • Haystack
 Mountain School of Crafts (Maine) • Alfred
 University (New York)
collections: Smithsonian Institution • Victoria and Albert
 Museum (London) • Walker Art Center (Minneapolis)
 • Everson Museum of Art (Syracuse) • Museum of
 Contemporary Crafts (New York)
residence: Near Alfred, New York

VESSEL: unglazed stoneware: 42½″ high:
1967

PAUL SOLDNER

One of the most respected artists working with clay, Soldner has covered all varieties of ceramics, including high fire, low fire, salt glaze and more recently raku. His containers cover a variety of forms, from the large floor pots of the fifties to the more recent bottles and plates. After a distinguished career of teaching (mainly at Scripps College, California), the artist has given up the classroom to create full time at his self-built studio (and home) in a valley a few miles from Aspen, Colorado. His work now is almost entirely in raku. Soldner experiments with surfaces to achieve textures as lyrically subtle as that on the *BOTTLE* shown here, or as bold as that of the *BEATLES AND PLAYBOY* plate, also illustrated. For the latter the artist has pressed actual objects into the wet clay, bringing out the figurative elements in relief.

Of the technique involved in these two works the artist writes, 'They are both fired at low temperatures (determined by my eye) and then removed from the kiln while red hot and smoked to develop the desired effects. This technique, although called raku, is related to the Japanese tradition only vaguely. It has become an American technique, for which we have no correct name.'

birthplace: Summerfield, Illinois, 1921
education: Bluffton College, B.A. • University of Colorado, M.A. • Los Angeles County Art Institute, M.F.A.
teaching: College of Wooster (Ohio) • Scripps College (Claremont, California) • Claremont College (California)
collections: Everson Museum of Art (Syracuse) • Smithsonian Institution • Oakland Art Museum • Krannert Art Museum (University of Illinois) • Butler Institute of American Art (Youngstown, Ohio)
residence: Near Aspen, Colorado

I consider clay to be just another art medium. Each artist must be totally responsible for any ultimate value he may make of it.
　　　　　　　　　　　　　　　　—Paul Soldner

BOTTLE: raku: 18¼" high: 1968

BEATLES AND PLAYBOY: raku: 19¾" wide: 1968

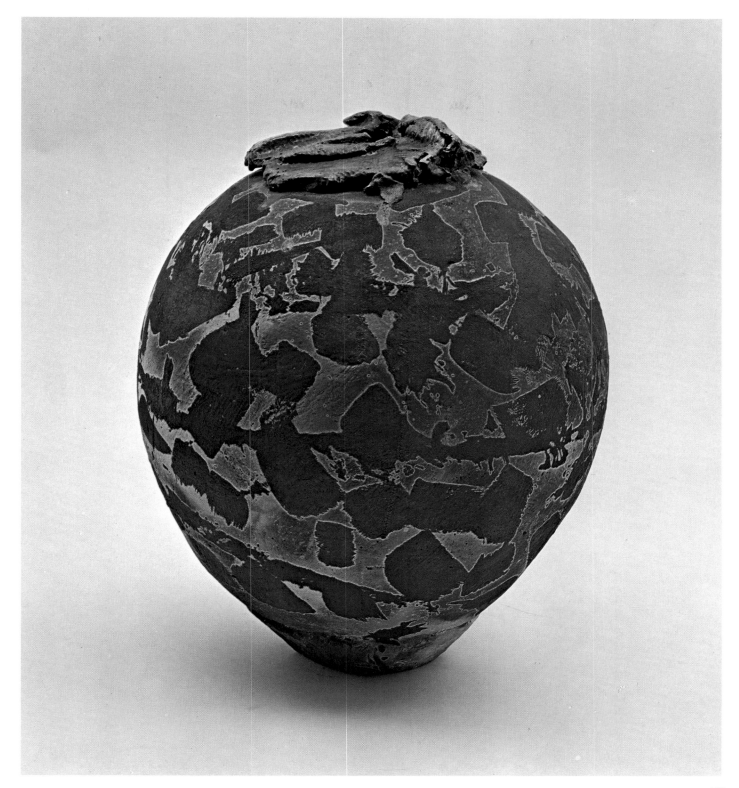

WILLIAM WYMAN

Wyman has been a professional potter since 1953. Currently he operates the Herring Run Pottery in East Weymouth, Massachusetts, which produces individually crafted functional and nonfunctional stoneware objects, from hanging planters to architectural murals.

Simultaneously Wyman has had far-reaching influence through teaching and through his inventive one-of-a-kind studio work. A few years ago he created a series of slab vessels, probing the possibilities of the form to its utmost. Most memorable were the slab pots with surfaces sgraffitoed with cartoons, poems, and catch phrases relating to contemporary jazz, rock-and-roll, and other popular expressions. Recently he has been working on a series of crosses, some starkly dignified with hard-edge lines, some more expressionistic with areas suggesting wreaths or material caught on the crossbar. An example from this series is illustrated here. Wyman's works have been shown in most major national and international ceramic exhibitions.

birthplace: Boston, 1922
education: Massachusetts College of Art • Columbia University
teaching: Drake University • University of Maryland • The Massachusetts College of Art • De Cordova and Dana Museum
collections: Smithsonian Institution • Museum of Contemporary Crafts (New York) • Addison Gallery of American Art (Andover, Massachusetts) • Des Moines Art Center • University of Iowa
residence: East Weymouth, Massachusetts

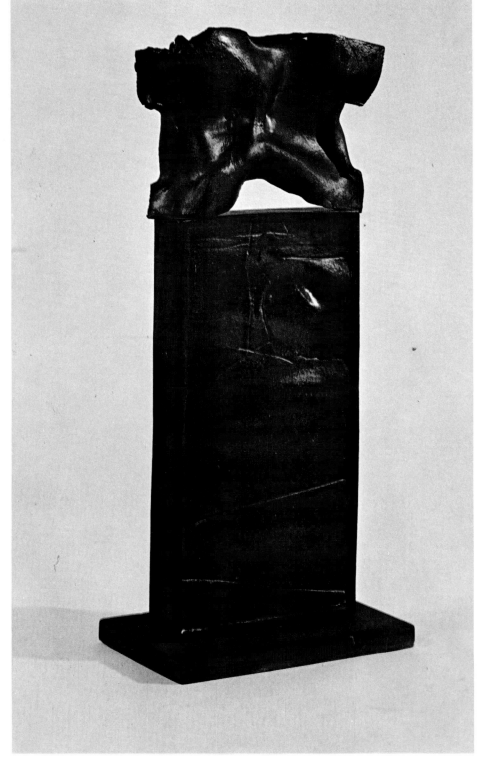

MOVING BLACK: glazed stoneware: 28" high: 1968

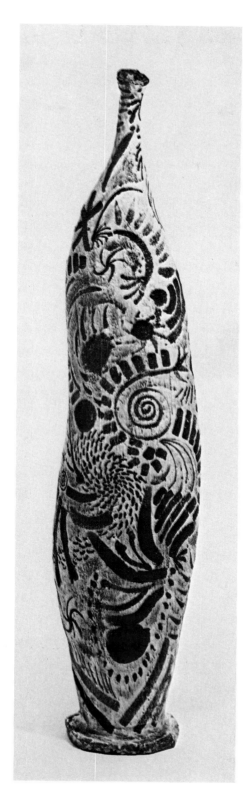

HENRY TAKEMOTO
The abundant organic references that recur in the exuberant compositional vocabulary of Takemoto reflect both his Hawaiian background and his natural *joie de vivre*. As has been the case with so many of his generation, Takemoto acknowledges the overwhelming influence that Peter Voulkos has had on his development.

Takemoto devotes most of his time at present to teaching. He has been inactive as a practicing ceramist in recent years, feeling that this is for him a period for absorption.

birthplace: Honolulu, 1930
education: University of Hawaii, B.F.A. 1957 • Otis Art
 Institute (Los Angeles), M.F.A. 1959
teaching: San Francisco Art Institute • Montana State
 University • California State College • Scripps
 College (Claremont, California) • Claremont College
 Graduate School
collections: Smithsonian Institution • Everson Museum of
 Art (Syracuse) • Wichita Art Museum
residence: Los Angeles

BOTTLE: hand-built stoneware: 41″ high: 1959

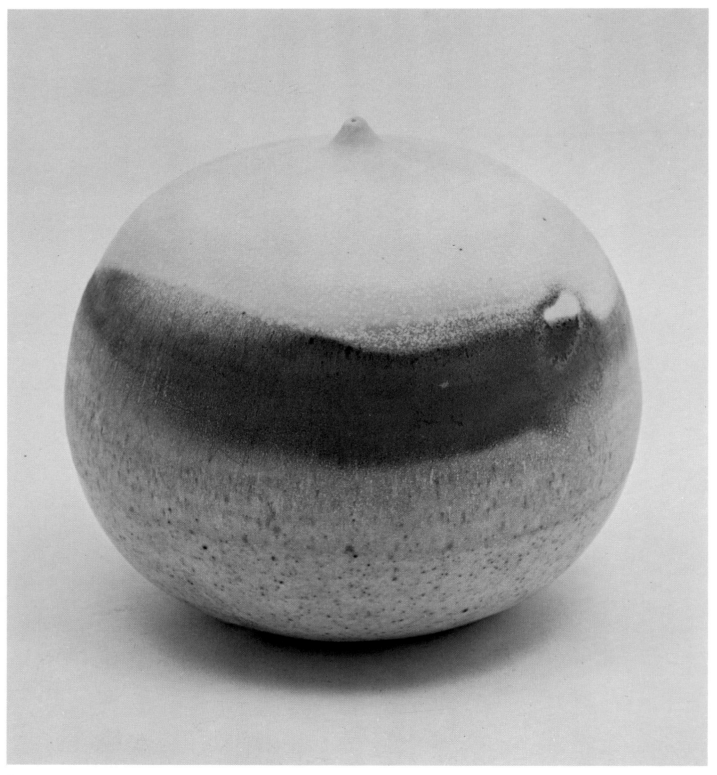

FORM A: porcelain: 5½'' high: 1968

TOSHIKO TAKAEZU

Like her native Hawaii, the pottery of Toshiko Takaezu is a blending of the East and West. Delicately asymmetrical forms, reminiscent of a Zen tradition, are balanced and vitalized by the application of abstract and lyrical 'color clouds' that recall the flora and sky of Hawaii. For Toshiko Takaezu the creative process is not a hurried affair: the works remain 'non-finito'—continually presenting new possibilities to be explored until finally placed in the kiln. Then the fire—the volcano—puts its mark on the porcelain. The quiet drama of Takaezu's pots demands an intimate participation from the viewer. Even the new experimental direction on which she is working is a 'private affair': the artist now places small pieces of clay into her closed pots and bases of chalices before the firing. When the pot or chalice is lifted there will be a shade of sound: perhaps again Hawaii—waves breaking on quiet shores.

After a distinguished teaching career, Takaezu has mainly given up the classroom in order to concentrate more fully on her studio work. (See also under FIBER.)

birthplace: Pepeekeo, Hawaii
education: Honolulu School of Art • Cranbrook Academy of Art
teaching: Cranbrook Academy of Art • University of Wisconsin • Haystack Mountain School of Crafts (Maine) • Penland School of Crafts (North Carolina) • Creative Arts Program at Princeton University, present (part-time)
collections: Cleveland Museum of Art • Cranbrook Museum of Art • Honolulu Academy of Arts • Detroit Institute of Arts • Everson Museum of Art (Syracuse)
residence: Clinton, New Jersey

INAZUMA: pair of porcelain plaques: 12'' x 12'' each: 1968

JIM CRUMRINE

A graduate of the School for American Craftsmen, Alfred, New York, in 1948, Crumrine was one of the early studio artists in ceramics in the U.S. He has always been a superior technician, and his objects have evolved in form from the traditional to the present high-color glazed abstract forms. Crumrine has exhibited in most national ceramic shows, and in two international exhibitions.

birthplace: Paw Paw, West Virginia, 1925
education: School for American Craftsmen (Alfred, New York) 1948
teaching: Queens College (New York) • Greenwich House Pottery (New York)
collections: Museum of Contemporary Crafts (New York) • Museo Internazionale delle Ceramiche (Faenza, Italy)
residence: New York, New York

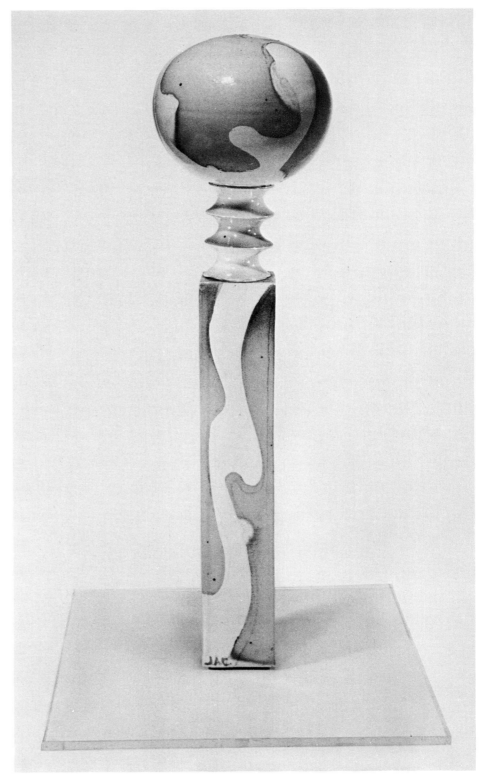

COLUMN: earthenware, lead glaze, yellow overglaze: 36¾″ high: 1969

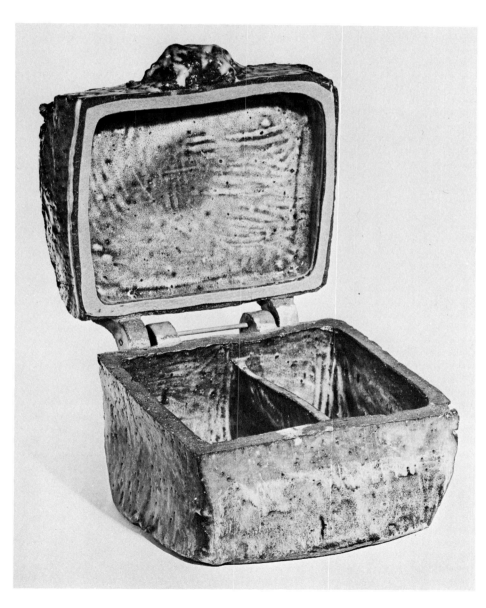

ROY CARTWRIGHT
Cartwright started his college education on the West Coast in 1955, studying architecture, and he finished it with a masters in ceramics at Rochester's School for American Craftsmen in 1963. His clay objects, usually in stoneware, are bold personal statements achieved through form and texture alone. The artist seldom works in other than neutral colors. He creates equally well in large scale, and in 1968 he completed a commissioned fireplace in Rochester that seems to grow out of the earth below, as if the house had been built around it. Again neutral in tone, its strength is maintained through interlocking expressionistic sculptural forms.

birthplace: Westmoreland, California, 1937
education: California College of Arts and Crafts, B.F.A. 1961 • Rochester Institute of Technology (New York) M.F.A. 1963
teaching: Cleveland Institute of Art, 1963–1964 • University of Illinois, 1964–1965 • University of Cincinnati, present
residence: Cincinnati, Ohio

HINGED BOX: stoneware: 7 ¼″ x 11 ½″ x 11 ¾″: 1965

references by utilizing frequent erotic suggestion. Earl has exhibited in several local one-man and group shows, and many national juried shows.

birthplace: Uniopolis, Ohio, 1934
education: Bluffton College (Ohio) B.A. 1956 · Ohio
 State University, M.A. 1964
teaching: Toledo Museum of Art School for Design,
 present
residence: Toledo, Ohio

Satin ribbons, velvet cushions, plastic roses, hand-painted landscapes, fresh stuffed sausage, knotholes, grapefruit, pimples, hair, slugs, and fat dogs is what it's made of.

—Jack Earl

JACK EARL

Earl, who received his graduate degree in 1964, has evolved a highly amusing and satirical style. He creates outrageous spoofs on the just as outrageous Victorian pieces he lampoons. Working mainly in porcelain, Earl goes a step beyond the Victorian

FIGURE WITH BANANAS: porcelain: 7″ x 8″: 1968

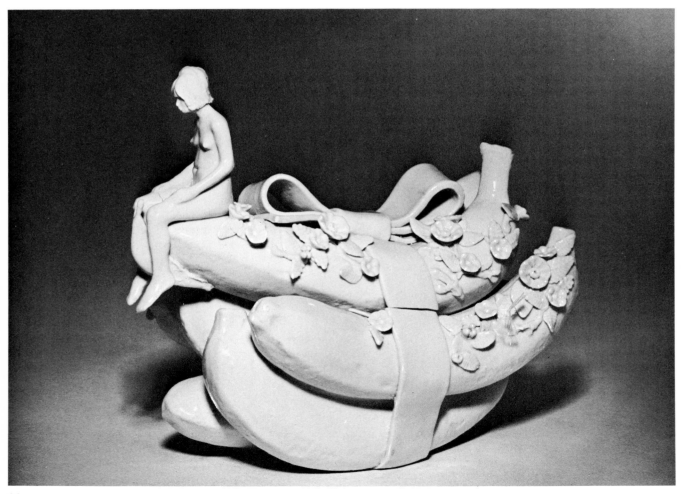

BILL FARRELL

Farrell's early work suggests the strong Abstract Expressionist influence of West Coast ceramists. Recently, however, he has involved himself with boldly painted, bent tubular forms. *POPEYE WITH RED STRIPE,* illustrated here, is one of a series of ceramic variations on this theme which plays up hard edges and crisp contrasts, but relies mainly upon the powerful impact of the form itself.

The artist's work has been exhibited in many invitationals and competitive exhibitions throughout the country, and was included in the Salt Glaze Invitational at the State University at Geneseo, New York. In addition to his regular teaching responsibilities, he has conducted numerous workshops in colleges and universities.

birthplace: Phillipsburg, Pa., 1936
education: Indiana State University, B.A. • Pennsylvania
 State University, M.A.
teaching: School of the Art Institute of Chicago, present
residence: Chicago

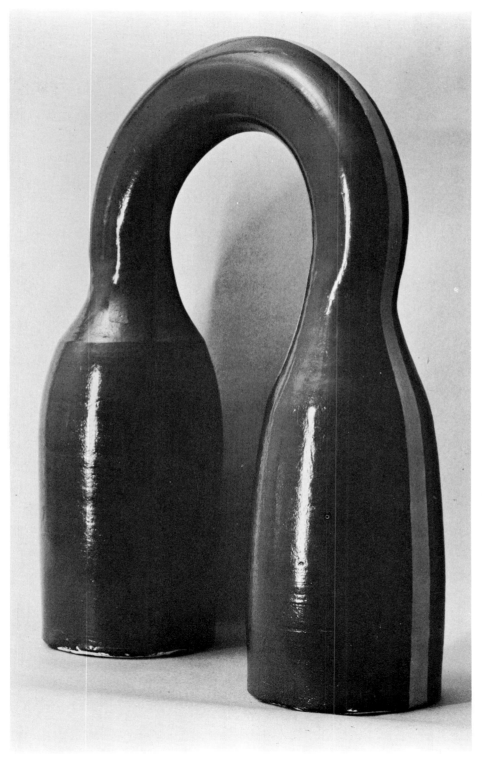

POPEYE WITH RED STRIPE: bisque ceramic, enamel paint: 22½" high: 1968

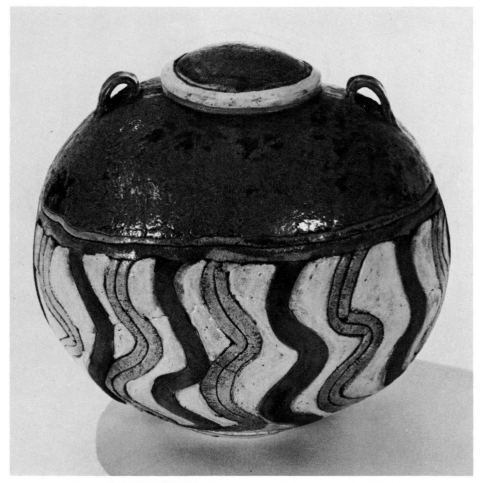

WAYNE HIGBY

Higby has only recently appeared on the ceramic scene, and he is rapidly gaining a reputation for his strong syntheses of basic classical shapes with combinations of ancient and contemporary techniques.

The artist's statement printed here expresses his mode of working.

birthplace: Colorado Springs, Colorado, 1943
education: University of Colorado, B.F.A. 1966 •
University of Michigan, M.F.A. 1968
residence: Omaha

This Egyptian-paste and earthenware clay jar is my most successful piece done in a series of pieces exploring the possibilities of Egyptian paste in full-scale pottery.

I am interested in the paste because of its depth and intensity of color after firing. To a certain degree, these coloristic qualities are due to the fact that the colorants are mixed with the paste rather than applied to its surface. This texture is a result of incorporating the glaze and structural qualities of the material as one unit. The intensity, depth of color, and molten texture together create a crude or primitive effect which I like.

This crude effect is also due to the paste's natural limitations. Because the body lacks significant inner structure it cannot easily be made into large forms. Therefore, in order to make larger, more controlled forms I have integrated the Egyptian paste with an earthenware clay. This integration is achieved by inlaying the paste and the clay into a one-piece mold. When the pot is completed and fired, the clay body serves as an armature to support the inlaid paste. This combination of paste and clay also produces a subtle interplay of contrasting surfaces. I feel that this contrast lends a highly desirable dimension to the over-all aesthetic which I try to obtain.

In terms of aesthetics I am primarily interested in man's ability to create something beautiful. Specifically, in relation to pottery, I am impressed and influenced by the past. I use the past as a catalogue of ideas which inspires me to create objects in clay that express my concern with visual beauty rather than function.

—Wayne Higby

DOYLE LANE

During the first nine years of Lane's career as a ceramist he threw functional pots and experimented with various glazes and clay bodies. 'Then I felt the need to expand my art experience, so I gradually turned to the large-scale mural medium,' he says. Although his architectural murals have been successful, recently Lane again expanded into a new area of expression, creating what he calls 'clay painting.' Here the technique involves the application of glazes to clay slabs under tremendous heat so that their natural flow and overlapping create unusual color and texture combinations. One of the basic reasons for the clay paintings was the fact that they could be hung out of doors.

birthplace: New Orleans, 1925
education: Los Angeles City College • University of Southern California
commissions: Tile mural, Mutual Savings and Loan (Pasadena) • Ceramic fountain, Pantry Foods (Pasadena) • Ceramic mural, Miller Robinson (Santa Fe Springs, California) • Temple B'nai David, Gold Ark Mural Wall (Southfield, Michigan) • Ceramic wall mural for the California Lutheran Health Center (Alhambra, California)
residence: Los Angeles

Why not take paintings out of doors where one may sit and watch the changing play of sunshine on the glazes, and thus have changes of mood during the day?
—Doyle Lane

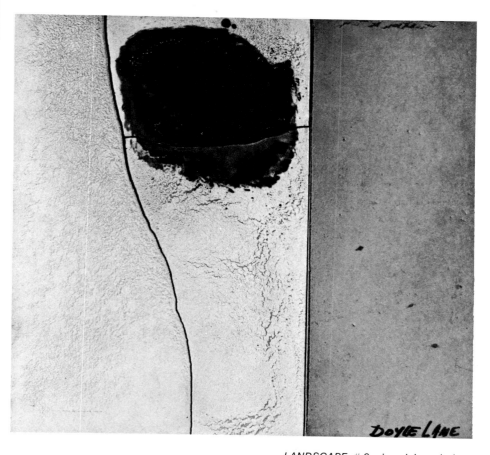

LANDSCAPE #9: clay slab and glaze technique: 15¾'' x 16¾'': 1967

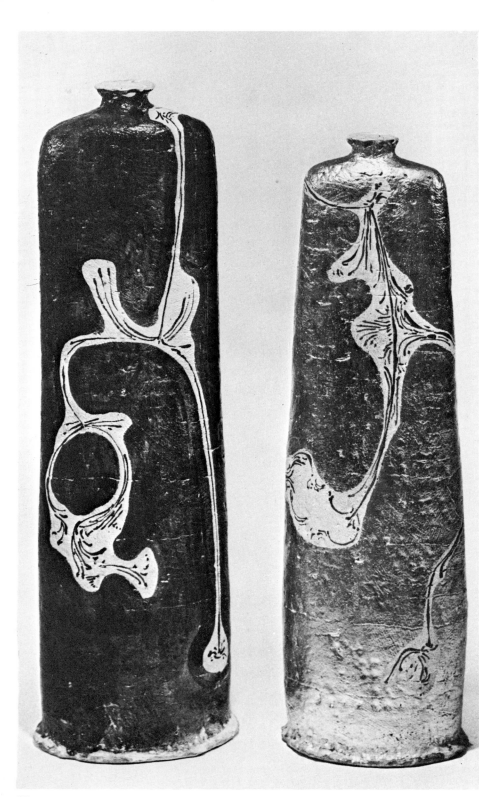

BRUNO La VERDIERE
One of the Pacific Northwest's most noted potters, La Verdiere was an active and versatile monk of St. Martin's Abbey (near Olympia, Washington) as artist-in-residence, until 1969, when he left the Order to marry. His pottery has been both functional and free form, both figurative and abstract. Discussing one of his earlier pots with a nativity scene, La Verdiere commented: 'I had a basic idea I wanted to say, and I was trying to reach as many people with this as I could without being esoteric. I wasn't trying to be fancy or intellectual. I wanted to say someting profound, simply.' In quite a different mode the craftsman has recently created a series of ceramic horns, meant to hang from the ceiling, that function—that blow!

La Verdiere could also be called 'peripatetic,' for a good part of each year is generously spent teaching workshop classes across the country.

birthplace: Waterville, Maine, 1937
education: St. Martin's College (Olympia) • St. John's University (Minnesota) • Art Students League (New York)
teaching: St. Martin's College • Greenwich House Pottery • Penland School of Crafts (North Carolina) • Pottery Northwest (Seattle)
collection: Mills College (Oakland, California)
residence: New York, New York

I like to make beautiful things that have a sense of humor, that live a little; not trite but real.

—Bruno La Verdiere

PAIR OF BOTTLES: stoneware, coil construction; one oxide painting underglaze, other gold-leaf overglaze: higher 41": 1968

RALPH BACERRA

The organically oriented, clay-based forms of Bacerra reflect a close and intimate relationship with the artist's immediate environment. His studio is located under Eagle Rock in the Los Angeles area, and it is this solid mass of granite and the surrounding mountains and hills that are always present in the concept of his objects. Bacerra works his clay and glazes at high- and low-fire combinations to achieve varied textural surfaces.

As chairman of the ceramics department of the Chouinard Art School, he has by his teaching exerted an influence on a still younger generation of ceramists.

birthplace: Orange County, California, 1938
education: Chouinard Art School (Los Angeles), B.F.A.
 1961
teaching: Chouinard Art School, present
collections: Everson Museum of Art (Syracuse) •
 Krannert Museum (University of Illinois) •
 Wichita Art Museum • Northern Illinois University
 • Sacramento State College
residence: Los Angeles

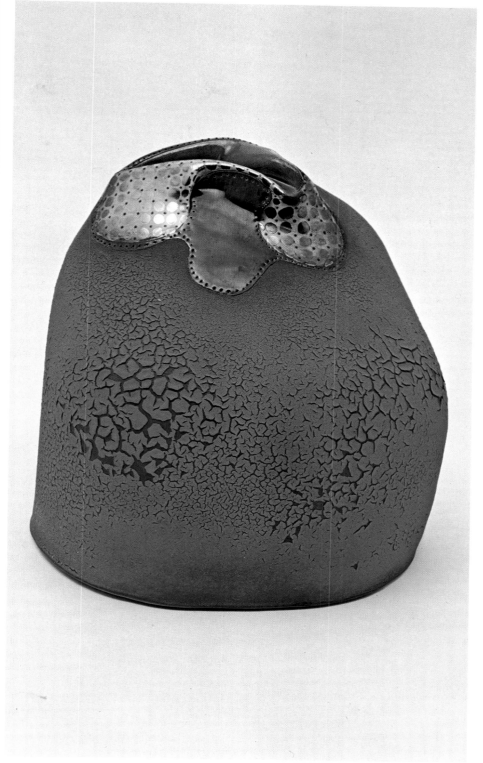

ORANGE FORM: earthenware with chrome and lead, metallic overglaze: 9″ high: 1968

HARRISON McINTOSH

McIntosh is one of the early figures in contemporary American ceramics, an artist who comes from California, one of the few places in the U.S. where there has always been an interest in clay—perhaps simply because clay was there. A master of many ceramic techniques, McIntosh has worked in stoneware, mostly with container shapes which are marked by their restraint, understatement, and by a distinctive use of color. Only recently has he turned to the form illustrated here. The artist has shown nationally and internationally, and has had numerous one-man exhibitions. From his personal credo it is obvious that McIntosh chose to work with clay not only as a vocation, but as a way of life, and it is significant that he studied with three key ceramists: Glen Lukens, Bernard Leach, Marguerite Wildenhain.

birthplace: Vallejo, California, 1914
education: University of Southern California, 1940 •
 Claremont Graduate School, 1949–1952 • Pond
 Farm Workshop (Guerneville, California) 1953
collections: Belgian Royal Collection • Everson Museum
 of Art (Syracuse) • Kiushu Museum (Japan) •
 Museum of Contemporary Crafts (New York) •
 Musée National de la Céramique (Sèvres, France)
residence: Claremont, California

*BLUE EGG is among the first in a series
that has been the natural outgrowth of
the 'bottle' as thrown on the potter's
wheel, eliminating the opening as well as
the foot, leaving the hollow and even more
simplified form to move in any direction
or, as in some instances, suspended in
space.
 How can clay express all that the potter
feels and is only too conscious of in this
day: the speed of discovery, the greatness
of humanity, the destruction of nature
and ourselves, the new freedoms? . . .
Still, this simple material can help man
find his way toward the serene beauty
needed to keep all in perspective.*
 —Harrison McIntosh

BLUE EGG: stoneware: 6″ high (without base): 1968

JEFF SCHLANGER

One of the serious younger artists working in clay, Schlanger uses organic forms to build works that are about growth and human body rhythms. The final pieces show the sense of gesture that inspires them in both their freely handled surfaces and boldly drawn color.

birthplace: New York, New York, 1937
education: Cranbrook Academy of Art • Swarthmore
 College, B.A.
residence: New Rochelle, New York

Find the shape of the form Inside
that connects the sexpart zone to the heartlung
or the one that connects shouldermass to the footsole pads
and the form of the wire from headtop to the toetips.
Show how it holds the changing air,
and its posture.

Reveal the shape which that form would take Outside.
Open its glow until the throbbing
synchronizes with the crossing rhythms Inside.
The real thing, It, *exact hue, exact scale, exact densities.*

A researchfruit offered as a fact—
Important information,
not a toy, not an object but
a condensation of Spirit.

Can we show each other the core we have together,
our Connection Drum?
Belief might rise,
and with it sanity and hope.
 —Jeff Schlanger

MY OWN BONE: glazed stoneware: 47½"
high: 1967

HUI KA KWONG

The recent wheel-thrown, nonfunctional vessel forms of Hui imply a marked departure from his earlier work, which was characterized by soft, subtle brushwork and matte, earthy glazes. His new approach is more formal, stressing an equal interplay of color, shape, and texture. It has been pointed out, however, that this apparent antithetical implication is more superficial than real—that the early work and the new contain the same internal consistency and that the progression from soft, organic forms to hard-edge geometric ones is a logical development. The observant are quick to point out that Hui's technical collaboration with Pop painter Roy Lichtenstein in 1967, when he developed the latter's limited editions of ceramic tableware, encouraged this apparent transformation. But Hui disclaims any interest in the comic-strip aesthetic and acknowledges only that the association might have led to a greater clarity of color and closer technical precision.

Hui Ka Kwong is held in high regard among his colleagues for his sustained performance in the field of ceramics. He has been awarded many top prizes since coming to the U.S. in 1948, and has been represented in major exhibitions throughout the country.

birthplace: Hong Kong, 1922
education: Canton School of Art (China) • Pond Farm
 Workshop (Guerneville, California), 1948 • Alfred
 University (New York), M.F.A. • Louis Comfort
 Tiffany Foundation grant (Spain, 1962–1963)
teaching: Brooklyn Museum of Art School • Greenwich
 House Pottery (New York)
collections: Cooper-Hewitt Museum of Design (New York) •
 Museum of Contemporary Crafts (New York) •
 University of Michigan Art Museum
residence: New York, New York

FORM: earthenware, lead, and colemanite glaze with yellow and black overglaze: 20¼'' high: 1968

VASE: stoneware, fritted white glaze with red, yellow, and blue overglazes: 19¼'' high: 1968

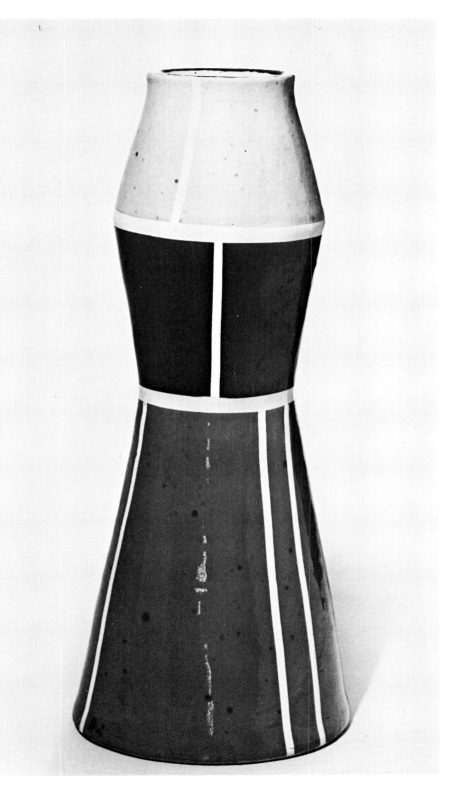

DONALD L. REITZ
Associate Professor at the University of
Wisconsin, Reitz is a ceramist who has
distinguished himself by his explorations
into the medium of salt glazing. Although
noted in the past for his powerful traditional
forms, more recently Reitz has turned to
modeling nonfunctional objects.

birthplace: Sunbury, Pennsylvania, 1929
education: Kutztown State College (Pennsylvania), B.S.
 1957 • Alfred University (New York), M.F.A.
teaching: University of Wisconsin, present
collections: Smithsonian Institution • David Campbell
 Memorial Collection (New York) • Canadian Potters
 Guild (Toronto) • Mills College (Oakland, California)
 • Gilmore Art Center (Kalamazoo)
residence: Spring Green, Wisconsin

*The piece is formed from wet clay; slips,
stains, and other coloring oxides are then
applied. If glaze is desired, it is applied
while the piece is wet. Before the piece
becomes leather-hard it is placed in the
kiln. The door is closed and sealed as
tightly as possible. The burners are lit and
the steam from the wet clay allows it to
dry from inside out, preventing cracking
and blow-ups. When I reach my desired
temperature, I introduce rock salt into
the fire box by throwing a few handfuls in
at a time. The salt melts and volatilizes.
Salt, being sodium chloride, breaks down
and the sodium is attracted by the silica
in the clay which forms a glaze on the
surface. The chloride goes off as a gas.
For this reason, it is important you work
in a well-ventilated area. My kilns are
outside, completely open. After using
several pounds of salt, a rod is put into a
kiln and a draw tile is pulled out. By this
process, one can judge the amount of
sodium that has formed on the piece.
The salting and drawing of tiles is repeated
until the desired coverage is reached. I
often introduce chlorides, strips of metal,
oil, wood, and most anything that's handy.
This can increase the flashing effects on
the ware. However, it also increases the
chance factor and can be disastrous.*
—Donald L. Reitz
EX-VOTO # 1; stoneware, salt glaze: 19½"
high: 1969

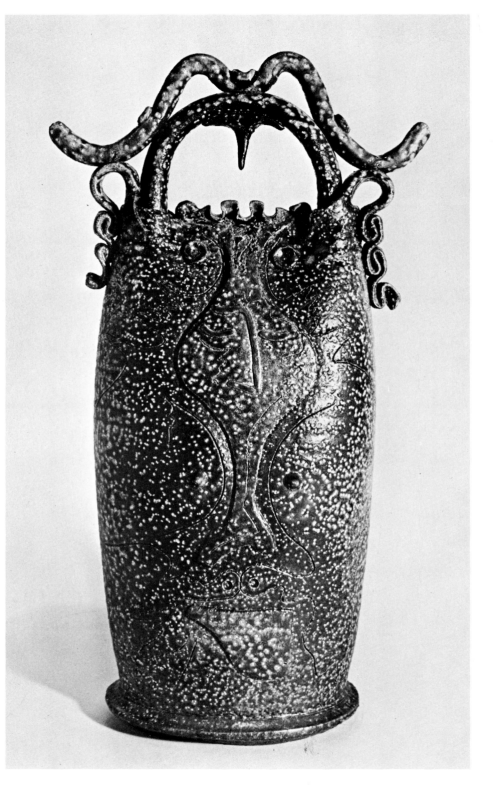

ROBERT STULL
Stull, who received his master's degree
from Ohio State University in ceramics
(1963), probably acquired his greatest
stylistic direction from his trip to the
Orient on a Fulbright grant during 1965–
1967. In Japan he built his own ceramic
studio and kilns near Kyoto, and he traveled
throughout the country—and in Korea—
photographing primary pottery sites and
major museum collections. The monumental
vessel forms the artist creates today
reflect the dignity and grace of Oriental
containers. However, he has personalized
and Westernized the shape and the surface.
For the latter, he often uses a single
color applied with epoxy resin, as in the
work illustrated here.

birthplace: Springfield, Ohio, 1935
education: Ohio State University, B.S. 1962; M.A. 1963
teaching: University of Michigan, present
residence: Ann Arbor, Michigan

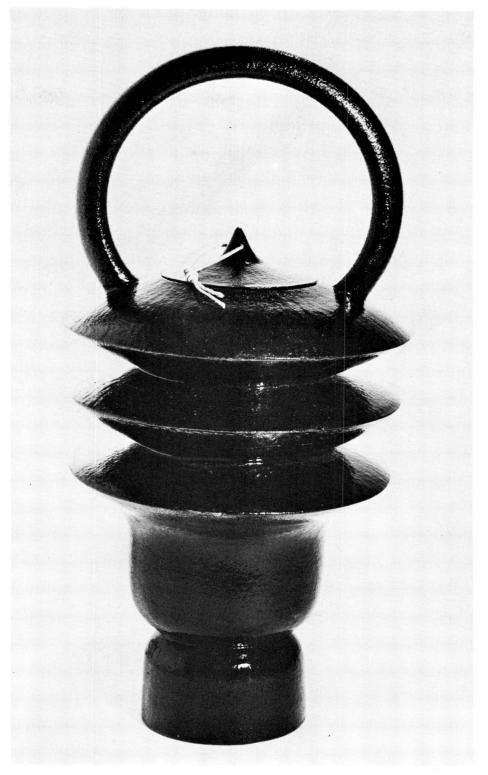

VASE WITH LID AND LOOP HANDLE:
stoneware with epoxy resin surface: 28⅝"
high: 1969

birthplace: Benicia, California, 1930
education: College of Marin (Kentfield, California),
1949–1952 • California College of Arts and Crafts
(Oakland), B.A. 1954 • Mills College (Oakland,
California), M.F.A. 1958
teaching: Mills College (Oakland, California), 1960–
1962 • University of California (Davis), present •
Numerous ceramic workshops throughout the U.S.
including Haystack Mountain School of Crafts
(Maine)
collections: San Francisco Museum of Art • Santa
Barbara Museum • Henry Art Gallery (University
of Washington) • Mills College (Oakland, California)
• Museum of Contemporary Crafts (New York)
residence: Davis, California

ROBERT ARNESON

One of the undisputed leaders in the Funk
movement and mentor to a generation of
younger ceramic artists, Arneson derives
from the revolutionary impact of Peter
Voulkos and Abstract Expressionism in
the late fifties. His own impact on
contemporary American ceramics would
be difficult to exaggerate, both in his
capacity as teacher and as frequent
exhibitor.

Working largely in polychrome, low-fire
clay, Arneson has transformed the familiar
objects of modern life into vehicles of
brash and virulent social commentary. These
have included typewriters with keyboards
of red-nailed fingertips, Oreo cookie jars,
six-packs, bathroom sinks, toothbrushes,
urinals, toasters, and teapots—to indicate
but a few of his preoccupations.

More recently a series of ceramic
depictions of his house in Davis,
California, have served his Funky
vocabulary. In commenting upon these
works, he has stated that he conceives of
his house '—as a monument, a sculpture,
a wall, a trophy, a jar and a souvenir
plate. It is a slab-floor, one-story, three-
bedroom, two-bath, two-car garage,
California-style house. It is for sale.'

Arneson has cited a predilection for the
work of 'little old ladies' and for the art of
Marcel Duchamp and René Magritte.
Within the context of Funk Art he exhibited
in 1966 at 'The First Group Mess' (Sacra-
mento) and at the Funk show held at the
University of California in 1967. He
received a one-man show of his work that
same year at the San Francisco Museum of
Art.

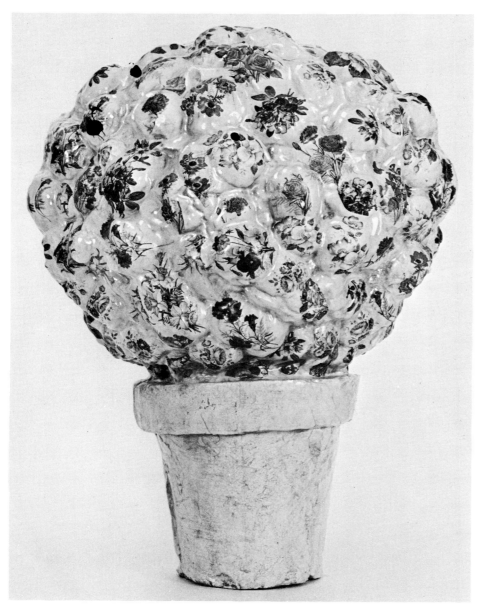

POT WITH FLOWERS # 3: clear glazed
earthenware with ceramic decals: 26¾"
high: 1967

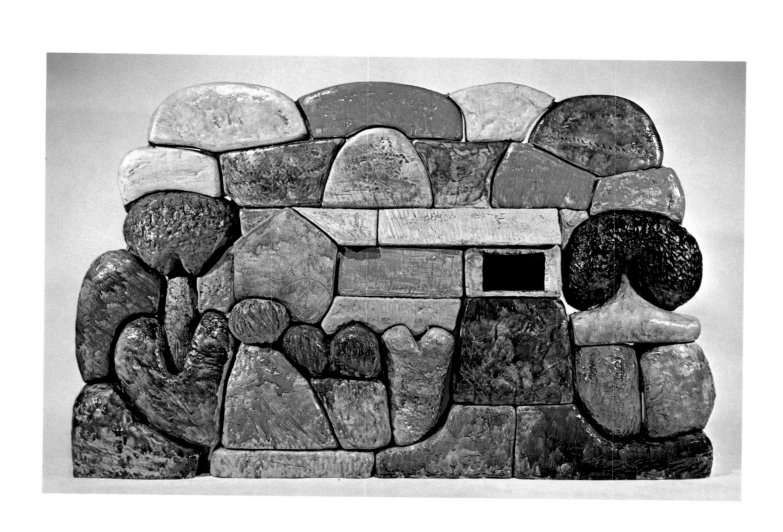

ALICE HOUSE WALL: polychromed
earthenware: 59½'' × 80'': 1967

ROBERT ARNESON

SINK: white earthenware with platinum
luster: 26½'' × 18'' high: 1966

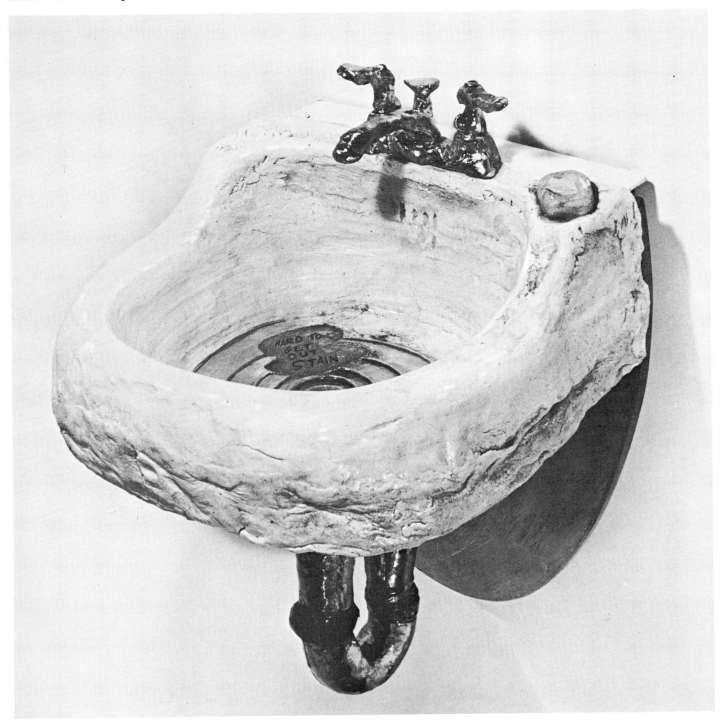

RUDOLF STAFFEL

Staffel has made his major ceramic statements in porcelain, throwing and building containers with free forms that both heighten the facets of transparency of the medium and lend a sculptural presence to the work. In 1966 the Museum of Contemporary Crafts in New York gave him a one-man exhibition. His work has also been shown in most of the major national ceramic invitationals.

birthplace: San Antonio, Texas, 1911
education: School of the Art Institute of Chicago •
 Escuela Para Maestros (San Juan Teotihuacan,
 Mexico) • Private study with José Arpa and
 Xavier Gonzalez
teaching: Tyler School of Art (Philadelphia)
collections: Smithsonian Institution • Philadelphia
 Museum of Art • Witte Memorial Museum (San
 Antonio)
residence: Philadelphia

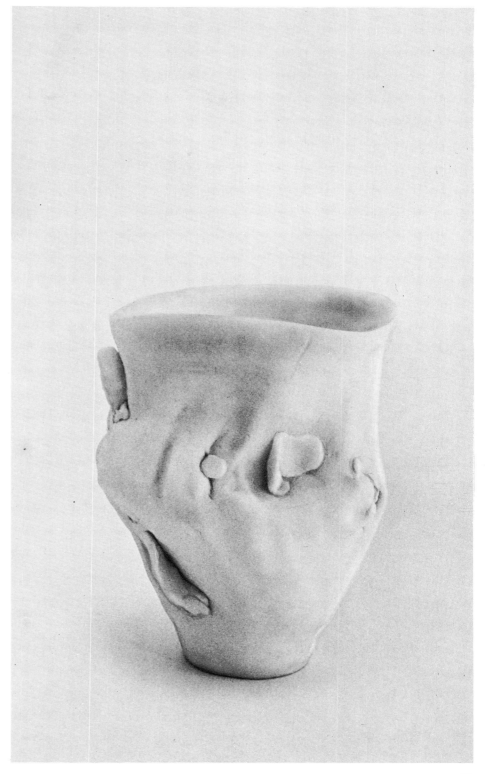

VASE: unglazed porcelain: 7″ high: 1968

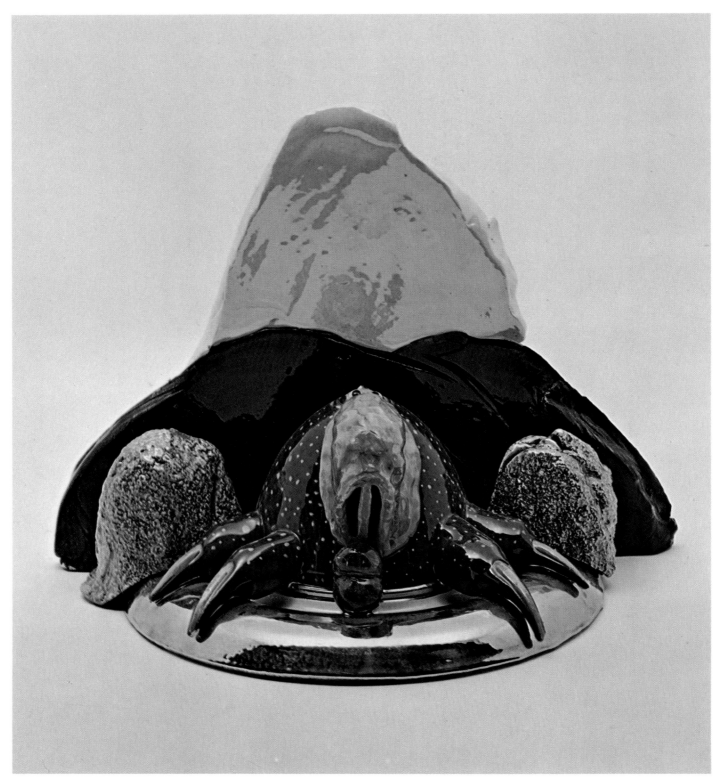

CLAYTON BAILEY

'Think ugly—but make beautiful things' is basic to the Funk philosophy of Clayton Bailey. His ceramic and, more recently, rubber and plastic objects result from an almost obsessive preoccupation with the redefinition of traditional values. These redefinitions, conceived within an anti-establishment context, are chiefly concerned with elements of the grotesque, the humorous, and, most of all, the absurd.

The evolution of Bailey's work over the past five years has been consistent and logical, beginning with traditional processes and materials (i.e., clay and salt glazes) and developing to the present through constant experimentation with clay technology and new materials (i.e., synthetics, electric hardware). Discussing this development, he has written, 'The Pinch Pots were attempts to see what could be done with fingers squeezing clay. The Critter and Nose Pot series were equally involved with processes and subject matter; this eventually led to Dead Critters. Painted clay pots of 1965 and 1966 were a relief from the problems of making and firing glazes. They helped make way for the Rubber Grub aesthetic. The rubber grubs, masks, neckties, hats, and miscellaneous objects which I am now involved with require handling, use, and involvement much like pottery, toys, and other crafts.'

Like his Funk mentor, Robert Arneson, Bailey has remained committed to subject matter—rubber bugs, grubworms, 'kiss' pots, hanging noses, nose lamps, and clay critters.

At thirty the artist has already had ten one-man shows, including those at New York's Museum of Contemporary Crafts (1964) and the Milwaukee Art Center (1967). In addition, he has been represented in numerous national and international exhibitions.

birthplace: Antigo, Wisconsin, 1939
education: University of Wisconsin, M.A. 1962 • Louis Comfort Tiffany Foundation grant, 1963
teaching: University of Wisconsin • California State College (Hayward) • University of California (Berkeley and Davis)
collections: Addison Gallery of American Art (Andover, Massachusetts) • Milwaukee Art Center • Brooks Memorial Art Gallery (Memphis) • State University of Iowa • University of Wisconsin
residence: Crockett, California

LIZARDSCAPE STASH ALTAR WITH TWO SECRET ROCKS: whiteware with luster, fake stone, and plastic: 13½'' high: 1968

STEPHEN J. DALY

Although now teaching in the Midwest, Daly is a product of San Jose State College, from which most art students are graduated with skills in many media. Daly continued his studies (with a scholarship) at the Cranbrook Academy of Art, concentrating on metals. His two usual media are now clay and metal, and the work here illustrated contains both. His bronze vessels and candlesticks, although functional, are clearly sculptural in concept; and his recent machinelike constructions in bronze (as well as the ceramic-bronze pieces) are clearly art objects.

birthplace: New York, New York, 1942
education: San Jose State College, B.A. 1965 • Cranbrook Academy of Art, M.F.A. 1967
teaching: University of Minnesota • Penland School of Crafts (North Carolina) • Humboldt College (Arcata, California)
residence: Arcata, California

The art talks; I just make it.
—Stephen J. Daly

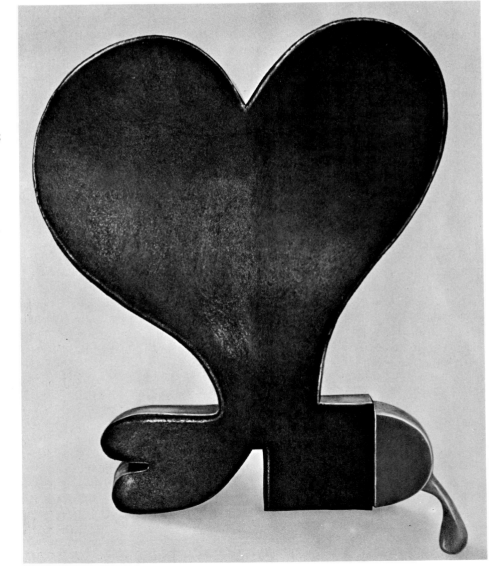

VALENTINE FOR SABINA: stoneware with high-fire copper-reduction glaze and cast aluminum: 27¼″ x 19″: 1969

STEPHEN DE STAEBLER

The sculptural forms of De Staebler would appear to sustain a deep and often spiritual dialogue with the earth. The clays are fired in their natural colorations, and cracks and crevices become an integral part of the artist's statement. He credits this abiding respect for the expressive quality of naked earth media to his study and work with Peter Voulkos at Berkeley, California, De Staebler's sculptures are particularly notable for their structural articulation.

The work illustrated here was conceived as an earth-mountain form, the torso suggesting the splayed thorax of an insect. Its earthy ochers only serve to underscore its powerful organic source.

De Staebler has executed a number of architectural commissions, which reveal his involvement in the kinesthetic experience of the viewer.

His work was represented in the Second Paris Biennale (1963) and in the International Exhibition of Contemporary Ceramic Art held in Japan (1965).

birthplace: St. Louis, 1933
education: Princeton University (religion), A.B. 1954 • Black Mountain College (North Carolina) • University of California (Berkeley), M.A. 1961
teaching: San Francisco Art Institute, 1961–1967 • San Francisco State College, present • University of California (Berkeley), part-time
commissions (architectural): Newman Center Sanctuary (University of California, Berkeley) • Salt Lake City, relief (William Pereira, arch.) • Art Museum, University of California (Berkeley), sculpture garden and lounge • Oakland Art Museum
residence: Berkeley

A WOMAN: high-fired clay: 54″ long: 1964

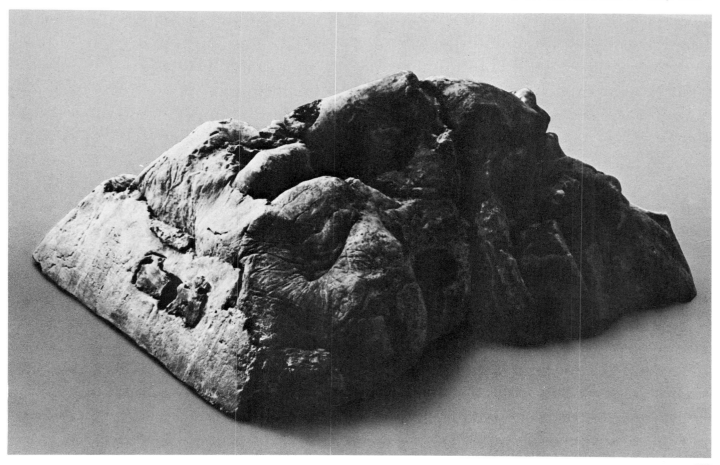

PATTI BAUER

Recently Patti Bauer, wife of ceramist Fred Bauer, has concentrated on urn-shaped ceramic holloware painted with brightly colored acrylics. She usually works independently from her husband, although a certain exchange of ideas and aesthetics is apparent. She has shown her work extensively in competitive and invitational exhibitions throughout the U.S.

birthplace: Spokane, 1939
education: University of Washington, B.F.A. 1962; M.F.A. 1964
teaching: Wisconsin State University, 1964–1966 • Eastern Michigan State University, 1967–1968
collections: Everson Museum of Art (Syracuse) • Claremont College (California)
residence: Seattle

PITTER-PODDER: hand-built earthenware with acrylic painting: 26″ high: 1968

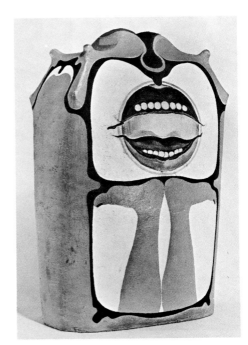

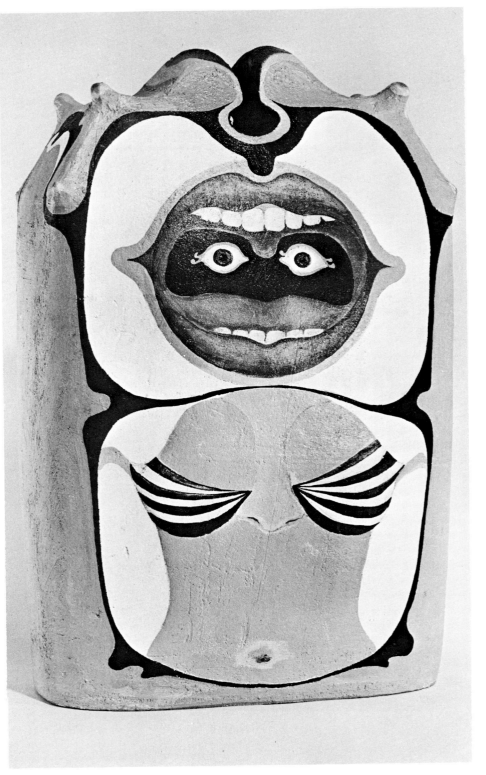

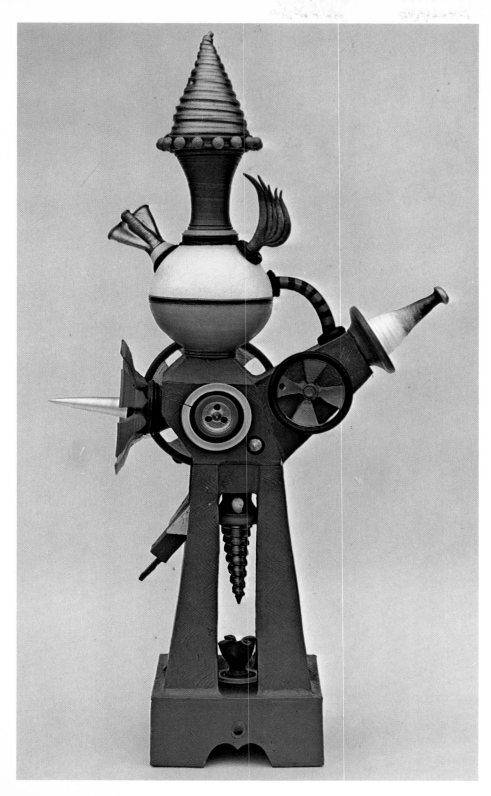

FRED BAUER
Typical of many of the younger generation of ceramic artists, Bauer uses his obvious technical expertise as a vehicle for the projection of idea-images. In his case, ideas are extended through Funk machine and gadget concoctions, built of slab and wheel-thrown parts and painted or glazed in flat, bright colors.

Bauer has been represented in more than one hundred and twenty-five museum and university exhibitions in the U.S., eighty-six of which were invitational, and has won over twenty awards.

birthplace: Memphis, 1937
education: Memphis Academy of Art, B.F.A. 1962 ·
 University of Washington, M.F.A. 1964 · Louis
 Comfort Tiffany Foundation grant, 1966 · Archie
 Bray Foundation (Montana), 1964
teaching: Wisconsin State University, 1964–1965 ·
 Haystack Mountain School of Crafts (Maine),
 1967 · University of Michigan, 1965–1968 ·
 University of Washington, present
collections: Everson Museum of Art (Syracuse) · St.
 Paul Gallery and School of Art
residence: Seattle

STEAM DRILL–SLOT PUMP: painted
earthenware: 65" high: 1967

ROBERT ENGLE

Engle's most significant contribution to the art of potting occurred when he began experiments with transferring photographic images onto clay surfaces. Since Engle teaches photography as well as ceramics at Ohio Wesleyan University, he had access to techniques and equipment to evolve this new process, and he has created forms covered with images of Ernest Hemingway, Brigitte Bardot, Bertrand Russell. These photographic decals add new compositional and connotative excitement to his traditional forms.

birthplace: Lansing, Michigan, 1928
education: Albion College (Michigan), B.A. 1951 • Michigan State University, M.A. 1958 • Instituto Allende (San Miguel, Mexico), summer, 1959
teaching: Wesleyan University, Ohio, present
collections: Dayton Art Institute • Columbus Gallery of Fine Arts •
residence: Delaware, Ohio

I am not interested in pots which are simply pleasant to live with—items for interior decoration. I am interested in pots which are visually challenging and which pose intellectual problems to be solved.

I've had my therapeutic belch with art that is autobiographical and soul-searching . . . but that therapeutic value no longer has any value for me. The immediate world is much more important. I feel Pop is the best thing that has happened to art in the past two hundred and fifty years. It has pulled art out of the rare atmosphere of the artist's world down to the blood and guts of everyday living. It's like the catharsis early Dadaism was. . . . We have grown up to a point where mass culture is accepted and we are no longer worried that the IBM machine will take over. Pop art rejoices in man's ability to create and use the computer. The craftsman is still behind the painter in his acceptance of industry . . . still hung up in William Morris' fears of the Industrial Revolution.

—Robert Engle

HARLOW POT: stoneware, fired decals: 15½" high: 1968

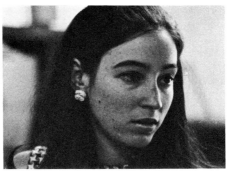

MICHELE DONER

As a child in Miami Beach, Michele Doner was particularly fascinated by beachcombing, especially for shells. 'The fluted edges of a clam shell are familiar to my fingers, and I know the tense curve of a snail's shell intimately.' In 1963 Doner entered the University of Michigan, and there found an instant rapport with clay. 'I loved the feel of clay as I had loved the sand and soil around my house.' The first objects she created were of ocean forms and fossil bowls. Her concern with texture led her to the present 'tattooing' technique, and after making a series of masks, she developed the present series of fertility dolls, torsos, and heads. 'Snails and the eggs of sea creatures became breasts and bellies. Ovaloid shapes from earlier reliefs organized the patterns of these human figures.' Doner's work began being accepted for exhibition while she was still a graduate student, and now she maintains a studio, converted from a two-car garage, in Ann Arbor. A recent article in *La Revue Moderne des Arts et de la Vie* states of her work: 'The curious tattooed porcelain pieces of Doner are rather disturbing truncated body parts, as if eaten away by some leper. These bizarre open-stomached puppets, tattooed like the natives of the Amazon, or exhibiting configurations resembling those of certain sea shells, their heads (when they have them) with eyes closed, mouth half-open and brain visible, fall into the category of surrealistic objects, but with a surrealism filled with a sap which is naïve, barbaric and young.'

birthplace: Miami Beach
education: University of Michigan, B.S., M.F.A.
residence: Ann Arbor, Michigan

TWO TATTOOED BABY DOLLS: porcelain: 13″ x 9″ each: 1968

RICHARD E. DE VORE
Despite a full teaching commitment as head of the ceramics department at Cranbrook Academy of Art, Richard E. de Vore works long hours in his studio creating personal forms. His work, never imitative, varies from the functional to the art object. Usually he works on one thematic series at a time, probing a particular problem until he feels it has been aesthetically solved.

birthplace: Toledo, Ohio, 1933
education: University of Toledo, B.E. • Cranbrook Academy of Art, M.F.A.
teaching: Cranbrook Academy of Art, present
collections: Joslyn Museum of Art (Omaha) • Museum of Contemporary Crafts (New York)
residence: Bloomfield Hills, Michigan

Ceramics as a medium presents unlimited potentials of shapes and surface, yet some aspect of form is assumed in choosing it as a material for expression. The total process is inherently allegorical. The product pervasively intimates human fundamentals.
 SHRINE TO GRACEFULNESS aspires to nostalgia through material, basic vessel shapes, frozen floral memorabilia, etc. It was hoped that such form would insidiously eclipse the more obvious satiric image.

—Richard E. de Vore

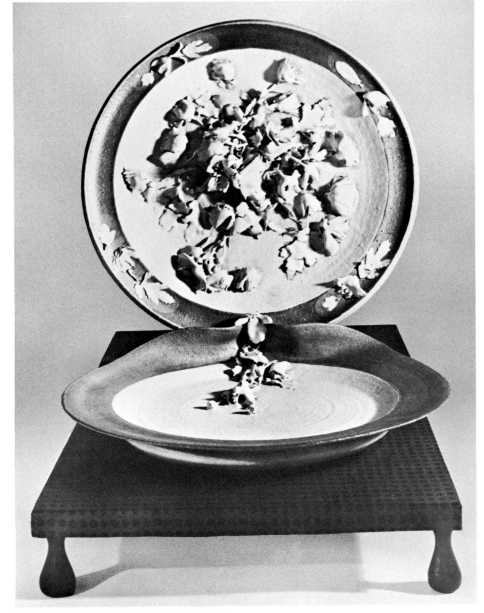

SHRINE TO GRACEFULNESS: stoneware with gilt, wood, and fabric: two plates of 13″ diam. each (platform 12″ x 19″): 1968

108

KURT E. FISHBACK

Fishback received his early training at Sacramento City College and the San Francisco Art Institute; then he came East to pursue graduate work at Cornell University. Recently he has become known for his ceramic plates that depict lyrical genre scenes where human forms are metamorphosed into playful nonhuman shapes. In this current series, the tableau is built up from the plate surface into a three-dimensional construction, as if the usual plate design had suddenly popped up into reality. An elegance is given the plates by keeping them all white.

birthplace: Sacramento, 1942
education: Sacramento City College • San Francisco Art Institute, B.F.A. • Cornell University, M.F.A.
residence: Sacramento

My main concern is whether or not whatever I do pleases me. If it does, it is worth doing. If it does not, it is not. My biases are fading and my ideas growing. Beyond this, I am waiting for whatever else is worth my while to do.

—Kurt E. Fishback

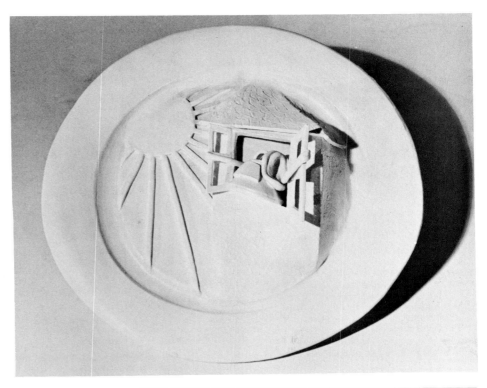

PAIR OF PLATES: SUNSHINE BRIGHT and *MILKER OF MY EYE:* painted ceramic: 14¼" diam. each: 1968

VERNE FUNK
Although his first pottery course was with
Claude Horan at the University of Hawaii
in 1954, Funk did not become seriously
involved with clay until the early sixties,
when he received his master's degree under
Robert Schellin at the University of Wis-
consin. Schellin's influence was toward
intellectual analysis and aesthetic refinement
to the smallest detail, resulting in an
elegance that has since marked most of
Funk's work. After studying with Bob
Arneson at Haystack Mountain School in
1967 he came to be more involved with the
object as an end in itself, and began
creating machine forms with human
elements. However, in addition to object-
ideas and machines, he has continued his
refined approach, often using dull black
stoneware contrasted with luster areas.

birthplace: Milwaukee, 1932
education: Wisconsin State College (Milwaukee) •
 University of Hawaii • University of Wisconsin,
 B.S., M.S. • Haystack Mountain School of Crafts
 (Maine)
teaching: Carthage College (Kenosha, Wisconsin) •
 Charles A. Wustum Museum of Fine Arts (Racine)
collections: Milwaukee Art Center • Alverno College •
 University of Wisconsin • Kenosha Museum
 (Wisconsin) • Wisconsin State University
 (Whitewater)
residence: Whitewater, Wisconsin

*Whatever I am working on, whether it be
an object in porcelain or black lusterware,
the projection of an idea, or a clay machine,
I am also concerned with the control over
my materials. Little is casual.*
 —Verne Funk

BOX: stoneware, bronze luster: 12¾″ x 5¾″
x 5¾″: 1968

DAVID GILHOOLY

Influenced by the Funk approach to ceramics as exemplified by Robert Arneson, Gilhooly, while still a graduate student, made his own contributions to the aesthetic: he attacked the fantasy world of fairy tales, particularly those involving animals. Before long, however, Gilhooly in his ceramics was approaching the subject sympathetically, with the bite gone out of his humor. He has maintained only the technical approach to Funk Art, that of ignoring all the finesse of art ceramics: his glazes are standard manufactured ones, his modelings rude. There have been one-man shows of his work at the Richmond Art Center in 1965 and the M. H. de Young Museum in 1968.

birthplace: Auburn, California, 1943
education: University of California (Davis) B.A.; M.A. 1967
collection: Oakland Art Museum
residence: San Jose, California

MAP OF AFRICA *contains all the important places and animals, all of which everyone knows about—as Tarzan's mythical Africa. Done as an educational piece, best displayed as an island floating in a big pool of water, maybe with lots of lily pads all around.*
—David Gilhooly

MAP OF AFRICA: white earthenware, commercial glazes: 78″ long: 1966

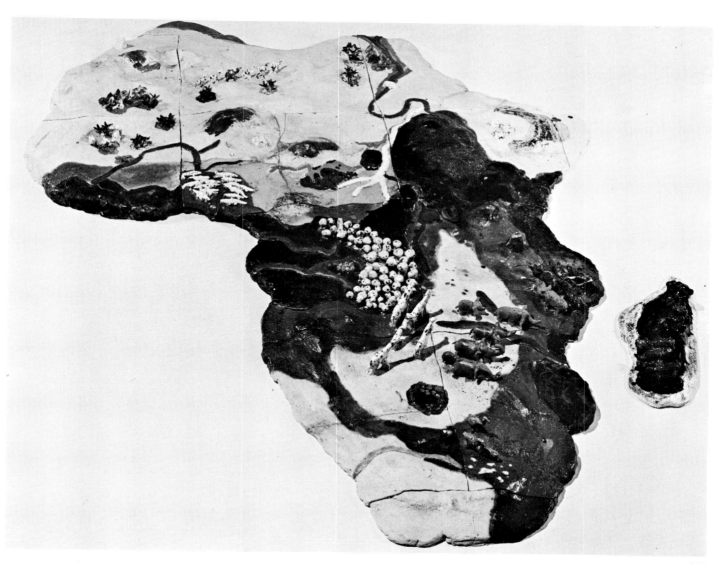

ERIK GRONBORG

Gronborg came to the U.S. in 1959 and went to California, where he received his training in art. He started out as a sculptor and only recently turned to ceramics. His work has been exhibited widely in one-man and group exhibitions throughout the U.S. and Europe.

birthplace: Copenhagen, Denmark, 1931
education: University of California (Berkeley), B.A. 1962; M.A. 1963
teaching: Reed College (Oregon)
residence: Las Vegas, Nevada

The new generation of ceramic artists are not craftsmen in the conventional sense of the potter, the weaver, the metal-worker. A generation raised on cars and television is no longer romantically inclined toward the natural primitive ways of the village potter in Japan and Mexico. It is typically American. The result, the finished work is what counts; whatever method or material will give the result is acceptable. In my ceramic activity I have tried to make a contribution to the three most important problems in contemporary ceramics.

The first is the problem of finding a meaningful contemporary form for ceramics, one which responds to our contemporary sensitivity in a highly mechanized and intensely colorful society. This form is approached through the use of forms and patterns of a mechanical regularity and colors bright enough to maintain a presence in our environment.

The second challenge is to see ceramics as part of a thousand-year-old tradition and try to live up to the best ideals and conventions in ceramics. An imaginative and at the same time craftsmanly sound use of clay and glazes has always been the mark of the great ceramists; and this, rather than a mechanical repetition of the forms of the last generation, is traditional ceramics at its best. The history of ceramics has many examples of great periods using bright-colored glazes and highly decorated surfaces as styles with matte stoneware glazes, earthy colors, and random (natural) patterns. I am accepting the challenge of keeping the plate and cup and bowl vigorous.

The third and most important problem in ceramics today is the effort to convince the public and the craftsman that ceramics can be art of equal merit to that of painting and sculpture. The plate is no less valid as a subject for art than the human figure in sculpture or stripes in painting. In other cultures and at other times pottery was held in high regard, equal to the other fine arts; all works were judged solely on expressiveness. So long have both potters and the public accepted pottery as a minor art with emphasis on its utilitarian functions that, because it can be useful, we have disqualified the ceramic object without really looking at it and experiencing it as art.

—Erik Gronborg

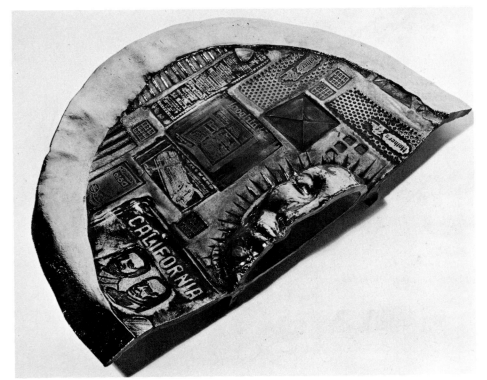

HALFPLATE: stoneware with lead glazes and lusters: 20½" high: 1968

112

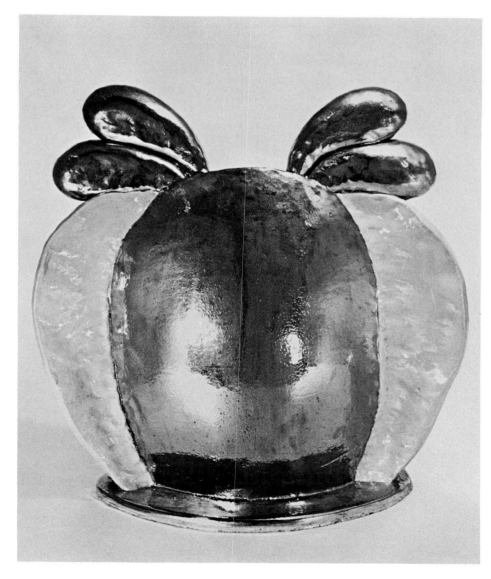

MONDO REFLECTO: earthenware with lusters: 18¼" high: 1968

HOWARD KOTTLER

The art of Howard Kottler assumes very special qualities when examined within the context of his own definitions—definitions which involve his well-known decal plates and 'palace-pottery.' As Kottler describes them:

DECALCOMANIA, 1. the art or process of transferring pictures or designs from specially prepared paper to wood, metal china, glass, etc. 2. the decals used in the Kottler series of decorated and re-decorated decorated plates are all ceramic decals. they are commercial decals used on everyday dinnerware or souvenir plates which are mass produced by the ceramic industry for collectors' curio cabinets, thrill seekers and rapid sales. these decals are silk screened and during the process are impregnated with a low-fire glaze. 3. the application process is simple: the decals are placed in water and release from their backing within a minute, after which they are transferred to the ceramic plate and fired in a kiln to 1250 degrees F. 4. after firing, these ceramic decals are quite permanent—for ever and ever, really . . . for $50 a plate, would I kid you???????

DECALCOMANIAC, 1. one who suffers from an irresistible and insatiable craving to work with decals. 2. Howard Kottler. 3. a person who suffers from psycho-neurotic tendencies derived from excessive frustrations due to poor sales of decal plates. 4. to aid and abet such persons suffering from this disease, purchase Kottler ceramic decal plates.

CERAMICS, 1. the art and technology of making objects of clay and similar materials treated by fire. 2. there are no limitations to the variety of forms that can be produced in clay. 3. it is possible to envision objects made from clay which might be impossible to classify as to pot, sculpture, or painting; such objects might have characteristics of all these forms. 4. there are no rules or restrictions in handling clay—anything is possible.

SURREALISM, 1. a style of art developed principally in the 20th century, stressing the subconscious or non-rational significance of imagery arrived at by unexpected juxtapositions. 2. using techniques employing ceramic decal cuttings transferred to a plate—sometimes with the addition of fur, vinyl, and other extraneously suggestive materials.

CRAFTSMANSHIP, 1. the idea is one of a changing attitude of working with materials. 2. the craftsman maintains a respect for skill, but enlarges his concept of craftsmanship by supplying himself with a series of techniques to meet his new conceptual needs, repudiating any technique or mechanical device which might encroach

upon his freedom of action. **3.** *not to be confused with that slick or tricky stuff that pervades the living rooms of "craft" conscious dilettantes.*

PALACE-POTTERY, 1. *clay ware which exemplifies the style of a nation, as opposed to folk-pottery where the primary concern is aimed toward the production of utilitarian objects for daily use.* **2.** *the stylistic singularities found in the palace ware of any given period are similar to other works of art produced at the same time in that area and national setting.* **3.** *absence of any regimentation imposed by function or utilitarianism with a shift to individual freedom of expression.* **4.** *ritual objects.* **5.** *experimental search in the development and extension of the possibilities of working with clay.* **6.** *objects that stimulate the intellect in places that stimulate the body.*

FINGER, 1. *any of the terminal members of the hand.* **2.** *the breadth of a finger as a unity of length: a digit.* **3.** *the length of a finger, 4½ inches or approximately that.* **4.** *something like or likened to a finger, or serving the purpose of a finger.* **5.** *any of various projecting parts of machines.* **6.** *to filch.* **7.** *to touch or handle: to be fingered.*

HICKEY, 1. *a pimple; any skin blemish.* **2.** *any rich dessert.* **3.** *a discoloration to the skin caused by playful passion.*

WHIP, 1. *an instrument for striking, as in driving animals or in punishment, typically consisting of a lash or other flexible part with a more rigid handle.* **2.** *to move, snatch, jerk suddenly.* **3.** *to belabor with stinging or biting words.* **4.** *any of various pieces that operate with a quick vibratory motion.* **5.** *to overcome defeat.*

PITCH, 1. *to place and set-up or erect.* **2.** *to throw, fling, hurl or toss, usually with a definite aim.* **3.** *to arrange.* **4.** *to plunge.* **5.** *a sales talk or spiel.* **6.** *a preliminary exploratory, or speculative amorous gesture or verbal proposition.*

FOOT, 1. *the terminal part of the leg.* **2.** *a measure of length.* **3.** *the foot as the member used in locomotion; hence, figuratively, motion or power.* **4.** *to tread to measure.* **5.** *to pay or settle: e.g. in purchasing Kottler plates, you are footing my expenses.*

GUN, 1. *any weapon from which a shot is discharged by an explosive.* **2.** *something suggestive of a gun, especially in shape or function.* **3.** *to accelerate the motor.* **4.** *'This is my rifle. This is my gun. This is for shooting. This is for fun,' an old Army poem used to teach recruits the proper nomenclature for 'rifle.'*

THE LAST SUPPER, 1. *an experiment.* **2.** *a work on plaster in oil by Leonardo da Vinci, 1497.* **3.** *a search for psychological expressiveness in painting.* **3.** *Christ supping with his apostles the evening*

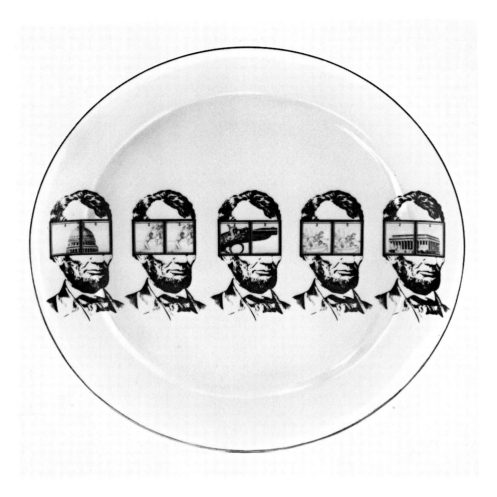

before the passion. **4.** *a meal catered by Schwartz Deli.*

DEFINITION, 1. *explanation of the meaning or meanings of a word.* **2.** *distinctness or clarity.* **3.** *any facsimile to previously listed words or to actual names, places, or words in Webster's dictionary is purely coincidental.* **4.** *ad hoc semasiologist N.B.*

In less than ten years, Kottler has been represented in more than one hundred and fifteen juried and invitational exhibitions, won more than thirty-five awards, and had twenty-five one-man shows.

birthplace: Cleveland, 1930
education: Ohio State University, B.A. 1952; M.A. 1956; Ph.D. 1963 • Cranbrook Academy of Art, M.F.A. 1957 • Fulbright Scholarship grant, School for Industrial Crafts (Helsinki), 1958
teaching: Ohio State University, 1961–1964 • University of Washington, present
collections: Cleveland Museum of Art • Detroit Institute of Arts • Museum of Contemporary Crafts (New York) • Portland Art Museum (Oregon) • Dayton Art Institute
residence: Seattle

HOWARD KOTTLER:

(STICKS) (STONES) > (BONES); porcelain blank plate with ceramic decals: 10¼" diam.: 1968: ed. 1/10

FRED LUCERO

Since graduating from San Jose State College, Lucero has become proficient in many art media. Recently he has embarked, successfully, on the technically difficult problem of combining clay and glass in sculptural forms as exemplified here. His statement concerns the work illustrated.

birthplace: San Diego, 1942
education: San Jose State College, B.A., M.A.
teaching: San Jose State College, 1968 • Chico State
 College (California), present
residence: Chico, California

CREATION OF LIFE is one work from a series done on the seven days of creation. This piece represents the creation of life as it is described in Genesis. The clay portion represents the sea from which life emerges. The glass forms coming out each end represent life. Since completing this series my efforts have been involved in blowing glass forms which appear to be living and growing.

 —Fred Lucero

CREATION OF LIFE: clay and free-blown glass: 23″ long: 1967

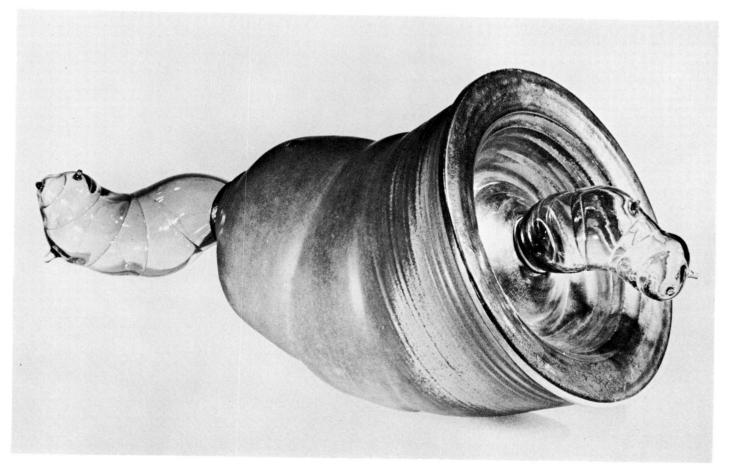

JAMES MELCHERT

Melchert, who is considered to be one of the more profound artists working in clay, took his B.A. in art history and his M.A. in painting. Only when forced to work with clay because of a teaching job did he discover his rapport with the medium. Not long after, he saw an exhibition of Peter Voulkos' work in Chicago, and because his reaction was so strong Melchert decided he must study with him. He did, first for a summer at Montana State University, and then again at Berkeley when Melchert took his second master's degree. He recalls that Voulkos had an integrity and power that challenged indecisiveness. 'He is not one to avoid issues. This is the way you've got to be with yourself.'

Melchert's first series of ceramic sculptures to gain attention were his *LEGPOTS,* one of which is illustrated here. In the statement below the artist comments on his involvement with these works.

The 'Ghost Wares,' which he began in 1964, were the next key works. These jars and plates showed an involvement with an iconography of ghosts from the past, some public, some private. Highly introspective, the series was triggered by the Ingmar Bergman movie *Silence* in which a character observes that one must tread carefully among the ghosts from his past.

More recently Melchert has evidenced an attraction to Surrealism and particularly the early work of de Chirico. One of the manifestations of this concern has been his current series of 'games,' such as the one illustrated here. These game-sculptures require the involvement of the viewer, who is asked to detect and develop relationships among the fragments of information presented by the pieces on the board. Objects from the room may be included so that the viewer is free to continue the game beyond the sculpture itself. The 'games' are typical of much of Melchert's recent work, which is intended to 'sensitize the viewer's awareness' of his relationship to things with which he lives and interacts.

Melchert's work has been shown in a number of important sculpture shows, such as the Whitney Museum of American Art Sculpture Annual. He has had one-man shows in San Francisco, Los Angeles, and Boston.

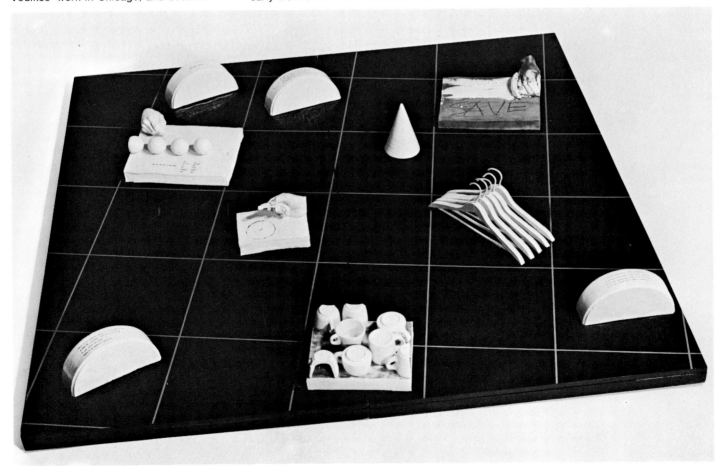

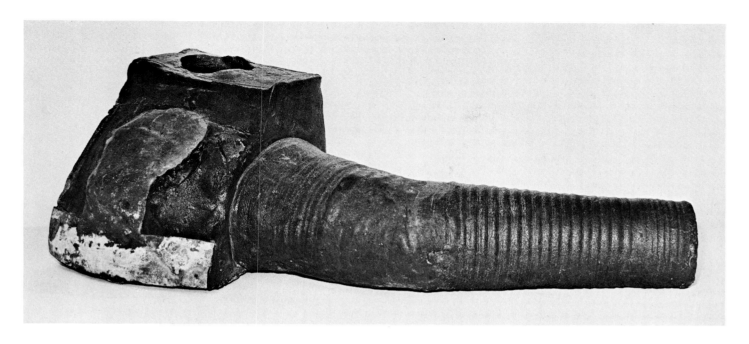

LEG POT I: stoneware with lead and cloth inlay, slab and thrown forms combined: 32½″ long: 1962

birthplace: New Bremen, Ohio, 1930
education: Princeton University, B.A. 1952 • University of Chicago, M.F.A. 1957 • University of California (Berkeley), M.A. 1961
teaching: Tohoku Gakuin Schools (Japan) • Carthage College (Illinois) • San Francisco Art Institute • University of California (Berkeley), present
collections: San Francisco Museum of Art: • Massachusetts Institute of Technology • Mills College (Oakland, California)
residence: Oakland, California

About the LEG POT Series:

During the summer of 1961 I was teaching a ceramics class at the San Francisco Art Institute. At that time I was becoming aware of formal structures that were suggested by the human figure. I was hiring models for the pottery class and was combining thrown cylinders to make limb forms and torso sections. I was intrigued by the way that the arm on a broken Greek torso would abruptly terminate in a cross section, a no-nonsense ending that revealed much about the form. The pots that I made were big and simple and not too successful. Most of them eventually found their way into sculptures as a section of a mixed media construction. Yet I was still concerned with the idea of using limb shapes in pottery and felt it necessary to see at least one through to the end. The trouble was that I had been trying to make the wares solely from figure parts when all I actually wanted was the suggestion of it. Finally one night in the fall I hit on the idea of using a block for the central body of the pot and attaching a leg shape to it. The two shapes proved to be a good match for each other in terms of their opposition. Along with my interest in the figure I also spent a great deal of time those days looking at primitive art, mostly from Africa and New Guinea. What impressed me so much was the juxtaposition of incongruous shapes without transition. The encounter of two radical elements has always intrigued me. I suppose it's evident in most of my work.

Another aspect of primitive sculpture that impressed me was the mixing of materials. Wood against metal and glass became something much richer. In my clay work I make use of tensions between wet and dry, hard and soft, tight and loose, but at that time I needed to see metal against clay and even, as in the LEG POT, a patch of tough fabric imbedded between the two. I was impatient with the conventions that seemed to tyrannize potters, the vertical, bilaterally symmetrical structure of a vessel and the unquestioning acceptance of a single material.

—James Melchert

GAME ON BLACK FIELD: cast earthenware objects on painted plywood boards, transparent glazes: board 72″ x 72″: 1968

JOSEPH A. PUGLIESE

Pugliese's efforts to make his ceramic surfaces resemble or simulate other material is typical of a number of artists involved with the current Pop and Funk scene—Robert Arneson, Clayton Bailey, Claes Oldenburg, to name a few. The example illustrated here is one of a series Pugliese has made on tennis shoes, boots, sneakers, including 'his and her' combinations.

Pugliese is also a professor of art history, Asian cultures, and ceramics. He has exhibited in many of the major national ceramic shows and has written extensively about Funk Art and artists in professional periodicals.

birthplace: Cleveland, 1928
education: Miami University (Oxford, Ohio), B.F.A. 1950 • Ohio State University, M.A. 1955; Ph.D. 1960
teaching: Ohio State University, 1955 • San Francisco Art Institute, 1960–1961 • University of California (Berkeley), 1957–1964 • California State College (Hayward), present
residence: Hayward, California

HARRY: earthenware and enamel: 12½″ long: 1968

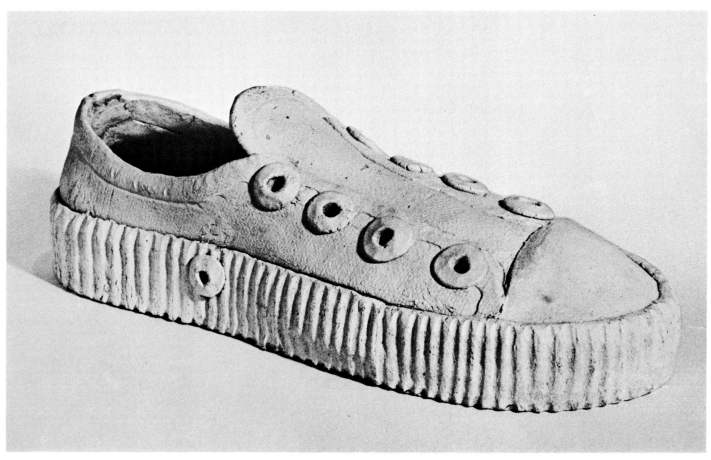

KENNETH PRICE

In the late fifties, Kenneth Price was among the Los Angeles group including John Mason, Peter Voulkos, and Michael Frimkess who introduced a revolutionary attitude toward clay. These artist-craftsmen took the medium forever beyond the traditional limitations of ceramic containers and decorative panels. From that day on Price treated clay as a medium for sculpture, and his first exhibition at a Los Angeles gallery in 1960 established him as an artist of exceeding promise. His works were egg-shaped, of bright glazes, and had disturbing intestinelike shapes protruding through breaks in the forms. Two more shows followed in Los Angeles, and one in London. The artist has also shown in most major national sculpture exhibitions of the sixties.

birthplace: Los Angeles, 1935
education: University of Southern California, B.F.A. • Alfred University (New York) M.F.A.
collections: Museum of Modern Art (New York) • Whitney Museum of American Art • Los Angeles County Museum of Art • Art Institute of Chicago
residence: Los Angeles

S. G. WHITE: fired and painted clay: 9" long: 1966

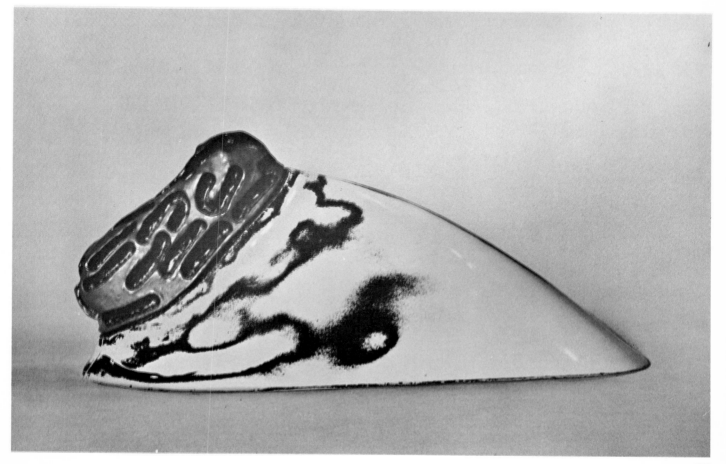

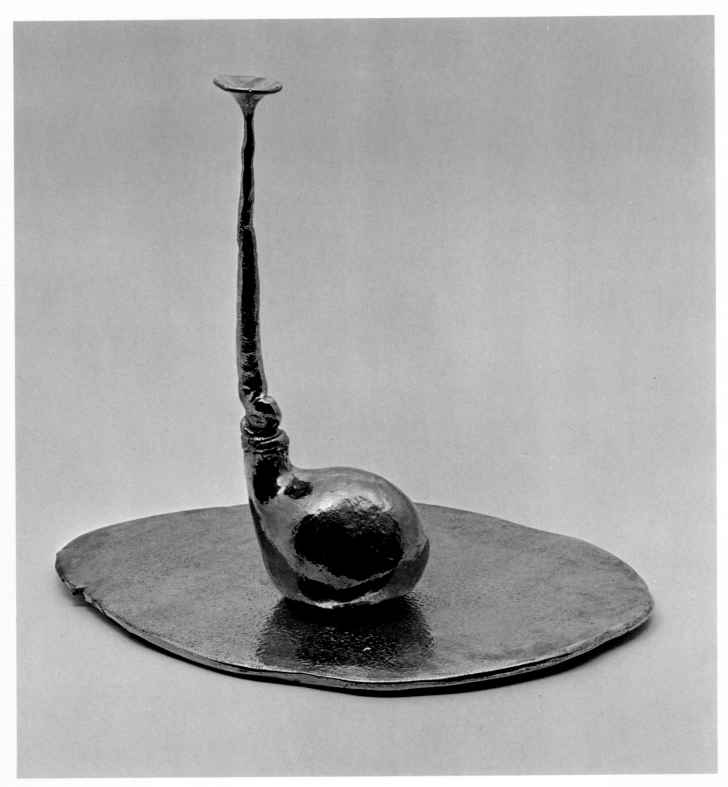

PATRICK F. McCORMICK
McCormick came onto the ceramic scene with dramatic attention after his 1968 one-man exhibition at the Northwest Craft Center in Seattle. In an exhibition of over three hundred works, all but some seventy-five were sold during the month-long showing. Word quickly spread of this prolific and inventive young potter. Before moving to the West he taught ceramics at the Norfolk Museum Art School, where he also set up a glass workshop.

birthplace: Longview, Washington, 1942
education: University of Washington, B.A., B.F.A. •
 Cranbrook Academy of Art, M.F.A.
teaching: Norfolk Museum Art School (Virginia) • Western
 Washington State College, present
collection: Sacramento State College
residence: Bellingham, Washington

TABLE SCULPTURE: two-piece earthenware with gold-luster combinations: 20½'' high: 1968

ANN STOCKTON

For as long as she could remember, Ann Stockton wanted to be a painter. But in 1960 she was confronted with clay for the first time. 'It changed my life,' she says, 'the facile quality of the clay turned me on.' Since then Stockton has been working with glazed and high-fired stoneware—large plates, ceramic cups, and sculptural forms. Her particular interest now, however, is porcelain, and she uses several brushes to apply as many as five glazes when 'painting' a plate. The results may juxtapose glossy and pitted surfaces, luminous and dense colors, active and serene designs. She is fond of animals, and in her living room she has made a clay 'environment' for her two pet alligators.

birthplace: Coceselo, Panama, 1936
education: University of California (Santa Barbara) •
 University of California (Berkeley) • San Francisco
 Art Institute
teaching: University of California
residence: Berkeley, California

Porcelain was a crazy thing to go into. It is more like putty than like some swinging clay. . . . I just love it because it's white and I can 'paint' on it practically like I'm painting on a canvas.

—Ann Stockton

PLATE: porcelain, high-fire glaze: 18¼″ diam.: 1968

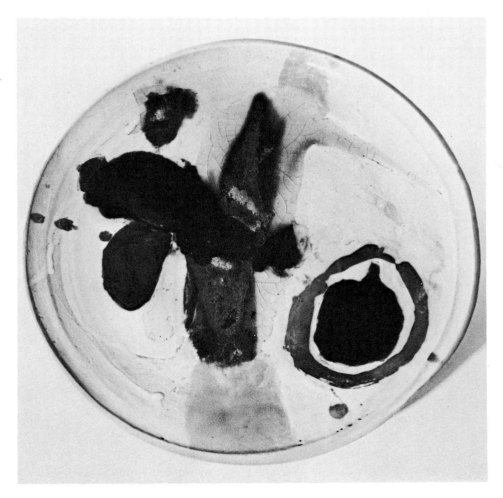

RON NAGLE

Born in San Francisco, Nagle studied at San Francisco State College, and later with Peter Voulkos. He is now lecturer in ceramics and design at the University of California (Berkeley). His most recent series—cups enclosed in elaborate and precious wood and plexiglass boxes— creates an environment that certainly a cup has never known before. Actually Nagle is making us look at the everyday objects in our surroundings: his work is in a sense not *a cup:* it is instead *about cups.*

Other artists in the Bay Area are also concerned with the involvement of the viewer with the object, but few make the statement so unpretentiously: despite (or perhaps because of) the unusual box container, this work commands the viewer's awareness of a cup as certainly never previously.

birthplace: San Francisco, 1939
education: San Francisco State College, B.A. 1961
teaching: San Francisco Art Institute • University of California (Berkeley)
residence: San Francisco

CUP: ceramic; with wood and plastic box: cup 3″ high: 1968

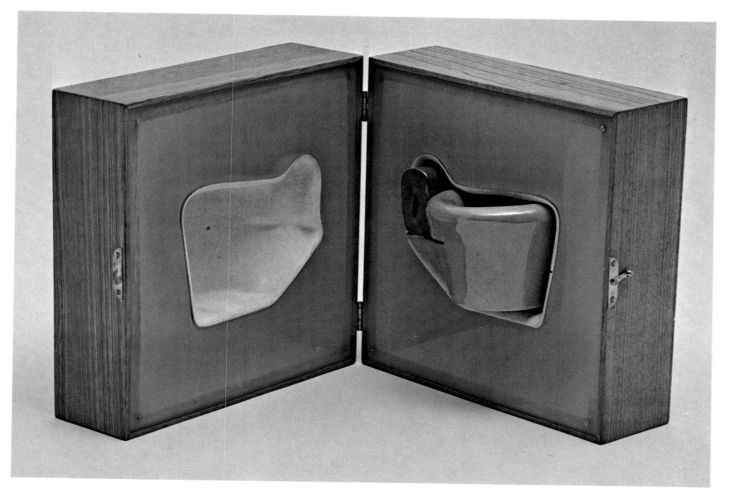

GEORGE P. TIMOCK
After attending the Flint Community Junior
College in Michigan, Timock went on to
the Cranbrook Academy of Art, where he
majored in ceramics. But in January 1969
his graduate studies were interrupted by his
induction into the Army. Thus far Timock's
work has been with free forms, especially
fantasy containers that juxtapose geometric
shapes with twisting, spiraling organic
sections.

birthplace: Flint, Michigan, 1945
education: Flint Community Junior College • Cranbrook
 Academy of Art, B.A.
residence: Pontiac, Michigan

BOX: raku: 18½″ high: 1968

ROBERT STRINI

A year before receiving his graduate degree in art from San Jose State College, Strini was showing ceramics in national exhibitions and had been given a show at a gallery in San Francisco. As with so many younger West Coast potters, Strini, while learning his craft, worked only with functional forms, but later, as he began forging a personal statement, moved directly into clay sculpture. His pieces, often assemblages with both organic and mechanical associations, usually involve leather as well as clay surfaces.

birthplace: Hayward, California, 1942
education: San Jose State College, B.A., M.A. • San Jose Junior College, A.A.
teaching: San Jose State College
residence: Santa Clara, California

HALF-TRAK: stoneware: 26¾" long: 1968

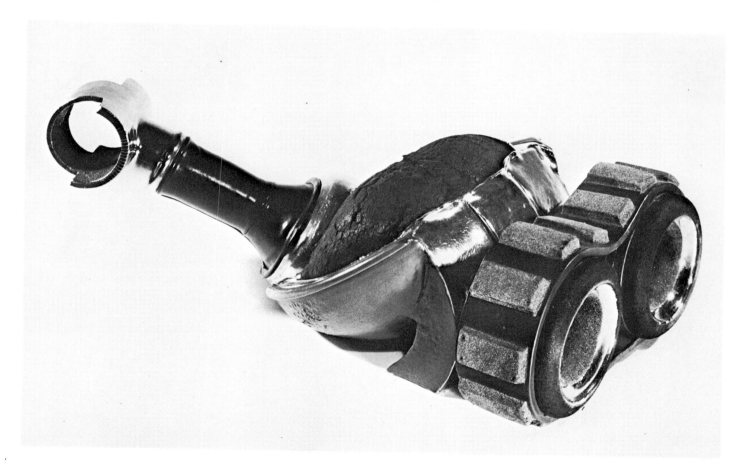

landscapes. Unlike many Funk artists, Shaw's craftsmanship is impeccable.

Born in Hollywood, educated in San Francisco at San Francisco Art Institute under Ron Nagle and Jim Melchert, he also studied at Alfred University, and then received his master's degree at Davis.

birthplace: Hollywood, 1941
education: San Francisco Art Institute, B.F.A. • University of California (Davis), M.A.
teaching: San Francisco Art Institute, present
residence: Stinson Beach, California

RICHARD SHAW

Shaw represents one of the younger generation of artists steeped in the Funk Art credo. His personal refinement of the Funk approach has resulted in objects with both a nostalgic and romantic flavor. *COUCH AND CHAIR WITH LANDSCAPE AND COWS,* illustrated here, is part of a tour de force series the artist has created which effectively unites the object with an environment. Shaw has constructed a notable series of houses in miniature, leaving one wall blank so the viewer can look into the lonely rooms which have back windows overlooking vacant, sad

COUCH AND CHAIR WITH LANDSCAPE AND COWS: earthenware painted with acrylics: couch 9½″ x 18½″ x 8½″; chair 9″ x 10″ x 8½″: 1966–1967

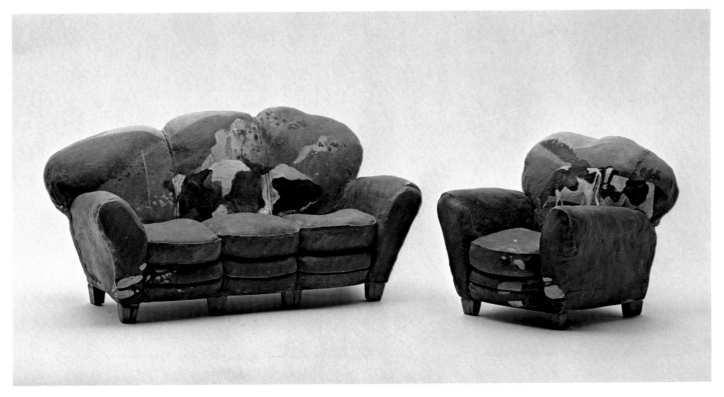

PATRICK SILER

Siler entered college in his native state of Washington to become a high-school art teacher, but painting itself soon became his dedication. He continued art studies at the University of California, Berkeley, working in an Abstract Expressionistic idiom. But in the Bay Area he came into contact with ceramics and soon found himself working in this medium.

birthplace: Spokane, 1939
education: Washington State University • University of California (Berkeley), M.F.A. 1963
teaching: University of South Dakota • University of California (Berkeley)
collection: State of California (Sacramento)
residence: Oakland, California

In 1966 I started working with clay, mostly realistic objects like kitchen appliances, radios, and typewriters, and even some 'ceramic sculpture.' But after looking at pictures of Japanese Momoyama-period pottery and seeing pieces by Voulkos and Mason I started making pottery. Most serious artists would not waste their time with clay when there are so many exciting and different new materials to explore. The ceramic industry is a huge and flourishing business, but for the artist, clay is an anachronism. Perhaps the process of working with and firing clay is more attractive than the end product. I know the fact that few people work with it any longer makes it attractive to me. With clay I have been able to make some personal statements, and working with it is fun, but I doubt if I will always be working with it, and make a life of it like Bernard Leach or Hamada and Rosanji. In a couple of years I will probably be doing something else.
—Patrick Siler

PAIR OF BOXES: laminated whiteware: one 8½'' high; other 5¾'' high: 1968

JOHN H. STEPHENSON

Stephenson has consistently forged new statements by experimenting with ceramic techniques. In this context he has been assisted by three Rackham Faculty Research Fellowships from the University of Michigan: the first he used for the study of natural glazing in Japan; the second for the creation of ceramic sculpture; and the third for experiments with three-dimensional objects involving mixed media.

birthplace: Waterloo, Iowa, 1929
education: University of Northern Iowa, B.A. • Cranbrook Academy of Art, M.F.A.
teaching: Maryland Institute (Baltimore) • Cleveland Institute of Art • State University of Iowa • University of Michigan, present
collections: Alfred University (New York) • Ohio State University • Otterbein College • Eastern Michigan University • Museo Internazionale delle Ceramiche (Faenza, Italy)
residence: Ann Arbor, Michigan

I do not have enough 'factory' in me to want to produce a line of pottery. Artistically speaking, my attention span is short, constantly moving on; I am fascinated with new possibilities in the work. What was 'taboo' yesterday may provide a fruitful tangent from which to work today. I honor the past, evolve from it. The persuasion of 'the lovely' is not for me, but I am interested in 'Truth and Beauty.'

The use of the newspaper collage in my clay work is the result more of a fascination with the concept of 'Contemporary Cuniform' than a 'gimmick,' and is a recycling of writing in clay, but which is markedly different from the original form. I am also concerned with its compositional importance. On the other hand I am not hung up on newspaper impressions and am moving on to other things.

—John H. Stephenson

PEDESTALED PLATE WITH NEWS IMPRESSION: stoneware: 7¾″ x 22¼″: 1969

CHRIS UNTERSEHER

Unterseher, one of the younger artists who has been subject to the spell of Bob Arneson, is a proponent of the Funk tradition. Most of his work involves tiny figures arranged in beautifully wrought, comic tableaux. More recently he has created plates and plaques involving a series of humorous variations on sentimental and nostalgic themes. Typically, a title impressed into the clay in squarish capital letters announces an event such as, 'Mrs. Calvin Coolidge Releases Homing Pigeons,' or 'Charles Evans Hughes, Secretary of State, Receives a Delegation of Boy Scouts.' The subjects seem to have been taken from magazine articles or pictures from bygone eras that manifested the Great American Dream of the twenties.

birthplace: Portland, Oregon, 1943
education: San Francisco State College, B.A. 1965 •
 University of California (Davis), M.A. 1967
collections: Memorial Union Art Gallery (Davis,
 California) • Jim Newman Foundation (San
 Francisco)
residence: Davis, California

In my early work I was recording unimportant historical subject matter in clay because I felt these minor events were just as worthy of memorialization as the so-called major events, such as Washington Crossing the Delaware and Custer's Last Stand, historic scenes already quite well recorded. More recent work still deals with nostalgia and recording historical events, but of a more personal nature—a series of work dealing with model trains and surfing, both things I did as a kid in southern California.

 —Chris Unterseher

CHILDREN AND SQUASH GROW UP WITH THE COUNTRY: white earthenware tray with low-temperature glazes: 10¾'' x 13¼'': 1967

PETER VANDENBERGE

Vandenberge grew up in Indonesia, Holland, and Australia, and in 1954 he immigrated to the United States and settled in California. Later he took his master's degree in ceramics at Davis under Robert Arneson.

Working in the Pop Art tradition, Vandenberge has created a series of objects with everyday subject matter, the most notable of which are his studies of vegetables. Recently he has turned his attention to the neighborhood around his studio to produce a number of ceramics representing children in life-size dimensions.

birthplace: Voorburg, Holland, 1935
education: Sacramento State College, B.A. 1959 • University of California, M.A. 1963
teaching: San Francisco State College, present
collection: Sacramento State College
residence: San Francisco

I started making things out of clay when I was about eight years old. We had a basement in our house in Holland where I made people, animals, houses, and puppets: I fired them in our fireplace and they all turned out a sort of pale red. Somehow I was never able to give up making things out of clay.
　　　　　　　　　　　　　　—Peter Vandenberge

CHILIPEPPER BEANS AND BOX: whiteware with low-fire glazes: box 17″ wide x 12″ deep: 1969

ALLAN M. WIDENHOFER

Widenhofer, now working in California, creates nonfunctional objects which are often related to vessel forms. He is noted for his early experiments with electroplating. While he has a reverence for clay, Widenhofer says he is not a purist. Visually, if an idea for a pot calls for the inclusion of other media, he never hesitates to use them, and very often these same ideas involve the technical intrigue of challenging the structural tolerance of clay.

birthplace: Indianapolis, 1929
education: University of Montana, B.A. 1951 • San Francisco State College, M.A. 1964
teaching: College of Marin (Kentfield, California), present
collections: University of Arizona • City of San Francisco • City of Walnut Creek (California) • Sacramento State College • Mills College (Oakland, California)
residence: San Anselmo, California

contrasting or conflicting nature. One might call it a fascination for visual paradox. The reality of a clay form is combined with the illusion of a painted tree. The geometric versus the organic. The instability of leaves versus the stability of squares. Glaze surface versus metal surface. But surface and form remain as one. To me it becomes more than a pot with a tree on it. . . . It is a TREE pot. —Allan M. Widenhofer

CHECKERED TREE POT: high-fire stoneware, copperplated, china paints, luster glaze: 10½″ x 17¼″: 1968

In this piece [CHECKERED TREE POT, *illustrated here*] *I try to combine on a primarily formal basis elements of a*

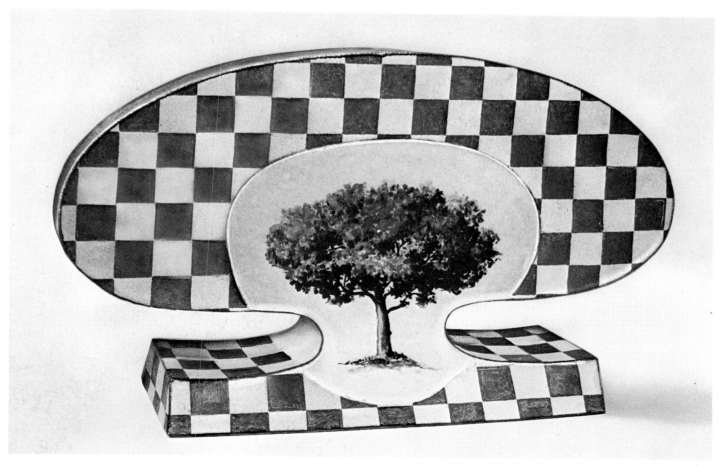

SHIGE YAMADA

Curious organic forms, earthen colors, and surface workings are characteristic of Yamada, the Hawaiian ceramist and teacher. Except for a two-year stay with the United States Army in Berlin and a one-year teaching position in Japan, Yamada has spent his entire life on the island and is now an Assistant Professor at the University of Hawaii. Regarding the work illustrated here, Yamada has explained that 'BARDO alludes to the Bardo Thodol which is concerned with death, rebirth, and the confrontations of the soul in limbo. It is one in a series of egg-shaped sculptures.'

birthplace: Wailuku, Maui, Hawaii, 1933
education: University of Hawaii, M.F.A. 1966 • San
 Jose State College
teaching: University of Hawaii, present
residence: Honolulu

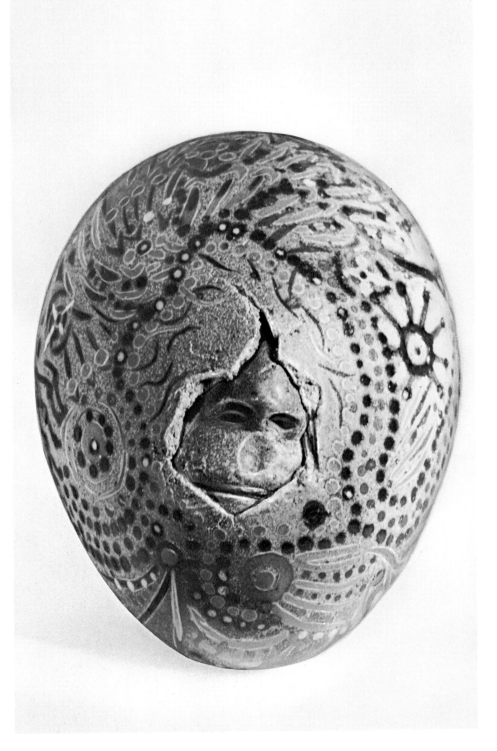

BARDO: raku with porcelain inlay: 6¾"
high x 9" long: 1968

JAMES LEEDY

Leedy is an artist and an art historian who has taught painting, printmaking, sculpture, and design, but his favorite medium is clay. His ceramic forms are intricate constructions of sculptured parts, often incorporating wheel-thrown pieces, 'found objects,' and mold-pressed forms. Rich earth tones and salt glazes characterize much of his work, but he occasionally uses bright paints, which are applied after firing. Working with clay slabs which are folded and shaped by hand, Leedy produces sculptural pieces which often have a fetishistic quality reminiscent of primitive ritual figures, yet the evidence of social and personal symbols reveals, perhaps, the essence of 'Everyman.'

birthplace: McRoberts, Kentucky
education: Southern Illinois University, M.F.A. • Michigan State University, M.A. • William and Mary College, B.F.A.
teaching: Kansas City Art Institute, present
residence: Lake Lotawana, Missouri

Unique, I feel, is the purely sculptural quality in my work. Most potters conceive a pot as an object that is always a container, whether they are straight or bentware potters, but most of my pots are sculpture, using the suggestion of a pot only as a point of departure to a purely aesthetic, personal, and sculptural statement. Other than aesthetic, my pots have no function; therefore raising them, at least in intent, to the level of the so-called major arts, such as painting and sculpture. As the painter and sculptor often use the human figure as a reason for creating, I use the pot.

—James Leedy

ALL-AMERICAN BOY TROPHY: hand-built glazed stoneware: 22½'' high: 1968

137

SALLY FLETCHER
Reflecting her Hawaiian environment, the large, fascinating coil-constructed pottery of Sally Fletcher is generally characterized by its subtle earth coloring and by a decorative vocabulary that derives from earth forms.

birthplace: Sacramento, 1933
education: University of California (Los Angeles),
 B.F.A. 1955 • University of Hawaii, M.F.A. 1965
teaching: University of Hawaii
collections: Honolulu Academy of Art • State
 Foundation of Culture and Arts (Honolulu) •
 Museum of Contemporary Crafts (New York)
residence: Honolulu

ROUND FORM: coil construction, stoneware, kamani ash glaze: 12½″ x 17½″: 1968

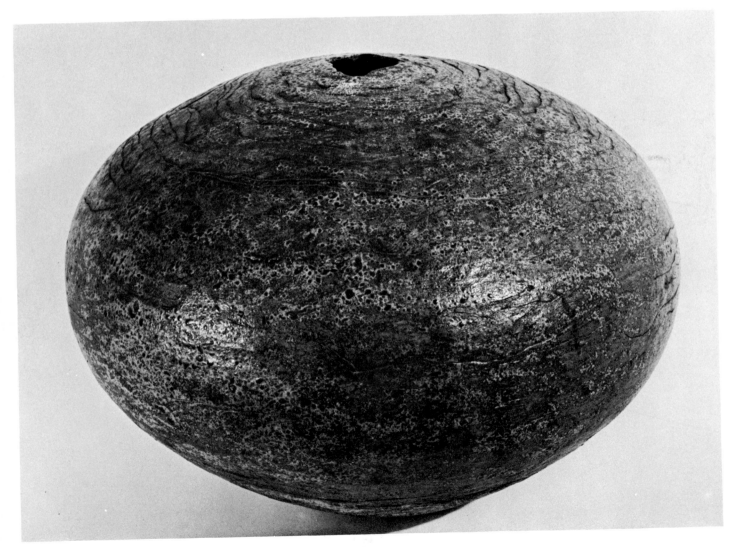

KEN SHORES

Shores received his art training at the University of Oregon and at the Pond Farm Workshop, where he studied under Marguerite Wildenhain. His personal statement took stature a few years ago with a series of highly glazed, abstract, and free-form ceramic plaques. More recently he has worked with objects involving feathers, mirrors, and gold leaf. Shores has traveled extensively in Europe, North Africa, Mexico, and Peru, translating through his sensitivities techniques and forms from these different cultures.

birthplace: Lebanon, Oregon, 1928
education: University of Oregon, B.S. 1955; M.F.A. 1957 • Pond Farm Workshop (Guerneville, California)
collections: Portland Art Museum (Oregon) • Henry Art Gallery (University of Washington) • Museum of Art (University of Oregon)
residence: Portland, Oregon

In an age of technology such as ours the use of new materials offers many possibilities for the execution of 'ideas.' Clay, however, is a distinguished material of antiquity long used for aesthetic and utilitarian purposes. It is the 'live' nature of clay as a medium of expression that has long held a fascination for me. During the past two years I have been using clay combined with other materials, such as feathers, plastics, steel, silver, and mirrors. The plasticity and soft/hard quality of clay integrated with the soft texture of feathers, the hardness of metal, and the reflective surfaces of mirror offer an inexhaustible variety of combinations. Due to the fragility of the feathers, the pieces have been encased in plastic boxes, sometimes reminiscent of the old bell jars, yet contemporary because of the angularity and sharpness of the structures.

—Ken Shores

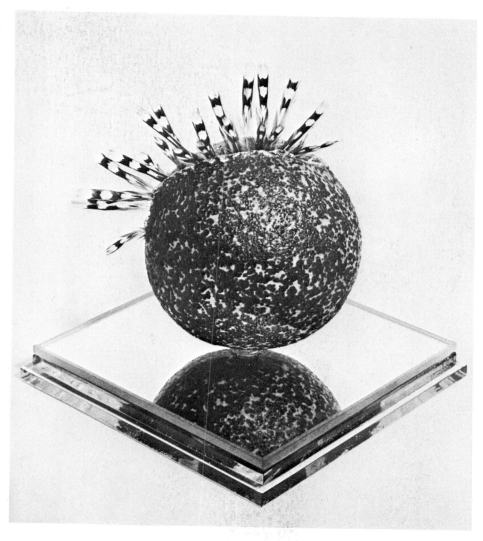

FEATHER FETISH #3: clay, feathers, mirror in plastic box: object 5" high: 1969

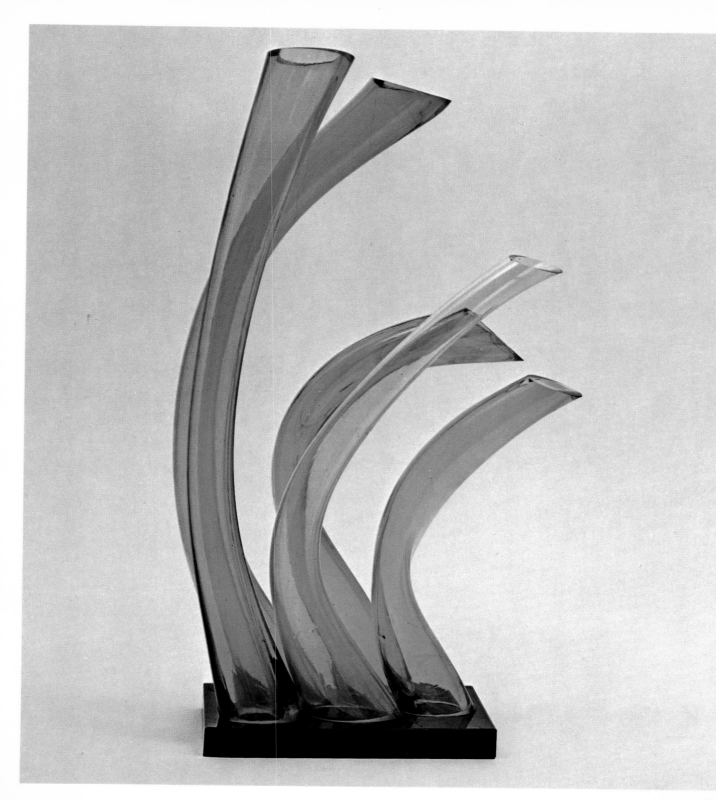

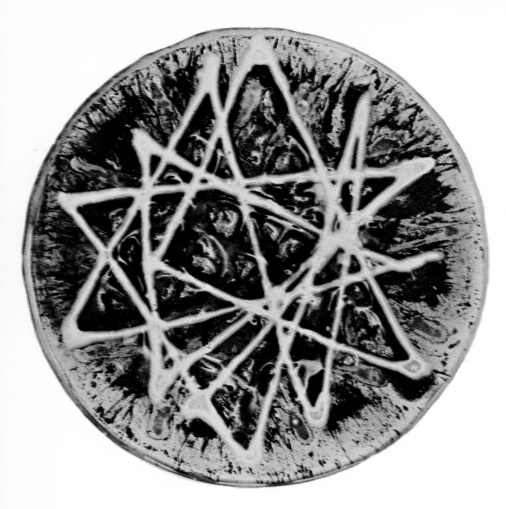

PLATE: laminated glass: 10″ diam.: 1965

EARL STUART McCUTCHEN

McCutchen has had a long and distinguished career in ceramics as well as glass, and through his teaching and published articles, has made significant technological contributions in both media. One of the earlier artists to work creatively with glass, McCutchen is well known for his award-winning laminated and molded objects. In recent years he has expanded his use of the material to include blown glass. His pieces, notable for their restrained use of color, have been shown internationally, and he has had more than a dozen one-man exhibitions at museums and universities. The laminated plate shown here creates an unusual illusion of depth by its juxtaposition of transparent and opaque areas.

birthplace: Ida Grove, Iowa, 1918
education: Iowa State College, 1936–1939 • Ohio State University, B.F.A. 1941; M.A. 1949 • Institute of Art (Florence, Italy), advanced study in ceramics, 1952–1953
teaching: Research Engineer, Ohio State University Research Foundation, 1942–1945 • School for American Craftsmen (Alfred, New York), summer, 1949 • Alumni Foundation Distinguished Professor of Art, University of Georgia, present
collections: Cleveland Museum of Art • Cooper-Hewitt Museum of Design (New York) • Corning Museum of Glass (Corning, New York) • Museum of the Institute of Art (Florence, Italy) • Witte Memorial Museum (San Antonio, Texas)
residence: Athens, Georgia

146

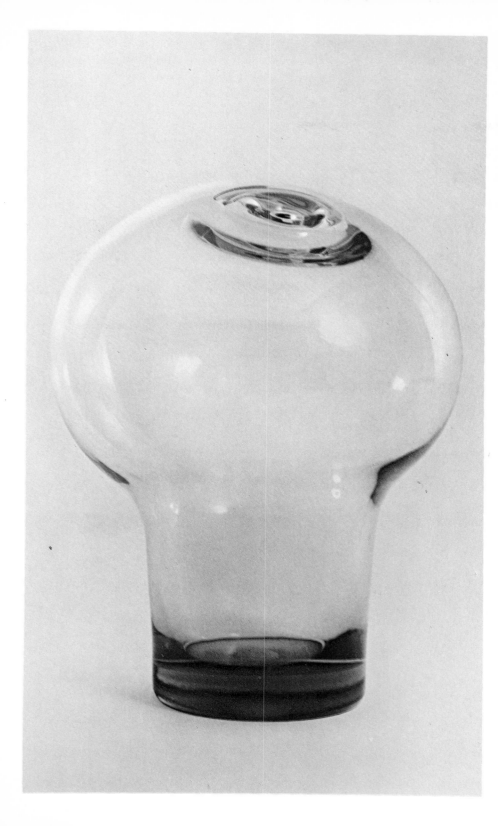

ANDRÉ BILLECI

Like so many other artists dedicated to glass, Billeci came to the medium through ceramics. In 1963 he turned his attention first to glass laminates, and later, after working with two retired glass blowers from the Steuben works at Corning, New York, to molten glass. Since that time Billeci has designed, built equipment for, and assumed complete responsibility for the glass program at Alfred University. In this capacity his influence has been widespread in attracting and training younger artists in the field.

The objects of Billeci have moved from functional forms to those manifestly sculptural in concept in which strong structural authority is stressed.

birthplace: New York, New York, 1933
education: Alfred University (New York), B.F.A. 1960;
 M.F.A. 1961
teaching: Alfred University (New York), present
collections: Corning Museum of Glass (Corning, New
 York) • Toledo Museum of Art • National Galleries
 of Prague (Czechoslovakia) • Addison Gallery of
 American Art (Andover, Massachusetts)
residence: Alfred, New York

At present it is my feeling that studio glass is the most virile of all the three-dimensional crafts. The problems of efficient studio equipment, technical information, and proficiency of craftsmanship are rapidly being solved, and many of our most talented and capable young craftsmen have come under its spell.

American art glass in the past one hundred years, with the rare exception of a few individuals around the turn of the century, has been a wasteland. Through the exploration of the material now being done by the studio craftsman things that glass makers have never before thought of are being and will be done. Few fields present so great an opportunity to the artist.

—André Billeci

LIGHT BLUE FORM: free blown: 12½" high: 1969

JOEL PHILIP MYERS

Myers functions as a creative studio artist in glass and also as resident-craftsman in industrial production. Since 1963, when he became director of design for the Blenko Glass Company, he has been solely responsible for providing the prototypes and experimental designs of that concern.

Trained in ceramics and industrial design, Myers has emerged as one of the outstanding artist-craftsmen in the field of blown glass, and has elevated utilitarian forms to a high level of aesthetic realization.

The studio facilities available to Myers at Blenko have provided him with unique opportunities for experimentation and research. Working essentially within a format of functional shapes, he extends his material to its maximum, permitting it to suggest ideas. His objects reflect a consistent commitment to the primacy of form.

Myers' numerous lectures and workshops at museums and universities have been of major and illuminating consequence.

DECANTER WITH FIVE GOBLETS: free blown: decanter 14½" high, highest goblet 17": 1968

birthplace: Paterson, New Jersey, 1934
education: Parsons School of Design (New York) • New School for Social Research (New York) • Kunsthaandvaerkerskolen (Copenhagen) • Alfred University (New York), B.F.A., M.F.A.
teaching: Haystack Mountain School of Crafts (Maine), summer workshops
collections: Krannert Museum (University of Illinois) • Mint Museum of Art (Charlotte, North Carolina) • Museum of Contemporary Crafts (New York) • Toledo Museum of Art • Wichita Art Museum
residence: Milton, West Virginia

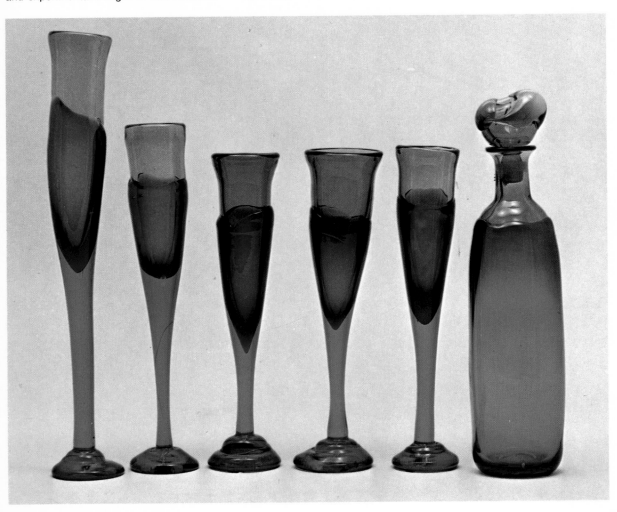

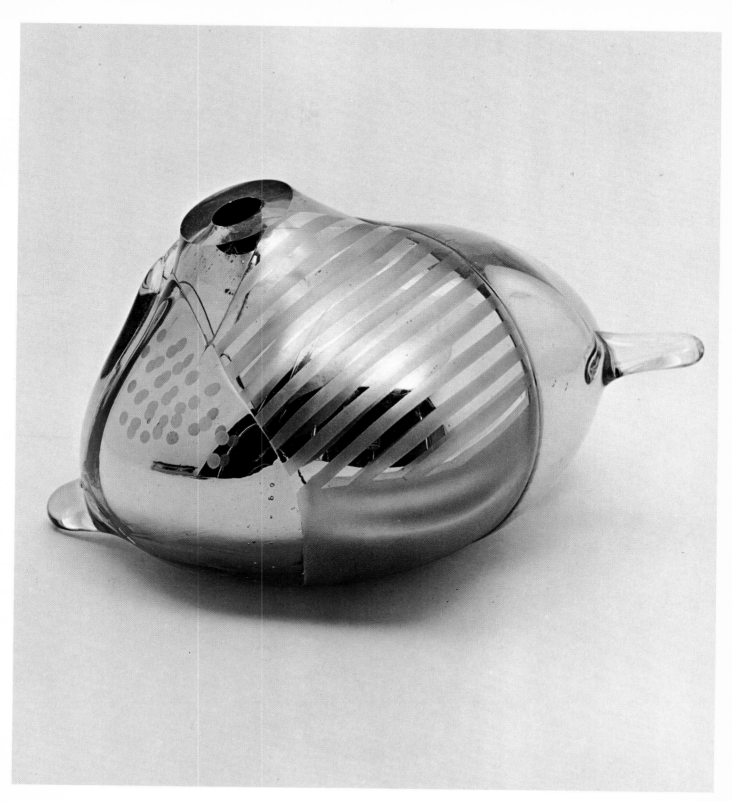

ROBERT FRITZ

Fritz has made important contributions to the technique of glass blowing both as a creative artist and as a teacher. He was a student of Erwin Eisch, Dominick Labino, and Harvey Littleton, and as associate professor of art in ceramics and glass at San Jose State College, has himself been mentor to a number of leading younger West Coast artist-craftsmen. Among his students were James Wayne, Fred Lucero, David Hopper, Robert Strini, and Kim Newcomb.

Fritz's sculptural forms are notable for combining a strong structural presence with lyricism. Unlike most contemporary artists, he often works figuratively in glass.

birthplace: Toledo, Ohio, 1920
education: San Jose State College, B.A., M.A. • Ohio State University, Ph.D. • California College of Arts and Crafts • University of Wisconsin • School of Design, Toledo Museum of Art
teaching: Ohio State University, 1957–1960 • San Jose State College, present
collections: Oakland Art Museum • Toledo Museum of Art • Sheldon Memorial Art Gallery (University of Nebraska) • Fine Arts Gallery of San Diego
residence: San Jose, California

WINDOWS: smoked glass with clear windows and prunts: 7¾" high: 1969

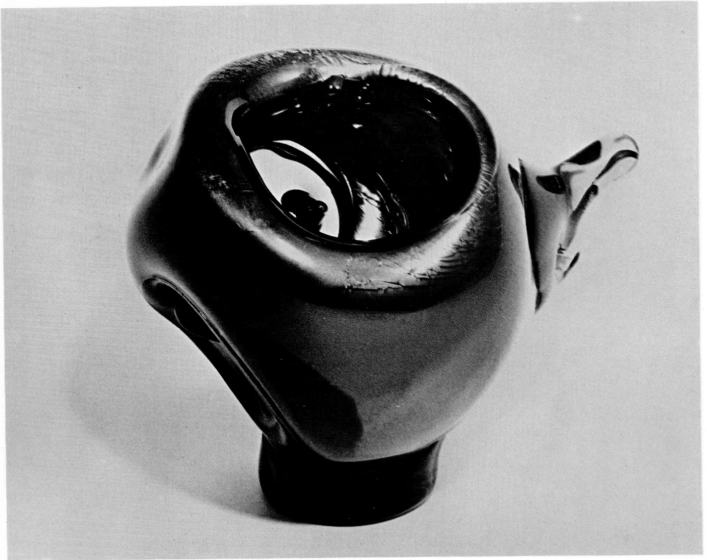

KENT F. IPSEN
Working in free-blown glass, Ipsen creates both utilitarian objects and organic, abstract sculptural forms. He has received numerous awards for his work in national competitive exhibitions, including the Toledo biennial. The bowl illustrated here, in deep blue with green pattern, is typical of Ipsen's lyrical approach to the medium.

birthplace: Milwaukee, 1933
education: University of Wisconsin (Madison), B.S., M.S., M.F.A.
teaching: Mankato State College (Minnesota) • The School of the Art Institute of Chicago, present
collections: Milwaukee Art Center • University of Wisconsin • Mount Mary College (Milwaukee) • La Crosse State University (Wisconsin)
residence: Northbrook, Illinois

BOWL: free blown: 7″ high x 12″ diam.: 1968

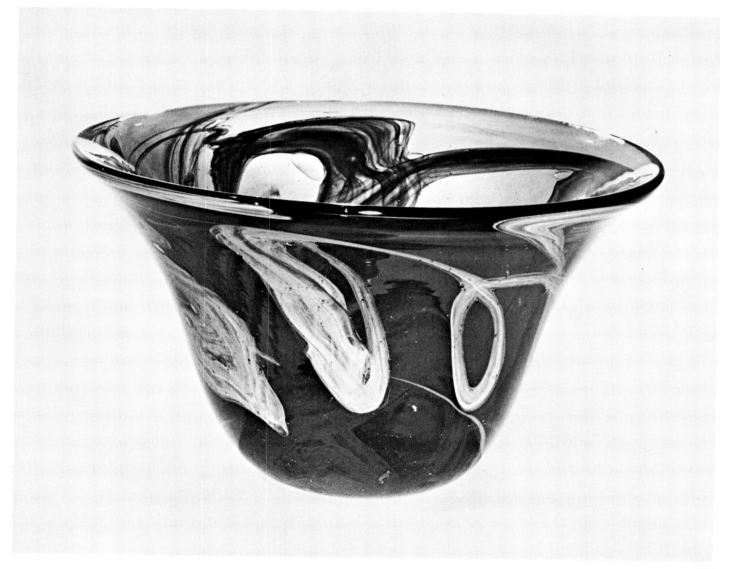

The object illustrated here is free hand blown and executed in one operation at the furnace door. The glass, from an original formulation by the artist himself, has silver as the coloring agent, and achieves in one composition a movement of color from blues to greens. Opaque in reflected light, this glass is dichroic and becomes amber-red in transmitted light. The simplicity of the form permits a full and free expression of the color movement.
—Dominick Labino

DOMINICK LABINO

One of the leading glass craftsmen in the country, Labino is also one of the most knowledgeable and innovative technicians in the field. His association with glass in industry has covered a period of more than thirty-five years and has included research and development of glass composition, processes, machines for forming glass fibers, and even furnace design. He holds more than fifty patents in America and hundreds abroad. Until his retirement in 1965, he was vice-president and director of research for Johns-Manville Fiber Glass.

Labino began his work with free-blown glass as an art form in 1963. Working more within a format of traditional shapes, his interest in form is often secondary to that of color. With his profound command of the chemistry of glass, he is able to alter properties to achieve certain colors which are uniquely his own.

Cooperating with Harvey Littleton in the First Glass Seminar at the Toledo Museum of Art, in 1962, he contributed substantially in making available technical knowledge on the forming of glass and in the building of glass furnaces that would be practical for craftsmen. The impact of his participation in countless other seminars and workshops has played a major role in the reestablishment of blown glass as an art form.

birthplace: Clarion County, Pennsylvania, 1910
education: Carnegie Institute of Technology (Pittsburgh) • School of Design, Toledo Museum of Art
book: Visual Art in Glass (William C. Brown Co., 1968)
collections: Pilkington Museum of Glass (Lancashire, England) • Cleveland Museum of Art • National Glass Museum (Leerdam, the Netherlands) • Phoenix Art Museum • Toledo Museum of Art
residence: Grand Rapids, Ohio

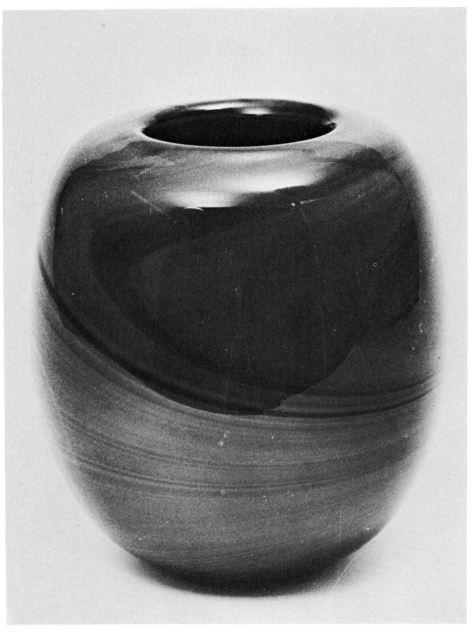

DICHROIC FORM: free hand-blown silver schmeltz glass: 7¼" high: 1968

FRED MARCUS

The objects created by Marcus derive from his interest in the blown-glass forms and decorative processes of artists of the late nineteenth and early twentieth centuries. Specifically, this interest is manifest in much of his work involving acid etching, faceting, and iridescent fuming. These processes are used in combination with the more modern techniques of copper and silver electroforming to produce the decorative effects of his utilitarian forms.

Marcus is also important as a teacher and has held assistantships under Harvey Littleton (glass blowing) and Arthur Vierthaler (research in creative electroforming). His work has been shown internationally and has received numerous awards.

birthplace: Chicago, 1941
education: University of Illinois, B.F.A. 1964 · University of Wisconsin, M.F.A. 1967
teaching: Illinois State University, 1967–1968 · Penland School of Crafts (North Carolina), summer, 1967 · University of Illinois, present
collections: University of Wisconsin · Lakeview Center for the Arts and Sciences (Peoria, Illinois)
residence: Champaign, Illinois

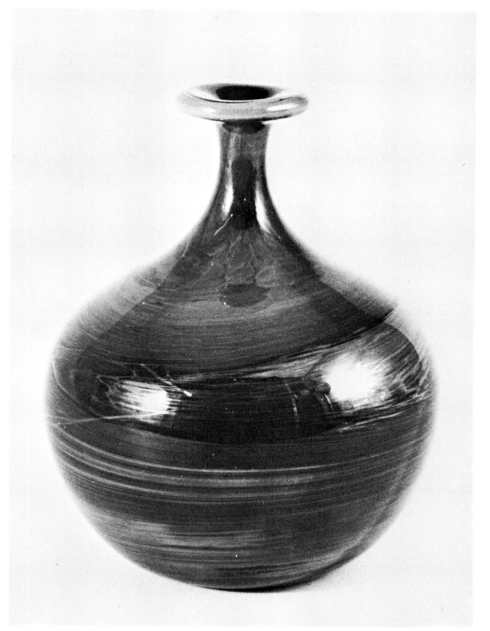

BOTTLE: hand blown, with reduced-copper decoration: 6¼″ high: 1968

TOM McGLAUCHLIN

The career of McGlauchlin has been closely identified with the events that led to the current renaissance of free-blown glass as a creative medium.

He studied under Harvey Littleton and Toshiko Takaezu in the late fifties, and in 1962 became a member of Littleton's first glass workshop at the Toledo Museum of Art. Since then he has been actively involved in the medium as an artist and as a teacher.

birthplace: Beloit, Wisconsin, 1934
education: University of Wisconsin, B.S. 1959; M.S. 1960 • University of Iowa, 1961 • University of Washington, 1966–1967
teaching: University of Iowa, visiting lecturer, 1964–1966 • University of Wisconsin, 1960–1961 • Cornell College (Iowa), present
residence: Mount Vernon, Iowa

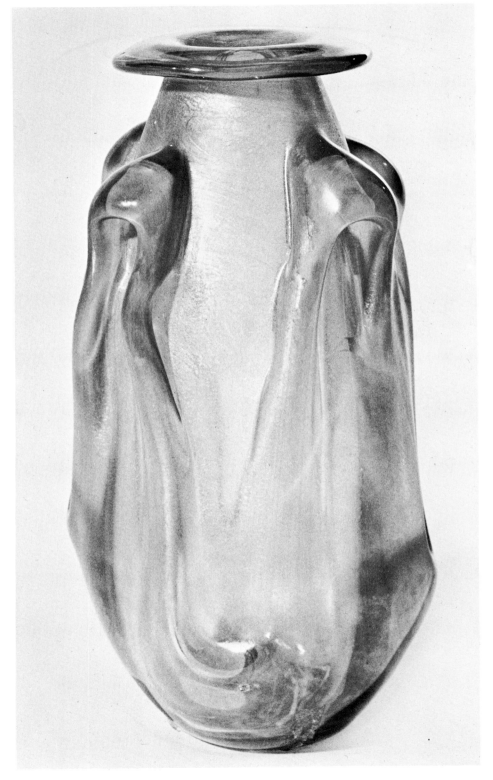

PINK VASE: blown glass with volutes: 11½″ high: 1967

MARK C. PEISER

Peiser's involvement with glass was arrived at through an unusually circuitous route. He studied electrical engineering, industrial design, and music composition, and then began to work with glass at the Penland School of Arts and Crafts in 1967. His rapport with the creative possibilities of this medium was so strong that he abandoned his career in the industrial-design field, closed his business in Chicago, and has remained resident glass blower at Penland, North Carolina, ever since.

He has attained his main mark of individuality by the startling surface effects on his basically functional forms, many of which are extensions and variations of art nouveau designs.

birthplace: Chicago, 1938
education: Purdue University, 1955–1957 (electrical engineering) • Illinois Institute of Technology, 1959–1961 • DePaul University, School of Music, 1965–1967
teaching: Penland School of Arts and Crafts (North Carolina)
residence: Penland, North Carolina

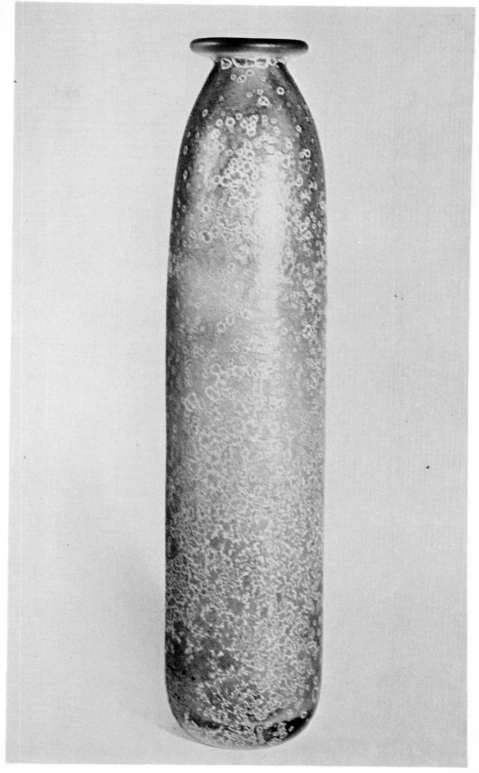

VASE: hand-blown glass: 11¾'' high: 1968

illustrated here marks a new direction in his work—the illuminating action of the gases imposes a quasi-kinetic dimension. Chihuly takes the fullest advantage of the delicate and fragile expressiveness of the medium, and his sinuous, lyrical forms subordinate utility to rhythmic imagery.

birthplace: Tacoma, Washington, 1941
education: University of Washington, B.A. 1965 · University of Wisconsin, M.S. 1967 · Rhode Island School of Design, 1968 · Louis Comfort Tiffany Foundation grant, 1967–1968 · Fulbright Scholarship grant, 1968–1969 (Italy)
teaching: Haystack Mountain School of Crafts (Maine), 1968, 1969
residence: Providence, Rhode Island

DALE CHIHULY

One of the younger generation of artists attracted to free-blown glass, Chihuly developed this interest while a student at the University of Washington. He went on to master the medium under Harvey Littleton at Wisconsin, and in Venice he studied and worked for a year with the glass blowers of Murano.

The sculptural form with neon and argon

FORM: blown glass, neon, and argon with high-frequency electronic coil: 12″ high: 1968

WINE BOTTLE: blown glass with gold stopper: 23″ long: 1968

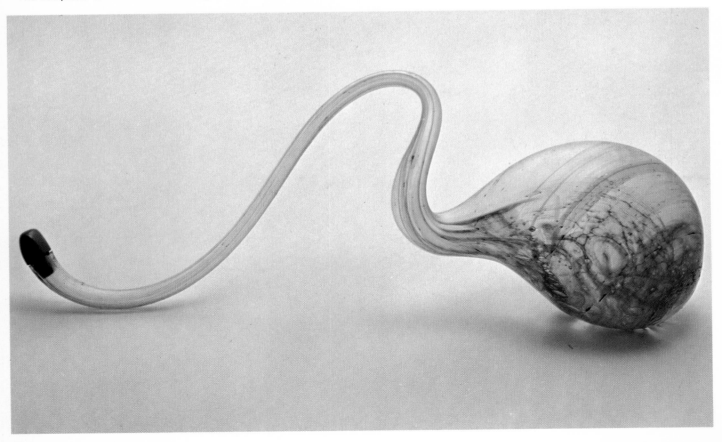

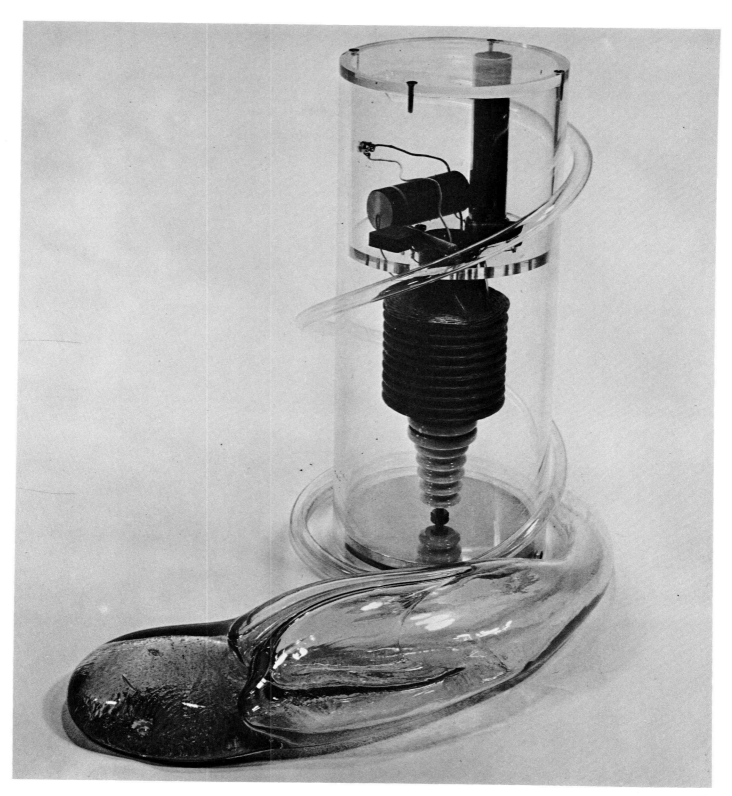

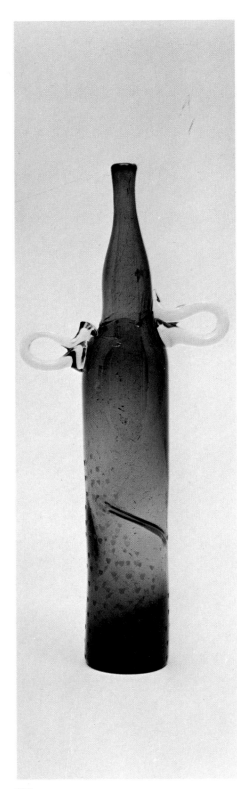

RICHARD MARQUIS

Marquis has already received unusual recognition for his delicate and innovative blown glass. His tall, functional bottle in iridescent, transparent glass accented with handlelike protrusions and the tiny-lipped, mold-blown trapezoidal bottle (both illustrated here) stem from an extension of the Abstract Expressionist aesthetic of his mentors, Marvin Lipofsky and Peter Voulkos. (He has also worked with ceramists James Melchert and Ron Nagle.)

In 1967 Marquis received the President's Undergraduate Research Fellowship to set up his own workshop on the Berkeley campus, and he was the recent recipient of a Fulbright Scholarship grant enabling him to spend a year in Venice working with the glass blowers of Murano.

birthplace: Bumblebee, Arizona, 1945
education: University of California (Berkeley), B.A., 1968; M.A. 1969
teaching: University of California (Berkeley)
residence: Berkeley, California

SMALL BLUE CHECKERED BOTTLE: blown glass: 4″ high: 1969

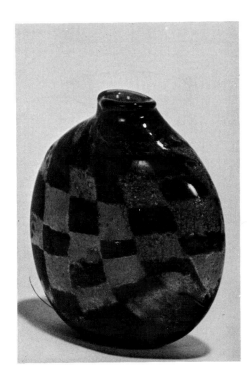

TALL BOTTLE: blown glass: 12½″ high: 1967

ROBERT SOWERS

Sowers first became seriously interested in stained glass as a contemporary art form in 1950 while studying on a Fulbright grant in London. Earlier he studied painting with Stuart Davis, art history with Meyer Schapiro, the psychology of art with Rudolf Arnheim, and the philosophy of art with Susanne Langer.

During extensive European travels in the early fifties, Sowers made penetrating studies of the qualities of medieval stained glass which led to the publication of his first book, *The Lost Art: A Survey of 1000 Years of Stained Glass.*

PANEL: leaded stained glass: 50" x 64": 1968

birthplace: Milwaukee, 1923
education: American University (Biarritz, France) • New School for Social Research (New York), B.A. 1948 • Columbia University, M.A. 1949 • Central School of Arts and Crafts (London), 1950–1953, on Fulbright Scholarship, 1950 • Louis Comfort Tiffany Foundation grant, 1956 (France and Italy)
teaching: Central School of Arts and Crafts (London), 1951–1953
commissions (stained glass): American Airlines Terminal (J. F. Kennedy International Airport) • Bankers Trust Company (New York) • St. Michael's Church (San Francisco) • Temple Beth Emeth (Albany) • Capitol Park (Washington, D.C.)
books: The Lost Art: A Survey of 1000 Years of Stained Glass (Universe Books, New York and London, 1954) • Stained Glass: An Architectural Art (Universe Books, New York and London, 1965)
residence: New York, New York

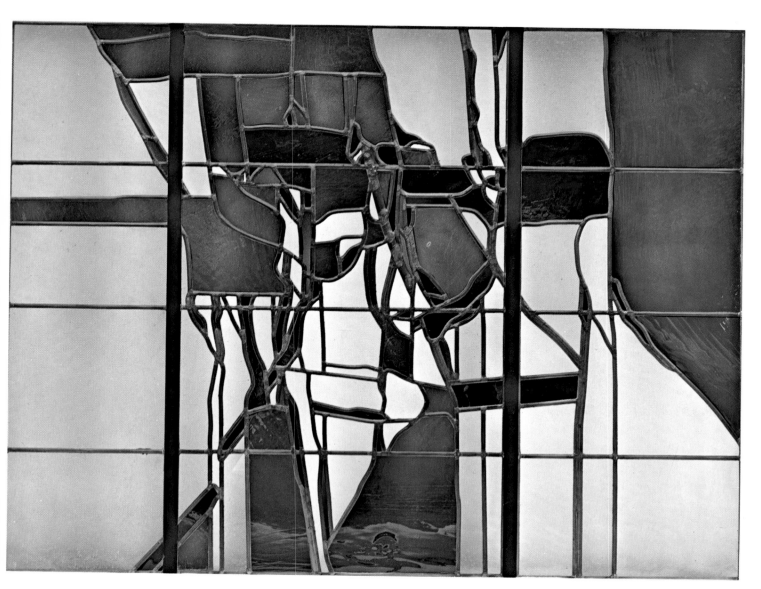

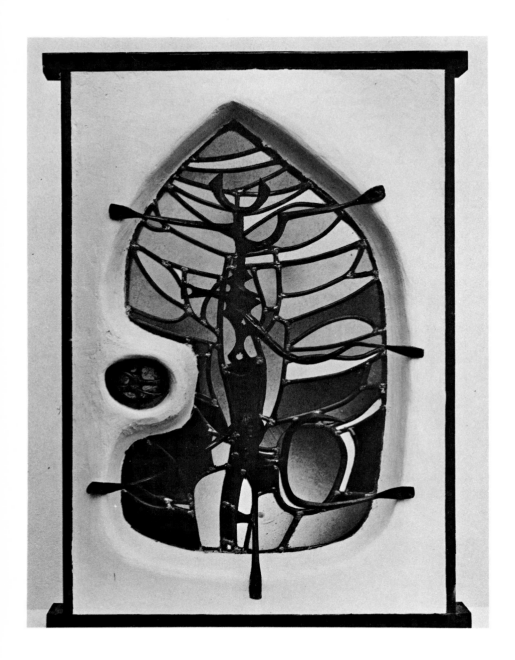

SVETOZAR RADAKOVICH
The stained-glass-window construction
illustrated here brings together an unusual
combination of materials—leaded hand-
blown glass, magnesite cement, and cast
bronze—and it reflects Radakovich's
mastery of many media. The artist is also
represented in this book with a bronze
sculpture and a gold necklace. (For
biography see under JEWELRY.)

WINDOW: leaded stained glass, bronze cast
grill, set in sculpture magnesite: 46″ high:
1969

SAMUEL WIENER, JR.

Stained glass is only one of a variety of media for which Wiener is well known. He has executed mosaic and ceramic panels, tapestries, and painted wood panels. He says that training, experience, and interest in both architecture and painting have led him to work in the field of commissioned architectural art, from which he earns his living completely.

Wiener's art is predominantly conceived within an architectural context. As in architectural practice, he first makes studies, drawings, and specifications; then, after selecting his materials, he works with and supervises craftsmen-assistants in the execution of the piece.

In creating the leaded glass panel illustrated here, Wiener responded to the expressive possibilities of commercial patterned glass, lenses, and mirrors, departing from the traditional hand-blown techniques used in most stained glass. (Stained glass is a confusing misnomer which comes from the English use of glass 'stained' to a gold color using silver salts. The colored glass used is not stained at all, but is colored by mixing various minerals in the molten glass.)

His multi-media works have been exhibited in museums throughout the U.S., and in 1961 he was given a one-man show at the Columbia University School of Architecture.

birthplace: Shreveport, Louisiana, 1928
education: Yale University, B.F.A. 1951 • University of Michigan
teaching: Columbia University School of Architecture, 1960–1961 • Cooper Union Art School (New York), 1967–1968
commissions (stained glass): Temple Israel (New Rochelle, New York) • Temple Emanuel (Eastmeadow, New York) • Park Plaza Apartments (Rego Park, New York) • Temple Israel (Columbus, Ohio) • Pleasant Valley Home (West Orange, New Jersey)
residence: Westport, Connecticut

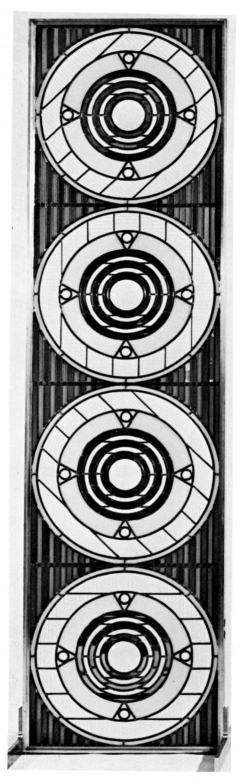

WHIRL: leaded mirror, lenses, antique and commercial glass: 96'' x 24'': 1969

169

FRED FENSTER

The holloware chalices of Fenster address themselves pertinently to the ceremonial functions for which they are intended. His work, executed for the most part in silver, gold, and pewter, also includes hand-wrought jewelry. He has been represented and won awards in many of the major designer-craftsmen exhibitions in this country and has exhibited at the Steffin International Competition in Pforzheim (Germany, 1965). One-man shows of his work have been held at Montana State University and the Philadelphia Art Alliance.

birthplace: New York, New York, 1934
education: City College of New York, B.S. 1956 ·
 Cranbrook Academy of Art, M.F.A. 1960 ·
 Rochester Institute of Technology, summer, 1960
teaching: University of Wisconsin, present
collections: Milwaukee Art Center ·
 Detroit Institute of Arts ·
 Saint Paul Gallery and School of Art
residence: Madison, Wisconsin

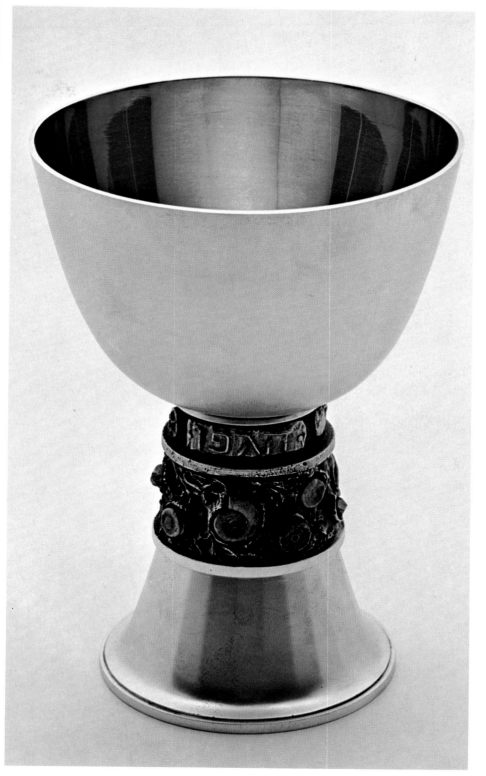

KIDDUSH CUP: sterling silver, raised, cast, fabricated: 7″ high: 1969

FLATWARE PLACE SETTING: six pieces,
silver and enamel: longest 9″, shortest
6¼″: 1955

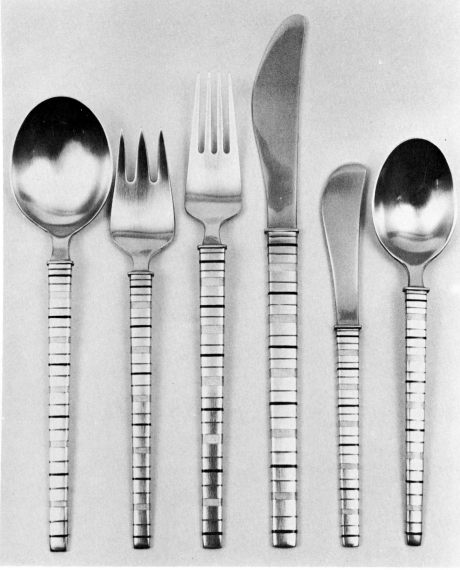

ROBERT J. KING

While he was a student at the University
of Wisconsin in the late thirties, King was
among the first U.S. artist-craftsmen to
experiment with the application of lost-
wax casting in creative jewelry. His
later interest in enameling on metal was
a direct source for the work illustrated
here, in which color is incorporated into
flatware. He studied enameling during this
period with Mitzi Otten, and silversmithing
with John Prip at the School for American
Craftsmen.

Since 1949 King has devoted most of
his time to industrial design, first with
Towle Silversmiths and presently with the
International Silver Company. During this
period he has continued to work inde-
pendently in flatware, holloware, jewelry,
and enamels, and has shown in competitive
and invitational exhibitions throughout the
country. He was represented at both the
Brussels (1958) and New York (1964)
World's Fairs, and in the United States
Information Agency traveling exhibition of
American crafts in Europe.

birthplace: Madison, Wisconsin, 1917
education: University of Wisconsin, B.A. 1940 ·
 Rochester Institute of Technology, 1947–1949
collections: Rochester Memorial Art Gallery ·
 Museum of Contemporary Crafts (New York) ·
 Saint Paul Gallery and School of Art ·
residence: Wallingford, Connecticut

ZAVEN ZEE SIPANTZI

The silver holloware of Sipantzi adheres rather essentially to the 'form follows function' aesthetic, which is the Scandinavian rationale. His work has been exhibited extensively at museums and universities on the West Coast and in Norway, where he studied under a Fulbright grant.

birthplace: Los Angeles, 1929
education: University of California (Los Angeles), B.A., M.S. • California State College (Los Angeles), M.A. • Royal Academy of Arts and Crafts (Oslo)
teaching: California State College • University of Southern California
residence: North Hollywood, California

My work tends toward the elimination of extrinsic line and adornment beyond that which is absolutely essential to the function of the object.

In relation to my COFFEE SET I have attempted to further this idea of eliminating extrinsic line and adornment by excluding the customary protruding handle and using the neck of the coffee pot for the grip. (The neck is insulated with black leather.)

In addition, the snout evolves out of the coffee pot, rather than being attached in the usual manner. The cream pitcher and the sugar server conform to the lines of the coffee pot and are also without the customary protruding handles.

—Zaven Zee Sipantzi

COFFEE SET: hand-raised sterling silver: coffee pot 10″ high, creamer 4″ x 4″, sugar bowl 3¼″ x 4¼″: 1965

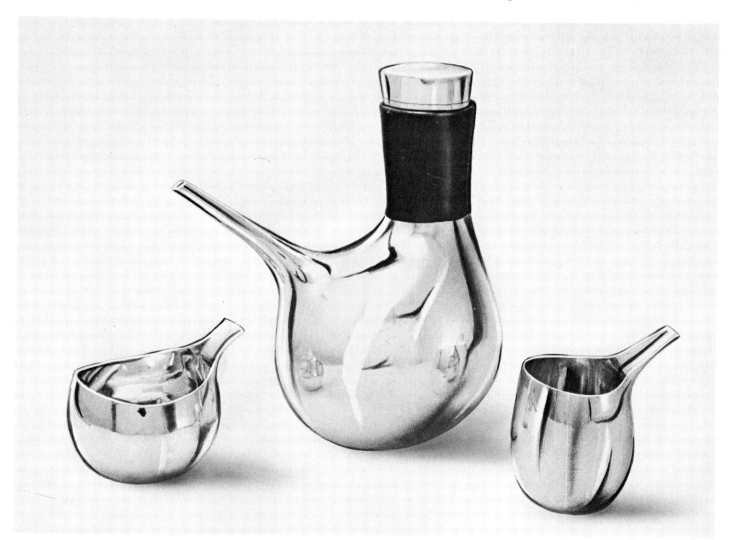

FRANCES FELTEN

Frances Felten represents one of the few artist-craftsmen in the U.S. working creatively and consistently with pewter. Further, through sales from her Connecticut studio, she has been able to support herself fully from her work. When not occupied with commissions, she creates studio pieces for exhibitions, and her pewter canisters, pitchers, and boxes have won awards both nationally and internationally. The plique-à-jour enamel on the top of *CANISTER* (illustrated here) was executed by Margaret Seeler, a noted enamelist living in Connecticut.

birthplace: Near Saugerties, New York
education: St. Lawrence University • Pratt Institute • New York School of Fine and Applied Art • Columbia University
teaching: Pratt Institute • Eastern Connecticut State College (summer school) • Brookfield Craft Center (Connecticut)
collection: Museum of Modern Art (New York)
residence: Winsted, Connecticut

I have always rejected the idea that a wall exists between the 'fine' and 'minor' arts. The artisan becomes artist when imagination takes place, and when his technical skill enables him to present the images in an orderly manner.

Hands may fashion a hollow gourd into an adequate drinking vessel, skill in the use of a brush produces a pleasant painting, but thought is required to bring beauty to the utilitarian article and to make the painting art, and many sensations, observations, and experiences must be brought from the cosmic consciousness— the attic of the brain—to accomplish this.

The ultimate in simplification of aesthetic quality is the entasis in a Greek column. Its presence is scarcely visible, but its absence would weaken the whole structure. When the craftsman becomes aware of the importance of this subtlety—the 'unheard melody'—when he learns to halt a curve before it becomes that beautiful but too frequently seen spiral, and to discard all clichés in line and form as he would shun them in speech, he is an artist.
—Frances Felten

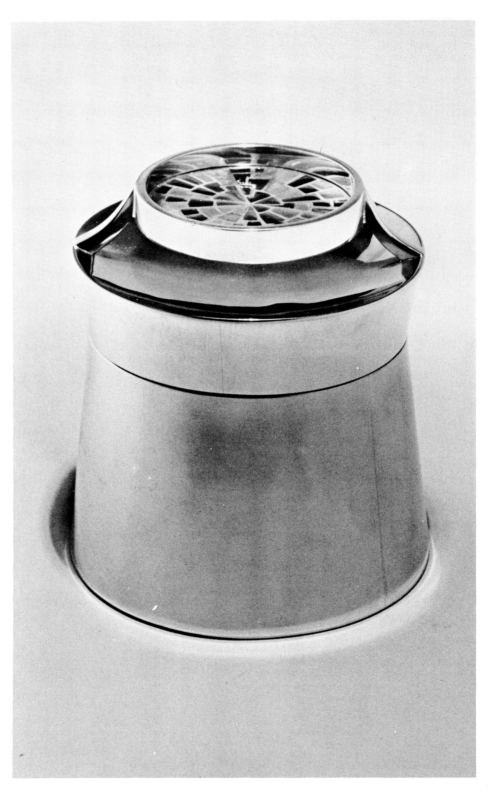

HELLYN R. MOORE

In her work Hellyn Moore is closely concerned with contrasts—organic forms in juxtaposition with geometric ones, natural crystal against plexiglass, matte against gloss. It was while studying at the University of Washington that she first became interested in three-dimensional forms as expressed in containers—bowls, bottles, and boxes. The idea of captured space and the forced relationships between the internal and external became a major preoccupation.

Miss Moore has exhibited extensively in the Northwest and in her native New Mexico.

birthplace: Tucumcari, New Mexico, 1937
education: Instituto Allende (San Miquel de Allende, Mexico) 1963 • University of Tennessee Craft Workshop, summer 1964 • University of New Mexico, B.F.A. 1965 • University of Washington, M.F.A. 1967
teaching: Highline College (Midway, Washington), present
residence: Seattle

Although I have always related deeply to the Mexican and Indian craftsmen, my own work does not seem to have been influenced directly by their work, perhaps because I really was, after all, an outsider to their cultural heritage of many generations. After leaving New Mexico, my work seemed to evolve in a direction which sought to contrast baroque, organic form and texture against austere, smooth, highly polished areas. I became concerned with the mystery of captured space which forced an interplay between the internal and the external of the container form.

This is why I chose to line the interior of both the top and bottom of this box with black plexiglass, which was repeated on the exterior of the lid and carried through in the black color within the crystal. Form and space were also captured in the exterior of the box by imprisoning the crystal—with a perhaps symbolic result. The organic, natural, primeval crystal (nature) is held constrained and in forced relationship to the bronze architectural stock and black plexiglass (mechanized, industrialized society of expediency). My involvement is to create the relationship between the two, which, after all, are really the two heritages of my existence. I do not feel a conflict between the two but rather the challenge of creating their interrelationship.

—Hellyn R. Moore

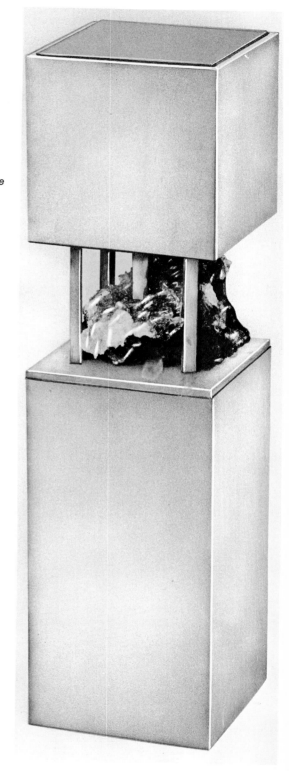

CANISTER: pewter with plique-à-jour enamel by Margaret Seeler: 4½″ high: 1968

BOX: bronze with black plexiglass and goethite crystal: 7½″ high: 1967

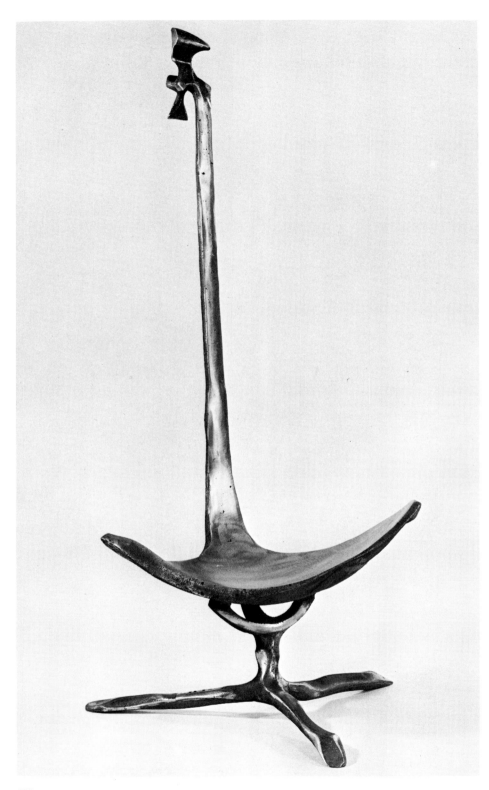

THOMAS LYNN
'Sitting on top of or inside a piece of sculpture gives one a great opportunity to become involved physically as well as aesthetically with that piece of sculpture.' To Lynn a piece of furniture is not primarily a functional object, but a sculptural form whose qualities are enhanced by being able to sit on it, lie on it, or eat from it. Currently this artist-craftsman is living with a group of artists in the country south of San Jose in a cooperative complex that includes an extensive foundry, studios, and living facilities.

birthplace: Pasadena, California, 1939
education: San José State College
residence: Morgan Hill, California

CHAIR WITH BACK: cast aluminum: 56½" high: 1968

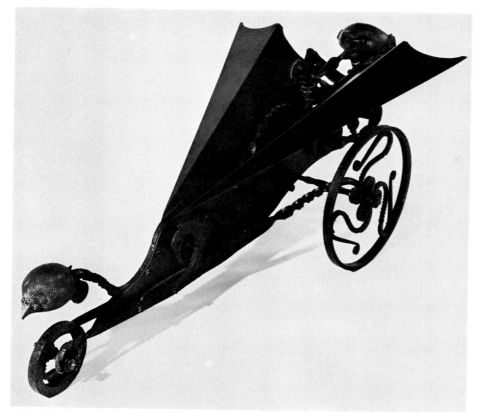

AIR MACHINE: forged mild iron and cast bronze: 51¼″ long: 1969

BRENT KINGTON

The fantasy and whimsy that play a dominant role in the work of Kington have found expression in a variety of objects ranging from bronze birds, candlesticks, necklaces, and other jewelry to the fantasy machine sculptures with which he is prominently identified.

Kington acknowledges a long fascination with miniature sculpture and with eighteenth-century English toys. Further, watching his own son play with toy cars led him directly to the idea of 'push-toy' sculpture. Make-believe is a pervasive element in these works, and springs from a recognition of man's persistent need to imagine and dream. Kington noted that just as a child on a tricycle will imagine it to be a car or a pony, so an adult driving his Ford on the freeway may imagine it to be a Ferrari.

Kington, a master of forging and casting techniques, has exerted considerable influence as a university professor and frequent guest artist or workshop director at schools and museums throughout the U.S.

birthplace: Topeka, 1934
education: University of Kansas, B.F.A. 1957 •
 Cranbrook Academy of Art, M.F.A. 1961
teaching: Southern Illinois University, present
collections: St. Paul Gallery and School of Art •
 Krannert Art Museum (University of Illinois) •
 The Evansville Museum of Arts and Science •
 Middle Tennessee State College • University of
 Wisconsin (Milwaukee)
residence: Carterville, Illinois

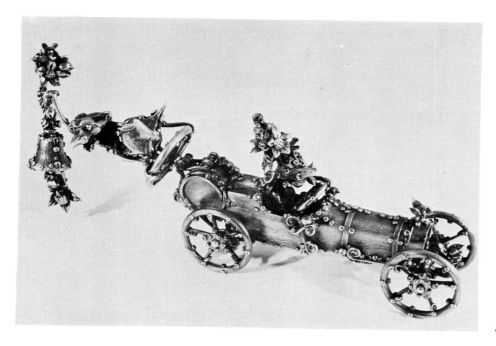

A-WAY-WE-GO: cast sterling: 13″ long: 1967

187

FREDERICK A. MILLER

One of the nation's most renowned silversmiths, Frederick Miller has worked as an artist-craftsman and teacher for more than twenty years. He was among the first in the U.S. to revive the technique of 'stretching' in creating free-form bowls.

Since 1946 Miller has been associated with the firm of Potter and Mellen in Cleveland as a designer in charge of their custom metal workshop, and presently he is president of the company. His own handwrought holloware has been exhibited in leading museums throughout the U.S., including the Cleveland Museum of Art and the Metropolitan Museum of Art, and he was represented at the 1958 Brussels World's Fair.

birthplace: Akron, Ohio, 1913
education: Cleveland Institute of Art • Western Reserve
 University
teaching: Cleveland Institute of Art, present
collections: Cleveland Museum of Art • Beaux Arts
 Museum (Columbus, Ohio) • Texas State
 Teachers College • Lawrence and Barbara
 Fleischman Collection of American Art
residence: Brecksville, Ohio

This sterling BOTTLE was raised from a twelve-inch disc of sterling. The challenge of forming an irregular unsymmetrical form by the raising technique was a natural development from earlier free-form low bowls stretched from irregular shapes. Most of my pieces could be considered as basically organic. I feel that silver should express and, if possible, amplify the inherent qualities of the material.

—Frederick A. Miller

BOTTLE: raised sterling silver with 23k gold: 7½'' high: 1969

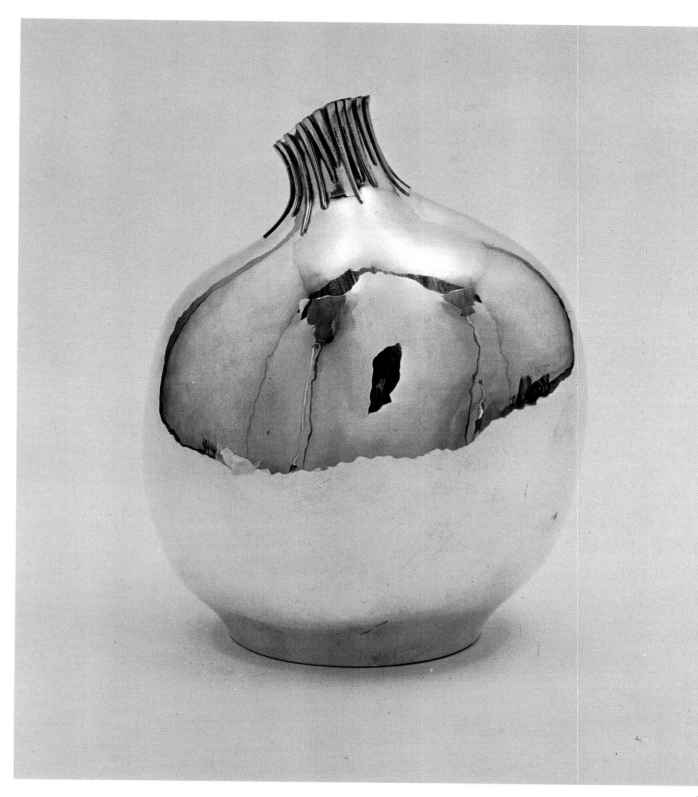

PAOLO SOLERI

Architect, theoretician, author, artist, and craftsman, Soleri is internationally acclaimed for the vision embodied in his projects. He is known principally for his architecture, both completed and projected, and he is generally regarded as one of the very few architects with an authoritative command of true craftsmanship in building. Since coming to the U.S. in 1947 to work on a Frank Lloyd Wright Fellowship, Soleri has executed buildings here and in his native Italy.

The experimental *EARTH HOUSE* illustrated here has been widely reproduced in leading architectural journals and in articles about the artist. His work has appeared in such publications as *Time, Architectural Forum, Life, Esquire, Horizon, Industrial Design, Domus,* and *Art in America.* The house, in which earth has been used to create form, is a learning and training center containing studios and workshops for his students. There plans are being developed for a projected new urban community, some seventy miles north of Phoenix. (Details of elevations illustrated here.)

The ceramic and metal bell clusters, for which Soleri is also well known, now occupy only a small amount of his time, and in fact, represent an avocation. Yet they reveal the same sensitive response to materials and embody the same visionary scope that characterizes his architecture. The work of Paolo Soleri has been included in a number of exhibitions dealing with architectural subjects, including 'Built in USA' and 'The Architecture of Bridges,' both at the Museum of Modern Art (New York). A one-man show for him was held recently at the Corcoran Gallery of Art in Washington.

birthplace: Torino, Italy, 1919
education: Polytechnic School (Torino) Doctorate, architecture • Taliesen West, Frank Lloyd Wright Fellowship (Arizona)
teaching: Cosanti Foundation (Scottsdale, Arizona), in collaboration with the College of Architecture of Arizona State University • Summer workshops for students from twenty U.S. and Canadian universities.
major architectural projects (completed): Dome-House (Cavecreek, Arizona) • Ceramica Artistica Solimene (ceramics factory near Salerno, Italy) • Barth House (Scottsdale, Arizona)
residence: Scottsdale, Arizona

EARTH HOUSE: (interior view) Paradise Valley, Scottsdale, Arizona: one of several dome structures housing the studios and workshops of the Cosanti Foundation and the residence of the architect. The artist is seen walking through the Earth House Studio.

jewelry

IRENA BRYNNER

Irena Brynner's approach to creative jewelry is decidedly sculptural. She works with precious metals and in recent years has often cast her pieces in the lost-wax process by centrifuge. She fashions rings, necklaces, and earrings which are distinctively three-dimensional and closely related to the human form. The earrings illustrated here provide a clear example of this relationship and indicate a notable characteristic of much of her work—the absence of clasps or fasteners. Her necklaces frequently wind around the neck, rather than hang, much in the manner of ancient Etruscan body ornaments.

Miss Brynner came to the U.S. in 1946.

She was trained as a painter and sculptor but turned to jewelry in 1950. Miss Brynner cites her substantial background in sculpture as a major source of the concepts she has developed and acknowledges influences that stem from her Oriental background. Her work has been exhibited and won awards internationally. At present she works full-time fashioning jewelry for her successful shop in New York.

birthplace: Vladivostok, Russia
education: In Manchuria and at the École Cantonal de Dessin et de l'Art Appliqué (Switzerland) • California School of Fine Arts
collections: State Museum (Darmstadt, Germany) • Museum of Contemporary Crafts (New York)
books: Modern Jewelry Design and Technique (Reinhold, 1968)
residence: New York, New York

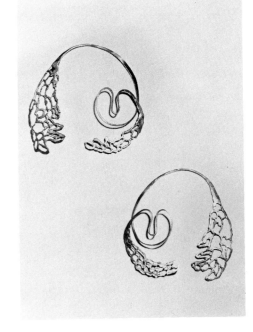

EARRINGS: 18k gold: 3⅜″ x 3″ each: 1967

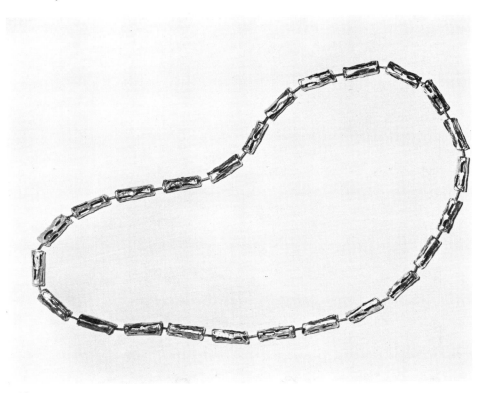

CHAIN: 18k gold: 34½″ long: 1968

birthplace: Pratt, Kansas
education: Kansas State College, B.S. • Kansas
 University • Columbia University, M.S., 1942 •
 With Gustav Hansen in Copenhagen; Baron Erik
 Fleming in Stockholm; and in Paris and Munich
teaching: Indiana University, present
residence: Bloomington, Indiana

Twentieth-century jewelry is an art of open continuous forms in space. Its aesthetic body is the relationship of solids and voids which define each other. As an artist I am concerned with fusing this kind of form with my own vision. If I make jewelry that expresses my own uniqueness, this may have some relevance to the uniqueness of my time.

—Alma Eikerman

ALMA EIKERMAN

Alma Eikerman works in bold, structural forms, her pieces assuming the compositional tensions one usually associates with sculpture. An authority on the art of jewelry, Miss Eikerman has traveled and researched in Mexico (Mixtec jewelry), Italy (Etruscan), Russia (Scythian and Sarmatian gold objects), India, Tibet, Turkey. She has just returned from a trip to study Celtic metal objects.

BRACELET: sterling silver, formed and constructed: 1½″ high x 3″ widest measurement: 1968

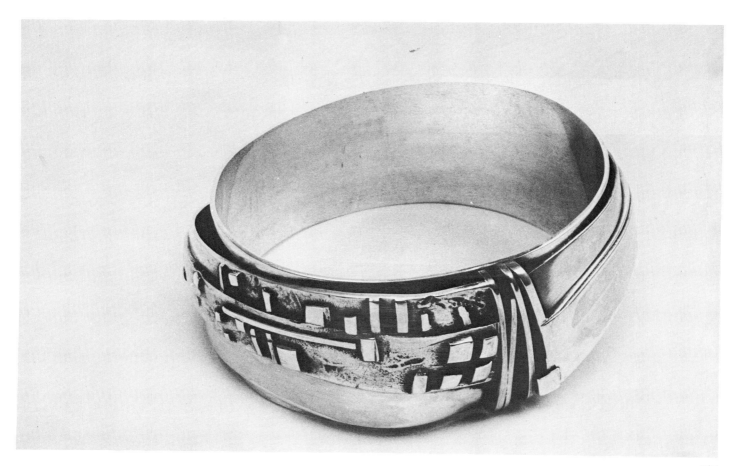

EARRINGS: 14k white and yellow gold:
3¾'' long: 1968

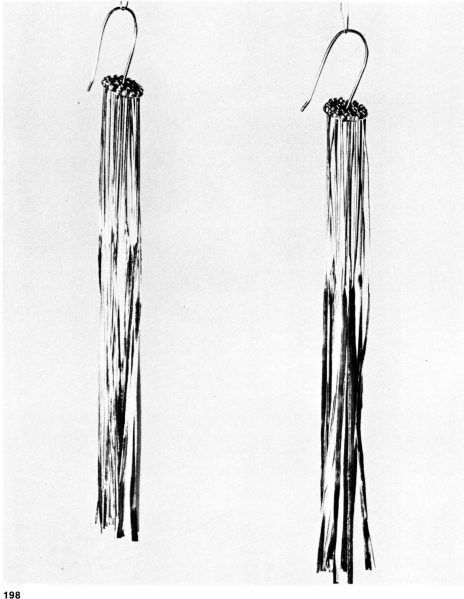

PHILIP FIKE
Much of the jewelry Fike has designed
derives from his intense interest in
the ancient counterpart of the safety pin,
known as the fibula. Ancient Greek and
Roman fibulae were notable for their
integration of the clasp into the decorative
elements. In the fragile gold *EARRINGS*
illustrated here Fike has achieved a unity
of the mechanical and the decorative in
much the same manner.

Artist and teacher, he has shown his
work in many of the major museum
exhibitions devoted to jewelry in the U.S.,
Europe, Asia, and South America.

birthplace: Reedsburg-Baraboo, Wisconsin, 1927
education: University of Wisconsin, B.S. 1950; M.S. 1951
teaching: University of California (Berkeley), summer,
 1968 • Wayne State University (Detroit), present
collections: Detroit Institute of Arts • Western Illinois
 University
residence: Detroit

IMOGENE BAILEY GIELING

Imogene Gieling was one of the earlier West Coast artists to direct her attention to creative jewelry. She studied painting with Hans Hofmann, and her Abstract-Expressionist approach to the medium is decidedly painterly.

The necklace illustrated here was directly influenced by the ancient metalwork of northern Europe, especially the Anglo-Saxon, Viking, and Celtic. The characteristic tapering circles of the Bronze Age torques and lurs, the writhing, interlaced surfaces of their brooches and shields, are the underlying influences of this piece.

birthplace: Corsicana, Texas, 1923
education: Texas Women's University (Denton), B.A. 1944 • Hans Hofmann, 1946–1947 • University of Washington, M.F.A. 1956
teaching: University of California (Berkeley), 1954–1961 • San Francisco State College (1966–1969)
collections: Nordenfjeldske Kunstindustrimuseum (Trondheim, Norway) • San Francisco Art Commission
residence: San Francisco

I have chosen techniques and processes which seem to capture the quality of metal in its fluid state. Forms and surfaces are derived experimentally—even accidentally—so that they remain fresh and immediate. To achieve this, I splash gold or silver into water, over stones, into precut molds, or manipulate the molten metal almost as though it were a painting technique. By this means, I am striving for forms that are so organic, so much a part of the entire life process, that it is undetermined whether they are being built up or worn away.
—Imogene Bailey Gieling

NECKLACE: silver gilt with Baltic amber: 21½" long: 1966

MARGRET CRAVER

Margret Craver was one of the first creative artists in the U.S. to revitalize holloware and traditional techniques of jewelry. One of her major achievements in returning interest and dignity to metalwork was the initiation of silversmithing workshops (the first in 1947) on a national level. Most of the major artists in the field today have at one time or another attended these sessions. Miss Craver has generously disseminated her knowledge of silversmithing not only through formal teaching, but through writings and two documentary films. Her most recent research has been into the sixteenth-century technique of en resille (see artist's definition below) which she so effectively uses in the work illustrated. Miss Craver has also produced two films on silversmithing and has written a number of booklets on jewelry techniques. She is currently consultant to the Museum of Fine Arts, Boston.

birthplace: Pratt, Kansas, 1907
education: University of Kansas, B.D. 1929 • London
 School of Art (London's Worshipful Company
 of Goldsmiths), special session, 1947 • Baron
 Erik Fleming, Silversmith to the King, 1938
teaching: Museum School, Wichita Art Museum
collections: Newark Museum • Museum of Contemporary
 Crafts (New York)
residence: Boston, Massachusetts

En resille enamel is without a metal backing and has a design of metal and enamel floating on its upper surface. Some fifteen examples of this fragile sixteenth-century French technique exist in museums of the Western world. The Victoria and Albert Museum labels its few as very rare. The literature on the process is limited to a few sentences and pertains to only one piece now owned by the British Museum.
—Margret Craver

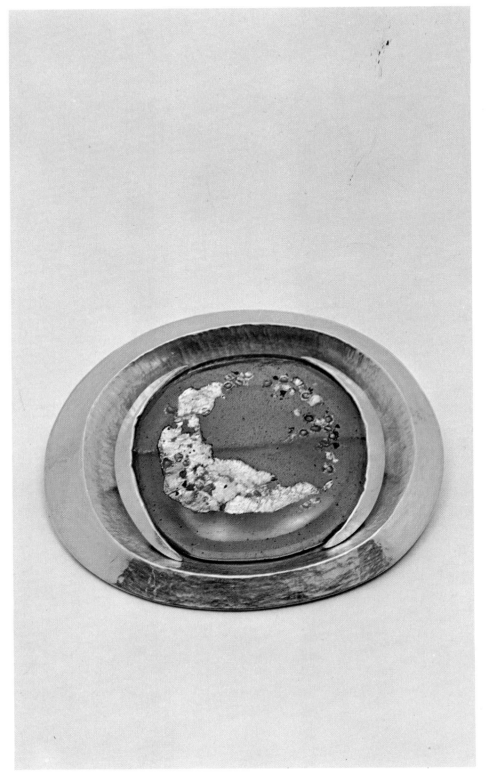

ECLOSION PIN: en resille enamel mounted in 18k gold: 2¼″ × 2¾″: 1967

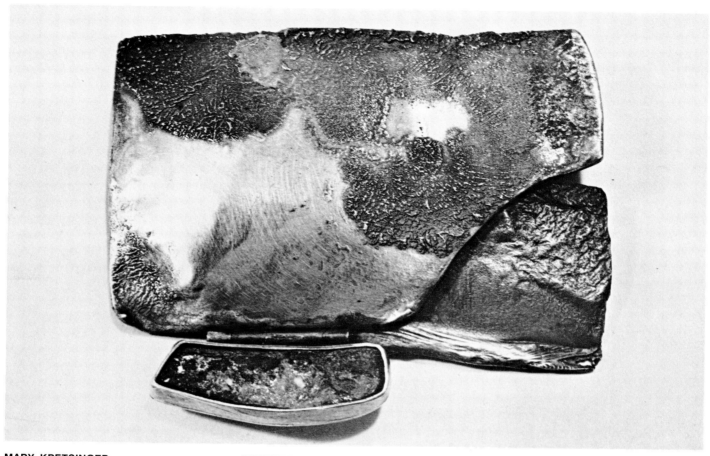

MARY KRETSINGER

Mary Kretsinger has been producing
enamels for many years, and her largely
experimental approach has been
consistently expanded. The religious
medallions, enamel and gold jewelry, and
especially her boxes are strongly structured,
yet notable for the subtlety of the
overglazes. She particularly acknowledges
Adda Husted-Anderson as having been a
major influence.

Miss Kretsinger's work has been
extensively shown throughout the U.S.,
and has received many prizes and awards.

birthplace: Emporia, Kansas, 1915
education: University of Iowa, B.A., M.A. • Columbia
 University • Indiana University • Rochester
 Institute of Technology • Rudolf Brom
collections: Rochester Memorial Gallery • Goldsmith
 Hall (London, England) • Wichita Art Association •
 Museum of Contemporary Crafts (New York) •
 Catholic Chapel (Brandeis University)
residence: Emporia, Kansas

SKETCH IN METAL: fused brass and silver pin
with ringed opal in matrix: 2¼″ × 2½″: 1969

201

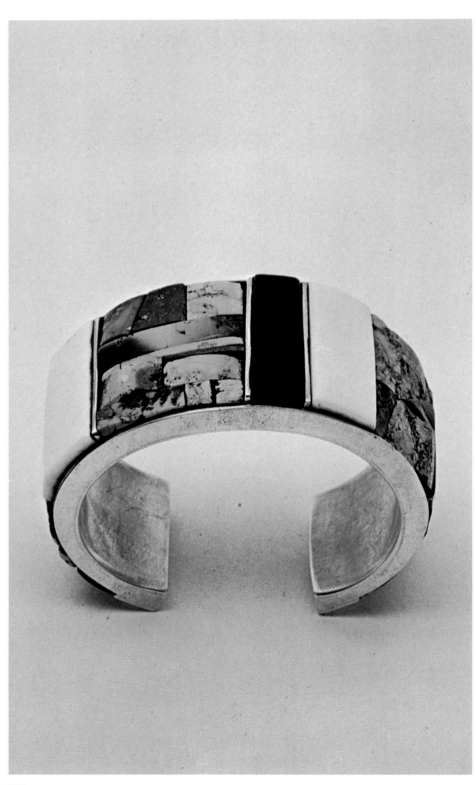

CHARLES LOLOMA

Loloma, whose workshop is located in his own village of Hotevilla on the Third Mesa in Arizona, has mastered a wide variety of media including painting, ceramics, and metal. In 1939 he initiated his career as a painter in San Francisco, working with the late René d'Harnencourt on the execution of murals for the Golden Gate Exposition. Later, in the mid-forties, he turned his attention to ceramics, and studied at Alfred University.

In 1954 Loloma opened his own ceramics and jewelry shop in Scottsdale. During this period—and into the early sixties—he devoted a good deal of his time to working for the Rockefeller Foundation on an Indian youth project in Tucson.

Loloma's jewelry is notable for its boldness of design and for the individuality of its conception. It has been shown extensively in museums and universities throughout the U.S.

birthplace: Hotevilla on Third Mesa, Arizona, 1924
education: Phoenix Indian School, 1940 • School for
 American Craftsmen (Alfred, New York),
 1945–1948
teaching: Arizona State University, 1954–1958 •
 University of Arizona
collections: Mrs. Dwight D. Eisenhower • Mrs. Frank
 Lloyd Wright • Her Majesty, the Queen of
 Denmark (presentation of President Lyndon B.
 Johnson)
residence: Hotevilla on Third Mesa, Arizona

BRACELET: sterling silver with inlaid
turquoise: 2½″ diam.: 1968

RUTH SCHIRMER ROACH

Working with both silver and gold and with a variety of semiprecious stones, Ruth Roach has indicated a preference for forged, one-of-a-kind jewelry. Her pieces often contain movable parts and are notable for their integration of mechanical and decorative elements. The example illustrated here is one of a series of 'Tea Parties' she designed. Originally a student of painting, she has devoted her full time to jewelry since 1954.

Awards for Mrs. Roach's jewelry have been numerous, and in addition to having participated in most of the major national exhibitions in her field, she has received one-man shows at the Des Moines Art Center and, recently, at the Sheldon Memorial Art Gallery (University of Nebraska).

birthplace: Chisholm, Minnesota, 1913
education: School of the Art Institute of Chicago • Iowa
State Teachers College
teaching: Des Moines Art Center • University of
Northern Iowa
collections: Memorial Art Gallery (Rochester) •
Huntington Galleries (Huntington, West Virginia) •
Brooks Memorial Art Gallery (Memphis) •
University of Northern Iowa • Sheldon Memorial
Art Gallery (University of Nebraska)
residence: Plainfield, Iowa

AMBER TEA PARTY is to be worn as an elegant piece; to catch light and movement; to be worn on velvets and silks, instead of the usual black sweater. The chain is constructed in such a manner that the length of the mass of amber can be adjusted from short and thick to long and thin. This adds to the wearing possibilities.
—Ruth Schirmer Roach

AMBER TEA PARTY: 14k gold with amber: 31″ long: 1968

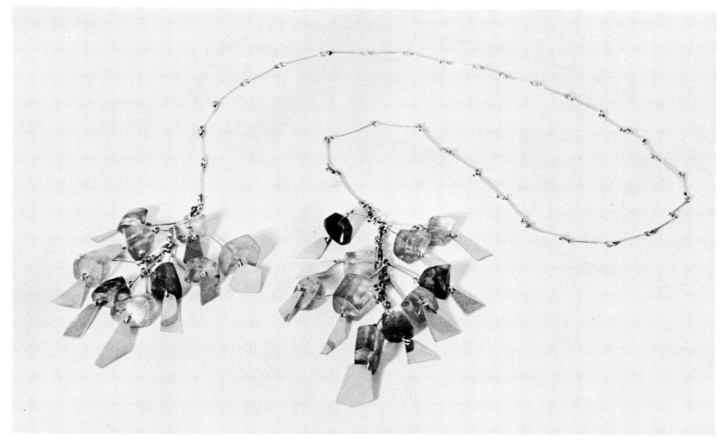

NECKLACE: sterling silver with pyrite
crystals, centrifically cast: 7″ x 5″: 1964

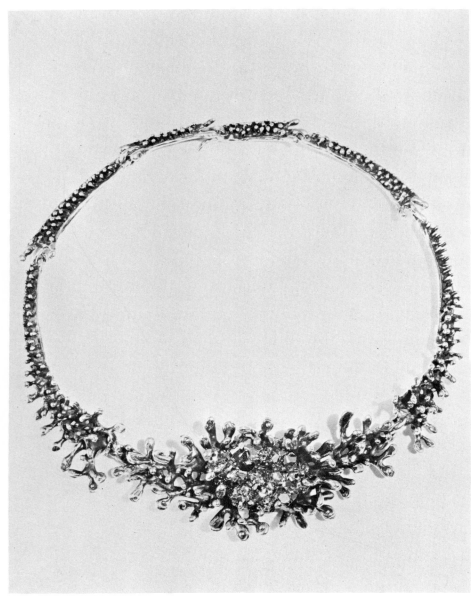

ALICE L. SHANNON
As has been the case with so many
contemporary artist-craftsmen, Alice
Shannon was educated in the fine arts—
painting and sculpture—and only later
came to the medium which has been her
principal interest for nearly twenty years.
She was an early experimenter in the field
of creative jewelry and her exploration of
the use of natural crystals has been
particularly distinctive. Conceived within
a sculptural context, her work is cast in
the lost-wax process and combines
technical expertise with a deep knowledge
of minerals and geological formations.
The casting process itself has proved a
perfect vehicle for achieving her intricate
organic forms usually derived from patterns
of nature.

The necklace illustrated here exposes
Alice Shannon's characteristic concern
with the textures of metal and natural
crystal integrated with continuous rhythmic
flow. Her jewelry has been exhibited
throughout the U.S. and Europe, including
a one-man show in 1966 at the Museum of
Contemporary Crafts, and out of thirty-two
exhibitions she has received twenty-seven
awards.

birthplace: Alpine, Texas
education: California College of Arts and Crafts
collections: Oakland Art Museum • City of San
 Francisco • Crocker Galleries (Sacramento)
residence: Oakland, California

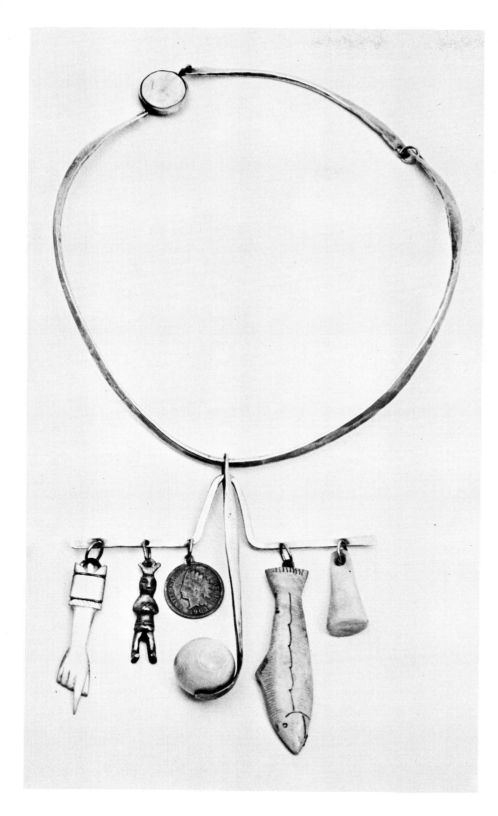

RAMONA SOLBERG

Ramona Solberg was one of the first jewelers to break away from making traditional decorative ornaments and to bring intensely personal statements into jewelry design. Her pieces, which reflect basically symbolic forms, appeal to those who regard their personal adornments as talismans of our time. Miss Solberg has traveled and studied in Mexico and the Scandinavian countries, and exhibits a definite rapport with primitive expressions. Her work has been shown in most of the major exhibitions throughout the U.S.

birthplace: Watertown, South Dakota, 1921
education: University of Washington, B.A., M.F.A. •
 University of Arizona • California College of Arts
 and Crafts • University of Michoacan (Morelia,
 Mexico) • State School of Arts and Crafts (Oslo)
teaching: University of Washington, present
residence: Seattle

Long a collector of curios, I found some of my 'treasures' too small for satisfactory display. I assembled favorite objects into jewelry, and recalling the magic necklaces of the Northwest Indians, called this piece SHAMAN'S NECKLACE.

—Ramona Solberg

SHAMAN'S NECKLACE: silver, Alaskan ivory, found objects: 10¼" high: 1968

RUTH and SVETOZAR RADAKOVICH

Among the outstanding artist-craftsmen represented in this book, none stands out more clearly for their mastery of many media than Ruth and Svetozar Radakovich. (See also GLASS, PLASTIC, METAL.) Working together, but independently, they exchange ideas about design and technology and in general sustain a remarkable aesthetic dialogue. That aesthetic is fundamentally and consistently organic and fully exploits the tensions and releases of line and movement. (Both started out as painters.)

The Radakoviches' radical approach to forged and cast jewelry in the late fifties marked a trend toward more sculptural concepts and had pronounced impact upon the younger generation of artists then turning to this art form. (Svetozar came to the U.S. in 1955.)

Since then, the Radakoviches have shown their work jointly and independently in museums throughout Europe and the U.S. They were represented at the 1958 Brussels World's Fair and received a Gold Medal in the 'Form and Quality' invitational at the Munich International Trade Fair (1963).

After moving to California in 1959, they discontinued teaching and now devote full time to their multi-media pursuits.

RUTH CLARK RADAKOVICH

birthplace: Chicago, 1920
education: Sarah Lawrence College, B.A. 1941 • University of Michigan, M.A. 1949 • Rochester Institute of Technology
teaching: Rochester Memorial Art Gallery, 1956–1958

SVETOZAR RADAKOVICH

birthplace: Belgrade, Yugoslavia, 1918
education: Royal Art Academy (Belgrade), 1938
teaching: Rochester Institute of Technology, 1955–1958 • Rochester Memorial Art Gallery, 1958–1959
collections: U.S. State Department, Embassy Collection • Memorial Art Gallery (Rochester) • Munson-Williams-Proctor Institute (Utica, New York) • St. Paul Gallery and School of Art
residence: Encinitas, California

In an age of the personality cult, it has become necessary to sell the artist along with the art. This, and the time pressure—essentially irrelevant to art itself—have introduced strong negative forces. These do violate the basic act of the artist, which is some form of positive, dynamic thinking, the growing and extending of the general vision, if only occasionally and imperceptibly. It is the most human of acts. It generates in the mind and soul the power that makes possible the realization of the fullest dimensions of life. Perhaps that's why the work should stand alone. The artist becomes irrelevant, as he was in ancient Peru and 'darkest' Africa.

—Ruth and Svetozar Radakovich

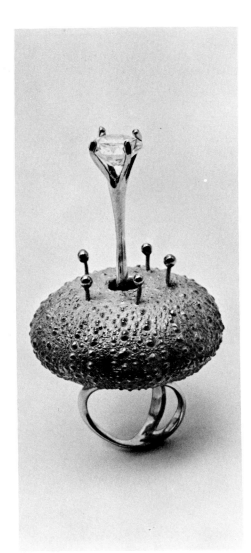

Ruth Clark Radakovich: *COCKTAIL RING:* forged and cast 14k gold, titanium rutile: 3'' high: 1969

Svetozar Radakovich: *NECKLACE:* forged and cast 14k gold, carved aquamarine: 9¼'' wide: 1969

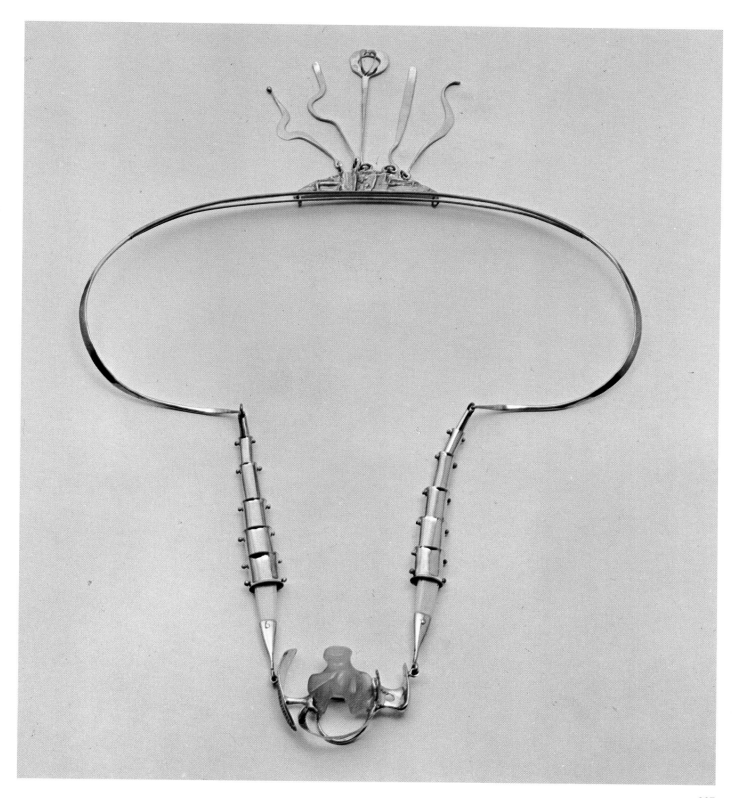

ARTHUR SMITH

Educated initially in commercial art, Smith first learned the fundamental technique of jewelry making from a colleague while he was teaching crafts at a children's workshop over twenty years ago. He immediately applied these techniques to his own personal expression and has been making jewelry ever since as a full-time artist-craftsman. Smith opened his own shop at about that time in New York's Greenwich Village and he has continued to operate successfully ever since. He has shown frequently in exhibitions at the Museum of Contemporary Crafts in New York and at Bennington College and Indiana University, where he has also lectured.

birthplace: Brooklyn, New York, 1923
education: Cooper-Hewitt Museum of Design (New York)
collections: Walker Art Center (Minneapolis) • Museum of Contemporary Crafts (New York) • Staten Island Museum of Arts and Science (New York)
residence: New York, New York

I see jewelry as bold—as an integral part of the face, arm, or body. It should be incomplete until it is on, related to the body. While it may display excitingly, its uncompromised existence, its full realization is when it's worn.

—Arthur Smith

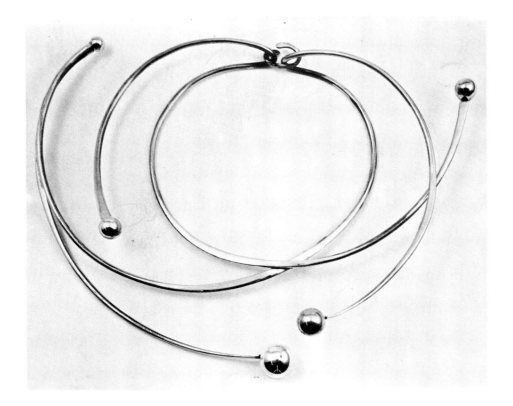

NECKPIECE: forged sterling silver: 7½" x 10": 1968

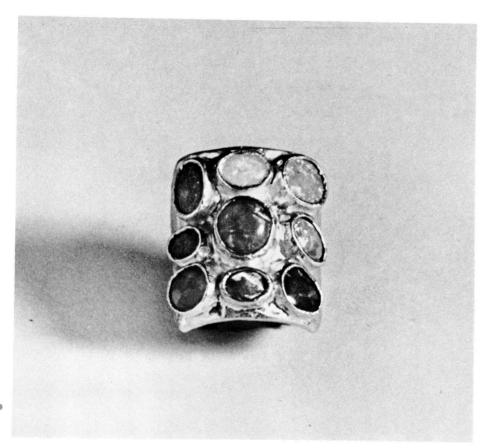

RING: 18k gold with nine opals: 1″ x 1″:
1969

ED WIENER

Jewelry is perhaps the one field where artist-craftsmen have attained notable commercial success by operating their own retail shops, and Wiener's Madison Avenue boutique is unquestionably one of the more successful of these ventures. Entirely self-taught, Wiener opened his first studios in Provincetown and New York in 1946. The Provincetown shop was closed in 1965 so that he could operate full time in New York. Wiener specializes in one-of-a-kind gold jewelry, with an occasional limited-production piece.

His exhibitions from 1949–1958 included more than forty one-man and group shows. Since 1958, the artist has for the most part chosen not to submit his work to exhibitions.

birthplace: New York, New York, 1918
residence: New York, New York

I seem constantly to dredge up older and less articulate cognitions of gold like sunlight, and gems like water and fire; and all are full of magical and symbolic energies.

—Ed Wiener

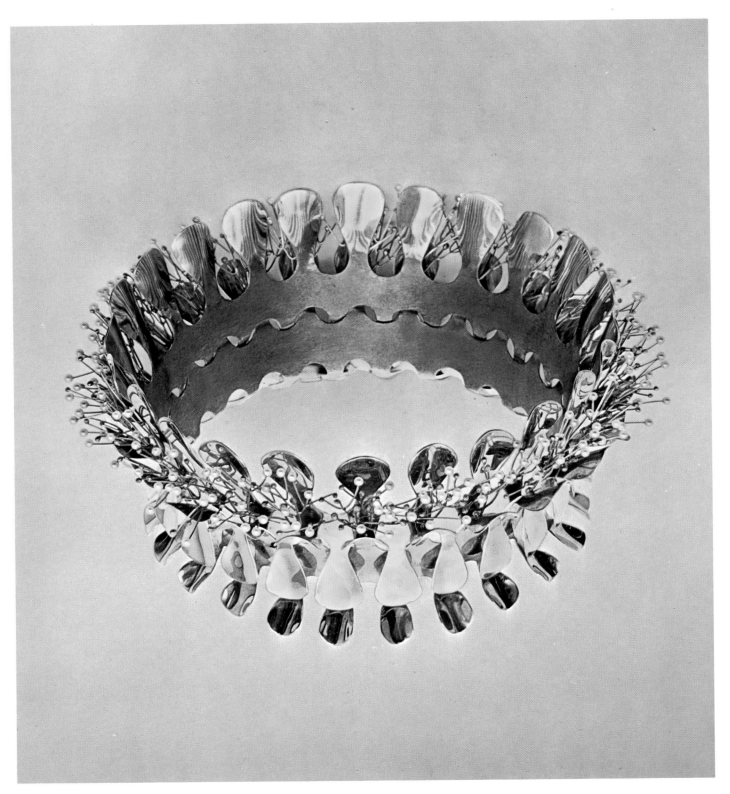

BARBARA ENGLE

Since 1939 Barbara Engle, who is married
to the actor Peter Whitney, has divided her
residency between Hawaii and southern
California. She began her professional
career as a painter, exhibiting widely in
Hawaii and on the West Coast. Only
recently did she turn to jewelry, starting
first with forged silver wire and manipulated
flat sheets of silver. Her interest then
turned to shapes which could be carved
from bone. Most of her present compositions
involve the interplay of silver and bones.
The ornaments are personal and feel
crafted, oriented in fact to primitive work,
which is undoubtedly due to a trip through
the South Sea Islands and to having lived
for several months in Tahiti and New
Zealand.

birthplace: Grandin, North Dakota
education: Honolulu Academy of Arts • Chouinard Art
 School (Los Angeles) • Otis Art Institute (Los
 Angeles) • University of Hawaii
residence: Oahu, Hawaii

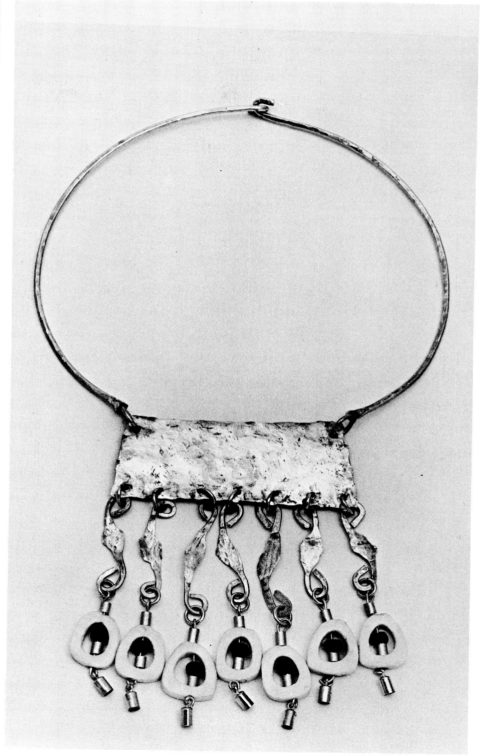

NECKLACE #2: forged silver, ceramic
beads, bones, silver tubing: 8¾'' high: 1968

MICHAEL JOHN JERRY

Jerry is distinguished by a highly
disciplined use of material and formal
clarity of design. Actively engaged as both
teacher and artist-craftsman, Jerry has
also done limited-production work in the
studios of Ronald Pearson and the
Radakoviches. His jewelry has been shown
frequently in exhibitions at New York's
Museum of Contemporary Crafts, and he
was recently represented with five pieces in
the exhibition at the International Trade
Fair in Munich.

birthplace: Racine, Wisconsin, 1938
education: Rochester Institute of Technology, B.F.A.
 1960; M.F.A. 1963 • Cranbrook Academy of Art,
 1960–1962
teaching: Stout State University (Menomonie,
 Wisconsin), present
residence: Menomonie, Wisconsin

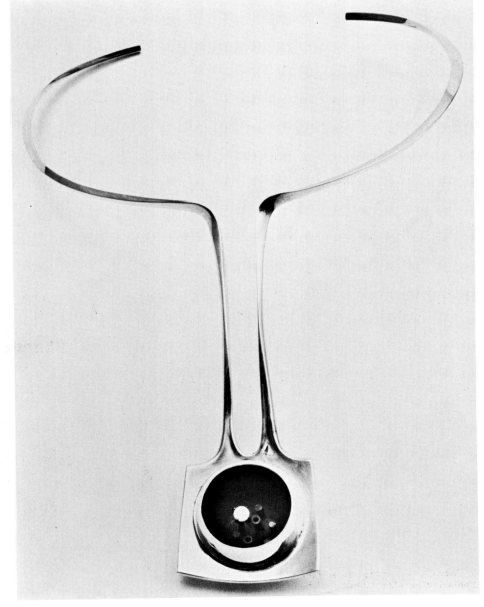

COLLAR AND PENDANT: chased sterling
silver with moonstone: 9¾" x 6¾": 1966

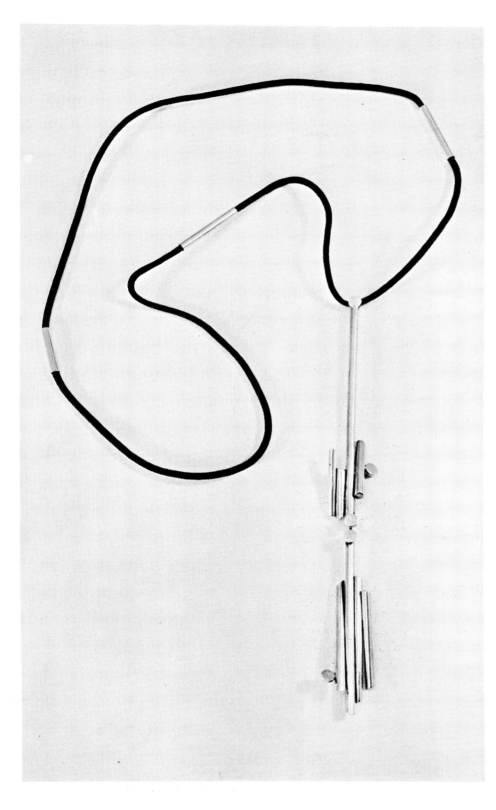

BOB JEFFERSON
Still in his twenties, Bob Jefferson came to jewelry making after training for other careers. He was a student majoring in architecture and was principally involved in furniture design and welded-steel sculpture. His metal technique has been completely self-developed.

Jefferson's work has received awards at both the Berkeley and San Francisco Art Festivals.

birthplace: New Orleans, 1943
education: Southern University (Baton Rouge, Louisiana) • Oakland City College
residence: Berkeley, California

PENDANT: silver and bronze: 5¾″ long: 1968

JOHN PAUL MILLER

Miller is one of the foremost goldsmiths in the U.S. His name is virtually synonymous with the technique of granulation, the art of embellishing a gold surface with infinitesimal spheres of gold, some as tiny as 1/200 of an inch in diameter. The technique reached its greatest peak in the Etruscan culture between the eighth and the second centuries B.C. Miller has brought this ancient art to its highest degree of refinement in contemporary jewelry.

As is indicated in *ARMORED POLYP* (illustrated here) Miller's jewels are customarily derived from animal or crustacean forms. In his personal adaptations he exploits materials to the utmost in achieving a full measure of elegance.

Miller's work has been shown extensively in such prestigious exhibitions as the 1958 Brussels World's Fair and the 1962 London Jewelry International. His many one-man shows have included those at the Art Institute of Chicago and the Museum of Contemporary Crafts (New York).

birthplace: Huntington, Pennsylvania, 1918
education: Cleveland Institute of Art · Handy and Harmon Silversmithing Conference · School for American Craftsmen (Rochester) · Institute of Technology (with Baron Erik Fleming)
teaching: Cleveland Institute of Art, present
collections: Cleveland Museum of Art · Museum of Contemporary Crafts (New York) · Huntington Galleries (West Virginia) · Lawrence and Barbara Fleischman Collection of American Art (Detroit)
residence: Cleveland

ARMORED POLYP: gold and enamel with granulation: 3″ long: 1969

218

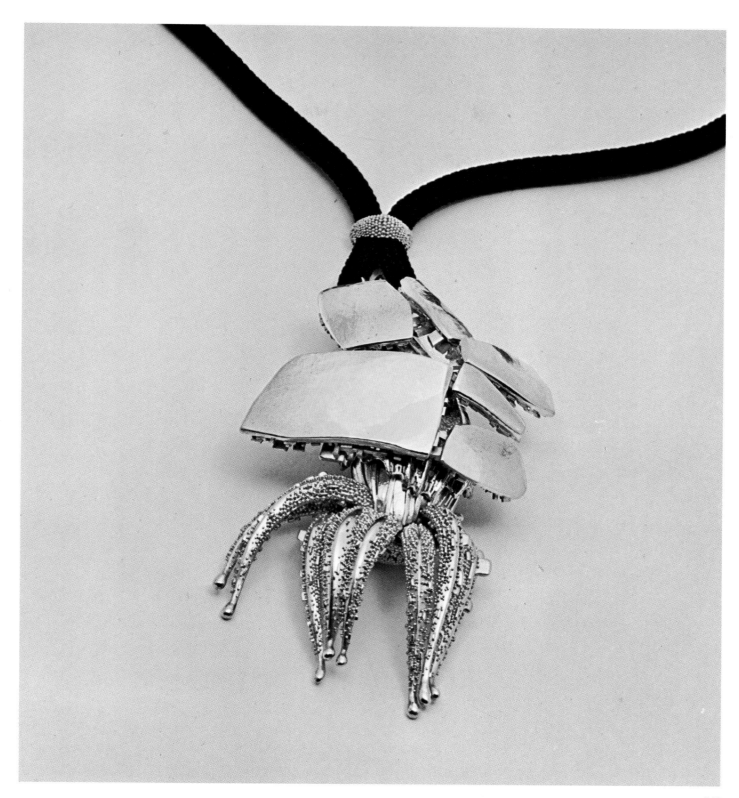

RONALD W. SENUNGETUK

The jewelry of Senungetuk is marked by restrained lyricism and a notable sensitivity to material. Although he brings to his work the traditions of a great heritage (Eskimo sculpture and carvings), his extensive travels and study have contributed to the evolution of an essentially international style.

At present, Senungetuk teaches in Alaska and works with projects designed to train and retrain area craftsmen.

He has shown jewelry in exhibitions in Alaska, New York, Washington, and in Norway and France.

birthplace: Wales, Alaska, 1933
education: Rochester Institute of Technology, B.F.A. 1960 • National Arts and Crafts School (Oslo) • University of Oslo, 1961 • Fulbright Scholarship grant, travel to Finland, Denmark, Sweden and Italy
teaching: Visiting Carnegie Professor of Art and Design, University of Alaska, present
residence: College, Alaska

PIN: cast sterling silver: 1½″ × 2¼″: 1969

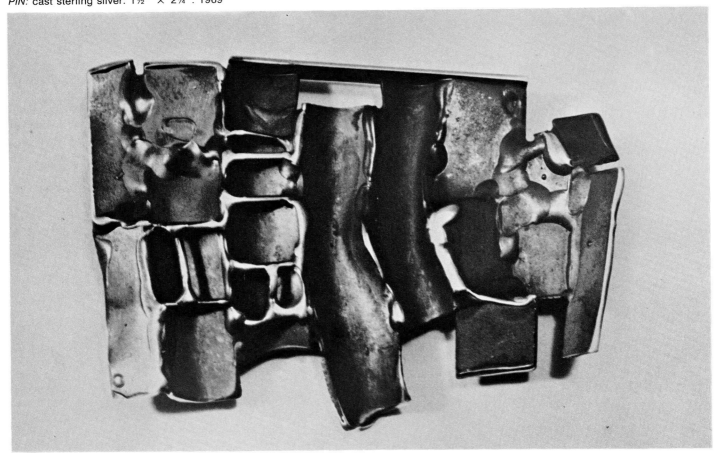

OLAF SKOOGFORS

The wrought silver and gold jewelry of Olaf Skoogfors is notable for being precisely integrated structurally and aesthetically. It has been exhibited in museums and universities throughout the world and accorded numerous awards.

In addition to teaching, the artist maintains his own workshop for creating production and special-order jewelry, holloware, and ecclesiastical metalwork, as well as awards and plaques for industry and institutions.

birthplace: Bredsjo, Sweden, 1930
education: Philadelphia Museum School of Art, 1949–1953 • Rochester Institute of Technology, 1955–1957
teaching: Philadelphia College of Art, present
collections: Memorial Art Gallery (Rochester) • Philadelphia Museum of Art • Museum of Contemporary Crafts (New York)
commissions: Radio Corporation of America • New York Association of Consulting Engineers • Federation of Jewish Agencies • Curtis Publishing Company • Philadelphia College of Art
residence: Philadelphia

Jewelry offers me the opportunity to control artistic expression from concept to realization and make a living doing so.

In most of my work the image is the dominant concern, technique serving as an important, necessary handmaiden, giving me the means to express forms, texture, color, and line.

I think of my pieces as compositions, in some cases in alliance with the human body, but often as independent objects (as in my pins). In many pieces a concern for limited space has dictated a framelike boundary, but more recently an escape from the confines of this space is occupying my thinking.

Despite these seemingly conceptual concerns, my work is not sculpture, for scale much affects the final result.

Jewelry is not small sculpture, nor is sculpture large jewelry, although both often suffer these accusations by the superficial observer. Jewelry need not, however, be sheer decoration.

—Olaf Skoogfors

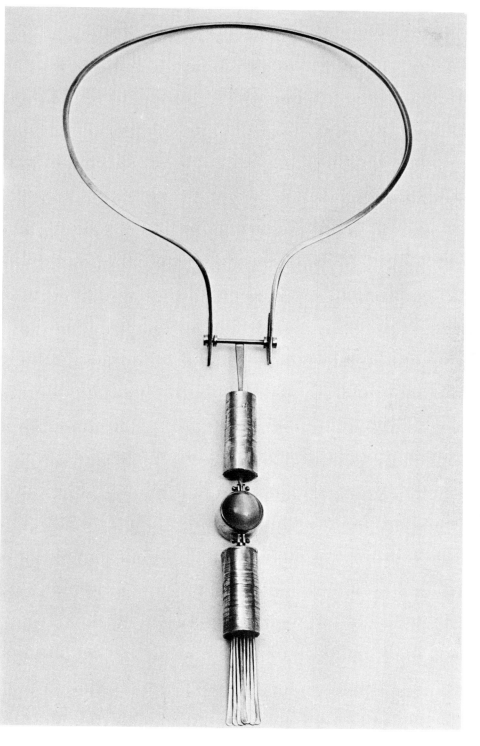

PENDANT: gold-plated sterling silver with cat's-eye moonstone: 13½'' high: 1969

LYNDA WATSON

Lynda Watson's involvement with jewelry
has been relatively recent, and yet she has
already received considerable recognition
through invitational and competitive
exhibitions on the West Coast. Her artistic
motivations and philosophy are well
expressed in her own statement printed
here.

birthplace: Orange, California, 1940
education: Chapman College (Orange), 1961–1962 •
 California State College (Long Beach), B.A. 1966;
 M.A. 1969 • Rochester Institute of Technology
residence: Long Beach, California

*The things I make are no more than a
tangible extension of my total way of seeing
and reacting. Decoration and embellishment
are what I do. Although everything in an
environment can be decorated, the human
body appeals most to me. When it is
adorned it becomes a showcase to which
reactions from others are immediately
concise and personally satisfying. Metal is
the medium that especially pleases me, and
precious metals possess the desired
workability. The appearance sought
determines the technique employed. With
a thorough knowledge and use of the many
available techniques, metal can show, say,
be, symbolize, or represent any idea.
Ideas come from everywhere and every
visual concept, pictorial or intangible, can
become adornment for the body. I translate
my ideas into metal and arrange them in a
format suitable for display on the human
body.*

—Lynda Watson

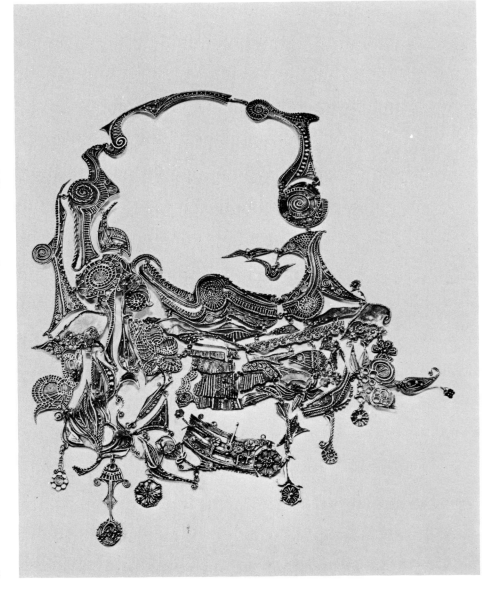

LANDSCAPE NECKPIECE: silver, lost wax,
cast, and fabricated enamel: 11″ x 9″: 1968

222

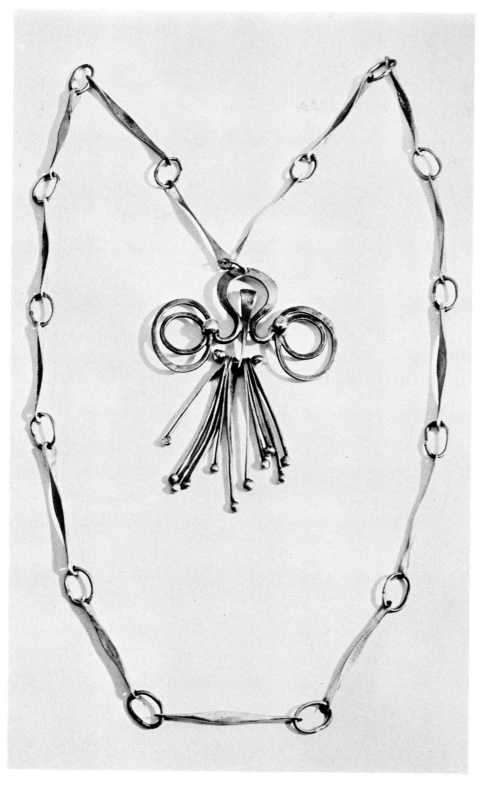

BILL MARTIN
Unlike most artist-craftsmen working with jewelry, Martin has received no formal training. He cites his experience in industry as having taught him most of his skills in metalworking.

Martin's work, from which he is self-supporting, derives from many primitive influences. After high school, he worked his way around the world, spending several years in Australia and New Guinea, where he came into direct contact with varied cultures.

birthplace: Richmond, California, 1941
residence: Los Angeles

PENDANT: forged brass: 20½" long: 1968

WILLIAM PERRY GRIFFITHS

Griffiths received most of his formal
education in Michigan. Then in the sixties
he moved to Wisconsin, where he finished
his studies at the University in Madison.
His approach to jewelry is closely allied to
that of current painters and sculptors;
Griffiths works out similar formal problems
in miniature. The work illustrated here is
typical of the cool hard-edge direction now
current; however, the undulating surface
on the pin adds a personal warmth and
lyricism.

birthplace: Traverse City, Michigan, 1937
education: Western Michigan University, B.S. 1959 •
 Michigan State University, 1964 • University of
 Wisconsin, 1966–1968
teaching: Wisconsin State University (Fond du Lac)
residence: Fond du Lac, Wisconsin

SIX REFLECTIONS: fabricated sterling
silver: 1¼″ x 1½″: 1969

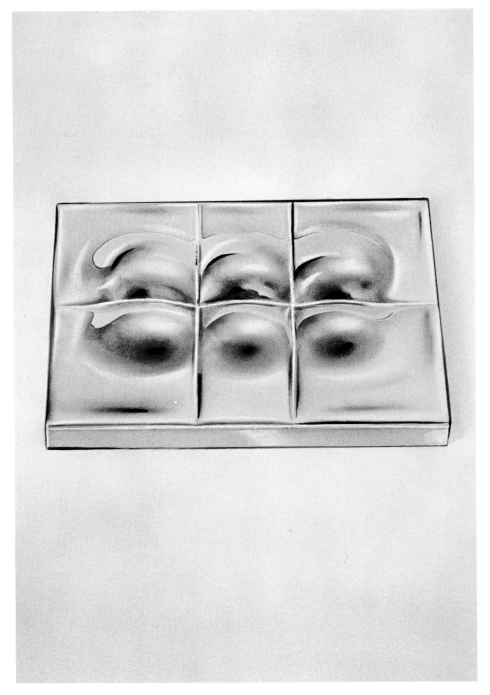

STANLEY LECHTZIN

One of the first artist-craftsmen to experiment with electroforming in creative jewelry, Lechtzin has used the process to create large-scale, light-weight ornaments. Electroforming is a means of producing or reproducing metallic objects on a master form, or matrix, which is then removed as a whole or in parts, leaving a shell of metal. This differs from plating, which consists of depositing metal on an existing metallic object. Through his teaching and lectures throughout the U.S. and Japan, he has shared his profound knowledge of the process and its creative applications to contemporary jewelry.

birthplace: Detroit, 1936
education: Wayne State University (Detroit), B.F.A. 1960 • Cranbrook Academy of Art, M.F.A. 1962 • Louis Comfort Tiffany Foundation grant, 1967
teaching: Tyler School of Art, present
collections: Detroit Institute of Arts • Museum of Contemporary Crafts (New York) • St. Paul Gallery and School of Art • Wayne State University (Detroit) • Temple University (Philadelphia)
residence: Philadelphia

Approximately six years ago, I reached the point in my work where the structures I wished to create were no longer possible within the realm of traditional tools and techniques. I therefore began to explore the possibilities presented by our contemporary industrial technology. I found it possible, using the electroforming process, to develop light objects which normally would have been unwearable due to their weight. Combinations of materials which had been difficult or impossible to achieve were made feasible.

In providing answers to immediate problems, electroforming has also opened form and structural possibilities which I could not have predicted before beginning my work in this technique.

—Stanley Lechtzin

PENDANT: silver gilt, amethyst crystal, and fresh-water pearls, electroformed: 14" high: 1967

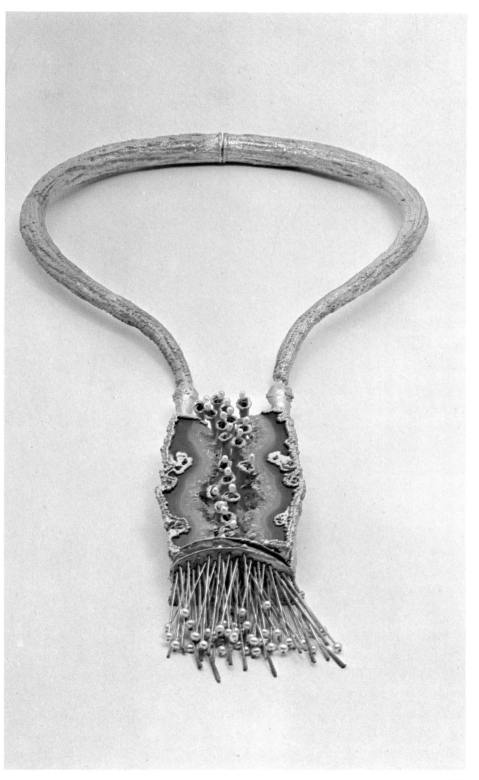

J. FRED WOELL

Humor, satire, and mimicry are the evident intention of Woell in his 'antijewelry' objects. His own statement defines his ideas regarding the pendant illustrated here and clearly sets forth his decided reaction to much contemporary jewelry. Woell is now working with sculptures—reliefs and life-size figures—in bronze and plastic resins, again incorporating searing social commentaries.

birthplace: Evergreen Park, Illinois, 1934
education: University of Illinois, B.A. 1956; B.F.A. 1960 •
 University of Wisconsin, M.S. 1960; M.F.A. 1961 •
 Cranbrook Academy of Art, M.F.A. 1969
residence: Bloomfield Hills, Michigan

I do not consider myself or my work unique. I am not a self-made artist. My aesthetics is an assemblage of ideas, influences, and images that are continually crossing my path. The pendant illustrated here I feel is an excellent example of this. This pendant is an assemblage of three buttons of comic-strip heroes mounted as if they were sacred icons. The humor in such a juxtaposition of images and content I often employ in my work. I like satire. In this work I tried to intensify its bizarre, sacrosanct absurdity by use of commonplace materials which have little or no intrinsic value.

I have certain feelings regarding what jewelry has become, and what jewelry can be. THE GOOD GUYS *is an attempt to say that jewelry doesn't have to be made of precious stones and metals to be valuable. I like to think that an object gets its value from what you make of it, and not of what it is made.*

I try to make an object look both new and old at the same time. By that I mean I like to keep the freshness of the fingerprint of the artist, while allowing the work to possess a quality of age and a life of its own.

My work is at best an eclectic statement with little or no innovations of style, techniques, or materials. It is a reflection of what I see and how I feel about it with a touch of humor added.

—J. Fred Woell

THE GOOD GUYS: walnut, steel, copper, plastic, and silver: 4" diam.: 1966

KEN CORY

Cory is one of America's younger artists who have taken an independent direction in the creation of jewelry. Not only does he avoid precious stones, the trademark of the commercial jeweler, but he utilizes materials such as plastic, wood, and leather which one usually would disassociate with body ornaments. His statements are direct, highly refined, and consistent in development. Cory's work was included in the American Craftsmen's Invitational at Seattle and in exhibitions at the Museum of Contemporary Crafts, New York.

birthplace: Kirkland, Washington, 1943
education: California College of Arts and Crafts, B.F.A. 1966
residence: Pullman, Washington

PIN: copper and plexiglass: 2″ x 2½″: 1968

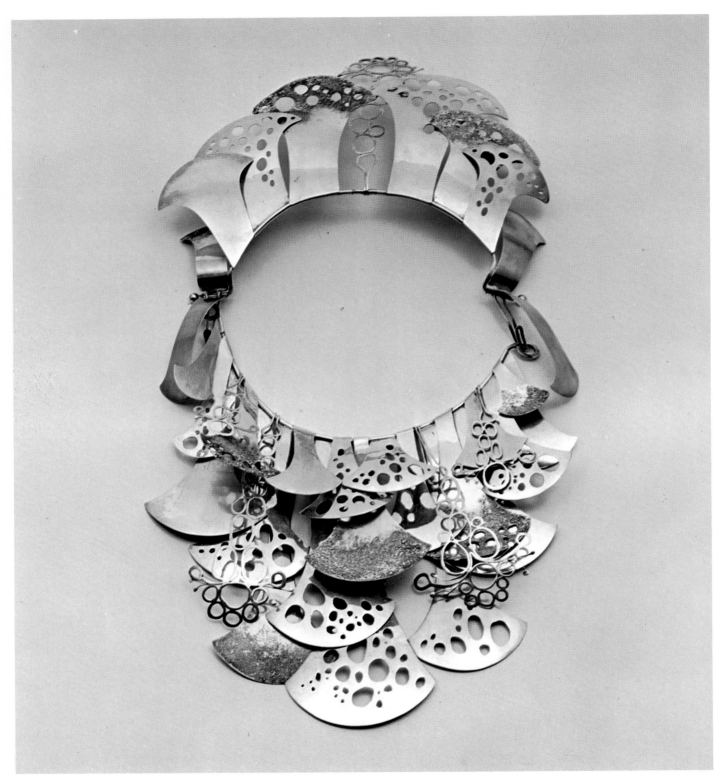

ARLINE FISCH

Intensive research into the ornaments of ancient cultures—especially pre-Columbian, Egyptian, and medieval European—has provided ideological bases from which Fisch has created some of the most spectacular jewelry being made today. The body ornament illustrated here is characteristic of her involvement with organic forms and dramatic, large-scale effects. Intricately engineered, all of the elements in the piece are linked or interlocked to exploit fully the elements of movement and reflected light when worn. The scale is directly related to that of the ritualistic and ceremonial costumes of primitive peoples, although the actual form and detail are quite different.

Utilizing primarily silver, Fisch works directly with the metal—either sheet or wire—and achieves form by cutting, hammering, chasing, fusing, or forging individual elements, which are later soldered or assembled to build larger and more complex forms. The ornamentation is most often achieved by treating the surface of the metal in a variety of ways, rather than by adding other materials or elements. Sometimes, however, to add texture and color, she combines other materials such as fabric, wood, ivory, glass, enamel, and shell.

(continued on page 230)

MEDUSA: silver: 4½″ wide: 1967

NECKPIECE: forged fused silver: 9¼″ wide: 1967

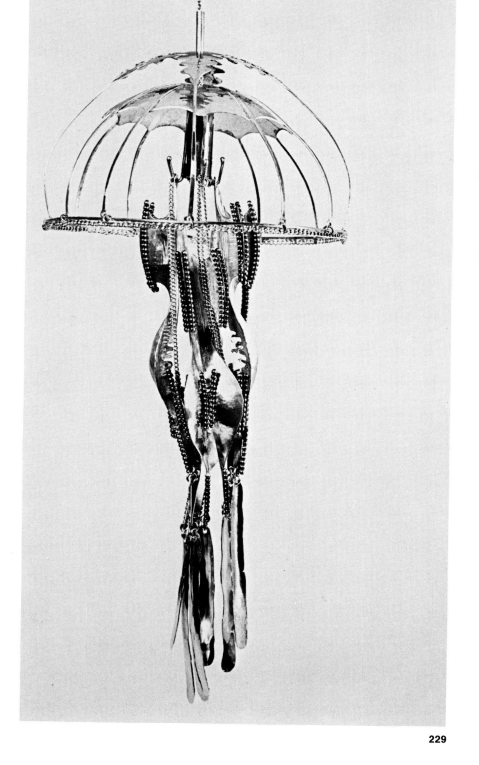

Not all of the objects created by Fisch are functional or intended to be worn. The suspended *MEDUSA* illustrated here is one of a whole series of 'object-jewels' notable for their fragile elegance.

Fisch's work has been exhibited widely throughout the U.S., Germany, and Latin America. Recently, she has had one-man shows at the Museum of Contemporary Crafts in New York and at the Museum of Decorative Arts in Copenhagen.

birthplace: New York, New York, 1931
education: Skidmore College, B.S. • University of Illinois, M.A. • School of Arts and Crafts (Copenhagen) on two Fulbright Scholarship grants • Haystack Mountain School of Crafts (Maine) • Rochester Institute of Technology
teaching: San Diego State College, present
collection: Crocker Art Gallery (Sacramento)
residence: San Diego

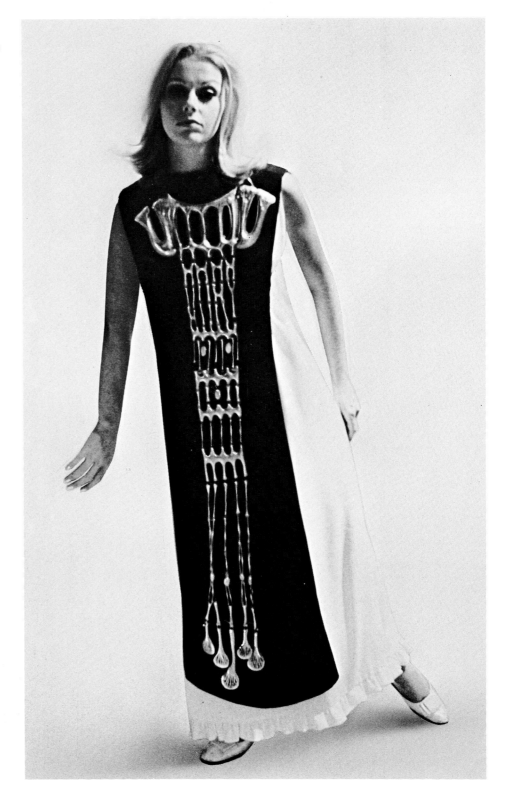

BODY ORNAMENT: silver: 52½'' long on front and back: 1966

LEE BARNES PECK
Peck is perhaps the perfect example of the younger university-trained artist-craftsman who has mastered more than one medium. After intensive research at the University of Wisconsin (under the aegis of the head of the metals department, Arthur Vierthaler) in electroforming, Peck turned to its creative uses, making pots, nonfunctional objects, and finally jewelry.

birthplace: Battle Creek, Michigan, 1942
education: Western Michigan University, B.S. 1965
collections: Detroit Institute of Arts • Kalamazoo Art
 Center
residence: Madison, Wisconsin

The glass square in the center of this PENDANT is mold cast from an investment carving. The textured center circle is cast sterling silver with a copper electroformed inlay. Glass spheres are at the top, and pieces of glass cane are at the bottom. The entire piece was assembled, then copper electroformed, and then plated in 24k gold. (See also under METAL.)
 —Lee Barnes Peck

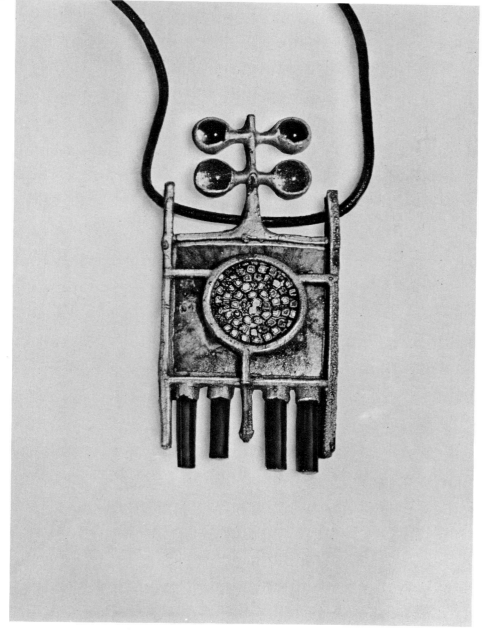

PENDANT: electroformed copper, gold, silver, glass: 3½″ x 1¾″: 1968

plastic

DAVID WEINRIB

Today Weinrib, who used to work in clay, is considered one of the most vital artists in the field of plastics, and over the years he has accumulated an impressive record of museum exhibitions. His forms in ceramic progressed toward the nonfunctional and finally assumed purely sculptural dimensions. His statement in plastic is an extension of this sculptural concern.

birthplace: Brooklyn, New York, 1924
education: Brooklyn College • Alfred University (New York)
teaching: School of Visual Arts (New York)
collections: Los Angeles County Museum of Art • Walker Art Center (Minneapolis) • Whitney Museum of American Art
residence: New York, New York

In my work I have been concentrating on making suspended, rather than ground-oriented, sculpture, in order to explore the implications of weightlessness in sculpture. I choose the walls and ceilings as starting points to get a more aerial look, as opposed to our normal gravity-oriented perspective. At the same time, I have tried to use hard clear colors as an integral part of the sculptural structure rather than as applied to it. I have found that these goals are best realized with plastics, and with acrylic in particular.

One of the primary advantages in the use of plastics for sculpture is that one can work directly with colored material. Plastic, in its immediate response to heat and pressure, opens for me the possibilities of greater and greater moldability and a fluidity, which I want to bring to my forms as they move through space.

—David Weinrib

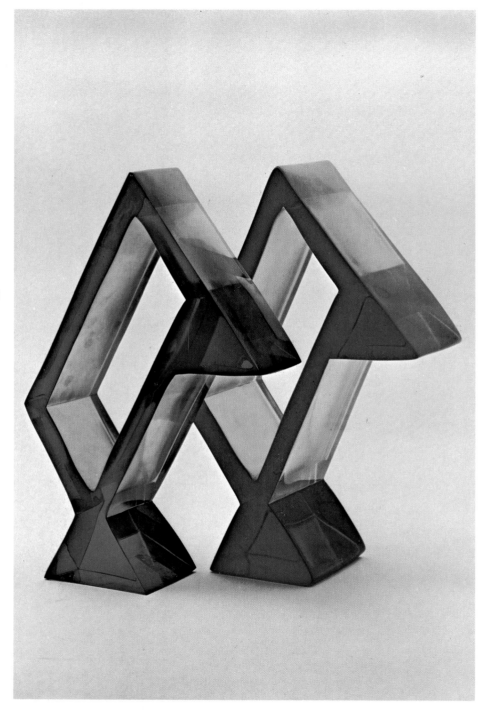

P2: two cast plastic forms: 19¼" high: 1967

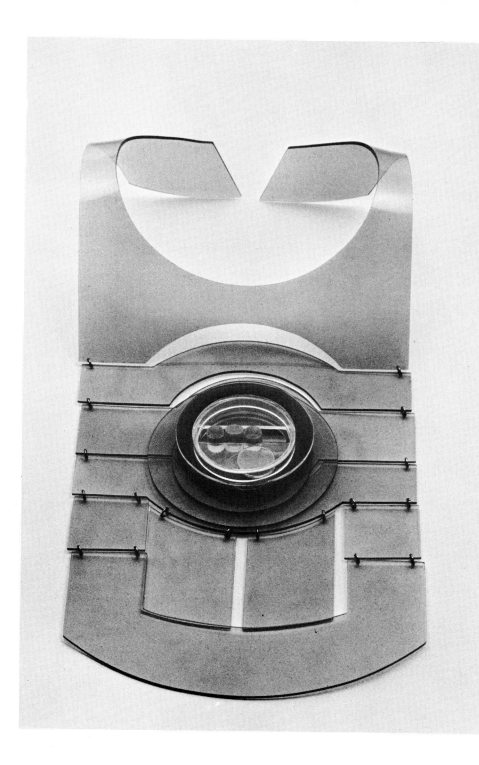

CAROLYN KRIEGMAN
The body ornaments of Carolyn Kriegman are, in effect, large-scale sculptural assemblages which appropriately exploit the qualities of light, color, and transparency inherent in plastic. Her metal jewelry as well reflects a persistent concern for meticulously structured form, a concern which the artist traces to her studies with both Josef Albers and Olaf Skoogfors.

Carolyn Kriegman has received numerous awards for her jewelry in both competitive and invitational exhibitions.

birthplace: Orange, New Jersey, 1933
education: Yale University • Haystack Mountain School
of Crafts (Maine)
residence: East Orange, New Jersey

I believe in individual rather than multiple choice, and am convinced there are many who choose jewelry as they would sculpture, and wear it as an eclectic identification badge, lavishing upon it as much aesthetic consideration as they would upon the art which surrounds them in their homes. Each piece is a product of my long, sometimes serious, sometimes frivolous association with the arts. I credit Josef Albers for exposing me to a whole new sense of the visual intellect. I'm sure that my hands in some way produce a comment upon the recent sum of my continuing experiences, and I hope they act as the realization of the better world seen by my inner eye.
—Carolyn Kriegman

NECKLACE: plexiglass: 10″ wide: 1969

DONALD LLOYD McKINLEY

Born and raised in the Midwest, McKinley transferred from Wichita University to Alfred University, where he studied under Kurt Ekdahl. Since that time he has been continuously engaged in making furniture and accessories. In 1952 McKinley gave up a position as chief staff designer for a large furniture manufacturer to accept a Fulbright Scholarship to study furniture and interior design in Finland. Upon returning he pursued graduate duties as director and master of wood design at the Ontario Craft Foundation School of Design. His latest works show his interest in the expressive possibilities of plastics.

birthplace: Bartlesville, Oklahoma, 1932
education: Wichita University • Alfred University (New York), B.F.A. 1955 • Fulbright Scholarship, Institute of Crafts and Design (Finland)
teaching: Sheridan College of Applied Arts and Technology (Port Credit, Ontario)
residence: Port Credit, Ontario, Canada

CHAIR AND OTTOMAN: plastic: 66″ long including ottoman: 1968

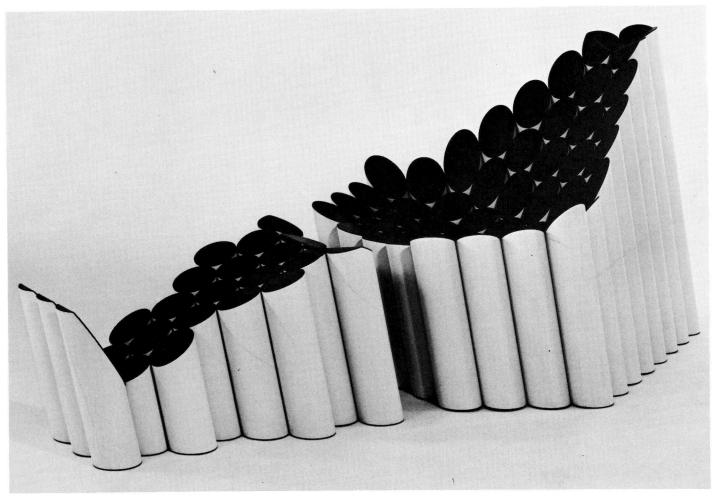

CURTIS STEPHENS

The plastic accessories of Stephens are decidedly utilitarian and functional; nonetheless they are conceived within a sculptural context, much as are the lamps of Noguchi. He designs his pieces for both limited and large-scale production, and makes one-of-a-kind objects as well. *GAMMA IV* (illustrated here) is one of his strikingly unusual pieces.

Stephens has received one-man shows at the Universities of Wisconsin and Georgia and was invited to participate in New York's Museum of Contemporary Craft's exhibition 'Design for Production,' in 1964.

GAMMA IV: scored and folded vinyl: 15½″ high: 1969: ed. ⅓

birthplace: Athens, Georgia, 1932
education: University of Georgia, B.S. Ed. 1954; M.F.A. 1961
teaching: LaGrange College (Georgia), 1961–1963 · Northern Michigan University, 1966–1968 · University of Illinois, present
residence: Champaign, Illinois

237

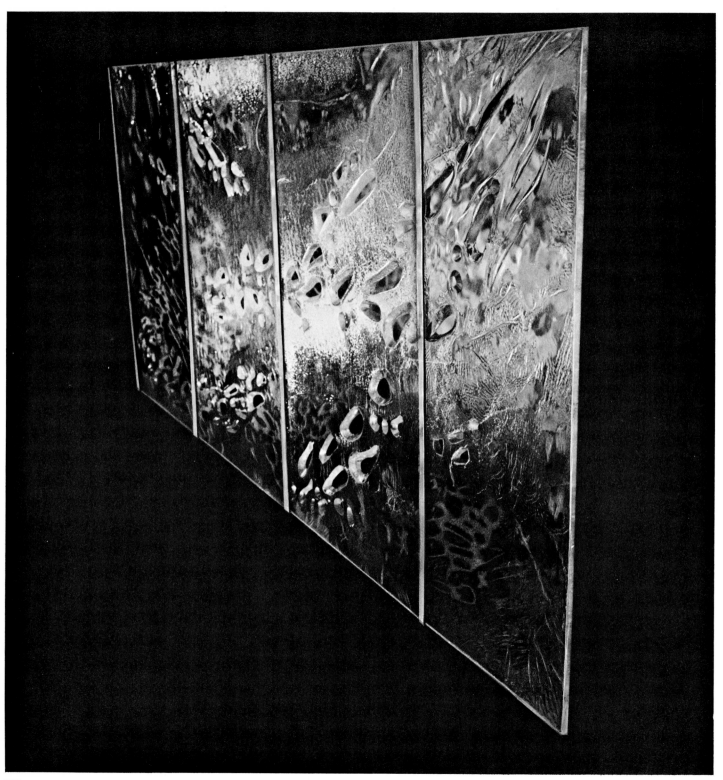

FREDA KOBLICK

The cast-acrylic sculptural forms of Freda Koblick bring to plastics the results of twenty-five years of study and experimentation. Pushing technology to the utmost, she fully explores the expressive possibilities of surface, transparency, reflection, refraction, distortion, magnification, and diminution that the material allows; and stylistically she expresses a lyrical and sensitive response to organic sources that one does not ordinarily associate with plastics.

From 1965 to 1967 she was Senior Research Fellow at the Royal College of Art in London, invited by that institution to set up an experimental study group in plastics. She has lectured and given workshops in the United States, Czechoslovakia, England, and Sweden.

Even though many of Miss Koblick's works have been commissioned for architectural uses, she finds such work 'frustrating because of its spatial limitations—no development, no sequential order.'

Miss Koblick has exhibited both abroad and in the U.S., including a one-man show at the Museum of Contemporary Crafts, New York.

birthplace: San Francisco
education: Plastics Industries Technical Institute (Los Angeles), 1943
teaching: Royal College of Art (London), 1965–1967, Senior Research Fellow
residence: San Francisco

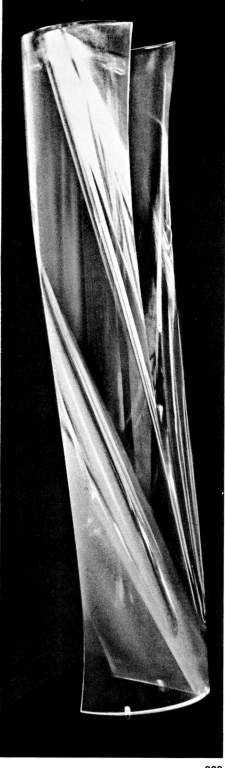

PIERCED RELIEF WALL: four panels, cast acrylic: over-all 73" x 144": 1969

COLUMN I: cast acrylic 47¼" high: 1968: A. P., ed. of 6

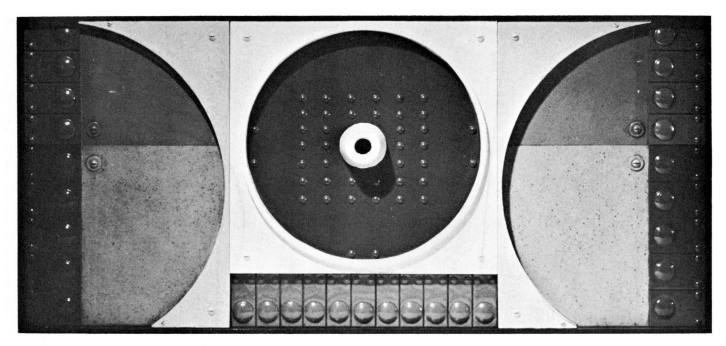

JACKSON WOOLLEY

The names of Jackson and Ellamarie
Woolley have been associated for many
years as a husband-and-wife team of
enamelists working directly with
architectural firms in the execution of
murals, walls, panels, and reliefs. (For
biography of Ellamarie Woolley, see under
ENAMEL.)

In recent years Jackson Woolley has
been involved increasingly with synthetic
media in his own work, and since 1965 has
used such materials as wood, fiberglass,
polyester resin, metal, and marine paints
in his constructions. These have had as
their source the forms, colors, and
patterns of the waterfront and industrial
areas of San Diego. It is from the contrast
of orderly, logical arrangements of
repeated elements such as rivets, bolts, and
perforations, with the accidentally enriched
textures of the corroded and repeatedly
overpainted surfaces to be found in these
areas, that he derives his ideas. By then
translating selected details from these
environments into free-standing or wall
constructions, he is able to make their
abstract qualities more apparent.

BONUS is constructed of wood,
surfaced and variously textured with
polyester resin, painted with industrial and
marine paints. The parts are joined with
adhesives and with actual screws and
bolts which have been incorporated into
the design. The artist has stated that the
work 'might be called second generation
in the present series of constructions in

that it makes no direct reference to any
specific waterfront source, although all its
elements and its general character derive
somewhat indirectly from that scene.'

birthplace: Pittsburgh, 1910
education: Carnegie Institute of Technology •
 Claremont Graduate School (California)
collections: Everson Museum of Art (Syracuse) • Joe
 and Emily Lowe Art Gallery (University of
 Miami) • Dallas Museum of Fine Arts • Wichita
 Art Museum • Krannert Museum (University of
 Illinois)
residence: San Diego

BONUS: polyester on wood: 19½″ x 40″:
1967

RUTH CLARK RADAKOVICH

The fiberglass door shown here is a revealing example of the inventiveness that one has come to associate with Ruth Radakovich in the creative use of new materials. The windows in the door, with their many lenses, take full advantage of the visual effects of magnification. (For biography, see under JEWELRY.)

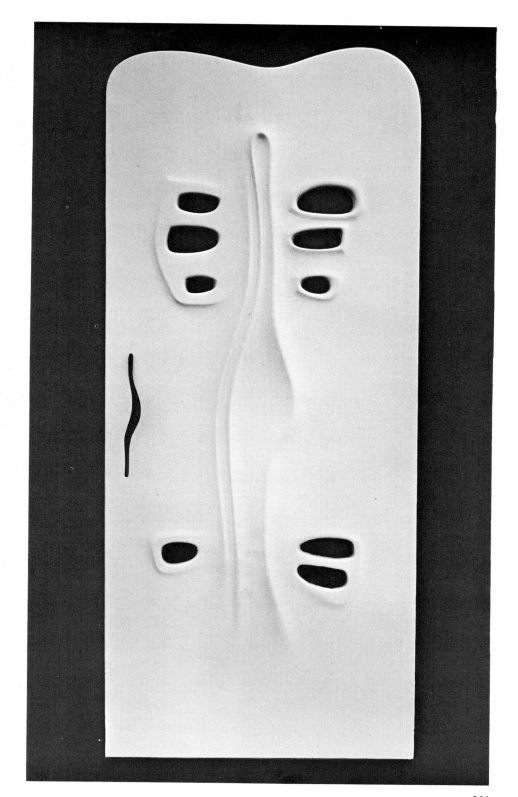

DOOR: fiberglass, resin lenses, wood: 84'' x 36'': 1969

TED HALLMAN
Since 1958 when he was awarded first
prize for a screen woven almost entirely
out of plastics, Hallman has been
experimenting with synthetics in weaving.
The screen illustrated here reveals the
artist's essential interest in the use of
transparent materials and the exploitation
of their luminous color qualities. (For
biography, see under FIBER.)

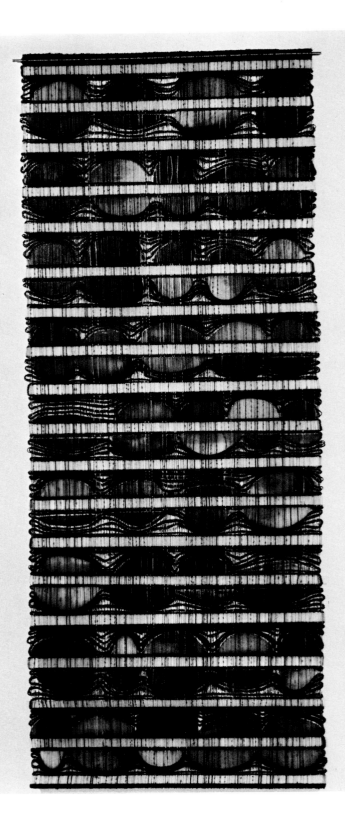

SCREEN: plastic and jute: 68″ x 26″: 1960

242

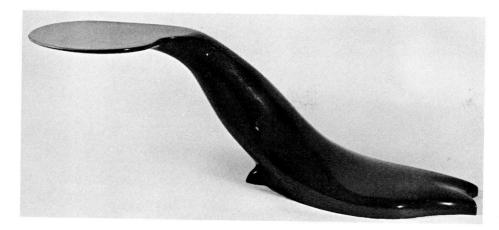

WENDELL CASTLE

As is the case with so many artists at present who are experimenting with new materials. Castle is currently working with plastics, specifically laminated plastic. He has infused this cold material with unusual warmth, retaining the lyrical sensibility and the organic references which characterize his work in wood. (For biography, see under WOOD.)

TABLE: laminated plastic: 61½" long: 1969

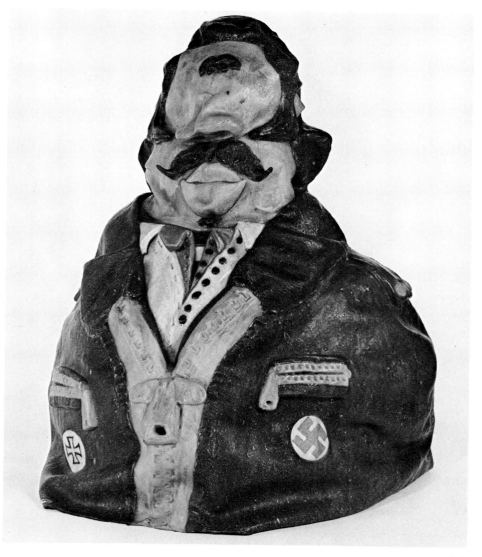

CLAYTON BAILEY

Clayton Bailey's latex face masks represent a unique application of the use of new materials in new ways. In making his rubber sculpture, Bailey pours the latex over a wet clay model, eliminating the necessity of a mold. The Hell's Angels theme is particularly pertinent to the artist's Funk philosophy and has been treated with many variations. Bailey remarks that he likes working with rubber because it enables one 'to kick the objects around, or to put them on and go places.' (For biography, see under CERAMIC.)

HELL'S ANGEL—VERMILLION, SOUTH DAKOTA: latex rubber: 31½" high: 1967

mosaic

GLEN MICHAELS

Michaels was trained as a concert pianist, and later switched to painting. It was while attempting to bring more texture to his canvases by using foreign material—such as wood, metal, and stone—that his interest in building reliefed sculptured surfaces began. Since then Michaels has created murals in shale, marble, wood, glass, and, more recently, in plastic. Not only has the artist received some of the most significant mural commissions in America, he has also been accepted into the art world through his exhibitions in leading New York galleries. John Canaday, art critic of *The New York Times,* said of Michaels, 'A perfect hybrid is Glen Michaels who paints (if you will) or sculpts (if you will) by applying thousands of stones, bits of wood, glass, terra cotta, metal, into dense ornamentally organized panels. . . . Whether he is a painter or a sculptor makes no difference, except that he is concerned, as any artist must be, with the process of transformation.'

birthplace: Spokane, Washington, 1927
education: Yale University, School of Music •
 Cranbrook Academy of Art
teaching: Cranbrook Academy of Art • Wayne State
 University (Detroit)
commissions: Continental Can Company (New York) •
 Bulova Watch Company (New York) • Chase
 Park Plaza Hotel (St. Louis) • J. Walter Thompson
 (New York) • Ford Motor Company, New York
 World's Fair (1964) (now in Dearborn Library)
residence: Birmingham, Michigan

MOON CRATER #2: black shale mosaic:
45'' x 45'': 1968–1969

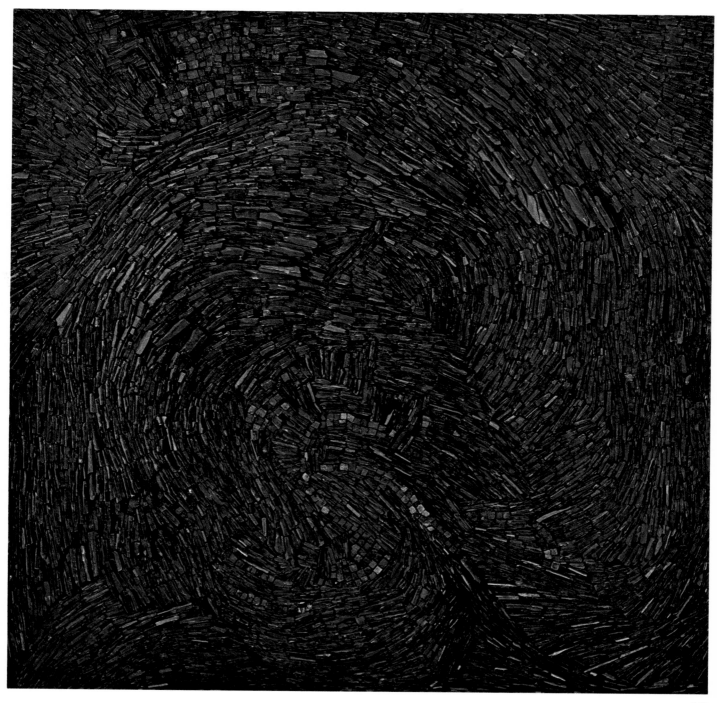

ALEKSANDRA KASUBA

A Lithuanian-born mosaicist known principally for large architectural commissions, Aleksandra Kasuba achieves remarkable illusions of depth and movement within a contexture of austere and geometric elements. The work illustrated here reveals her characteristic manipulation of multiple, undulating bands of fragmented, unpolished marble to accomplish these effects. Art critic Emily Genauer wrote, 'An austerely limited abstract idiom turns out to be most poetically expressive in Kasuba's work. The artist fixes marble tesserae to a surface, lining them up like paving blocks. But suddenly their direction changes, paths of swirling movement swing out, spaces widen between the rows of stones and the surface suggests ridges left in sand by wind or sea. It is alive with movement, in an atmosphere where time itself stands still.'

birthplace: Lithuania (came to U.S. in 1947)
education: Art Institute (Kaunas, Lithuania) • Academy
of Fine Arts (Vilnius, Lithuania)
collections: Isaac Delgado Museum of Art (New Orleans) •
Museum of Contemporary Crafts (New York) •
University of Atlanta
commissions: New York Hilton Hotel • Container
Corporation of America (Chicago) • The Bank of
California (San Francisco and Portland, Oregon) •
New York City Board of Education • Rochester
Institute of Technology
residence: New York, New York

THE BOOK: white marble relief mosaic set
on wood: 60″ x 72″: 1968–1969

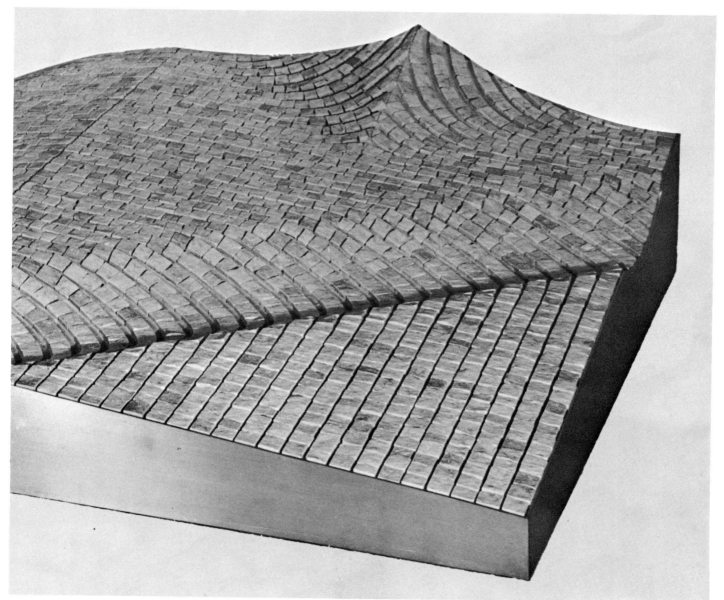

wood

WHARTON ESHERICK

Esherick, the undisputed dean of American wood workers, has played a decisive role in the re-establishment of the medium in contemporary art. His aim is to instill the utilitarian function of furniture with the same characteristics that govern sculpture—notably line, mass, and movement, and the juxtaposition of planes to create effects of light and shadow.

It was during the twenties, while principally absorbed with painting, that Esherick first became seriously involved with wood. Possibly his preoccupation with making woodcuts, and his practice of carving his own frames with designs that reflected the subject matter of his somewhat impressionistic paintings, prompted this interest. But the compelling result was the design and construction in the thirties of his now famous studio near Philadelphia. Every detail—floors, ceilings, the celebrated staircase illustrated here, the furnishings and accessories—involved a striking and original use of wood within a unified decorative scheme. During this period the angular and geometric forms of Esherick's earlier work gave way to the sinuous lines and curving planes that characterize the mature, organic style of the late thirties. This was the period when he began to receive important commissions, including the Bok House in Philadelphia, which is considered by many to contain one of the most important domestic interiors in this country. (continued on page 254)

CHEST-TABLE: walnut: 29″ high: 1969

This staircase in the artist's home is probably the most photographed contemporary staircase in the world.

THREE STOOLS: seats of coffeewood, bird's-eye maple, walnut; hickory legs: highest 25″: 1969

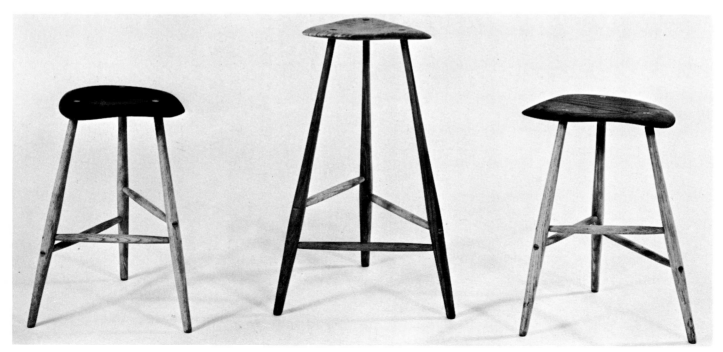

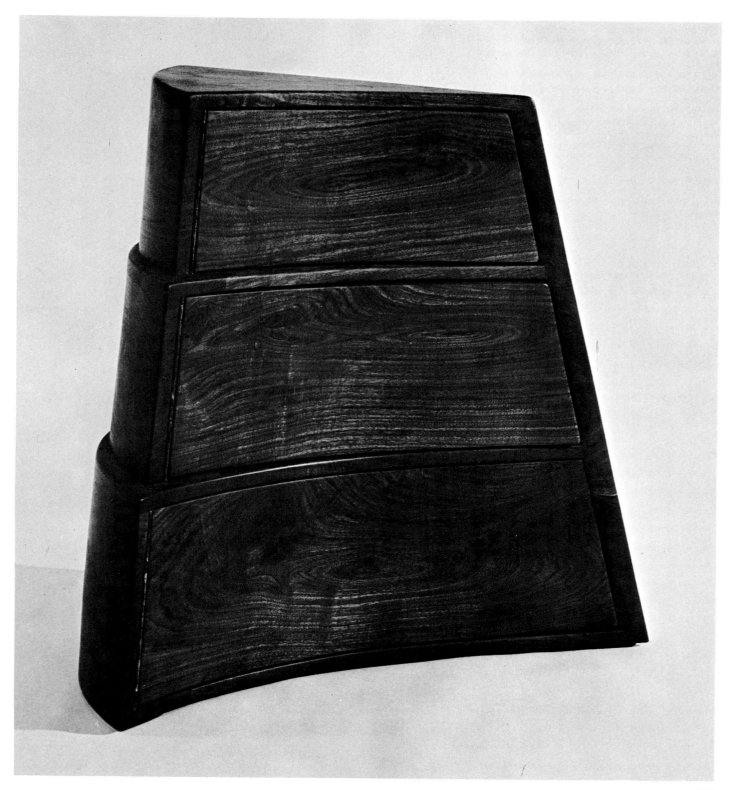

In his dual role of artist and craftsman, Esherick has achieved an uncommonly harmonious relationship between aesthetics and function. His works have been shown at the Metropolitan Museum of Art, the Tate Gallery in London, the Museum of Modern Art, as well as in numerous Whitney Museum Annuals, and at the New York (1939) and Brussels (1958) World's Fairs and the 1964 Triennale di Milano. A major retrospective exhibition of his work was held at New York's Museum of Contemporary Crafts in 1959. In keeping with the unique spirit of his work, it seems appropriate that he illustrated, among many books, Walt Whitman's *Song of the Broad Ax* (1924) and *As I Watched the Ploughman Plowing* (1927).

birthplace: Philadelphia, 1887
education: Philadelphia School of Industrial Art •
 Pennsylvania Academy of Fine Arts
collections: Philadelphia Museum of Art • Pennsylvania
 Academy of Fine Arts • Addison Gallery of
 American Art (Andover, Massachusetts) • Museum
 of Contemporary Crafts (New York) • Casa Del
 Libro (San Juan, Puerto Rico)
residence: Paoli, Pennsylvania

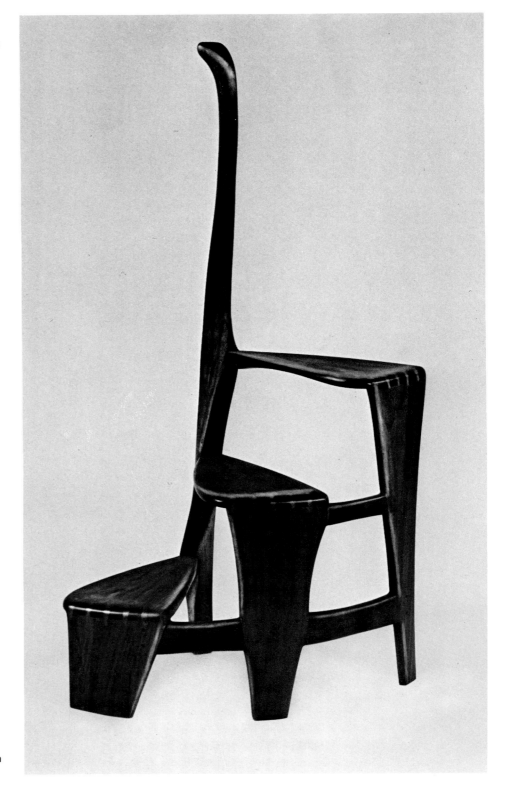

Wharton Esherick:
SPIRAL THREE-STEP LADDER: cherry with hickory legs: 48" high: 1969

HARRY NOHR

What began as a hobby for Nohr has developed into a full-time retirement occupation. Working to bring out all the natural beauty of each piece of wood, he is concerned with the full development and exposure of the grain. The bowls he creates, turned to a delicate one-eighth-inch thickness, are made from almost every variety of native Wisconsin wood. He has indicated a distinct preference, however, for maple, walnut, and birch because of the unique and often erratic grain pattern produced in the burls of these trees.

Nohr's work has been accorded considerable recognition, and has been included in the Smithsonian Institution tour of crafts. One of his wood pieces won an award at the Wisconsin Designer-Craftsmen exhibition.

BOWL: maple burl: 13½'' diam.: 1968

birthplace: Waupaca, Wisconsin, 1896
collection: University of Wisconsin
residence: Mineral Point, Wisconsin

Building up his forms from one-inch layers of glued and clamped wood, Castle carves as though from a solid block, and finally smoothes and finishes the forms of his pieces with several coats of hand-rubbed linseed oil. This laminating process has liberated him from the scale limitations inherent in log carving, and has enabled him to sculpt forms of uncommon strength.

Entirely self-taught in woodworking (sculpture and industrial design were his college majors), Castle's quasi-fantasy furniture has been exhibited at museums and universities throughout Europe and the U.S.

WENDELL CASTLE

One of the foremost artist-craftsmen and teachers in the woodworking field, Castle is largely responsible for the recent renaissance of wood as a creative medium.

His own laminated furniture reflects a surrender of mere utilitarian function to a primarily aesthetic one. The wandering, attenuated organic forms seem literally to have been drawn in space; their presence is one of incisive sculptural imagery.

birthplace: Emporia, Kansas, 1932
education: University of Kansas, B.F.A., M.F.A.
teaching: University of Kansas • School for American Craftsmen (Rochester), present
collections: Addison Gallery of American Art (Andover, Massachusetts) • Museum of Contemporary Crafts (New York) • Rochester Memorial Art Gallery • Joslyn Art Museum (Omaha) • Everson Museum of Art (Syracuse)
film: The Music Rack, Aci Films, Inc. (recipient of Cine Golden Eagle Award)
residence: Scottsville, New York

DESK: mahogany and silver leaf: 40″ x 96″ x 72″: 1967

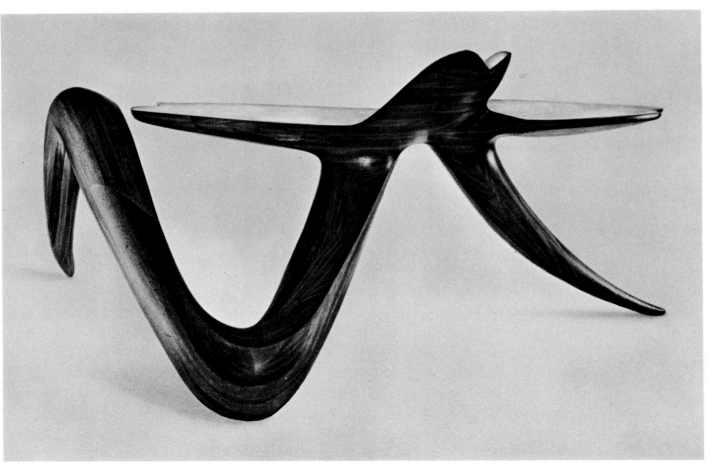

My work, because I now create in plastics as well as wood, may appear to represent different directions. Both media, however, have in common qualities I feel are important. Furniture should not be derived from furniture. This only leads to variations of existing themes. To me the organic form offers the most exciting possibilities—it can never be completely understood in one glance. I make no attempt to reconstruct or stylize natural form, but try to produce a synthesis or metamorphosis of natural forms. My pieces are not 'free form'; they are designed and constructed within strict boundaries. These limitations are scale, material, and the necessary function an object must perform. Their differentiation in form is accounted for by the fact that they are not shaped by standard furniture-building techniques or influenced by any current vogue in furniture fashion. They are evolved from inherent life forces.

The two large pieces are of laminated wood and the third is laminated plastic. (See also under PLASTIC.) It is important not to be subservient to a material. The significant thing about my work is not what it is made of but what it is. I would like always to be free to explore all the aspects of the useful objects we refer to as 'furniture.'

—Wendell Castle

TABLE-CHAIR-STOOL: afrormosia: 29" x 16" x 30": 1968

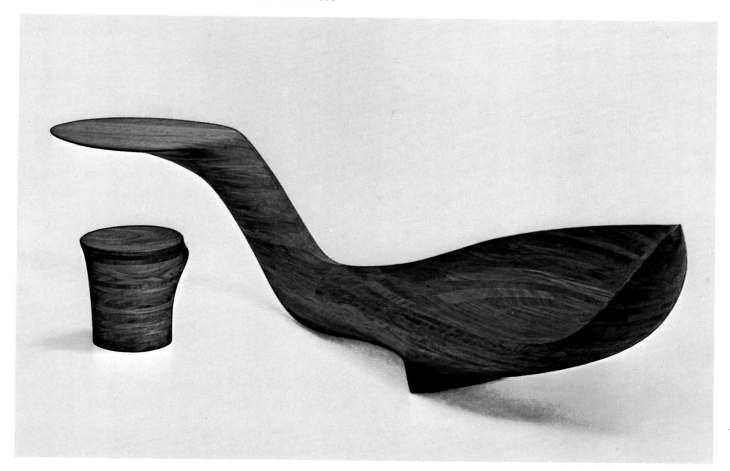

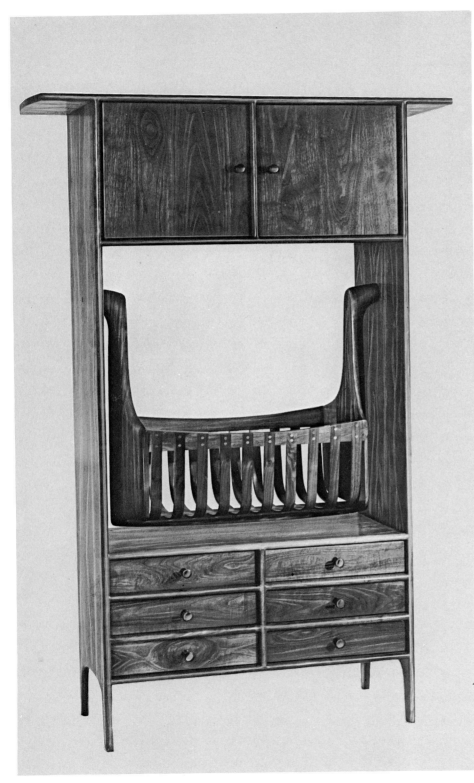

SAM MALOOF

Maloof was directed into woodworking after trying his hand in a variety of other areas—architectural drafting, graphic arts, and industrial design. His furniture, notable for its warmth and its strong emphasis on functionalism, has been shown at the 1962 New York World's Fair; at the Museum of Contemporary Crafts, New York; in 'California Design' at the Pasadena Art Museum; at the University of Chicago; and in a one-man show at the Oakland Art Museum. Maloof is completely self-taught and practices as a full-time artist-craftsman.

birthplace: Chino, California, 1916
commissions: Leo Baeck Temple (Los Angeles) •
 First Methodist Church (Sunland, California) •
 Henry Dreyfuss, office and residence (Pasadena) •
 Robert Andrews, apartment (New York) • Provost
 residence, University of California (Santa Cruz)
residence: Alta Loma, California

I am a furniture designer and woodworker, perhaps in the traditional manner, where craftsmanship and joinery are of prime importance, and also where design is of equal, if not more concern.

—Sam Maloof

(left)
CRADLE-CABINET: laminated walnut:
68½'' x 47¾'' x 18'': 1968

(upper right)
SMALL DROP-LEAF PEDESTAL TABLE:
walnut: 29'' x 94'' x 25½'': 1968–1969

(lower right)
CHEST: rosewood: 18'' x 33¾'' x 17½'':
1968

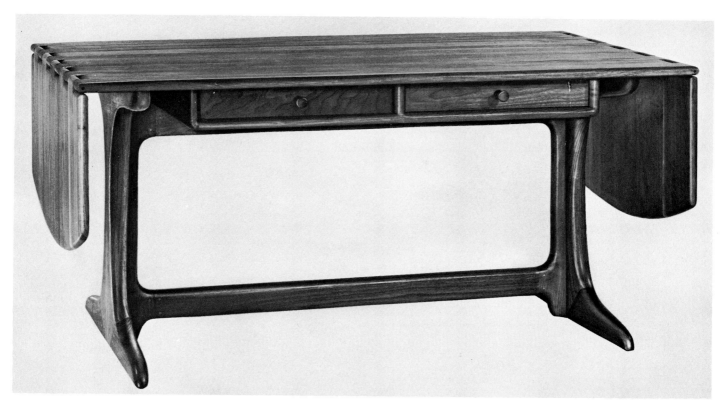

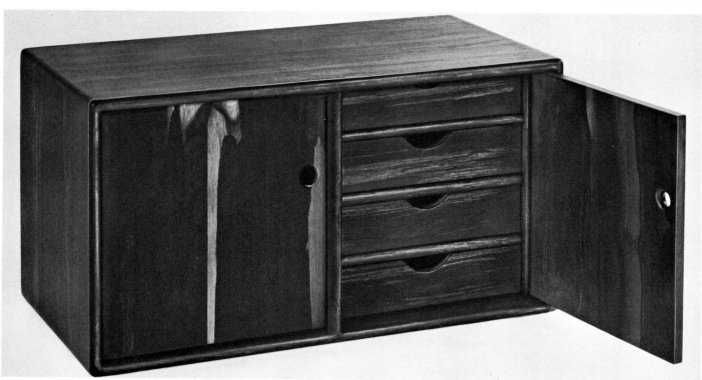

WILLIAM A. KEYSER, JR.
Artist, craftsman, and teacher, Keyser has executed (since 1962) numerous commissions in sculpture, wood furniture, and accessories. His furniture is characterized by its juxtaposition of functional and sculptural considerations.

birthplace: Pittsburgh, 1936
education: Carnegie-Mellon University, B.S. 1958 •
 Rochester Institute of Technology, M.F.A. 1961
teaching: Ohio University, 1961–1962 • Rochester
 Institute of Technology, present
residence: Rush, New York

My activity seems to organize itself around two concerns. One is the conception of forms in nonutilitarian objects which sometimes might become sculpture. But I am also preoccupied with the process of applying these formal ideas to functional furniture. Occasionally, the two categories become less definite, the distinctions unclear. These moments produce the most successful work.

The piece illustrated here was an attempt to effect a semiprecarious relationship between two distinct masses. These forms have movable parts (door and drawers) and so the relationships change in time as these enclosures function.

—William A. Keyser, Jr.

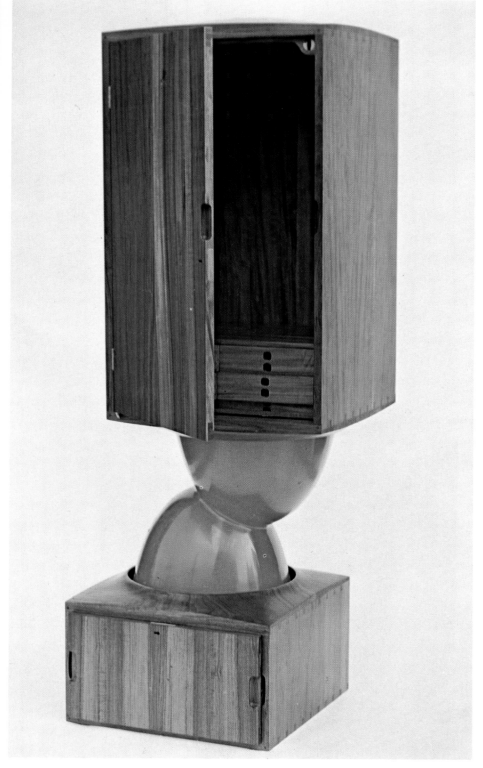

LIQUOR CABINET: benge wood with metal and plastic paint: 67" high: 1967

BOB STOCKSDALE

An entirely self-taught wood turner, Stocksdale is a perfect example of the artist-craftsman who responds completely to the natural characteristics of his material. The shape, texture, and finish of each of his utilitarian and decorative bowls, trays, and platters is determined by the fullest exploitation of its grain patterns and its intended use.

Using as many as fourteen woodworking machines, and working with as many as forty varieties of hardwoods from around the world, Stocksdale creates objects which are notable for their complete unity of material, form, and technique. These objects have been shown in numerous U.S. museums, and two of his turned bowls were exhibited at the Brussels World's Fair. He has also had a one-man show of his wood turnings at the Museum of Contemporary Crafts, New York.

birthplace: Warren, Indiana, 1913
residence: Berkeley, California

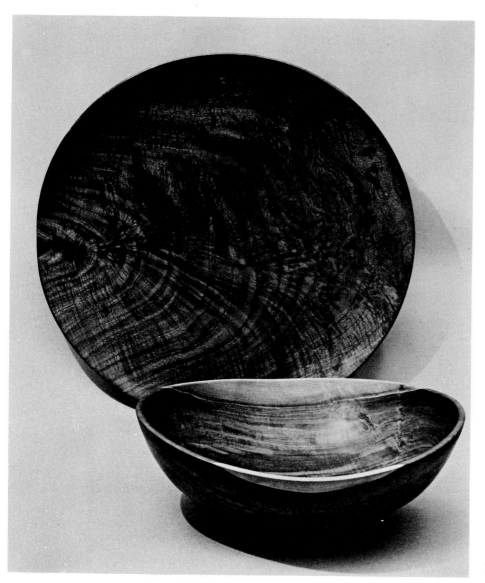

TRAY: black walnut: 22½'' diam.: 1968

SALAD BOWL: black walnut: 16¼'' diam.: 1968

GEORGE NAKASHIMA

One of the nation's foremost architects, designers, and wood craftsmen, Nakashima has received international recognition for his production furniture designs and his unique pieces. His woodwork is distinguished by its careful exposure of grain patterns and burls, its rich and deep coloring, and sometimes even for its utilization of areas of decomposition. He describes the finest of logs as akin to rough diamonds, which must be studied at length before any cutting is attempted. His innate respect for material has resulted in many unusual surface effects.

After more than seven continuous years of travel and work in France, India, and Japan, Nakashima returned to the U.S. in 1940. He has since conducted a private architectural practice, designed furniture for Knoll and Widdicomb, and has maintained a studio workshop in New Hope, Pennsylvania, where his one-of-a-kind pieces are made. He is the recipient of a silver medal from the Architectural League of New York and a gold medal from the American Institute of Architects.

birthplace: Spokane, Washington
education: University of Washington, B. Arch. •
 Massachusetts Institute of Technology, M. Arch. •
 École Americaine des Beaux Arts (Fontainebleau)
commissions (furniture):
 Golconda (Pondicherry, India) • Frenchman's
 Cove (Jamaica) • David Thompson residence
 (Maine) • Carnegie Institute of Technology
 (Pittsburgh)
commissions (architecture): Golconda, Shri Aurobindo
 (Pondicherry, India) • St. Paul's Church
 (Karuizawa, Japan) • Church of Christ the King
 (Katsura, Japan) • Christ of the Desert Church
 (Abiquiu, New Mexico)
residence: New Hope, Pennsylvania

Our approach is based on direct experience —a way of life and a development outward from an inner core; something of the same process that nature uses in the creation of a tree—with one addition, the aspiration of man to produce the wonder and beauty of his potentialities—no 'statements,' no 'pillars of design,' no personal expression, no frivolity, but an outlook both severe and spontaneous. A firm design, based on principles as universal as possible, producing objects without 'style,' is real and utilitarian. The subtlety of the evolvement of the finest materials shaped with intense skill, inadequately termed craftsmanship, can produce a basic sensitivity.

In a world where fine manual skills are shunned, we believe in them, not only in the act of producing a better product, but in the sheer joy of doing or becoming. We feel that pride in craftsmanship, of doing as perfect a job as possible, of producing something of beauty even out of nature's discards, are all homely attributes that can be reconsidered. It might even be a question of regaining one's own soul when desire and megalomania are rampant—the beauty of simple things.

It is not entirely sentimental for us to think in terms of devoted men—hands shaped differently after generations of being woodworkers—who can make a perfect ten-foot shaving from a ten-foot board. It is dedication that is traditional, but it is fast being lost—a tough skill that becomes increasingly valuable as it becomes rare.

To look for clues, we can go into the past: the moss garden and tea house at Sai Ho Ji, the wonders of stone and glass at Chartres, the Dipylon vase. These are all examples of excellence that can go unchallenged but also unnoticed. They are all formed inwardly with a nearly impersonal experience. Compared to our day, with its arrogance of 'form giving,' the shallowness of design slogans such as 'less is more,' 'machine for living,' or even 'form follows function,' the earlier examples are certainly intellectually uncluttered and organically sound.

All of the tortured and elaborate educational development might be legitimate if the results were good. In proportion to the flood of consumer goods, we are probably at one of the lowest ebbs of design excellence that the world has seen. It requires a genuine fight to produce one well-designed object of relatively permanent value. One of the difficulties is the lack of integration between the designer and the producer—the evolvement of material and method into a well-conceived idea. Big-city architecture has reached such a profound state of boredom that man might unwittingly destroy it in one last tragic gesture—without humor. Sentimentally again, we can look back to the thirteenth century, when almost every hinge was a museum piece; when there was a touch of greatness in the majority of acts and conceptions.

As the practical skills needed for this type of work are almost extinct in this country, most of our workers are young men with European training and experience who are basically interested in craftsmanship. It is a synthesis of old traditions with modern requirements, quite opposite to the usual art or design school in that the fundamental techniques of good workmanship are first resolved and then integrated into pieces designed for contemporary use.

Over the years we have built up a collection of extraordinary lumber: in a sense priceless, as many items are now unobtainable. From this material, we start the making of useful objects to fulfill man's life—again, we hope, in a manner akin to the disciplined way by which nature produces a tree . . . or a flower.
—George Nakashima

CONOID BENCH AND BACK: English
walnut, hickory, and black walnut: 31½″
x 86″ x 38″: 1969

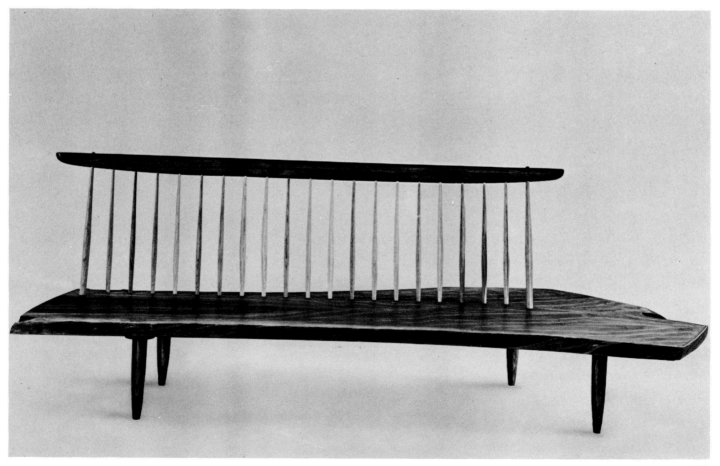

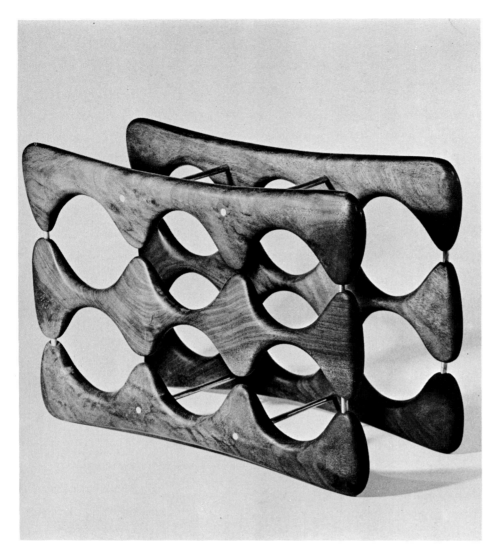

WINE RACK: walnut: 11½" high: 1968

ARTHUR CARPENTER (ESPENET)

The woodwork of Espenet (the name Arthur Carpenter uses professionally) is notable for its stress on functionalism and its strong emphasis on visual grace. He first began to work in the medium in 1948 after spending several years in the Navy, then in a New York importing business. 'I wanted to become independent,' he recalls. 'I chose woodwork because of all the crafts I knew, this required the least technical knowledge. I could break in right away.'

Entirely self-taught, Espenet has been producing award-winning furniture and wood accessories for twenty years. His work has been shown in leading U.S. museums and universities, and articles about him have appeared in numerous publications including *Life, The New York Times,* and the *Christian Science Monitor.*

Espenet, commenting on his objectives, has a clear and direct approach:
1. Utility
2. Durability
3. Pleasing tactility
4. Economy of material

birthplace: New York, New York, 1920
education: Dartmouth College, B.A. 1942
collections: Museum of Science and Industry (Chicago) • San Francisco Art Festival Purchase Award
residence: Bolinas, California

The craftsman has, I think, an important function in society: conserving a way of life, leading the way. However, I'd be delighted if the pay were commensurate.
—Arthur Carpenter (Espenet)

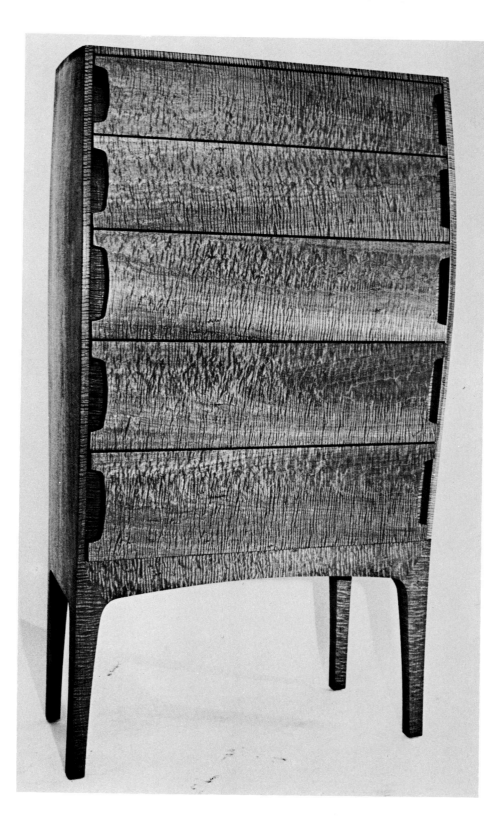

JERE OSGOOD

The sense of structural strength and unity in Osgood's furniture possibly derives from his earlier studies and interest in architecture. Yet, despite this apparent strength, there is a decidedly sensual grace that characterizes his forms. It is not inconsistent, in this respect, that the material he chose for the chest illustrated here—fiddleback mahogany—is the same kind used in the making of violins.

birthplace: Staten Island, 1936
education: University of Illinois • Rochester Institute of Technology, B.F.A. 1961 • One year in Denmark, graduate seminar, 1962
teaching: Craft Students League (New York) • Brookfield Crafts Center (Connecticut), present
collection: Museum of Contemporary Crafts (New York)
residence: New Milford, Connecticut

Wood is a living material and I am fascinated with its use as such. Each wood has an inherent structure—a color, texture, and workability—a feeling that will suggest the mass or shape of a piece of furniture.

Perhaps it is possible to take a tree apart and then to reassemble it as truthfully as it grew, but now in relationship to human needs and delights.

I feel that designing is a state of mind, and the process is constant; the only variable is in the immediate problem. Good design implies the equal relationship of construction, function, and beauty— transcending period or style.

On woodworkers in general: perhaps it is our purpose to serve as a foil, a foil to the mass of productivity, to produce a few things that will project a difference.
—Jere Osgood

CHEST OF DRAWERS: fiddleback mahogany: 59¾" x 33" x 17¼": 1969

DANIEL LOOMIS VALENZA

The wood furniture and accessories of Valenza give evidence of a highly personal response to form and function. Often the artist works on one subject at a time—such as a chair or chest—probing the different forms possible for the object without loss of its functional aspect. The jewelry chest illustrated here is from such a series. Valenza's work has been shown in museum and university exhibitions throughout the U.S., and was included in the 1964 New York World's Fair and Expo '67 (Montreal).

birthplace: Rochester, 1934
education: School for American Craftsmen (Rochester) • Rochester Institute of Technology, A.A.S. 1956; B.F.A. 1958; M.F.A. 1966
teaching: University of New Hampshire
commissions: University of New Hampshire • Durham (N.H.) Community Church • Christ Presbyterian Church (Rochester)
residence: Durham, New Hampshire

If I possess a particular field of strength, it would be the small, sculptured wood object, due in part to my feeling of positive control inherent when I work in a reduced scale—even though the problem at hand might truly be a new path of investigation. PIGGY II is one in a long line of small objects I have made in a fifteen-year period. Occasionally, during this time, some 'happy work' has occurred. During the past two years—in between the larger-scaled work—this particular form of personal fun has produced a series of three jewelry chests. I have no idea how the form evolved. It may have begun as a bit of a 'put on' for the benefit of my students (how serious the woodworker tends to be!) but gradually I got caught up in my own lark. The central theme was still to produce an amusing, if not indeed a ridiculous form, useful, and perhaps a bit satirical in its stated use. It still amuses me to see people fondle the little animal, feel its appendages and haunches, and wonder at the suck and whoosh of vacuum and compression in the workings of the little beast.

—Daniel Loomis Valenza

PIGGY II: walnut: 5½" x 11" x 13": 1968

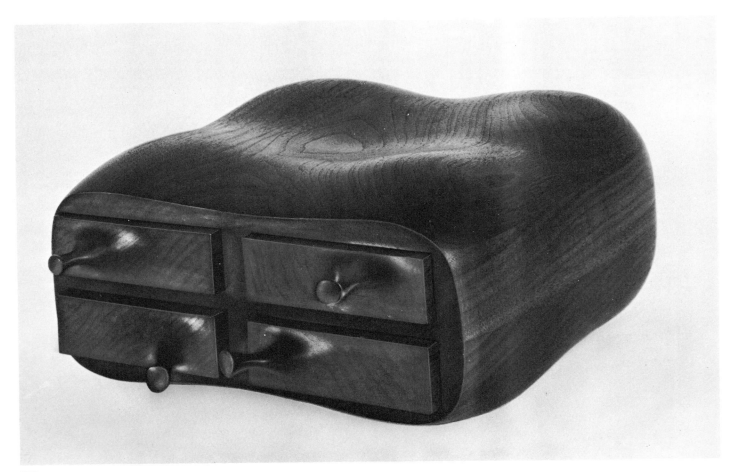

LEE M. ROHDE

Rohde began his woodworking career as an avocation. Both as a student and later as an engineer, he made furniture and accessories for his personal use. Since 1964 Rohde has worked in wood professionally, specializing in staved, layered, or end-grain pieced designs. More recently he has concentrated on bowls, jewelry chests, and carving boards.

Largely self-taught in his craft, Rohde credits the influence of his father, Gilbert Rohde, one of the pioneer industrial designers of the thirties, as important to the development of his interests and skills.

birthplace: New York, New York, 1929
education: Massachusetts Institute of Technology, B.S. •
 Ohio State University, M.S.
residence: Pleasantville, New York

CARVING BOARD: zebrawood: 19″ x 14″: 1968

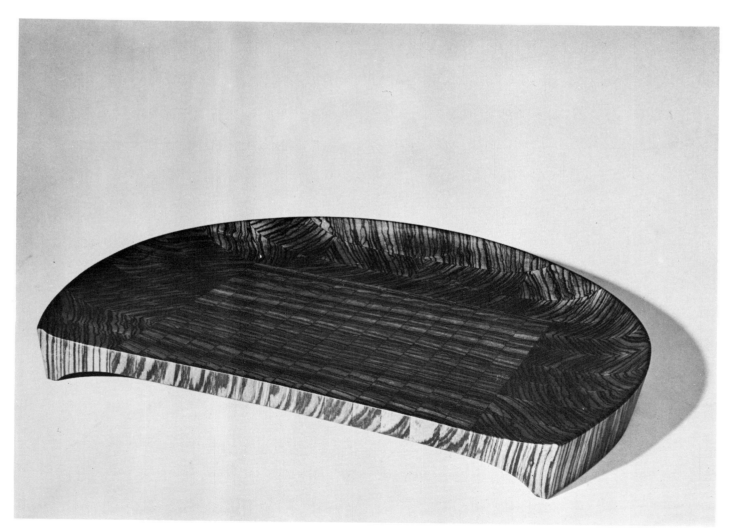

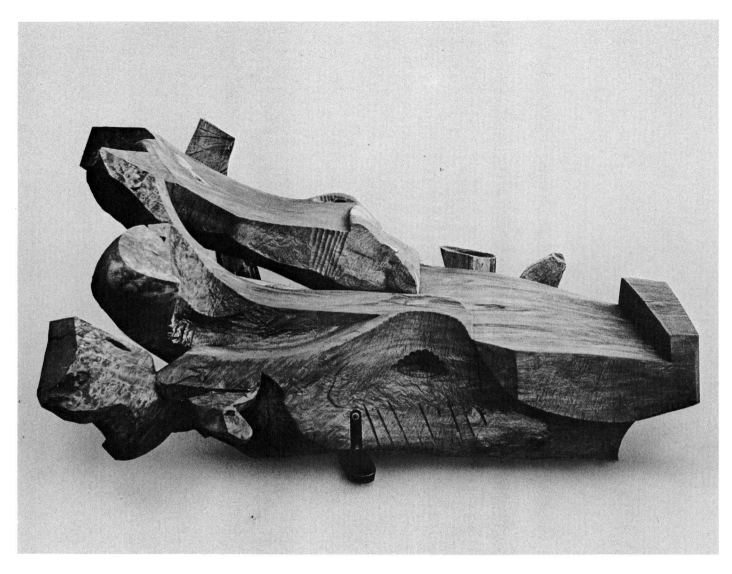

SEATING SCULPTURE: redwood: 36" x
120": 1968–1969

J. B. BLUNK

Since 1961 Blunk has been creating wood
sculpture in which functional elements are
only broadly implied. The monumental
scale of these 'seating sculptures' and
their wandering, organic forms combine
to produce vigorous presences. Living near
redwood country, Blunk has access to
logs which the proportions of his work
demand.

Blunk moved to California in 1946 to
study ceramics. Following his formal
education at the University of California,
he traveled in the West Indies and Japan
(where he served as a potter's apprentice),
and returned to the U.S. in 1954.

birthplace: Ottawa, Kansas, 1926
education: University of California (Los Angeles), B.A.
 1949
teaching: Palo Verde College, 1954–1955
collections: San Francisco Museum of Art • Oakland
 Art Museum • Stevenson College, University of
 California (Santa Cruz) • City Park of Mount
 Kisco (New York)
residence: Near Inverness, California

THOMAS SIMPSON

The painted polychrome fantasy furniture of Thomas Simpson is a joyous celebration of whimsy and 'sent-I-meant.' The frequent anatomical references with their bizarre, surrealistic overtones are in blatant revolt against the nonfunctional dehumanization characterized in so much of our contemporary environment.

birthplace: Elgin, Illinois, 1939
education: Northern Illinois University, B.S. • University of Iowa • University of London • Cranbrook Academy of Art, M.F.A.
book: Fantasy Furniture (Reinhold, New York, 1968)
residence: Elgin, Illinois

If I had a Kite
with a tale of bend, carry,
* touch, till, come,*
* open, and special*
I would let the string
Taught the wind
and pull me out
fresh and warm
Flying till seen
so to hug the eyes
of people I can not see
If I had a Kite

I am looking for some new understanding to add to the definition of support and storage, recline and surface. I approach the problem through the abstraction of the space, composition, line, etc., of furniture and the meaning of furniture. I desire my furniture to depict storage as an adjective as well as a noun. I see an object which is for the safekeeping of goods take on its meaning as the depository of hopes, loves, sorrows as well as for books, foodstuffs, and underwear. Furniture can expand to receive more of man's needs than be just the handler of material.
—Thomas Simpson

MAN BALANCING A FEATHER ON HIS KNOWS: pinewood, constructed with glue and wooden pegs, painted with acrylics, inside decoration of rice paper: 65" x 41½" x 13½": 1968

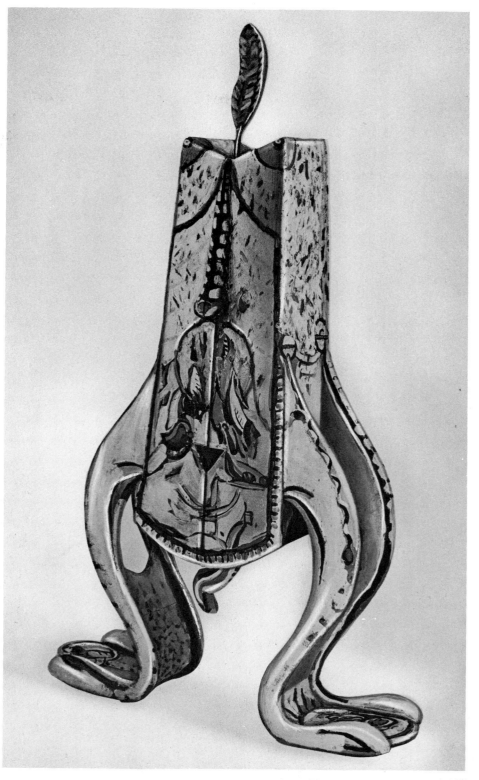

fiber

MARIAN CLAYDON

Drawn by the natural beauty and un-
explored potential of tie dye, Marian
Claydon gave up her paint brushes four
years ago and turned to textiles. She
works with a form of tie dye called
tritik in which the design is controlled
by preliminary sewing of the fabric. The
artist was born and educated in England,
and after spending several years in
Australia came to the U.S. in 1968 and
settled in California. Her most recent
technical explorations have led from wall
hangings to fabrics which have been
used in several theatrical productions.
The garment illustrated here is a projection
of that involvement; at the same time it
reflects a combination of both facets of
her work. It can be hung on the wall or it
can be worn. Claydon says the work
expresses sentiments of primitive rhythms
and ancient ceremonials.

birthplace: Lancashire, England, 1937
education: Kesteven College, 1955–1957 • Nottingham
 School of Art, 1958–1959
residence: Cupertino, California

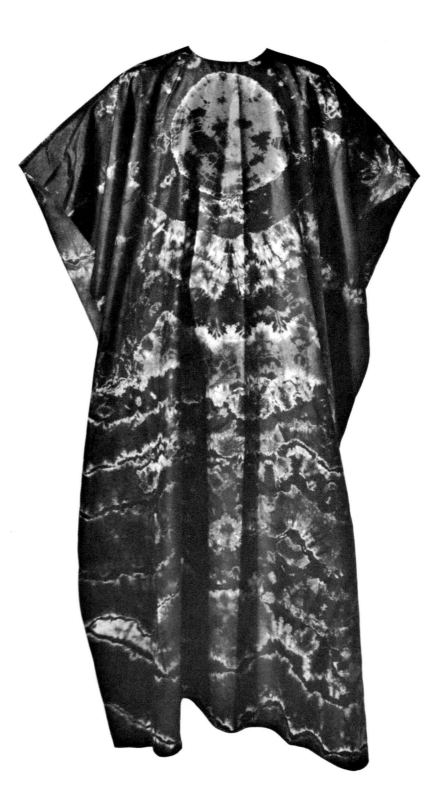

GARMENT: tritik on silk: 110″ x 40″: 1969

272

RUTH DANIELSON DAVIS

Ruth Danielson Davis, a native of Wisconsin, has had a lifetime of involvement in art, and, although married, has maintained a continuous professional life of teaching. Two degrees in art education were earned at the University of Wisconsin, where over the years she has advanced from instructor through assistant and associate professorships to full professor in the department of related art. In her personal works she has received recognition in water-color painting, and more recently in textile design. One of her painted fabrics received a 1969 Wisconsin Designer-Craftsmen Award at the Milwaukee Art Center.

birthplace: Waupun, Wisconsin
education: University of Wisconsin
teaching: University of Wisconsin, present
residence: Madison, Wisconsin

My particular concept of textile design seems to have grown out of an interest in landscape painting and an ever-increasing awareness of the correlation between earth textures and those of fabric. In defining the character of surface, I feel a flow of ideas through a brush or drawing tool that is a more rewarding experience than the tedium of exact repetition, as in printing techniques.

In discovering the larger dimensions of cloth, there is a certain exhilaration in being freed of the limitations of stretched papers, mat, frame, and glass. And, too, in the continuing length of fabric, there is room to improvise and extend an idea, like the ripples of the sea, to infinity.

—Ruth Danielson Davis

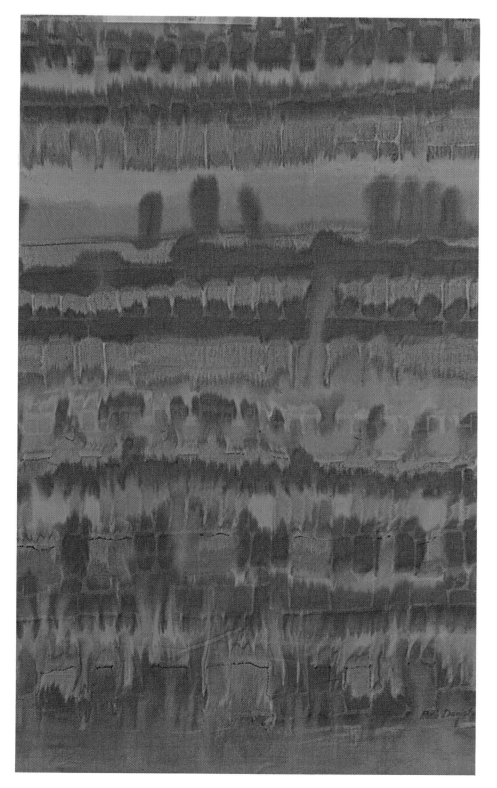

ABSTRACT: hand-painted cotton: 121″ x 46″: 1969

SISTER MARY REMY REVOR

Sister Mary Remy's métier is the printing of textiles, for which she uses a broad range of techniques including block printing, batik, and tie dye. She has exhibited her textiles throughout the country and has received numerous recognition awards. Her combining of various techniques within a single piece can be appreciated best in the viewing of a work like *PERSIAN THEME*, illustrated here, which makes use of both batik and block printing. The theme also gives a hint of the range of the subject matter from which Sister Mary Remy draws her inspiration.

birthplace: Chippewa Falls, Wisconsin
education: Mount Mary College, B.A. • Art Institute of Chicago, B.F.A., M.F.A.
teaching: Mount Mary College, present
residence: Milwaukee

PERSIAN THEME: batik and block print on silk organza: 105″ x 54″: 1967 **(detail)**

JEROME WALLACE

The abstract batik wall hangings of Wallace, which have attained international recognition, are considered to be among the most expressive examples of batik in the world. Using hand-woven silk as the ground fabric, he applies colors and dyes (in resist techniques) derived from native plants and earth and sea creatures found in the environs of the island of Kauai in Hawaii. The result is a luminosity of color reflecting the lushness of the exotic surroundings. Wallace creates not only fabric lengths, but also panels which are then stretched as paintings. A tour of his batiks was arranged by Scandinavian governments for museums in Norway and Sweden; and the French government requested a similar tour for its national museums. Wallace, an Ohioan of Cherokee Indian–Scotch heritage, has lived in Australia, California, New York. He learned the techniques of the ancient art of batik in Bali.

birthplace: Portsmouth, Ohio, 1931
education: Carnegie Institute of Technology • Texas Christian University
collections: Kunstindustrimuseet (Oslo) • Museum of Contemporary Crafts (New York) • Kauai Museum • Swedish National Museum (Stockholm) • Stavanger Kunstforening (Stavanger, Norway)

Where there is understanding no comment is needed, but where there is no understanding no amount of argument is convincing.

—Jerome Wallace

COOLNESS OF WATER ON NAKED BODIES: hand-spun, hand-woven silk batik: 107″ x 40½″: 1968 (detail)

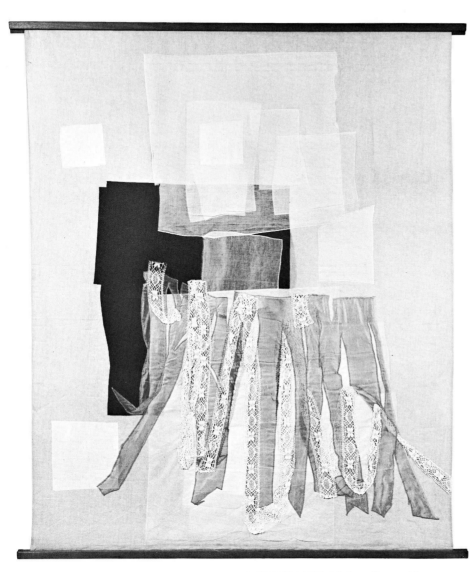

ELIZABETH JENNERJAHN

Having worked as a girl in the family-owned stained-glass studio in Wisconsin, and later, having studied with Josef Albers and Trude Guermonprez at Black Mountain College in North Carolina, Elizabeth Jennerjahn brings a unique sense of form and color to her craft. Essentially she is a painter using the medium of fabric in collage and stitchery, but recently she has become more involved in spinning, knitting, and the structure of weaving.

Jennerjahn's work has probably been shown in every major national exhibition involving fibers, and she has completed a number of important commissions, including a tapestry for a dormitory at the new Rochester Institute of Technology.

birthplace: Milwaukee, 1923
education: Rosary College • University of Wisconsin •
 University of Colorado • Black Mountain College
 (North Carolina)
teaching: Penland School of Crafts (North Carolina) •
 The Waldorf School (Long Island, New York)
residence: Garden City, New York

GOLDEN LACE: fabric collage with appliqué, cotton organdy, lace, silk, and pellon on natural linen: 69" x 54": 1965

PAIR OF PILLOWS: stitching with wool yarns: one 15" x 11", other 21" x 20": 1969

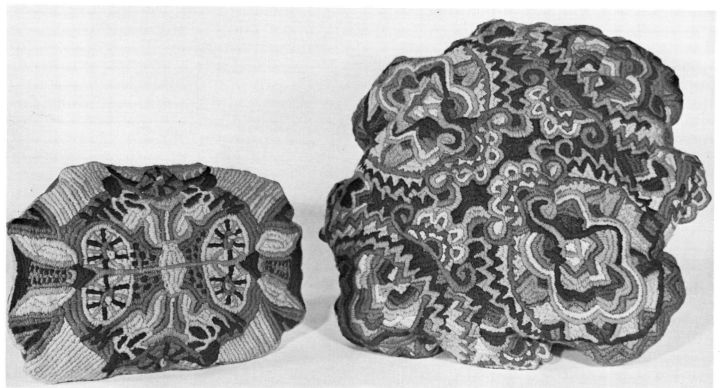

HELEN BITAR

Brilliant colors highlight the close-stitch pillows of Helen Bitar. The over-all pattern of her work is generally conceived in a painterly manner and with a particular emphasis on texture. Miss Bitar is also known for her free-form macramé wall hangings, and recently she exhibited her work at the Weaving International exhibition held at the Arts and Science Center in Nashua, New Hampshire. She was also represented in New York's Museum of Contemporary Crafts' exhibition, 'Stitchery,' in 1967.

birthplace: Centralia, Washington, 1940
education: University of Washington, B.A. 1963
teaching: University of Montana, present.
residence: Missoula, Montana

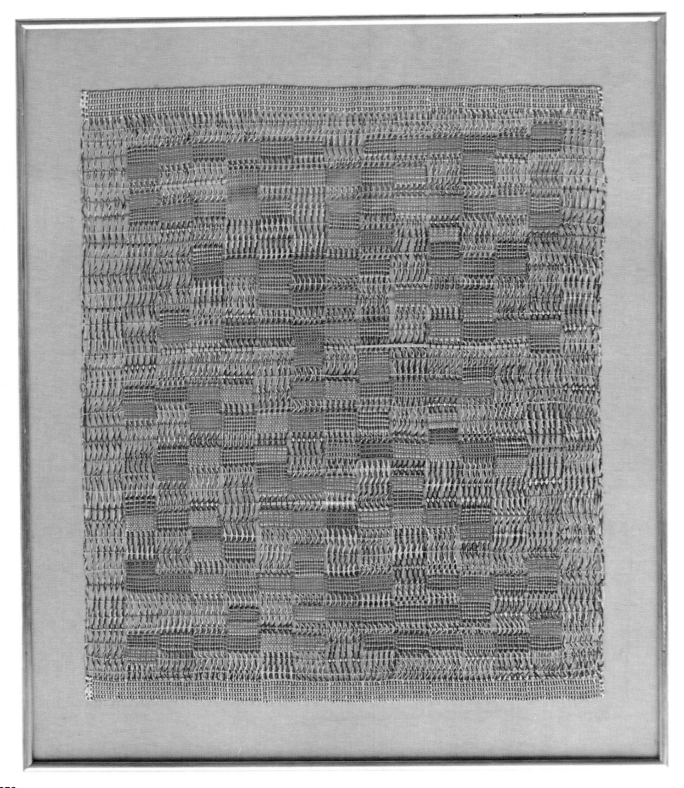

278

ANNI ALBERS

Anni Albers has been a dominant presence
among weavers for almost four decades—
dating back to her student work at the
Bauhaus. Celebrated as an artist, a
designer for industrial production, a
lecturer, teacher, and author, her work
and her ideas focus on the structural
side of weaving, with a particular emphasis
on thread as a linear element.

Conceived, in regard to her utilitarian
fabrics, within the framework of a machine
aesthetic and developed from a reduction
to basic elements and basic relations,
Albers's pictorial work on the other hand
is based on the direct work at the loom.
It is woven by methods which have
remained unchanged for centuries. She
masters the hand loom as well as the
machine.

Married to the distinguished painter
Josef Albers, her own visual images remain
within the sphere of the weaver; that is,
they are conceived in textile terms.

A one-man show of her work was held
at the Museum of Modern Art in 1949 and
continued on a tour for three and a half
years. One-man shows followed at other
leading American museums. In 1961 she
was awarded a Gold Medal from the
American Institute of Architects in
recognition of outstanding achievement
in her field, and in 1965 received a
Decorative Arts Book Award Citation
for her book, *Anni Albers: On Weaving.*

In addition to her creative work and
teaching, Mrs. Albers has lectured
extensively at museums and universities.

birthplace: Berlin, Germany, 1899
education: Bauhaus (Weimar and Dessau), 1922–1930
teaching: Black Mountain College (North Carolina)
collections: Museum of Modern Art (New York) •
 Bauhaus Archive (Darmstadt, Germany) • Museum
 die Neue Sammlung (Munich) • Kunstgewerbe
 Museum (Zurich) • Victoria and Albert Museum
 (London)
books: Anni Albers: On Designing (Pellange Press, 1959
 and Wesleyan University Press, 1962–1966) • *Anni
 Albers: On Weaving* (Wesleyan University Press,
 1965)
residence: New Haven, Connecticut

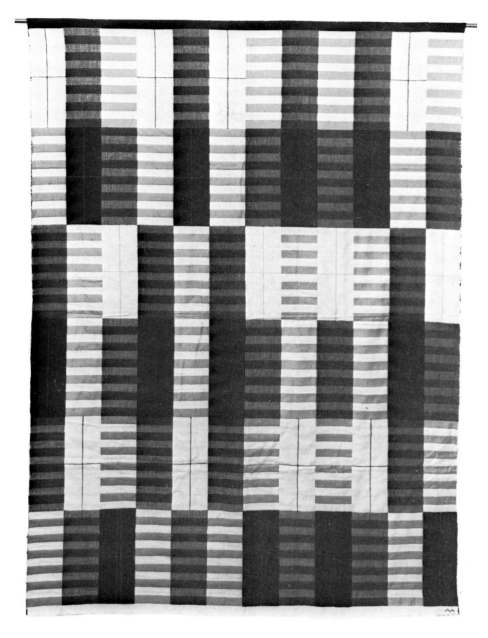

TIKAL: pictorial weaving of cotton—plain
weave and leno: 35½'' x 29½'': 1958

BLACK, WHITE, RED: double-weave silk
and cotton: 68'' x 47'': 1927, ed. of 2, lost
in war; 1965, ed. of 3

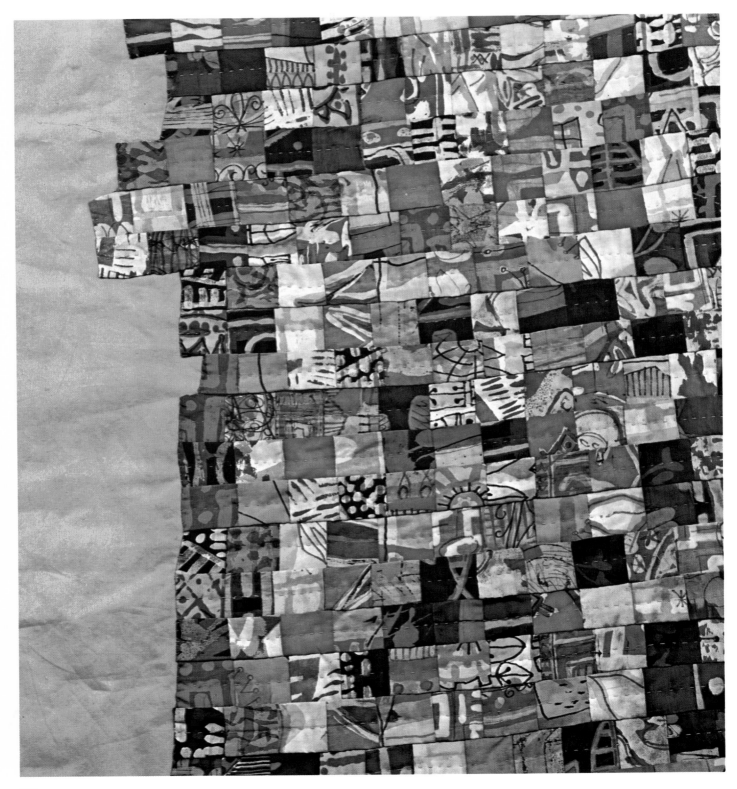

KATHERINE WESTPHAL

In a recent article, Spencer Moseley, head of the art department at the University of Washington, stated about Katherine Westphal, 'The quilted wall hangings of Katherine Westphal are unique examples of the unexpected possibilities of invention to be found in traditional techniques. Goethe observed that the air shapes the bird, that the forms of nature assume the contours demanded by their environment. For this artist, the materials and elements of design provide the environment, the demand, that shape form. Westphal is keenly sensitive to the characteristics of her medium. To her they are resources, not limitations. Her work is the result of a continuous, impressive and exhilarating dialogue between ideas and materials.

'Several textile techniques are combined in these works—appliqué, stitchery, batik, tapestry and quilting. The forms are built up, section by section, from disparate elements.'

birthplace: Los Angeles
education: Los Angeles City College • University of California (Berkeley)
teaching: University of Wyoming, 1945–1946 • University of Washington, 1946–1950 • University of California (Davis), present
residence: Berkeley, California

I was trained as a painter. I see things from that viewpoint. I build up; I destroy. I let the textile grow, never knowing where it is going or when it will be finished. It is cut up, sewn together, embroidered, quilted, embellished with tapestry or fringes, until my intuitive and visual senses tell me it is finished and the message complete.
—Katherine Westphal

TIEPOLO: multi-processed hand printing with stuffing and quilting: 96″ x 56½″: 1969

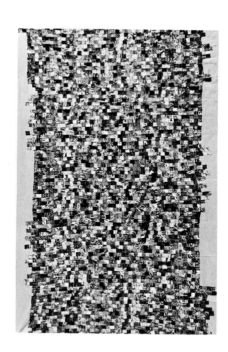

A SQUARE IS A MANY SPLENDORED THING: batik patchwork with quilting: 96″ x 58″: 1967
(detail in color at left)

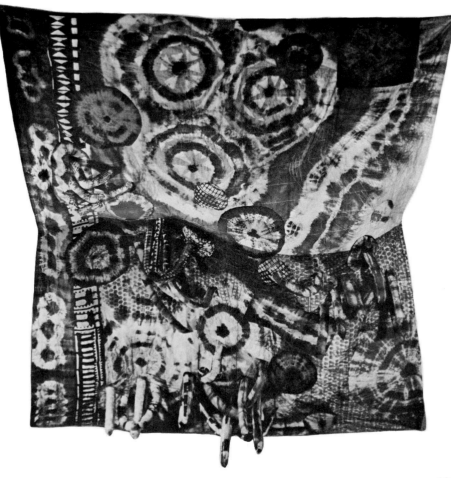

LAURE SCHOENFELD

Laure Schoenfeld came from Germany to the U.S. in 1943 and settled in New York. She studied painting with Hans Hofmann and Will Barnet, and in the late fifties began exploring techniques of rug making. She has since taught these techniques and has been included in numerous group exhibitions in the New York area.

birthplace: Saarbrucken, Germany, 1925
education: Brooklyn College • Hans Hofmann School (New York)
teaching: Workshops at the 92nd Street 'Y' (New York), North Shore Community Arts Center (Long Island), and Manhasset Adult Education School (Long Island)
residence: Great Neck, New York

I was a painter until I fell in love with wool. All at once I found myself involved in making rugs and wall hangings. The history of hooking rugs and its tradition then drew me on more deeply. Rug hooking, many years ago, was a true American craft. In the past, people dyed their own wool and created rugs with their own design imaginations. In modern America, hooking one's own thing is relatively unknown but, perhaps, it will not remain that way much longer.

—Laure Schoenfeld

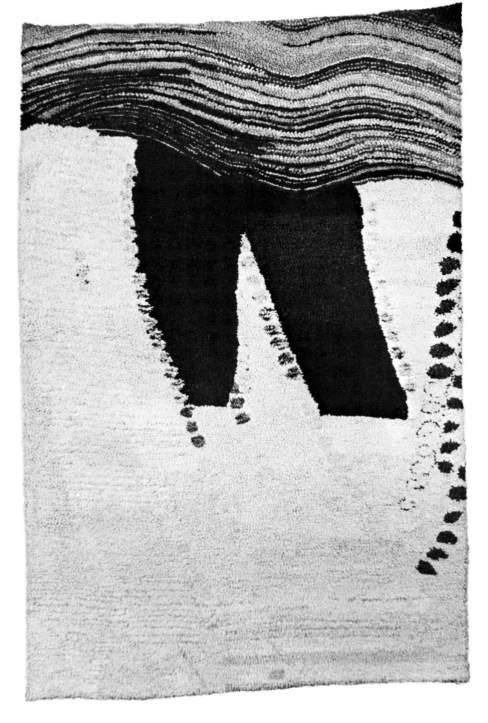

BLUE I LOVE YOU BLUE: hand-dyed, hand-hooked wool yarn: 70″ x 42″: 1966

GEORGE WELLS

Wells has been making rugs and wall hangings professionally since 1956 and during this time has played an important role in the restoration of rug hooking as a major expression. Working with a small group of assistants, he does all the designing and yarn dyeing and some of the hooking, and with the exception of what he describes as 'small gift rugs,' nearly all of the work is commissioned.

In both design and color, the rugs and wall hangings of Wells are notable for their great variety, and he feels that the challenge of commissioned work has served as a major creative stimulus in this respect. These commissions have brought his work into such collections as those of the offices of the President of Mexico, Mrs. Frank Lloyd Wright, and numerous celebrities of the entertainment world.

EMBERS # 2, illustrated here, was executed with a traditional rug hook on cotton backing. The extreme subtlety which he applies to this work is typical of Wells's concern for an appropriate relationship of design and color to subject matter.

Wells's rugs have been widely exhibited and have been reproduced in many leading national publications, and he has received top awards from such organizations as the New York Architectural League, the Home Fashions League, and the American Institute of Decorators.

birthplace: Brooklyn, New York, 1905
education: Rutgers University
teaching: Division of Vocational Rehabilitation, New
 York State Board of Education • Cornell University
 Appalachia Project (Blackey, Kentucky)
residence: Glen Head, New York

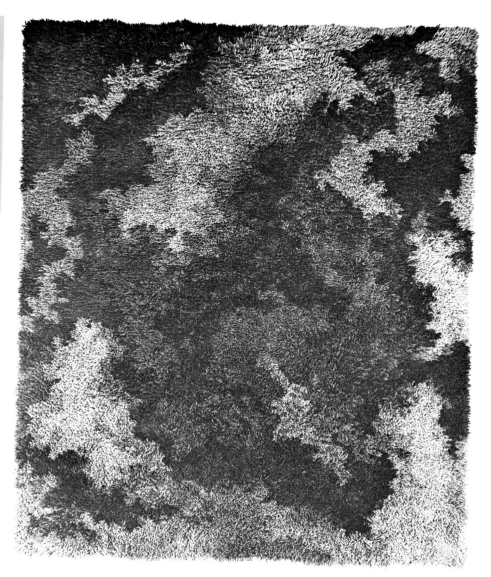

EMBERS # 2: shag-hooked, hand-dyed wool: 96" x 120": 1963

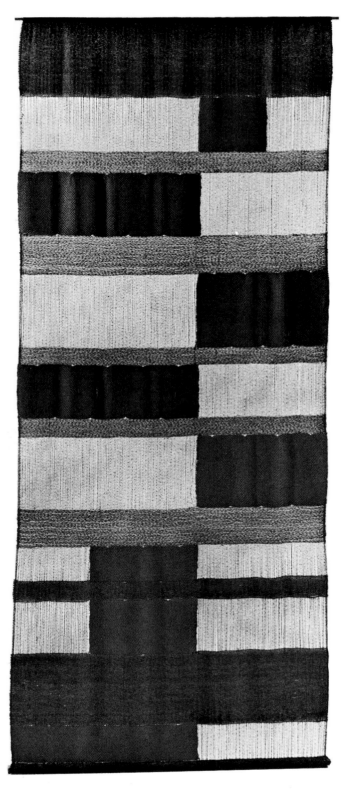

LILI BLUMENAU

Blumenau has been working in the field of textiles in a variety of capacities— weaver-designer, textile curator, lecturer, author, and instructor—and she has become a recognized leader in each. Her training in textile technology and aesthetics began in Berlin in 1931 and continued in Paris and New York. She believes strongly in giving her wall hangings a title and its ability to convey her thoughts and ideas. For her, expression assumes form through the artist's working within the given medium. The everyday words *transparent* and *opaque* in the hands of Lili Blumenau take on special meaning.

birthplace: Berlin, Germany
education: Academy of Fine Arts (Berlin) 1931–1933 •
 Académie Scandinave (Paris) 1933–1934 • Weaving
 Studio (Paula) 1934–1936 • New York School for
 Textile Technology, 1940–1944 • Black Mountain
 College (North Carolina), 1950
collections: Museum of Contemporary Crafts (New
 York) • Cooper-Hewitt Museum of Design (New
 York)
residence: New York, New York

TRANSPARENT AND OPAQUE: braided
ribbon and fine rayon: 84″ x 33″: 1958

JANICE BORNT

Structurally, tapestry is very simple. Partially due to this simplicity, weavers have been inclined to explore color and texture rather than confine themselves to the traditional representational graphic cartoon. Janice Bornt's tapestries are pictorial. She works with pencil cartoon mainly to arrive at the form: but for impact she relies on areas of texture and color, as in her *DOUBLE PINK WHEELS*, illustrated here.

Bornt has exhibited in local and national competitions since 1958, and has been represented in numerous invitational shows. For four years two of her tapestries traveled with the U.S.I.A. show that toured South America and the Far East.

birthplace: Troy, New York, 1934
education: Cranbook Academy of Art, 1953–1955 •
 Haystack Mountain School of Crafts (Maine)
collections: Addison Gallery of Art (Andover,
 Massachusetts) • Krannert Art Museum (University
 of Illinois) • St. Paul Gallery and School of Art
residence: Berkeley, California

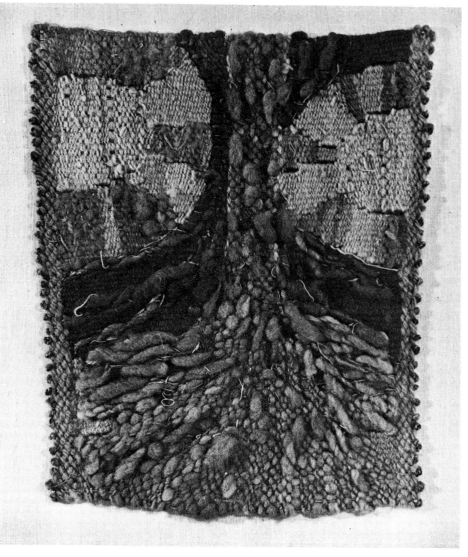

DOUBLE PINK WHEELS: tapestry: 13" x 9": 1962

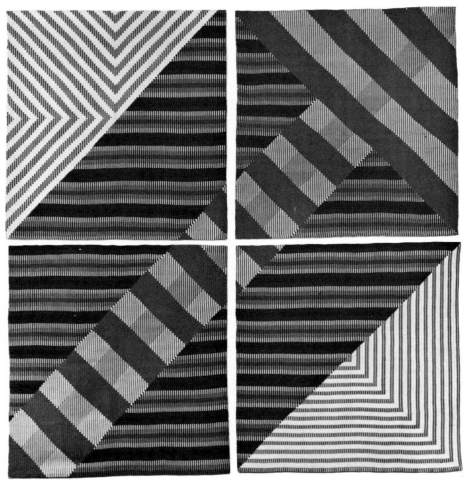

AHZA COHEN

From an interest in horned toads and lizards when she was a little girl to barber poles, banners, and runover string in the street, Ahza Cohen is constantly aware of her surroundings, no matter where she is, whether it be California, New York, or India. In her work she expresses a contemporary fondness for geometric shapes and units of interwoven color. In *ARROW IN FOUR PARTS* (illustrated here) Cohen has given 'hard edge' work the added dimensions of texture and light and shade.

birthplace: Los Angeles, 1936
education: Reed College (Portland, Oregon) • The
 Fashion Institute of Technology (New York),
 1960–1962 • Fulbright grant to India for weaving,
 1962–1963
residence: New York, New York

ARROW IN FOUR PARTS: woven tapestry of wool and rayon on cotton warp: 110" x 102": 1969

ANNE HORNBY

Anne Hornby is a young weaver from the West Coast who was exhibited for the first time nationally in the 'Young Americans' show at the Museum of Contemporary Crafts, New York, in 1962. She has been noted for her rich color blendings and for her adventurous shaping of the rug form. Many of her works, although employing rug techniques, are intended as hangings, as is the work illustrated here.

birthplace: Missoula, Montana, 1932
education: Stanford University, B.A. 1954 • Cranbrook Academy of Art, 1954–1955 • Haystack Mountain School of Crafts (Maine), summer 1955 • Columbia University Teachers' College, M.A. 1960
collection: St. Paul Gallery and School of Art
residence: Berkeley, California

My work is based upon close observation of the natural world about us and particularly upon its color relationships.
—Anne Hornby

FLOSSA I: flossa wool: 48″ x 27″: 1968

ALLEN and DOROTHY FANNIN
In an age when few weavers can afford
the luxury of using hand-spun yarns in their
work, Allen and Dorothy Fannin have
developed techniques of hand spinning
enabling them to use the spinning wheel
as a tool of contemporary design. The
Fannins spin not only the traditional
natural fibers—wool, cotton, and flax—
but man-made and synthetic fibers as
well. Their aim is to explore the nature
of fibers and the ultimate texture of yarn,
and to give a vitality to their fabrics through
the use of their yarns. Their casement,
STAIRWELL, illustrated here, is a blend of
flax and rayon.

birthplace: New York, New York; Dorothy, 1941;
 Allen, 1939
collection: Newark Museum
residence: New York, New York

STAIRWELL: woven hand-spun flax and
rayon: 216″ x 43″: 1969 (detail)

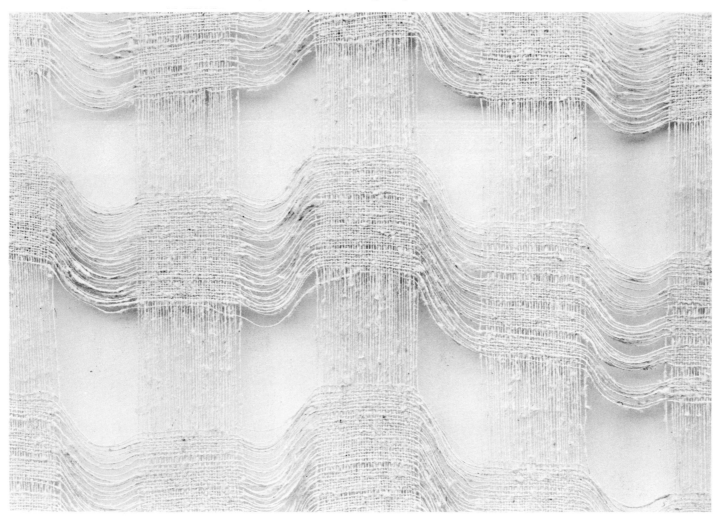

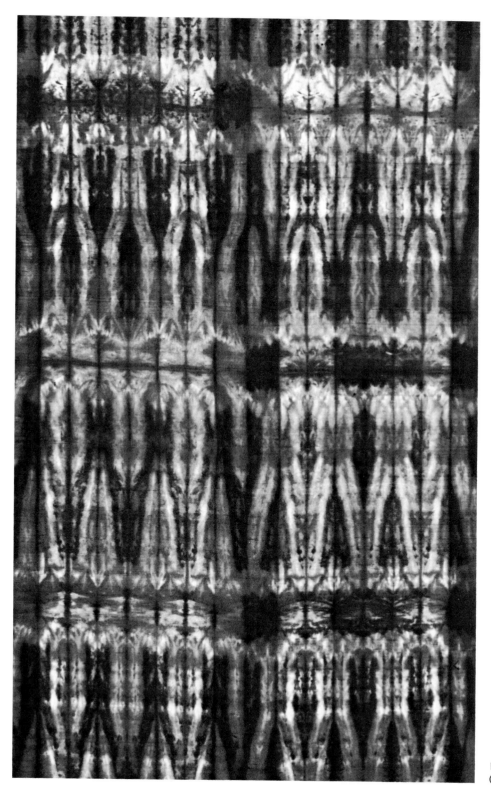

CAROL FUNAI

Carol Funai, a graduate of the University of California, lives in Los Angeles where she has set up a studio to dye and paint her fabrics as well as market them. She also leads beginning classes in ceramics. She has turned down several offers to design for production, preferring to create one-of-a-kind pieces that can be hung on a wall as well as worn. Her batiks—in a fabric-patterning technique using a wax resist—and her tie-dyed fabrics—made by a dyeing technique which includes tying, folding, or pleating—have great appeal in a world inundated with repetitive commercial patterns.

birthplace: Los Angeles, 1941
education: University of California (Los Angeles), M.A. 1967
teaching: Workshop, Carol Funai Gallery
residence: Los Angeles

WINDOW: tie-dye panel: 216″ x 44½″: 1968 (detail)

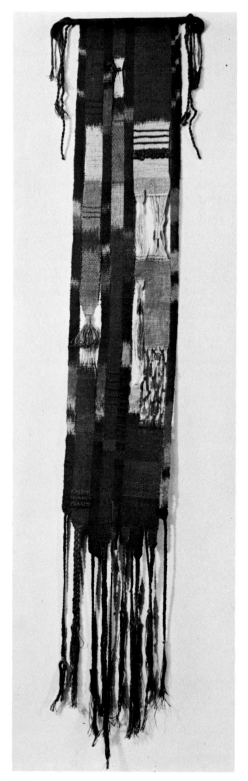

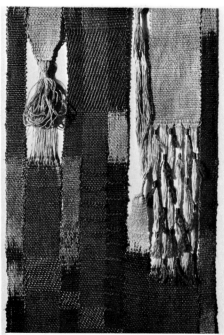

DOROTHY L. MEREDITH

Although trained as a painter, Dorothy Meredith switched allegiance after being confronted with creative weaving, and, unable to get formal instruction, she taught herself the technique of the medium. She is now a recognized leader and teacher in the field. For Dorothy Meredith the loom is a tool: she explores its possibilities and limitations by experimenting with weaves, textures, and dips, using natural materials as well as man-made fibers. She attempts to utilize the loom to its fullest potential, completing as much of her project on it as she can. Being both painter and weaver, Meredith considers color an absolutely essential element in her work. She has traveled around the world doing research on the ikat technique (tie dyeing yarns prior to weaving). Out of her studies of the process have come a number of works, including the hanging illustrated here.

birthplace: Milwaukee, 1906
education: Layton School of Art (Milwaukee) • Wisconsin State Teachers College, B.A. Ed. • Cranbrook Academy of Art, M.A.
teaching: University of Wisconsin
collections: Milwaukee Art Center • Cranbrook Academy of Art
residence: Milwaukee

In this work, the band covering the top bar is the original warp. The weft was extended beyond the woven band, then tied and dyed in the ikat process. After dyeing, the original weft was entered into the loom to become the warp. The piece was then woven in varying techniques.
—Dorothy L. Meredith

IKAT: woven linen: 81″ x 15″: 1968
(detail above)

290

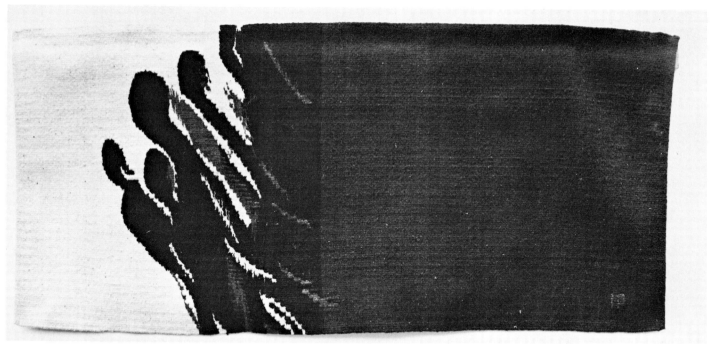

HAL PAINTER

Craftsman and teacher, Painter resides in the midst of the northern-California forest acreage which provides much of the mood and subject matter for his work. As a lover of plant life, he feels, in reviewing his designing, that it is related to that natural world—sometimes interpreted in quite realistic terms and at other times dealt with more abstractly. The aim throughout is to grasp the beauty and simplicity around him. Within the peaceful confines of his forest world Painter weaves, avoiding as much as possible the pressures of time and urban demands.

Despite his seclusion, the artist teaches, exhibits widely, and does commissioned works. A film on the artist has been produced, and a considerable number of articles have been written on his contribution to the field.

birthplace: San Francisco, 1922
education: American University (Biarritz, France) • California School of Fine Arts • Escuella de Bellas Artes (Mexico)
teaching: University of British Columbia • Mendocino Art Center (California) • Santa Rosa Junior College, present
collections: City of San Francisco • Santa Rosa City Hall
residence: Sebastopol, California

ROUGE ET BLANC: hand-spun wool tapestry: 22½" x 46½": 1968

DOROTHY LIEBES

In the course of her distinguished career, Dorothy Liebes has turned from the idea of one-of-a-kind to the concept of mass production, and in the process has had a tremendous influence on the growing use of synthetic fibers and unexpected color combinations. She has been one of the leading textile designers and innovators for the past several decades and has worked for more than two dozen textile firms, designing a wide range of fabrics including tablecloths, knits, blinds, upholstery, and rugs. Her ability to create fabrics for domestic and industrial interiors combining technical innovations of the past two decades is clearly seen in her small samples or explorations, and in the length of fabric of metal and linen illustrated here. She has won many awards for her work, and has served as director and juror for numerous exhibitions and committees.

birthplace: Santa Rosa, California
education: San Jose State Teachers College • University
 of California • Columbia University
teaching: Horace Mann. (New York)
residence: New York, New York

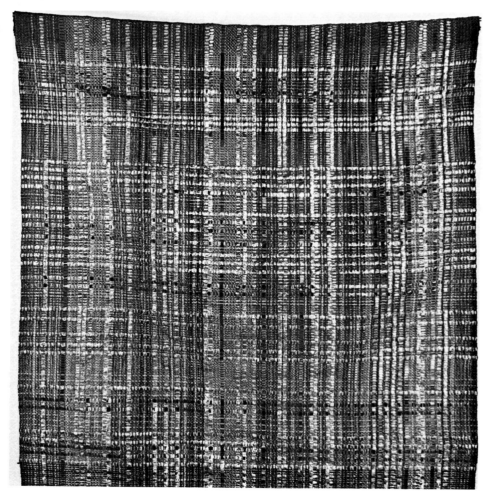

PANEL: hand-woven linen with metallic
(gold and copper) yarns: 109″ x 46″: 1968
(detail at right; enlargement of detail above)

NELL ZNAMIEROWSKI
Nell Znamierowski is well known for her rugs and fabrics, many of which are designed for industry. Her rugs have been given a new dimension and should properly be called 'soft-surface floor coverings.' The inspiration for her color and shapes is drawn from her travels to sunny corners of the world. The example illustrated here, with its infinite variety of tones and shades of colors, invokes the brilliant light of the Greek islands.

birthplace: Amsterdam, New York, 1931
education: Rhode Island School of Design (Providence), B.F.A. 1953 • School of Industrial Design (Helsinki), 1955–1956, on a Fulbright Fellowship
teaching: Fashion Institute of Technology (New York)
collections: Museum of Contemporary Crafts (New York) • Art Institute of Chicago
book: Step-by-Step Weaving (Golden Press, Inc.)
residence: New York, New York

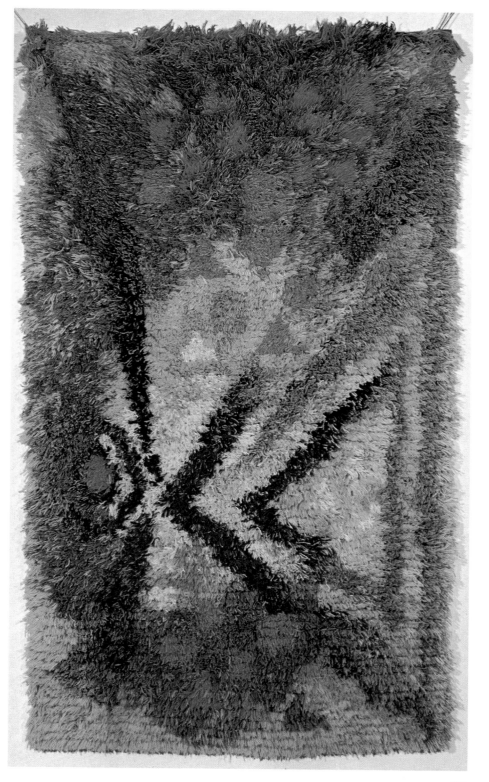

ICARUS: woven wool and linen: 80″ x 44″: 1969

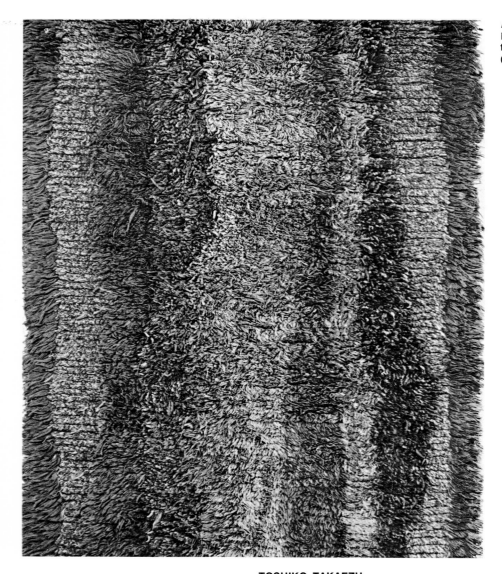

HALEAKALA: Persian wool, home-spun Mexican wool, silk, linen, cotton, and a touch of rayon and nylon: 120" x 60": 1963 (detail)

TOSHIKO TAKAEZU

Toshiko Takaezu is best known for her work in ceramics, but she is equally at home with weaving. Her feeling for texture and color takes on a new dimension in her rya rugs. The juxtaposition of a variety of materials including silk, wool, cotton, and nylon, each with its own texture and quality of light reflection, adds depth and richness to *HALEAKALA,* which is illustrated here. (For biography, see under CERAMIC.)

JAMES M. SOMEROSKI

Someroski studied the weaving of Ceylon—
as well as bringing Western compositional
ideas to the Ceylonese—during a series
of visits beginning in 1966. Living in a
small village, he was able to work alongside
the local weavers. It was here that he
began using pan, a native grass which
grows in the paddy lands of Ceylon, often
attaining heights of six feet. It is cut, dried,
dyed, and pressed flat before being woven.
Without the aid of a loom, the local
craftsmen crouch on the floor, manipulating
the pan fibers with their hands and feet
to create their traditional mats. The mat
illustrated here was woven in Ceylon
during the summer of 1968, and is based
on an idea inspired by Ceylon's Poya
Calendar, which allows flexibility in the
number of days during any given week
based upon the phases of the moon.
This particular mat hanging was woven
under the supervision of Someroski (and
from one of his sketches) by a Ceylonese,
Gunewathe of Wadduwa.

birthplace: Piney Fork, Ohio, 1932
education: Cleveland Institute of Art, B.F.A. 1955 •
 Kent State University, B.S. 1956; M.A. 1961
teaching: Kent State University, 1956, 1958, 1963–1965 •
 Stan Hywett Art Group, 1959–1961 • Baldwin
 Museum, 1960–1963
collections: Cleveland Museum of Art • Baldwin Museum
 (Massillon, Ohio) • Columbus Gallery of Fine Arts
 (Ohio) • Akron Art Institute • Canton Art Institute
residence: Kent, Ohio

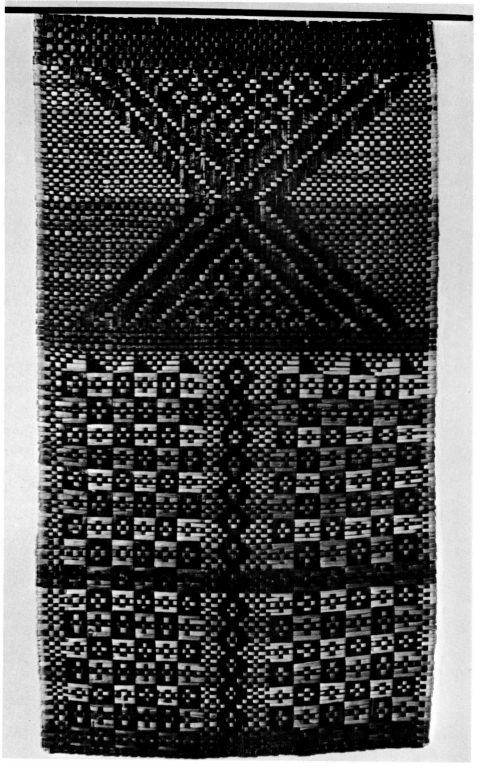

CALENDAR # 8: hand-woven pan grass:
38″ x 19″: 1968

RUBEN ESHKANIAN
Presently the director of the fabric department of the Philadelphia College of Art, Eshkanian works as a free-lance designer with architects and many fabric manufacturers. He has assisted in several U.S. government projects in Peru and Formosa, helping to train local designers and weavers and to promote the use of native materials. The example shown here, a combination of tapestry and knotted pile, was conceived and executed over a period of three months while Eshkanian was an artist-in-residence at the Haystack Mountain School of Crafts in 1962.

birthplace: Highland Park, Michigan, 1929
education: Wayne University, B.A. 1950 • Cranbrook
 Academy of Art
teaching: Haystack Mountain School of Crafts (Maine)
 summer • Philadelphia College of Art, present
collections: Detroit Institute of Arts • Museum of
 Contemporary Crafts (New York)
residence: West Redding, Connecticut

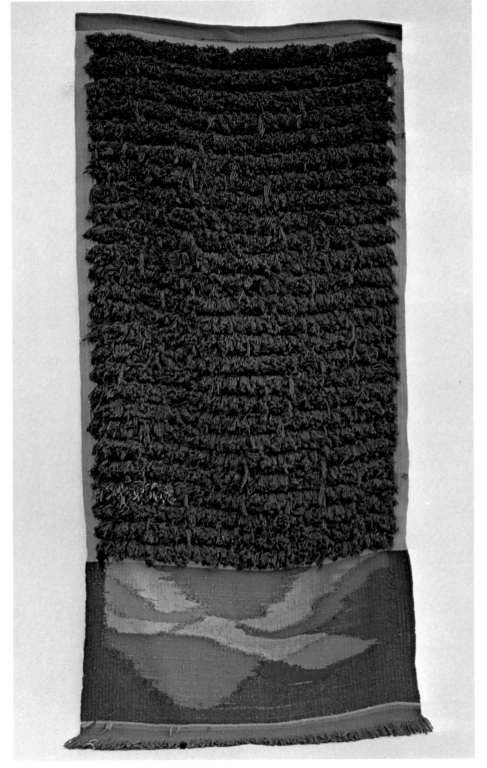

HAYSTACK: hand-woven wool: 135" x 61":
1962

SOPHIE NEW HOLY

Sophie New Holy is a Teton Sioux from the
Pine Ridge Reservation in South Dakota.
She attended the local Oglala grade school,
but her important craft instruction came
from her family home. The majority of
contemporary Indian craftsmen have
received instruction in a wide variety of
'tribal' media in the home, traditionally
instruction given by the grandparents.
As individual preferences and specialities
are developed by the most creative and
talented persons, expression broadens to
include inventive concepts gained by the
individual's experience in the nonreservation
world. Mrs. New Holy's work has acquired
a great sophistication in a contemporary
sense, and she has accepted commissions
for major works and thus adapted native
talents to contemporary requirements.
While she specializes in quillwork, she
is also expert in numerous other craft
media traditional to the Sioux.

birthplace: Oglala, Pine Ridge Reservation, South
 Dakota, 1916
education: Oglala Grade School (Pine Ridge)
commissions: Three-dimensional hanging of feather
 headdresses (in collaboration with husband, Joe
 New Holy), United States Information Agency
 for U. S. Pavilion at Expo 70 (Montreal) •
 Tabernacle and antependium of beaded buckskin,
 Our Lady of the Sioux Catholic Church (Pine
 Ridge) • Quillwork wallhanging, Sioux Indian
 Museum and Crafts Center (Rapid City, South
 Dakota)
residence: Oglala, South Dakota.

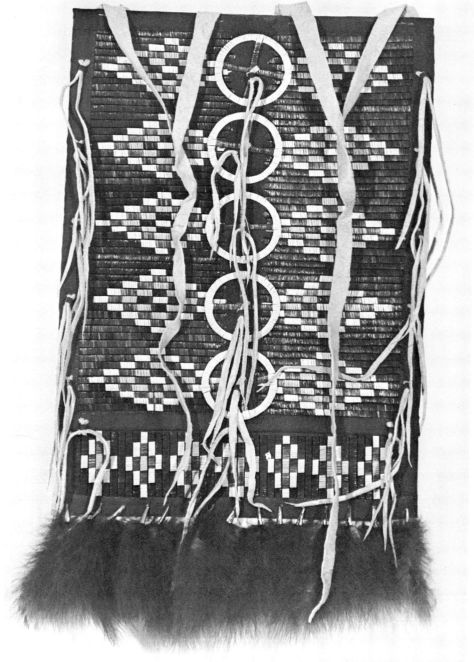

BREAST PLATE WALL HANGING: quillwork:
21½'' x 12'' (without straps): 1969

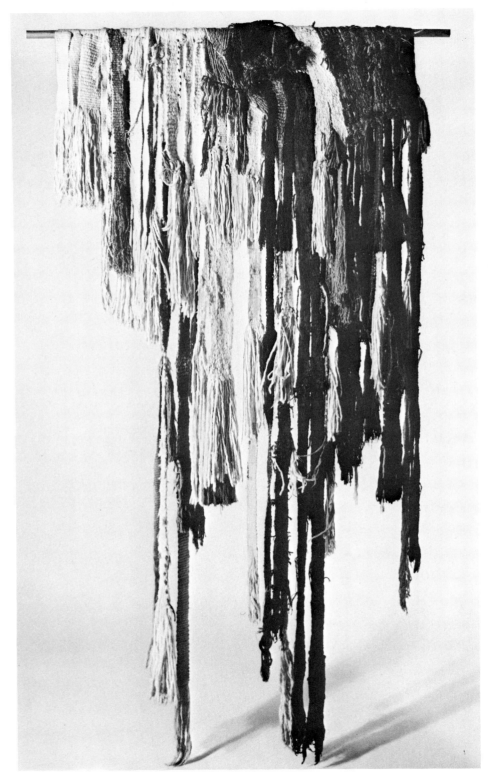

LILLIAN ELLIOTT

Card weaving is probably the oldest form of weaving, and is generally used for narrow bands or belts. *TITANIUM WHITE* (illustrated here) makes use of card weaving, intersecting itself and becoming alternately warp and weft. Some of the warps in this piece were bound and dyed before weaving.

birthplace: Detroit, 1930
education: Wayne State University (Detroit), B.A. •
 Cranbrook Academy of Art, M.S.A.
collections: Detroit Institute of Arts • Museum of
 Contemporary Crafts (New York) •
residence: Berkeley, California

I find the greatest artistic freedom in using card weaving because of its absolute simplicity.

—Lillian Elliott

TITANIUM WHITE: card-woven, silk: 96" x 46½": 1968

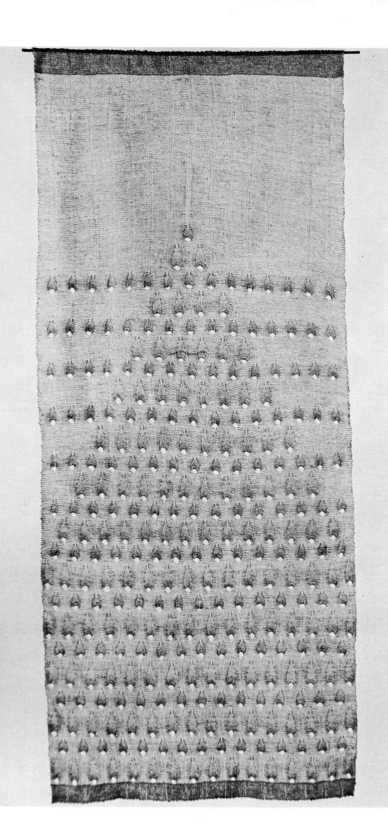

MARY WALKER PHILLIPS
In the field of nonwoven textiles, Mary Walker Phillips is an innovator. She has shown that knitting, long confined within workbaskets before cozy fires, need not be directly related to utilitarian objects. Knitting for its own sake can produce objects of delicate tranquil beauty. With a clear understanding of knitting and a great deal of experimentation with her materials, Phillips allows structure to speak for itself, becoming an integral part of her fabrics. The example illustrated here is one of the few pieces she has planned, and it was done with only minor changes as she was knitting. Miss Phillips has shown in most major national and international exhibitions in textiles.

birthplace: Fresno, California, 1923
education: Cranbrook Academy of Art (Michigan), B.F.A., M.F.A.
teaching: Numerous important workshops and summer craft schools
collections: Museum of Contemporary Crafts (New York) • Penland School of Crafts (North Carolina) • Cranbrook Academy of Art • St. Paul Gallery and School of Art • Museum of Modern Art (New York)
book: Step-by-Step Knitting (Golden Press, Inc.)
residence: New York, New York

Knitting as a technique for producing works of art is a relatively unexplored medium in the present day. A great deal of experimentation on my part with a variety of materials was done before I ever attempted to knit a large hanging. A clear understanding of the technique, its possibilities and limitations, is imperative. My training as a weaver has been invaluable.

—Mary Walker Phillips

NEAR EAST # 2: hand-knit panel of natural linen: 108″ x 46″: 1964

DOROTHY READE

Dorothy Reade's own comments give an insight into her aesthetics and involvement with knitting. 'The ability to produce ultra-fine hand-spun thread,' she states, 'led to the realization that the fabulous properties of hand-spun exotic fibers necessitated a break with traditional knitting techniques and designs.' Some of the results of this break are incorporated in the piece shown here. She maintains that there is still a place for elegance in the crafts as there is still a place for careful workmanship, especially in an evening stole meant to enhance the wearer.

This particular piece was inspired by the carved wooden posts on some of the Mexican-Indian storehouses (called 'trojes'). It contains two of the rarer elements in knitting, employment of ultra-fine hand-spun alpaca and generous use of the circle and curve, 'a technique almost nonexistent,' she says, 'and of which the knitting public seems to be unaware.'

birthplace: Seattle
book: 25 Original Knitting Designs (1968)
residence: Eugene, Oregon

TROJE: knitted, hand-spun natural black alpaca: 108″ x 25″: 1968 (detail)

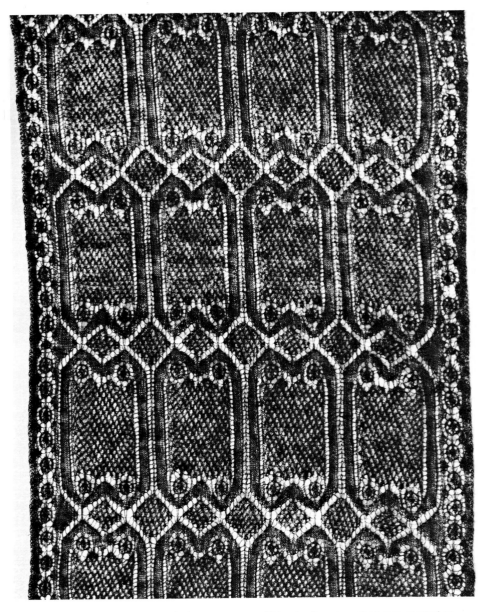

Knitting is universal, but the techniques and methods of communication have been at a standstill for over a century, so that designs have become stereotyped or simplified. Frustration and exasperation with these archaic methods led me over the years to gradually evolve a system of shorthand symbols, quick and easy to read and write, with the added attraction of being understandable (with a minimum of translation) in any language. An excellent indication of this is that the Eskimos on Nunivak Island, Alaska, are already using this system with apparently good results.

This shorthand method has proved so versatile it permits one to chart designs in advance, so that besides the creation of regular knitting designs, it has allowed me to transpose from one medium to another. For example: woven lace circa 100 B.C. and A.D. 1200 (Peru); seventeenth-century tapestry (Peru); architectural wood carving (Mexico); incised designs from an Eskimo harpoon blade (Alaska)—all of which have been worked out for the modern knitter.

—Dorothy Reade

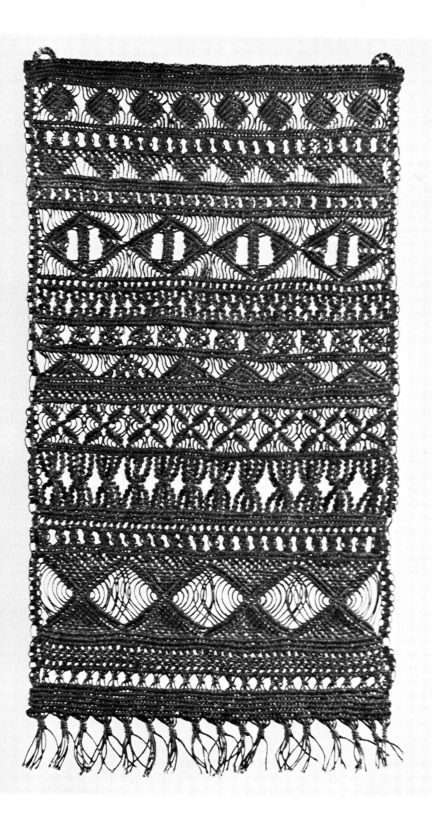

VIRGINIA I. HARVEY

Macramé has been rescued from the obscurity of Victorian trimmings and end finishes of Mexican shawls, and has been given a contemporary status by craftsmen such as Virginia Harvey. As preparator of the Costume and Textile Study Collection at the University of Washington, she has drawn on her accumulated knowledge of historic fabrics in promoting the revival of macramé. The patterns created by the juxtaposition of various knots in either tough linen or supple wool appeal to our contemporary enjoyment of an endless yet structured pattern. She has taught numerous workshops in weaving and macramé.

birthplace: Hot Springs, South Dakota
education: Mills College (Oakland, California) • University of Washington • Cornish School (Seattle)
book: Macramé, the Art of Creative Knotting (Reinhold, 1967)
residence: Seattle

WALL HANGING: macramé of black-brown upholsterer's linen: 19½″ x 10″: 1968

JOAN MICHAELS PAQUE

An awareness of form, unique concepts, and a sensitivity to the inherent qualities of fibers have enabled Joan Paque to make important contributions to the art of macramé. Her compositions of natural fibers are three-dimensional or done in relief. By enlarging the classical technique and loosening the knotting she has given her hangings a lightness and rhythmical delicacy. The work illustrated here is a good example of her interest in extending endlessly the possibilities of the technique.

birthplace: Menominee, Michigan, 1937
education: Layton School of Art (Milwaukee) • Marquette University (Milwaukee)
teaching: University of Wisconsin • Arrowmont School of Arts and Crafts. University of Tennessee. summer 1969 • Mount Mary College (Milwaukee), present
residence: Milwaukee

The piece illustrated here epitomizes my style. I control my medium, working within the inherent capabilities of the materials, capitalizing on its characteristics and designing within this context. I am constantly striving for objectivity of both work and self. I believe that art is the mirror of the soul and that every artist must strive for a personal integrity or his work will reflect the lack of it.
—Joan Michaels Paque

MONTAGE VARIATIONS: macramé, polished twine: 74″ x 14½″: 1968 (detail below)

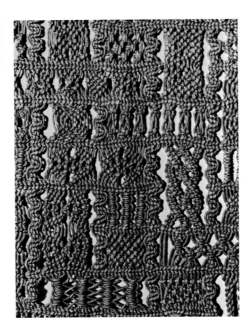

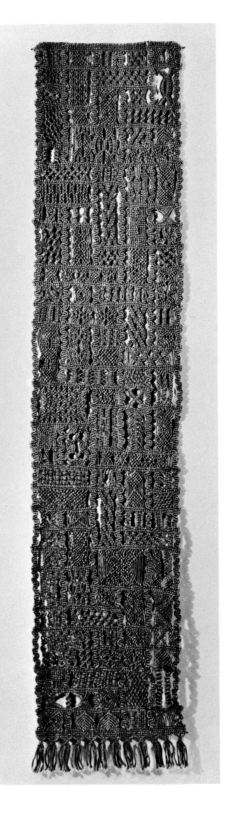

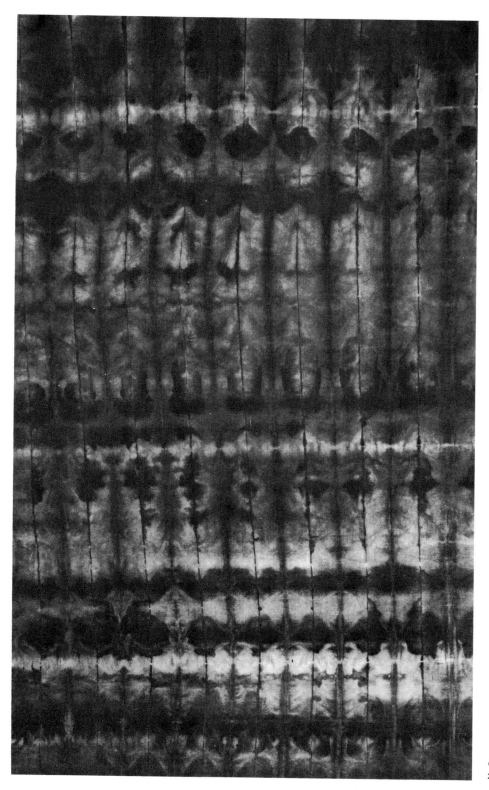

JACK LENOR LARSEN

Because Larsen believes that 'fabric design is a whole operation, not a blueprintlike projection,' he formed in 1952 Jack Lenor Larsen, Inc. This company set out to explore the design possibilities of combining hand and power weaving by converting to the power loom many costly hand-weaving operations. His main supporting tenet is that design should grow in natural beauty from the organic characteristics of the fiber to the ultimate function of the fabric. Larsen is a tastemaker whose design ideas branch out into architecture and fashion.

birthplace: Seattle, 1929
education: Cranbrook Academy of Art, M.F.A.
collection: Victoria and Albert Museum (London)
book: The Elements of Weaving (with Azale Thorpe) Doubleday, 1967
residence: New York, New York

CHIMU: fold dye on cotton velvet: 126½" x 50": 1965 (detail)

LENORE TAWNEY

Lenore Tawney is one of the most respected artist-weavers in the country, and one of the few who has had international influence. After her art education in Chicago, where Archipenko was one of her teachers, she started out to be a sculptor, and it was not until 1948, when she bought a second-hand loom, that she began to weave. She then studied for a while with Martta Taipale. Tawney is credited with being one of the first weavers—if not the first—to create three-dimensional hangings, thereby freeing the medium forever from functional uses or wall placements. One of her sculptured forms shown at the Seattle World's Fair in 1962 was twenty-seven feet high. She continues to explore within the arts, and an exhibition of her work today would include not only weavings, but drawings, collages, and boxes—all related by sensitivity to materials, be it paper, fiber, or feathers.

birthplace: Lorain, Ohio
education: University of Illinois, 1943–1944 • Institute of
 Design (Chicago), 1945–1946
collections: Museum of Contemporary Crafts (New
 York) • Art Institute of Chicago • Museum of
 Modern Art (New York) • Kunstgewerbemuseum
 (Zurich) • Cooper-Hewitt Museum of Design
 (New York)
residence: New York, New York

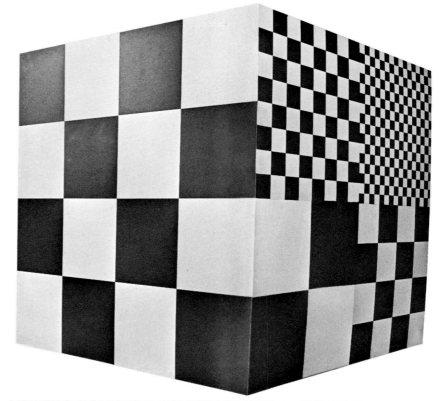

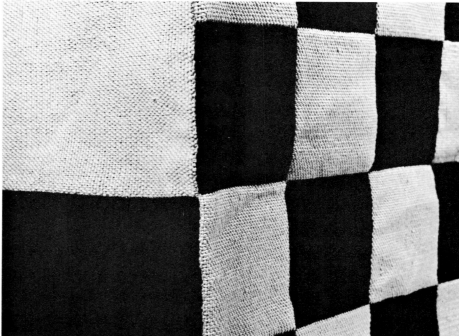

CUBED CUBE: woven construction of linen: 144″ x 144″ x 144″: 1969 (model above and detail below)

JUPITER: woven tapestry of silk and wool: 53″ x 41″: 1959

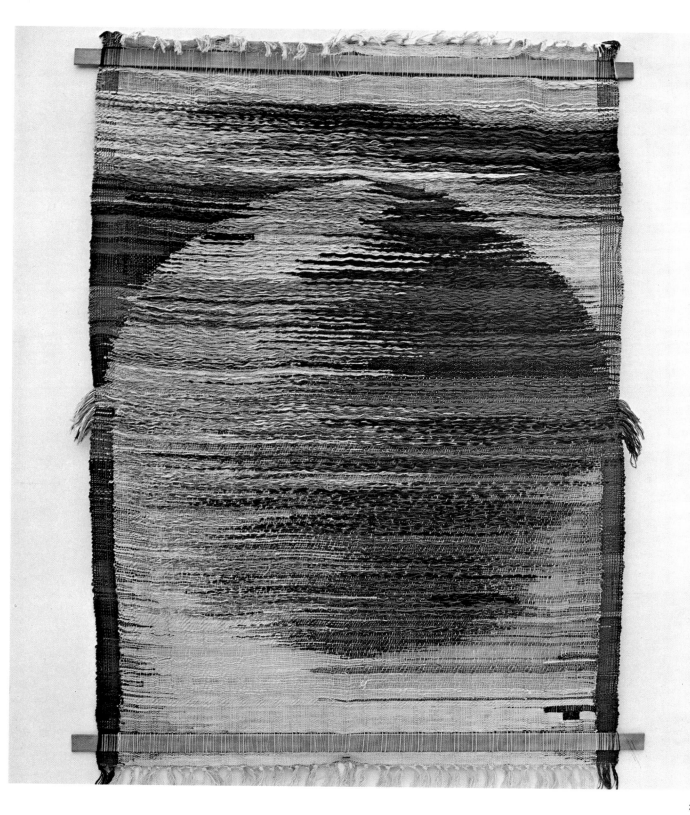

ALICE KAGAWA PARROTT

Alice Parrott, born in Hawaii of Japanese parents, came to the mainland in 1954 to study weaving at Cranbrook Academy of Art. Later she went to teach at the University of New Mexico, and eventually this state became her home. She married and settled in Santa Fe, where she and her husband have an outlet for production weaving that has established high standards in the field. Meanwhile Parrott continues her studio weaving, and her works have been shown in every major exhibition concerned with textiles. A recognized master of technique, her hangings particularly have been noted for their striking and dramatic color harmonics, undoubtedly influenced by the environments of both Hawaii and New Mexico.

birthplace: Honolulu, 1929
education: University of Hawaii, B.A. • Cranbrook
 Academy of Art, M.A. • University of Mexico •
 Pond Farm Workshop (Guerneville, California)
teaching: University of New Mexico
collections: Nordenfjeldske Kunstindustri Museum
 (Trondheim, Norway) • Museum of Contemporary
 Crafts (New York) • Museum of Albuquerque •
 Sheldon Memorial Art Gallery (University of
 Nebraska) • Victoria and Albert Museum (London)
residence: Santa Fe, New Mexico

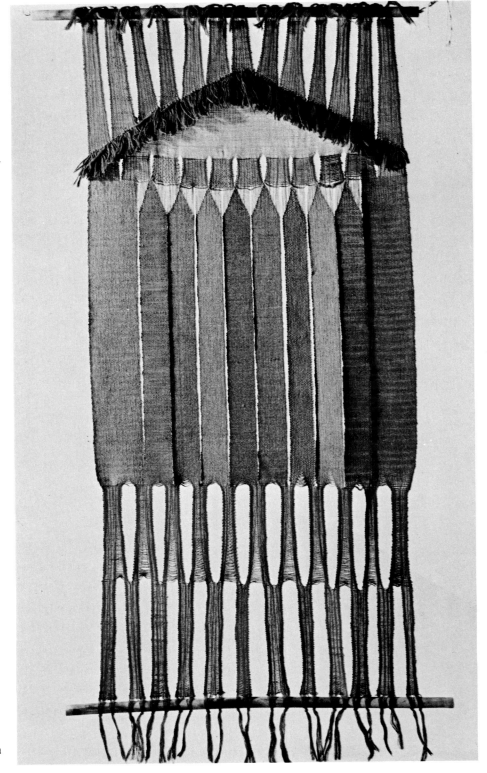

CAROUSEL: wool, split-wrap and rya
knots: 72″ x 30″: 1968

RAGNHILD LANGLET

Ragnhild Langlet came to this country a few years ago and settled in the San Francisco Bay area as a painter. But in order to get a teaching job—there were no painting jobs available—she had to return to the crafts which she had learned in her native Sweden as part of her general education. The return proved infectious, and she dropped her painting in favor of working with fibers. Her textile-printing, weaving, and embroidery techniques, plus her art training, led to the creation of some inventive new directions, particularly in embroidered and appliquéd panels. More recently Ragnhild Langlet has applied these techniques to works which also utilize acrylics and dyes, and by shaping her working surfaces she has produced painted wall sculptures. Although her works are usually untitled (or abstractly titled), there is no doubt but that most of the compositional references are concerned with the area where she works. Langlet lives on a boat moored in Sausalito, and from the deck one can view a wide stretch of the bay, and beyond Alcatraz rises San Francisco itself.

birthplace: Stockholm, 1934
education: Konstfackskolan
teaching: University of California, 1968
collections: Swedish National Museum • Rochester Institute of Technology • Intermountain Gas Company (Idaho)
residence: Sausalito, California

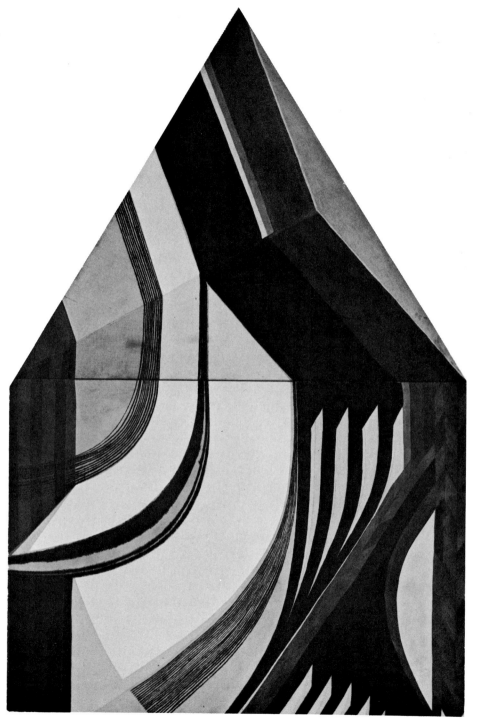

NUMBER ONE: Appliqué, vat dye painting, and acrylic: 119½″ x 72″: 1968–1969

TERRY ILLES

Terry Illes has made her most important contributions as a weaver with three-dimensional hangings. Her innate color sense and ability to suggest subject matter through abstracted form, joined with a technical mastery of the loom, have earned her a respected position in the field.

birthplace: Elwood, Indiana
education: Indiana University, A. B. 1955; M.A.T. 1957
teaching: Indiana University, present
residence: Bloomington, Indiana

Materials are frequently a lead into design and form. The character of a specific fiber suggests an idea which often is expanded into a series of four or five pieces.
Materials become less important and give way to the importance of color and shape when a covered warp tapestry is the piece of work at hand.
This naturally leads to contrasts in types of work. After completing a heavy, large piece it seems satisfying to turn then to a lighter, smaller project, just as it is satisfying to listen to contrasting types of music—a different joy in each instance—but all one in total.

—Terry Illes

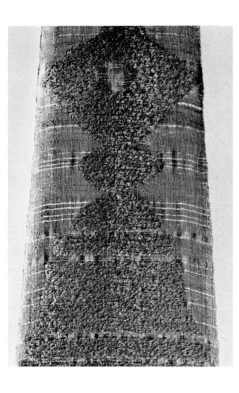

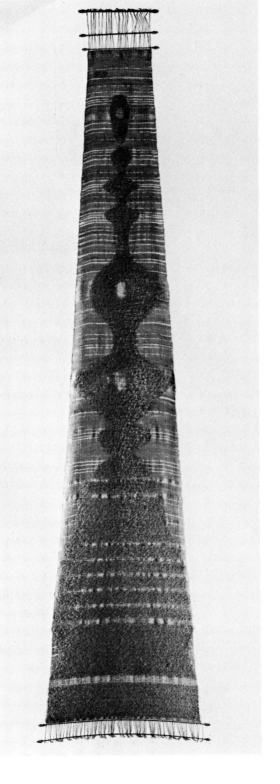

THAI SPIRE: Thai silk, loop mohair, and fine wool weaving: 92¾″ high: 1967 (detail above)

NANCY BELFER

Nancy Belfer established herself first as a painter—with several one-man exhibitions in Rochester in the fifties—but more recently, after studying weaving and serigraphic techniques, her interest in textiles deepened. Belfer was one of the first artists to create fabric-collage and stitching panels and to stretch them as a painter would a canvas.

birthplace: Buffalo
education: Albright Art School (Buffalo) • State University of New York (Buffalo), B.S. • School for American Craftsmen (Rochester), M.F.A.
teaching: State University College at Buffalo
residence: Buffalo

The circular panel illustrated here reflects the lines of attitudes and qualities that have pervasively guided my work for the past several years. On a background of yellow wool, fragmented pieces of tapestry and woven cloth are used in both flat and relief appliqué. Based loosely on primitive symbols, the stitching is used to define shape, as well as in a linear manner serving to relate the more vigorous collage elements. Areas of hooking and knotting suggest solidity and bring a relieflike quality to the richly varied textural surface. The colors are strong and warm—yellows, oranges, golds, with some black and red.

Yarns, cloth—the media of fibers—offer abundant opportunities for building a uniquely expressive visual and tactile imagery. The materials in themselves are commonplace and familiar, and their techniques part of an ancient tradition of hand weaving and hand embellishment. My work begins with a bringing-together of certain kinds of yarns and fragments of cloth selected from a haphazard assortment of possibilities. Then, awareness and response. By color, by weight, by surface, by juxtaposition, the materials indicate direction—direction in technique as well as toward a particular mode or language. Thus, the work evolves, with a kind of organic complexity, into a coherent statement.

—Nancy Belfer

ANCIENT SHIELD NOTATIONS: cloth collage with stitching: 36½" diam.: 1969

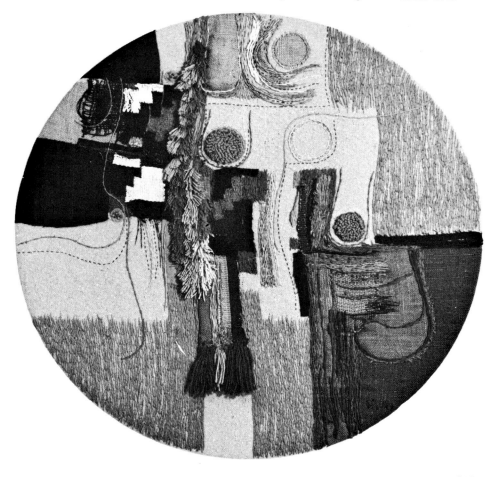

MARIE TUICCILLO KELLY

Artist-craftsmen today differentiate between embroidery and stitchery—the latter being the expression of an individual who is not necessarily committed to using the traditional embroidery stitches and materials. Stitchery for Marie Tuiccillo Kelly has assumed a new meaning—stitched forms. Trained as a painter and calling herself a 'Pittsburgher,' Kelly soon dropped her paints to take up a tool she considered more challenging, the needle. At first her work was closely related to paintings, and she employed yarns, strings, and ropes on burlap peanut bags, which are made of an open tough quality of jute. Today she creates boxes containing cloth, string, and 'web-things.' Some of her pieces combine painting, while others are free-standing or hanging forms.

birthplace: Pittsburgh, 1916
education: University of Pittsburgh, B.S. • Carnegie Institute of Technology
collections: Museum of Art, Carnegie Institute • Butler Institute of American Art (Youngstown, Ohio) • Westmoreland County Museum of American Art
residence: Pittsburgh

THE PARLOR: cloth, string, and wood construction: 14¾″ x 19¾″ x 7¼″: 1966

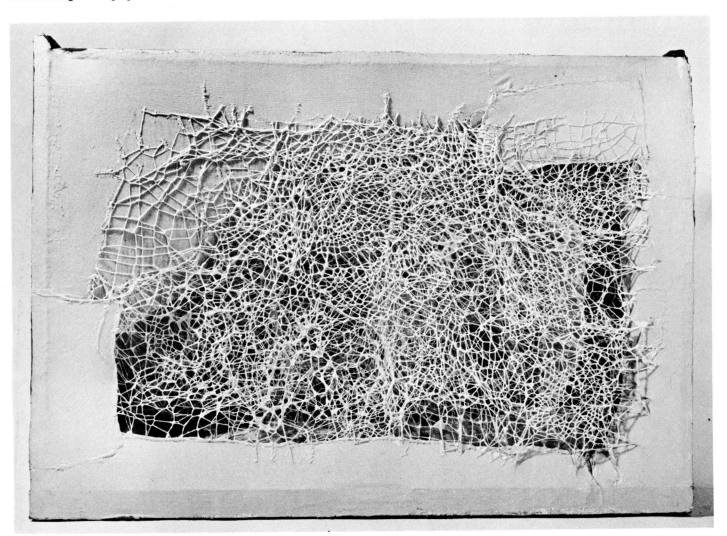

314

SUSAN LONG
Besides working with fabric compositions, Susan Long paints. She is also a dancer and choreographer. Her compositions, collages, and constructions she calls 'dream effigies.' In order to accomplish all the things she wants to do she has also given up the confines of the loom.

birthplace: San Diego, 1943
education: San Diego State College, B.A. 1965 ·
 Haystack Mountain School of Crafts (Maine), 1966
teaching: University of California (San Diego)
residence: Alpine, Texas

FLORA'S PILLOW: EVEN THE PRETTIEST SHOE MAKES A SORRY HAT: sewing and cloth collage: silk satin, mother's wedding lace, Old Mill cigarette print: 9″ x 11¼″: 1968

My work is regional, with no exception. . . . I pick up things, mostly old, rusty and weathered stuff. . . . I also like to collect certain things in second-hand stores. . . . I like to lay down a visual structure from the start. . . . Although my use of various media is expanding, my point of reference is closing in to a point of intensity, which I hope to close in even more.

—Susan Long

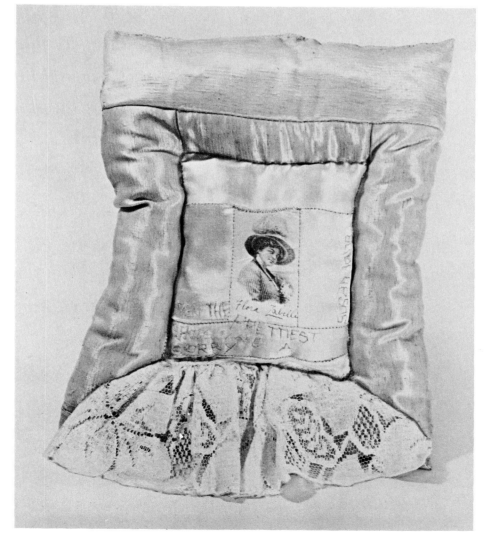

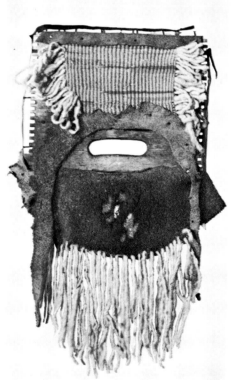

EARTH THING WITH LEATHER #1: weaving (sumak technique), leather, wood, homespun wool: 27″ x 13¼″: 1967

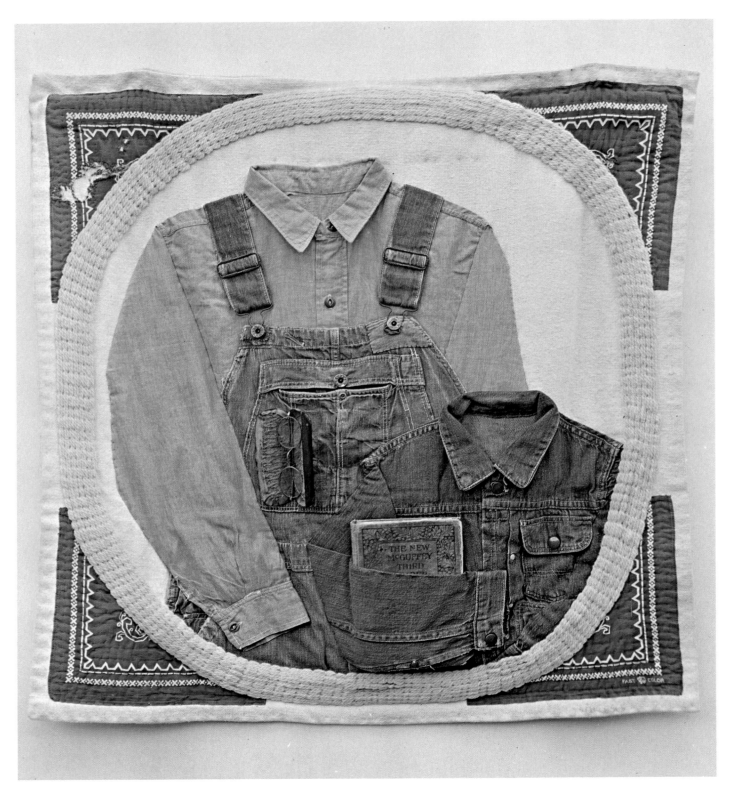

ALMA W. LESCH

Alma Lesch does not limit her materials to traditional wool and linen. In one of the examples illustrated here, for instance, she has used blue and natural-white: overalls, a shirt, overall jacket, eye glasses and case, third-grade McGuffey *Reader,* a bandana handkerchief, and stitchery on heavy cotton. Many of these materials are typical of Kentucky, where she grew up and where she still lives with her husband. Lesch has been working within a Biblical theme on and off for many years. In addition to devoting much time to her craft, she teaches classes in textile design at the Louisville School of Art, where she has been an instructor since 1961. She is credited with being one of the first artists—along with Marilyn Pappas—to create pictorial hangings utilizing stitching with found objects.

birthplace: McCracken County, Kentucky
education: Murray State University (Kentucky), B.A. 1941 • University of Louisville, M.E. 1962
teaching: Haystack Mountain School of Crafts (Maine), summer, 1966 • Louisville School of Art, present
residence: Shepherdsville, Kentucky

LIKE FATHER, LIKE SON: fabric collage: 32½" x 32½": 1967

BATHSHEBA'S BEDSPREAD: stitching and appliqué: 98" x 80": 1968

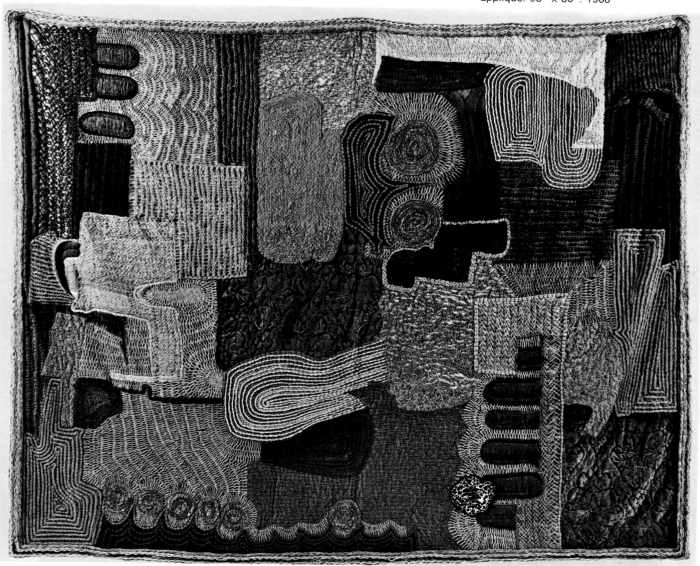

NIK KREVITSKY

Using stitchery and transparent fabrics, Krevitsky has refined his statement in painterly terms. His linear compositions with thread and yarns darting through the space of his framed surfaces have won him numerous awards, and his work is to be found in many collections. He has also made valuable contributions in the field through his magazine articles, through his teaching, and through the books he has written on arts and crafts. Krevitsky also works in large scale in the medium of enamel for architectural settings.

birthplace: Chicago, 1914
education: University of Chicago, A.B. • Columbia
 University, M.A., Ed.D.
books: Batik: Art and Craft (Reinhold, 1964) •
 Stitchery: Art and Craft (Reinhold, 1966)
residence: Tucson, Arizona

NIGHT: stitchery with appliqué: 30'' x 30'': 1966 (detail below)

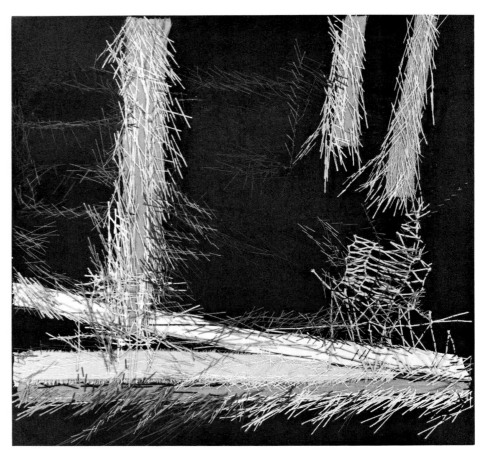

ADELA AKERS

Most of Adela Akers's life prior to her introduction to weaving was spent in Spain and Cuba. Later she worked directly with Peruvian Indians in the Andes and with weavers in several Mexican villages. She considers these experiences as plenishment of her heritage, and it is not surprising that she draws much of her inspiration for patterns and colors from these countries. Adela Akers is presently craftsman-in-residence at the Penland School of Crafts, North Carolina, where she wove the piece illustrated here.

birthplace: Santiago de Compostela, Spain, 1933
education: University of Havana (Cuba) • School of the
 Art Institute of Chicago • Cranbrook Academy
 of Art
teaching: Penland School of Crafts (North Carolina),
 summer, 1968
residence: Penland, North Carolina

SHIELD OF A NEW STANDARD: woven
wool, cowhair, linen: 76″ x 52″: 1968

MARILYN R. PAPPAS

Pappas has shown in most major national textile exhibitions, and is credited, along with Alma Lesch, with being among the first artists to combine 'found objects' with stitching in the creation of pictorial hangings. She claims that no single influence has dominated her work, but she has been subjected, enthusiastically, to such varied influences as San Blas Indian molas, Rauschenburg assemblages, Schwitters collages, and Matisse's use of space.

birthplace: Brockton, Massachusetts
education: Massachusetts College of Art, B.S. •
 Pennsylvania State University, M.Ed.
teaching: Pennsylvania State University • Miami Dade
 Junior College, present
collections: Edinboro State College (Pennsylvania) •
 Pennsylvania State University • Krannert Art
 Museum (University of Illinois)
residence: Miami, Florida

My approach seems to be based mainly on visual aspects of the work. Pieces of clothing, fibers, and fabrics that are available to me begin to suggest possibilities. Any philosophical or psychological motivations are on a subconscious level.

There are no tricks involved in the production of my work. Once a general design or motif has been established (perhaps suggested by an existing object or objects), the stitchery grows more or less spontaneously, and may frequently involve the changing of the original design by removal or addition of objects and stitchery.

The opera coat, by itself, was to me an elegant and appealing object. I wished to involve myself more completely with it by producing a work of my own upon it. In so doing, I did not wish to change its basic character.

—Marilyn R. Pappas

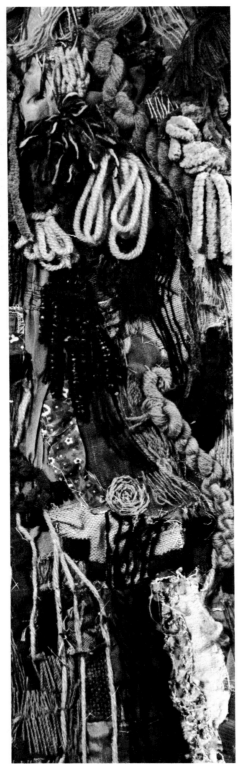

OPERA COAT: fabric collage and stitchery: 62″ x 45″: 1968 (detail at left)

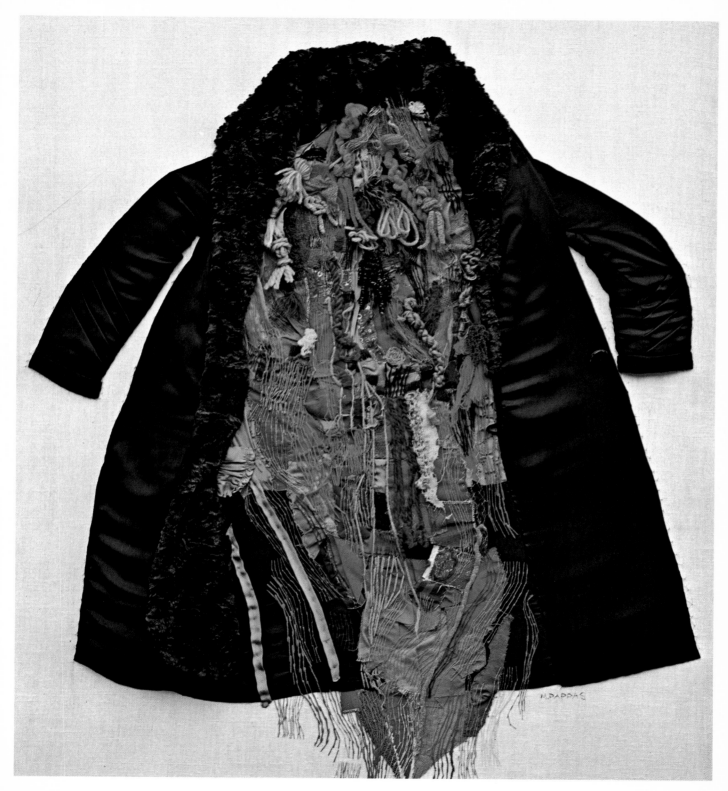

RUTH MARY PAPENTHIEN

Ruth Papenthien, who has studied both in this country and Sweden, indicates that her inspiration is derived mainly from architectural motifs and nature. From the latter she finds ways to break through the emphatic structure of a weave by incorporating the light and color of the outdoor world. For example, *COLUMNS OF VERNAL LIGHT,* illustrated here, evokes the changing moods of the forest. She has also emphasized the slits in tapestry to free her surfaces and thereby introduce a flow of light.

birthplace: Milwaukee
education: University of Wisconsin, B.A. • Konstfackskolan
(Stockholm) • Cranbrook Academy of Art, M.F.A.
teaching: Alverno College (Milwaukee) • Ohio State
University
residence: Columbus, Ohio

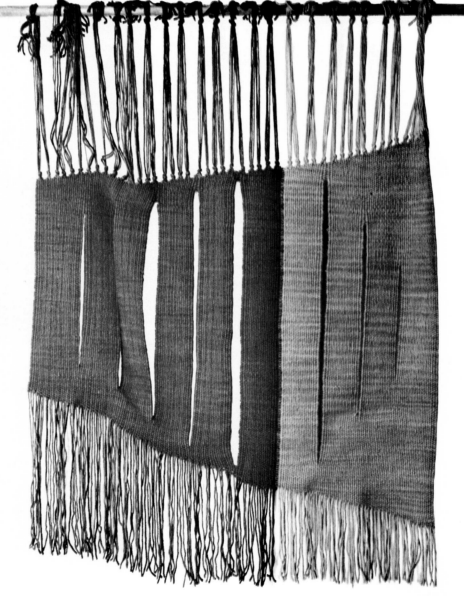

COLUMNS OF VERNAL LIGHT: hand-dyed
weaving: 72″ x 48″: 1967

322

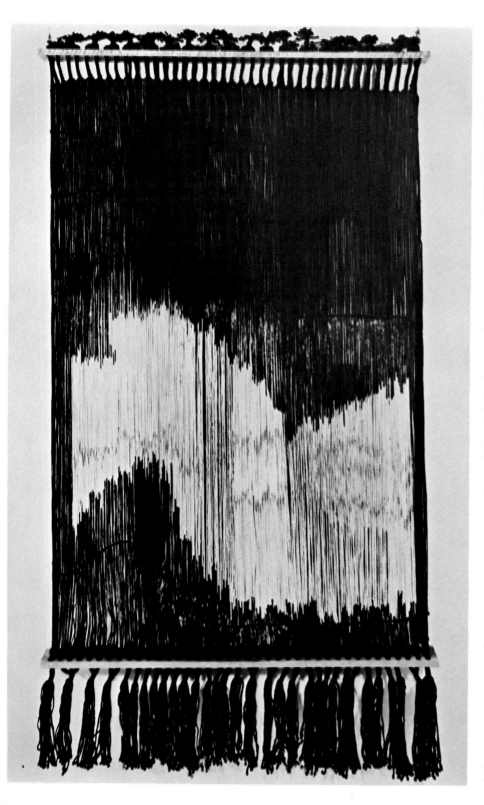

CYNTHIA SCHIRA
Within the past decade weavers have turned increasingly to nonweaving techniques. Some of these include knitting, crocheting, and macramé—not to mention fabric-embellishing techniques such as stitchery and tie dye. The loom in many cases is the simplest of tools. Schira has explored weft twining—a technique in which two or more strands continuously twist around warps to produce a fabric. Areas of weft twining can be built up to cover warps completely or used simply to hold warps in place. In *IKAT WITH WALNUT*, illustrated here, predyed warps have been held together by weft twining and given a third dimension with the addition of a second layer.

birthplace: Providence, Rhode Island, 1934
education: Rhode Island School of Design, B.F.A. 1956 •
 L'Ecole d'Art Decoratif (Aubusson, France),
 1956–1957 • University of Baroda (India), M.S. •
 University of Kansas, M.F.A. 1967
residence: Lawrence, Kansas

IKAT WITH WALNUT: off-loom, weft-twined jute: 79″ x 40″: 1968

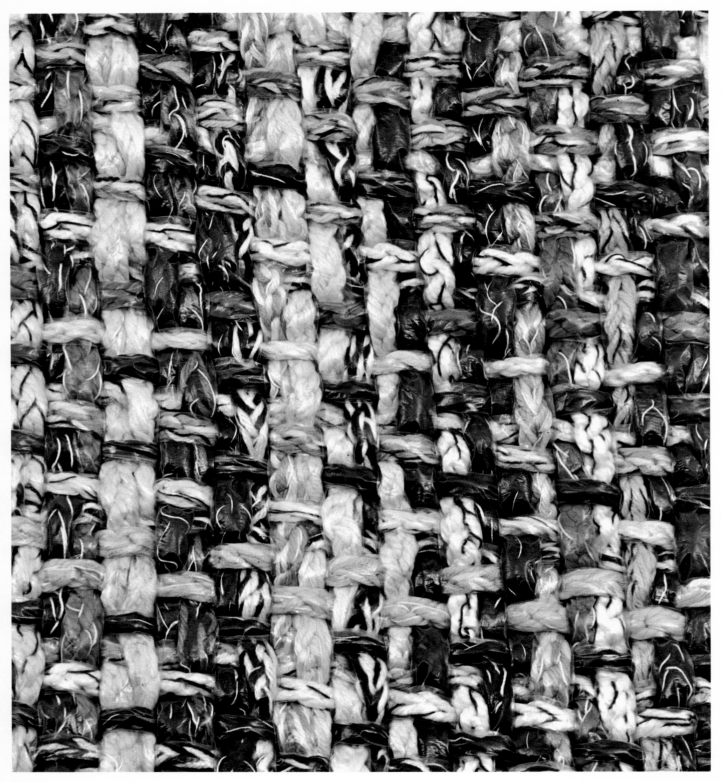

ED ROSSBACH

Rossbach is mainly concerned with exploring the aesthetic problems of textiles, and has no interest in their utilitarian aspects. To a large extent this attitude reflects his educational and teaching background. His interest in and personal involvement with new and unexpected materials is combined with a lively sense of humor. 'Wall Hanging' has become *HANGING WALL*, and a basket has been given a life of its own as simply structure on an armature. Rossbach's work reveals his interest in ancient Peruvian techniques, which he has translated into a contemporary and personal idiom. Plastic tubes stuffed with 'foreign' nonfabric material have been woven in an ancient Peruvian manner with four selvedges. Whether his work is woven or nonwoven, as in the braided, light and airy *NEW IRELAND*, Rossbach is serious yet whimsical. (continued on page 326)

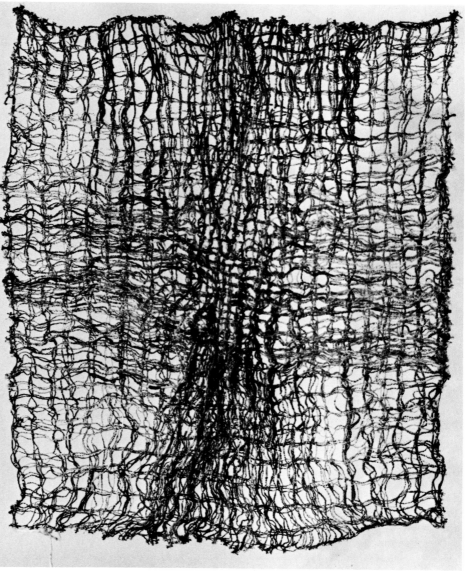

NEW IRELAND: braided plastic and twine: 59″ x 44½″: 1965

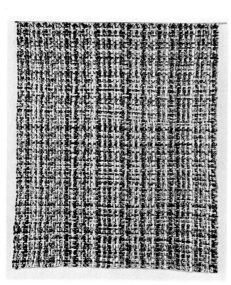

HANGING WALL: woven plastic: 92″ x 111″: 1969 (color detail at left)

Having studied painting, design, and ceramics, Rossbach makes no distinction between fine arts and crafts. His production has included upholstery, suiting, and rugs, for which he has won top awards in international exhibitions. In the early fifties he became interested in raffia, and in the mid fifties, in tie-dye and ikat techniques as well as in nonwoven forms. Recently he has begun to think about the possibility of a 'textile environment' and of having, for example, a collection of pure, woven textiles—cotton, linen, etc.—moving past each other in such a way as to produce sounds. 'I want to amplify these sounds, put them on tapes, chop up the tapes, and then create musical compositions from the sounds and use them in conjunction with textile environments. You could build your whole world of textiles. . . . There is no telling what textile environments would be like.'

birthplace: Chicago, 1914
education: University of Washington, B.A. 1939 •
 University of California, 1950
teaching: University of California (Berkeley), present
collections: Museum of Modern Art (New York) •
 Krannert Museum (University of Illinois) •
 California State Fair • Women's College of North
 Carolina
residence: Berkeley, California

Ed Rossbach:
BASKET WITH HANDLE: raffia over wire
frame: 11½″ high: 1966

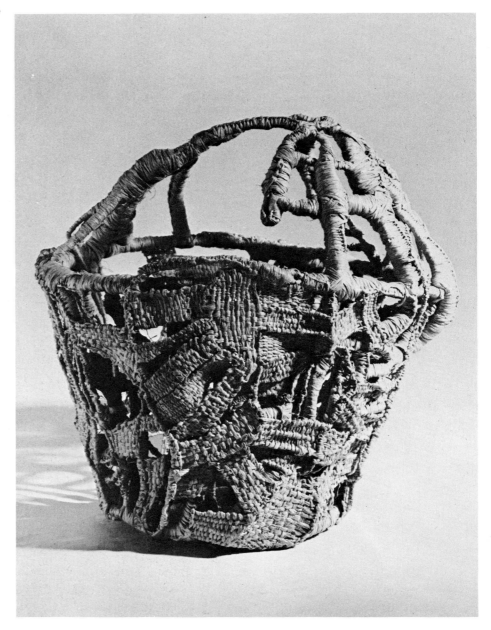

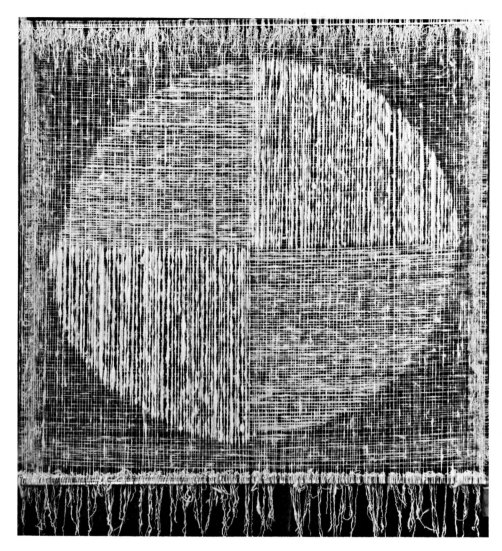

UNWOVEN TAPESTRY: hand-spun wool; two layers of exposed warp with differential of twist: 53" x 53": 1969

SUSAN WEITZMAN

To extend the aesthetic qualities inherent in yarn texture, Susan Weitzman has done much exploration with the potentials of materials as well as with methods of construction. The preparation of her yarns, especially the drop-spindle hand spinning which she has been utilizing, has permitted a flexibility of handling which is evident in her present work. The technique gives a luminous depth to the essentially simple composition, and the work communicates the directness of the approach to structure as well as the feeling of and for the materials used. The sophistication of the present-day aesthetic combined with the directness of the folk past merge in a subtle blending in UNWOVEN TAPESTRY, which is illustrated here.

Susan Weitzman has exhibited extensively throughout this country and abroad, and her work has appeared in numerous craft publications.

birthplace: Montgomery County, Pennsylvania, 1931
education: Smith College, B.A. 1953 • New York
University, M.A. 1958
collection: Museum of Modern Art (New York)
residence: New York, New York

NAOKO KUWAHARA

One of the youngest weavers represented in the book, Naoko Kuwahara has been a resident of the U.S. since 1965. Her fabrics range from gossamer linear panels to *EN #3* (illustrated here), a double-woven fabric with long, hanging knotted strands. She has in a short time developed a fine sense of craftsmanship combined with dramatic flair.

birthplace: Tokyo, 1941
education: Tama Fine Arts College (Tokyo), B.F.A. 1964 • Cranbrook Academy of Art, M.F.A. 1967
teaching: University of Illinois
residence: Champaign, Illinois

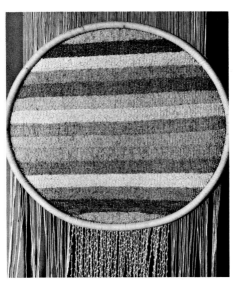

EN #3: double-weave hanging with knotting: 145½″ x 37″: 1969 (detail above)

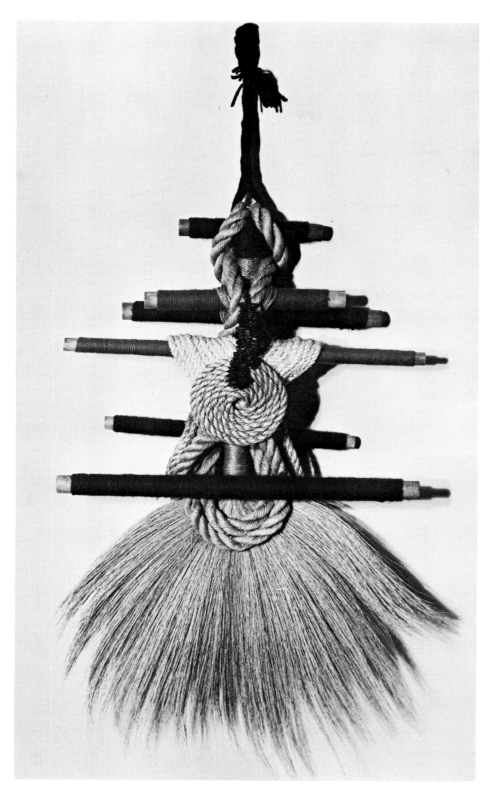

JANET KUEMMERLEIN

Janet Kuemmerlein is a younger artist who has been trained in painting, drawing, silversmithing, metalsmithing, and sculpture. Along the line she also learned the techniques of stained glass and a variety of textile approaches. Her work has been shown in several major national shows, winning her three awards. Several galleries show her work with regularity, and she has been mentioned in several magazines, including *Craft Horizons*. The work illustrated here is from a current series occupying Kuemmerlein, a hanging of mixed fibers suggesting a fetish or hex symbol.

birthplace: Detroit, 1932
education: Detroit Society of Arts and Crafts • Cranbrook Academy of Art
commissions: Copper and brass sheet sculpture, Lincoln University (Missouri) • Textile wall hanging, St. Paul's Episcopal Church (Kansas City) • Knotted wall hanging, dormitory of Rochester Institute of Technology • Series of four liturgical banners, St. Patrick's (Kansas City) • Chancel stitchery, Faith Lutheran Church (Kansas City)
residence: Prairie Village, Kansas

CONSTRUCTION: rope, wool, yarn, seeds, Philippine straw: 44¼" high: 1969

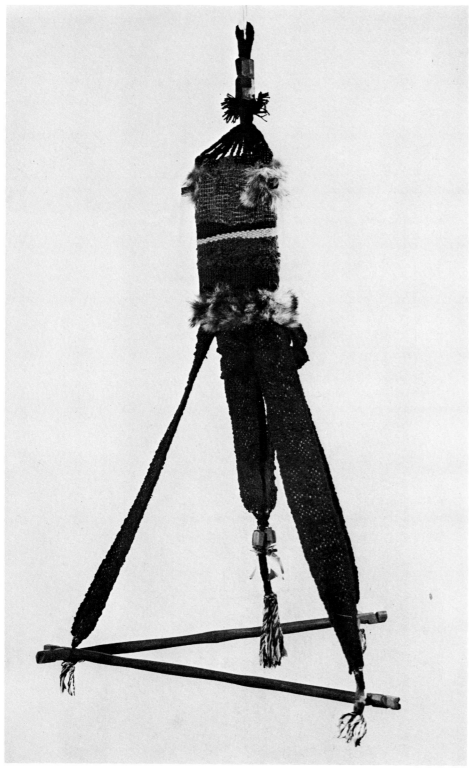

ANNA KANG BURGESS

Hanging constructions in mixed media
mark a relatively new direction in the work
of Anna Burgess, who is well known for
her woven rugs and wall hangings. A
native Hawaiian, Mrs. Burgess has taught
weaving at several institutions and for a
period was a designer for Dorothy Liebes
Textiles in New York. Her work has been
represented in a number of invitational
exhibitions.

birthplace: Oahu, Hawaii, 1930.
education: University of Hawaii, B.A. 1952 • Cranbrook
 Academy of Art, M.F.A. 1953
teaching: University of Hawaii, 1954–1956 • Cranbrook
 Academy of Art, summer, 1958 • Cleveland
 Institute of Art, 1958–1959
collections: Joslyn Art Museum (Omaha) • St. Paul
 Gallery and School of Art • Flint Institute of Arts
residence: Carmel, California

HANGING CONSTRUCTION: wool, fur,
metal, carved wood: 60″ high: 1967

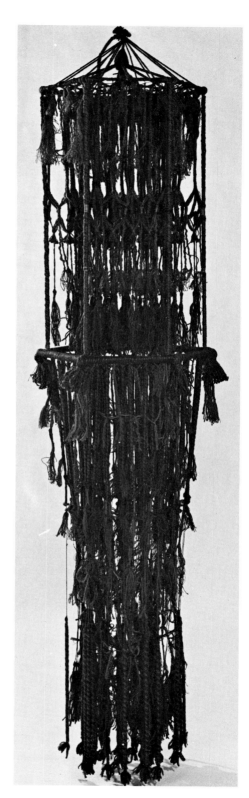

NEDA AL-HILALI

Al-Hilali brings a European and Middle-Eastern tradition to the American scene. After leaving Czechoslovakia the artist received her formative art training in London, Munich, and Baghdad, and in 1961 she immigrated to the U.S. She did not begin to work seriously with fibers until she attended the University of California in Los Angeles and came under the influence of Bernard Kester, although she states that 'all my life I had been influenced by and had practiced various local textile crafts.' In the past few years her ambitious large constructions involving many techniques (the work shown here represents an experiment in three-dimensional lace) have not gone without notice, and she has won several awards and prizes.

birthplace: Czechoslovakia, 1938
education: University of California (Los Angeles), B.A., M.A. 1968
residence: California

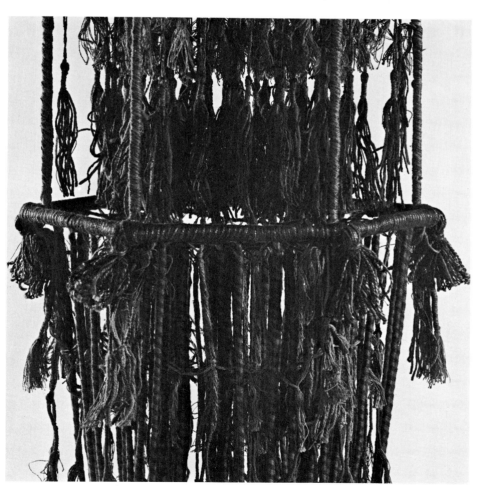

RIKAATH: lace of wool, cotton, linen: 100''
high: 1968
(detail above)

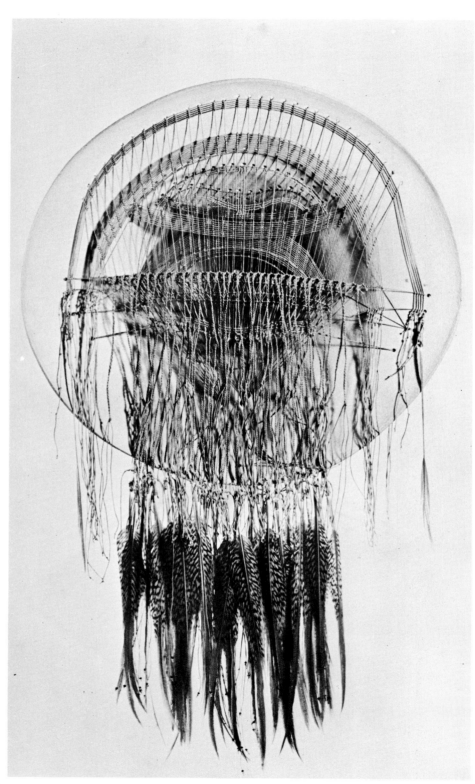

MASK: clay with linen thread and feathers:
8¼'' wide: 1968

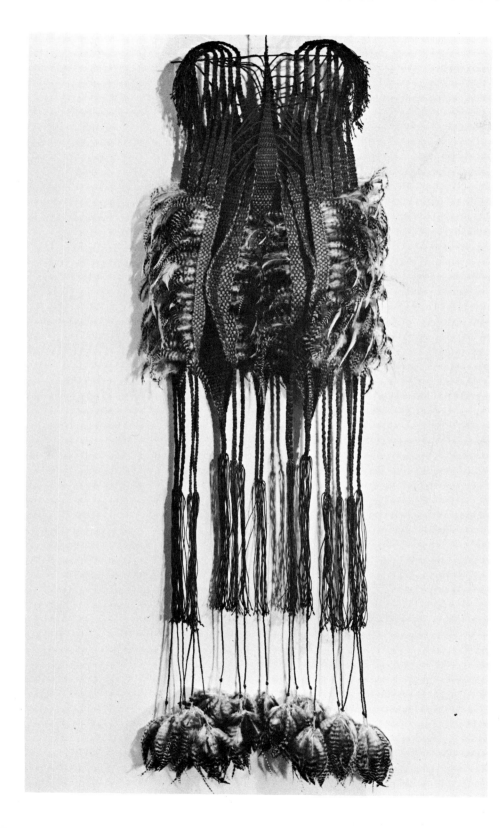

DOMINIC DI MARE
Unconcerned with production and the demands of output, Dominic di Mare concentrates on pure personal expression. Some of his forms are three-dimensional and are allowed to move to establish changing relationships with the viewer, while others set up spatial settings with specific emotional impacts.

His personal use of color, ceramic shapes, and foreign objects, such as feathers, helps identify his one-of-a-kind statements.

Dominic di Mare spends much of his time teaching young people in San Francisco, leaving his summers free for his own work.

birthplace: San Francisco, 1932
education: California College of Arts and Crafts,
 1950–1951 • Monterey Peninsula College,
 1951–1953 • San Francisco State College,
 1953–1955, 1958–1959 • Rudolf Schaeffer
 School of Design, 1963
teaching: San Francisco Unified School District, present
collections: Museum of Contemporary Crafts (New
 York) • St. Paul Gallery and School of Art
residence: Tiburon, California

FORM: woven linen, jute, wool, feathers:
70″ high: 1966

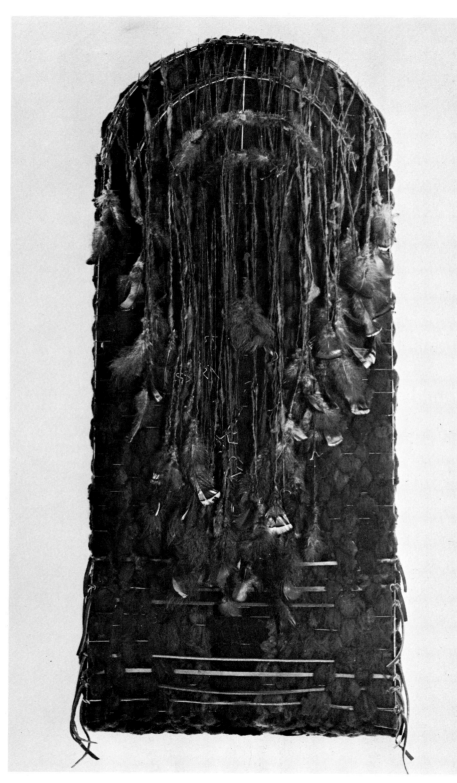

MARILYN MILLER HEIMOVICS
Marilyn Heimovics is a new talent in the field of fiber, and like so many recent university graduates she has immediately adopted the medium for three-dimensional constructions. She has also exhibited sculpture, jewelry, ceramics, and etchings. With her engineer husband Jack, she has opened a studio called T.H.A.T. (the Heimovics Art and Technology studio) in Silver Lake, Ohio. T.H.A.T. produces metal crafts and decorative furnishings both for the retail market and for architectural commissions.

birthplace: Lawrence, Kansas
education: University of Kansas • Washburn University •
 Kent State University (Ohio), B.F.A. 1968
residence: Silver Lake, Ohio

DAKOTASLED: welded steel; feathers; hand-dyed, carded, and spun wool: 58" x 24": 1968

WALTER G. NOTTINGHAM

Nottingham's woven, crocheted, and macramé forms reflect his reactions to his environment. 'I feel pain from my world—I scream, but it does not relieve the pain. I don't know what I want, but I am constantly finding what I don't want. I search for the forms of things unknown. Fabric can and often does have within its aura a pent-up energy, an intense life of its own. I am not trying to make the visible seen, but the unseen visible.' Nottingham has traveled extensively throughout the U.S. and Europe.

birthplace: Great Falls, Montana, 1930
education: St. Cloud State College (Minnesota), B.S., M.S. • Michigan State University • University of Minnesota • Haystack Mountain School of Crafts (Maine) • Cranbrook Academy of Art, M.F.A.
teaching: Wisconsin State University, present
residence: River Falls, Wisconsin

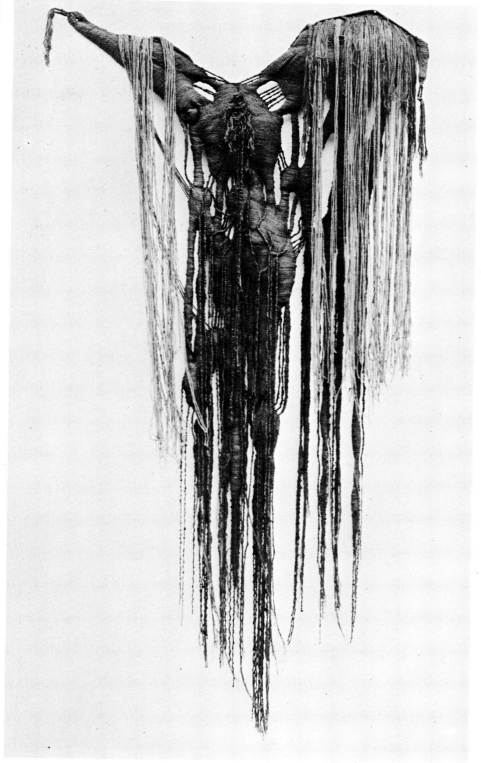

SOUL TOUCH: multiple weave of wool, rayon, jute, linen: 114″ x 60″: 1968

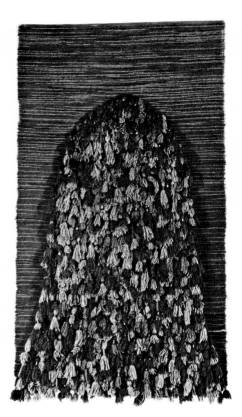

DARK PRAYER RUG: wool: 116" x 67":
1968

SHEILA HICKS

Sheila Hicks, born in Nebraska and now
living in Paris, studied painting with Josef
Albers and Rico Lebrun at Yale University.
Her M.F.A. thesis, 'Pre-Incaic Textiles,'
was supplemented in 1957, with the aid of
a Fulbright, by weaving research in Peru,
Bolivia, Ecuador, and Chile. She then lived
and studied in Mexico for five years and
traveled and worked in India in both 1966
and 1969. In 1967 she founded the Atelier
des Grands Augustins in the ancient
Passage Dauphine of Paris. She considers
that her home now but travels annually
to Chile, where she directs the weaving
cooperative workshop of Hacienda
Huaquen.

It can be said that she is limited only
by thread—but what she is able to do seems
limitless. Her work is deeply rooted in
searching for a sound and rational structure
which will enable poetic liberties. Many of
her inspirations can be traced to ancient
Andean sources—twining, looping,
wrapping, knotting, braiding (all nonloom
techniques). When she does employ the
loom, the structural methods used are
straightforward and self-evident, as in
the woven base of DARK PRAYER RUG, a
notable, mysterious presence. An example
of threads manipulated, THE PRINCIPAL
WIFE GOES ON, is an assemblage of
eleven fifteen-foot linen branches or coils
grouped, wrapped, grafted together. It
expands our appreciation of what yarn is
and what it can do in changing spatial
juxtapositions and environments.

birthplace: Hastings, Nebraska, 1934
education: Yale University • Universidad de Chile
residence: Paris, France

THE PRINCIPAL WIFE GOES ON: eleven
elements of linen, silk, wool, and synthetic
fibers, spliced and grafted: each element
180" long: 1969 (color detail at right)

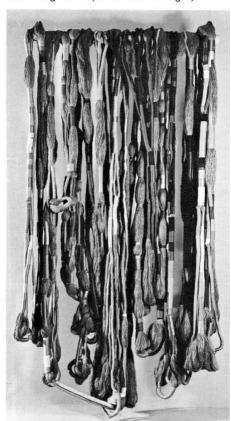

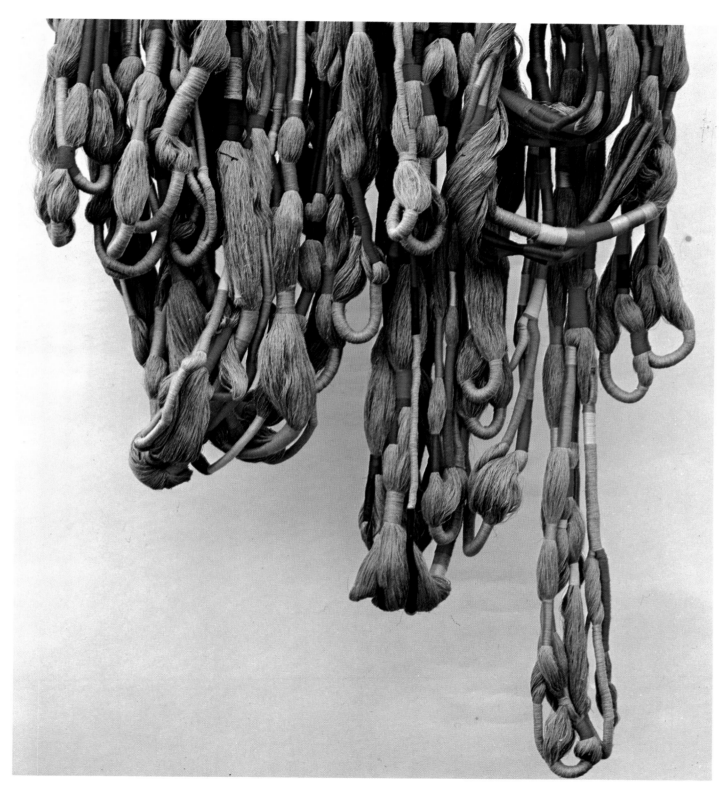

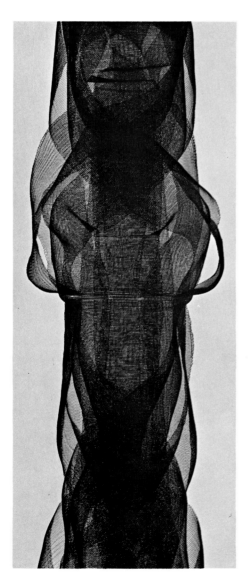

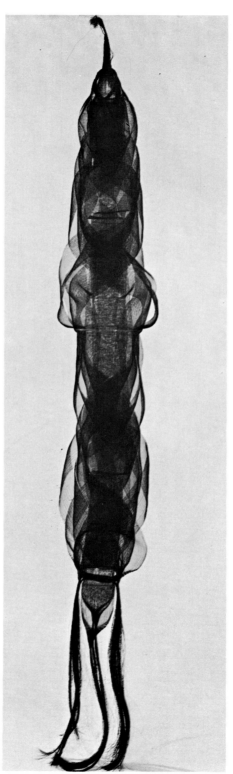

KAY SEKIMACHI

Kay Sekimachi has in the past several years been represented in major weaving exhibitions in all parts of the country and is included in several important private collections. Her most recent pieces, such as *NAGARE III* (illustrated here), are magically light and as transparent and absorbing as a rippling stream of water. This is one of the few woven forms which can be defined as a three-dimensional sculpture. Sekimachi has been one of the first artists to experiment with the synthetic strand monofilament.

birthplace: San Francisco, 1926
education: California College of Arts and Crafts •
 Haystack Mountain School of Crafts (Maine)
teaching: California College of Arts and Crafts,
 summers, 1958–1962 • Mendocino Art Center,
 summers, 1964–1967
collections: Oakland Art Museum • San Francisco State
 College • St. Paul Gallery and School of Art
residence: Berkeley, California

NAGARE III: woven nylon monofilament:
87″ high: 1968
(detail above)

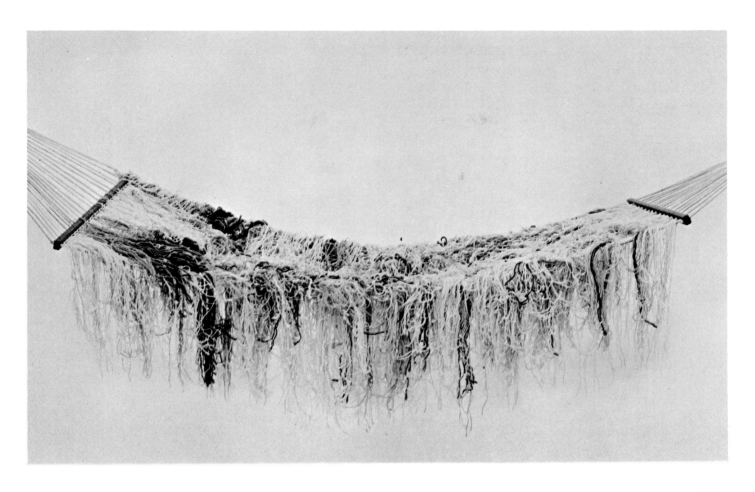

HAMMOCK: knotted wool and cotton: 83″ long x 48″ deep: 1967

TED HALLMAN
Anyone reclining in Hallman's hammock could not fail to sense the artist's feeling for yarns—the way they move suspended in space or fall loosely on a surface. Well known for his fabrics and nonwoven forms, Hallman is a respected teacher and is presently head of the weaving department at Moore College of Art (Philadelphia). (See also under PLASTIC.)

birthplace: Bucks County, Pennsylvania, 1933
education: Tyler School of Fine Arts (Philadelphia), B.F.A. • Cranbrook Academy of Art, M.F.A.
teaching: Moore College of Art, present
collections: Cooper-Hewitt Museum of Design (New York) • Victoria and Albert Museum (London) • Museum of Contemporary Crafts (New York) • Addison Gallery of American Art (Andover, Massachusetts) • Smithsonian Institution
residence: Souderton, Pennsylvania

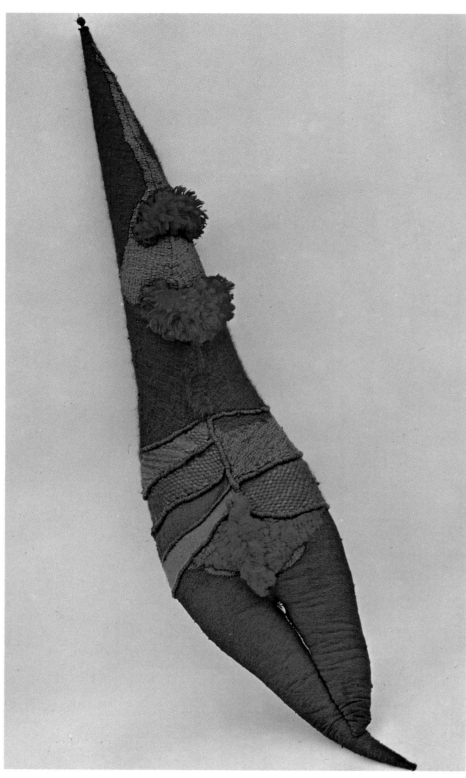

DORIAN ZACHAI

The essence of Dorian Zachai's woven forms and figure compositions, *WOMAN* and *ALLEGORY OF THREE MEN* (illustrated here), is directly related to her experiences as she outlines them herself in the following biographical sketch:

1932　Born: Jersey City, New Jersey.

1933　Started drawing and painting.

1949–1950　Graduated High School, Teaneck, New Jersey. Packed my bags and left home to live in the West Village, paint, and attend Cooper Union of Science and Art. Supported myself working in display, met the first man of my life, married him, and flunked out of Cooper Union.

1950–1955　Lived in furnished rooms and had a succession of interesting and strange jobs lasting from one day to three months, each with unemployment-insurance periods used to full advantage in between. Also got disillusioned with my ability to paint and turned seriously to dancing. Scholarship student at the New Dance Group in Manhattan.

1955　Finally stumbled into a job I could stick with and which paid well (sort of mechanical drawing), left my husband, saved money, gradually became convinced that sweaty rehearsal rooms and the artificial landscape of the city was not the life for me.

1957　Quit my job with savings and had a very happy time living a bachelor life in my seventh-floor walk-up penthouse for $18 a month on the Lower East Side. Started to learn traditional tapestry weaving at the Craft Student's League of the Y.M.C.A.

1958　Scholarship to Haystack Mountain

WOMAN: woven wool with feathers: 102″ high: 1968

School for Arts and Crafts and spent the summer there studying with Jack Lenor Larsen, Azaylia Thorpe and others. Began to know for certain that tapestry was my medium.

1958–1960 Scholarship to The School for American Craftsmen in Rochester, N.Y., and taught weaving and drawing at a progressive educational camp in the Berkshires called Shaker Village.

1960–1961 Got disgusted with the school in Rochester and went to California to study with Trude Guermonprez. Did lots of drawing and camping up and down the coast of California. Did first woven forms, serious tapestries. My direction became clear.

1961–1963 Returned to Rochester. I worked in a tiny studio and began to show my work. Frans Wildenhain became a very large influence on my life.

1963 Returned to Shaker Village in the summer and stayed for the winter in a barn with no heating or plumbing. It was difficult, but there was ample living and studio space. I lived beautifully there and accomplished a good deal of work. I learned how I wanted to live.

1964 Moved to Richmond, New Hampshire, where creative work was cut in on by work on the house, garden, and studio.

1967 Large commissions caused me to outgrow my farmhouse-ballroom-studio, and so I acquired another old house which was converted to my present studio.

collections: St. Paul Gallery and School of Art • Rochester Institute of Technology
residence: Richmond, New Hampshire

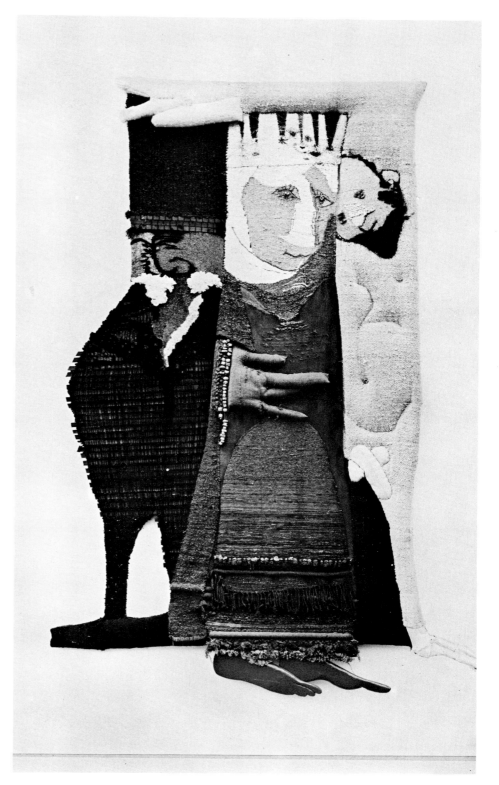

ALLEGORY OF THREE MEN: wool, silk, rayon, wood, cotton, ceramic, metallic threads, dacron stuffing: 114½″ x 78½″: 1962–1965

GLEN KAUFMAN

Artist-weavers today have turned to structural techniques not directly related to the loom. Many techniques have been revived or given a new dimension. One of these is macramé, a structural grouping of knots—most commonly the square knot. Macramé in the hands of Kaufman assumes monumental proportions, particularly in relation to a commonly used knot.

birthplace: Fort Atkinson, Wisconsin, 1932
education: University of Wisconsin, B.S. 1954 • Cranbrook Academy of Art, M.F.A. 1959 • Fulbright grant, State School of Arts and Crafts, Copenhagen, 1959–1960
teaching: Cranbrook Academy of Art (Michigan), 1961–1967 • University of Georgia, present
collections: Museum of Contemporary Crafts (New York) • Ithaca College Museum of Art
residence: Athens, Georgia

The character of material and the potential of a structural process are prime in the transformation of my ideas into objects. . . . Self-imposed limitations on choice of material work to the advantage of structure, resulting in forms that have a distinguished quality—configuration and surface are organic manifestations of this total involvement.

—Glen Kaufman

NINETEEN-SIXTY-EIGHT TOTEM: macramé, black and natural linen, plexiglass: 76″ high: 1969 (detail below)

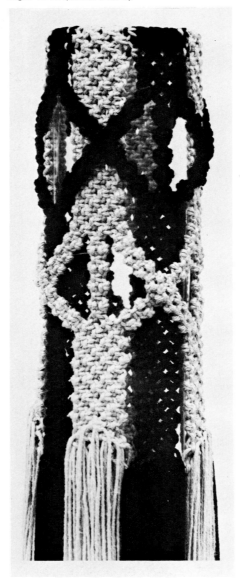

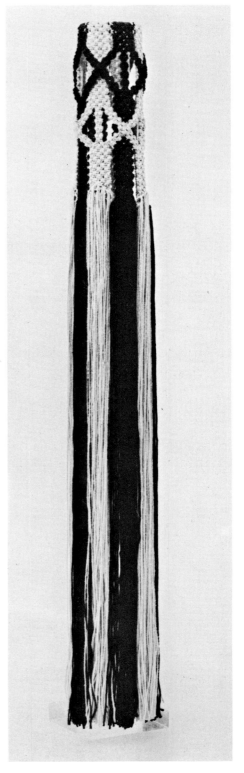

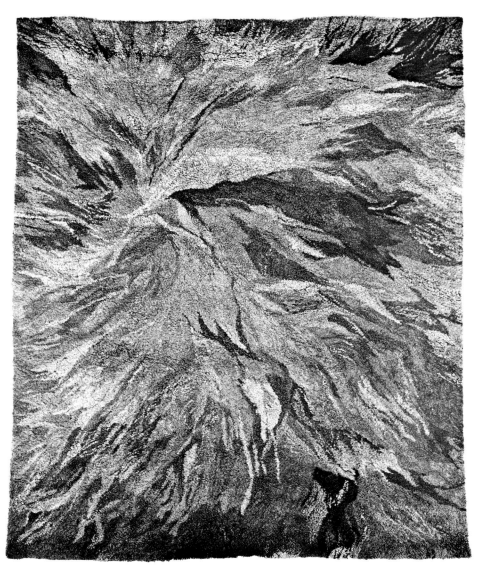

RACHEL APPLETON

Rachel Appleton is a rare contemporary weaver in that she has had no formal training in the arts; yet her rugs and wall hangings are abstract and highly sophisticated. Her special forte lies in creating new textures and new dyes. Although she has not formally taught, she has demonstrated stitchery and hooking techniques at a number of university workshops.

birthplace: Brooklyn, New York, 1920
teaching: Demonstrations at New York University • Post College (New York)
residence: Great Neck, New York

To compliment the smooth, rather cold materials used in building today, I create wall hangings that offer the viewer a variety of visual, tactile, and textural sensations to add warmth and drama to the scene.

—Rachel Appleton

WALL HANGING: hooked, hand-dyed, hand-cut wool: 120″ x 94″: 1963

WOLFRAM KRANK

Krank is one of the few inventive basket weavers in the U.S. today. After spending his boyhood in the area of Salzburg, Upper Austria, Krank entered the school of fine arts and textiles in 1957 and began collecting European folk art. This awakened his interest in American Indian designs, which influenced his own work. Calligraphy, which was included in the art courses he took, aroused Krank's interest in this nearly lost art, and he has made use of calligraphic forms in recently completed pieces. After finishing his art studies in 1962, Krank came to the U.S. on an exchange assignment as an instructor in arts and crafts.

Interest in Indian crafts coupled with the fact that the art of basketry was dying in Europe led Krank to his first experiments with weaving. The technique he developed differed from both the Indian and European basketry, and made possible more intricate designs as well as steadier forms and shapes, even though the materials he uses are the traditional reed and raffia.

Some of his later works show that traditional forms and shapes do not prevent the use of contemporary designs. This combination keeps the old art alive and vigorous in the twentieth century.

birthplace: Laufen, West Germany, 1941
education: Salzburg Fine Arts Institute (Austria)
residence: Albuquerque, New Mexico

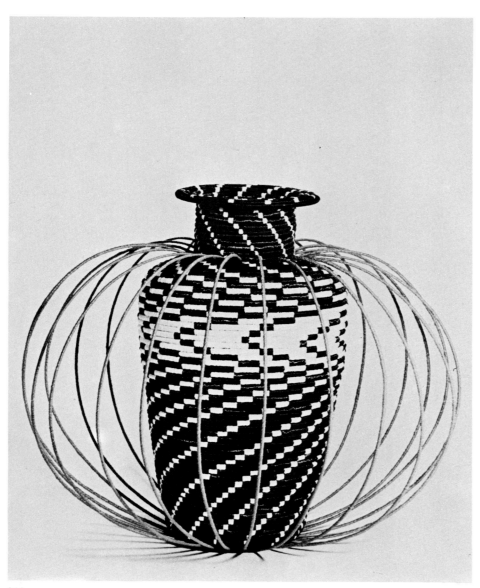

VASE WITH OUTRIDING STRINGS: woven raffia and reed: 15″ high: 1969

INDEX WITH PHOTOGRAPHY CREDITS